P9-ARU-818

THE *NATIONWIDE* TELEVISION STUDIES

The 'Nationwide' Television Studies brings together for the first time David Morley and Charlotte Brunsdon's classic texts Everyday Television: 'Nationwide' and The 'Nationwide' Audience. Originally published in 1978 and 1980 these two research projects combine innovative textual readings and audience analysis of the BBC's current affairs news magazine Nationwide.

In a specially written introduction, Brunsdon and Morley clarify the origins of the two books and trace the history of the original Nationwide project. Detailing research carried out at the Centre for Contemporary Cultural Studies at the University of Birmingham, Brunsdon and Morley recount the internal and external histories of the project and the development of media research and audience analysis theories.

In a final section The 'Nationwide' Television Studies reprints reviews and responses to Everyday Television and The 'Nationwide' Audience including comments by Michael Barratt, the main presenter of Nationwide.

David Morley is Professor of Communications at Goldsmiths College, London. **Charlotte Brunsdon** teaches film and television at the University of Warwick.

ROUTLEDGE RESEARCH IN CULTURAL AND MEDIA STUDIES

Series Advisers: David Morley and James Curran

THE *NATIONWIDE* TELEVISION STUDIES

David Morley and Charlotte Brunsdon

London and New York

First published 1999
by Routledge
11 New Fetter Lane, London EC4P 4EE

Simultaneously published in the USA and Canada
by Routledge
29 West 35th Street, New York, NY 10001

Typeset in Joanna and Bembo
by M Rules

Printed and bound in Great Britain by
Biddles, Guildford and King's Lynn

British Library Cataloguing in Publication Data
A catalogue record for this book is available from the British Library

Library of Congress Cataloging in Publication Data
A catalogue record for this book has been requested

ISBN 0–415–14879–0

For Ian Connell (1949–1998),
who always preferred *Newsnight*

CONTENTS

ACKNOWLEDGEMENTS

As the text makes clear, our first obligations are to colleagues at the Centre for Contemporary Cultural Studies, University of Birmingham, in the 1970s – particularly Stuart Hall. Ed Buscombe, then of the British Film Institute, funded part and published all of these studies – our thanks to him, and to Rebecca Barden, the current publisher, for her very considerable patience. We also thank Michael Barratt, Graham Wade, Michael Tracey and John O. Thompson and the publishers listed below for permission to reprint responses to Everyday Television: 'Nationwide' and to The 'Nationwide' Audience: Structure and Decoding.

The excerpt from 'Profile: Michael Barratt' appears by permission of Michael Barratt, Graham Wade and the publishers of Video. Graham Wade's review of Everyday Television: 'Nationwide' which was first published in Film and Video International appears by permission of the author and King Publications Inc. Michael Tracey's review appears by permission of the author and Broadcast. John O. Thompson's review appears by permission of the author and Screen Education. John Corner's review appears by permission of the author and Media, Culture and Society.

INTRODUCTION

The *Nationwide* project: long ago and far away . . .

The two books reprinted here together, *Everyday Television: 'Nationwide'* (1978) and *The 'Nationwide' Audience* (1980), were first published separately nearly twenty years ago. Each took its title from an early evening television news magazine programme broadcast on BBC 1 between 6.00 and 7.00 pm on weekday evenings from 1969 to 1984. *Everyday Television: 'Nationwide'* (henceforth ETN) was a detailed textual reading of the programme, focusing on one edition from 19th May 1976, but drawing on a year's viewing. *The 'Nationwide' Audience* (henceforth NWA) reported the findings of audience research in which the same (19/5/76) programme was shown to a range of different audience groups for discussion. Both were published by the British Film Institute, as part of their innovatory *Television Monographs* series, launched in 1973 by Christopher Williams with the publication of Nicholas Garnham's *Structures of Television*, and continued by Ed Buscombe when he became head of BFI Publishing Division. Indeed, it was Ed Buscombe who had authorised the BFI's funding for the empirical audience research which provided the material for the NWA book. The history of the research which generated these books is somewhat convoluted, and they have had a strange post-publication life, in which they have been much referred to but mainly out of print and frequently muddled up with each other (see, for example, the introduction to *Camera Obscura*, No. 20–21, where the editors of this special issue on 'The female spectator' conflate the two different books – Bergstrom and Doane, 1990: 11).

As will become clear in the narrative we recount below, the re-conceptualising of the television audience which saw publication, eventually, as NWA began some years before the analysis of the television programme *Nationwide* which was published first (ETN). Some part of our intention here is to clarify the origins of these two books and the relations of the two parts of the project which they represent. As will also become clear as this narrative unfolds, in its different phases, the work on which these books were based was done over a long period, by a large number of people besides the two of us whose names are most commonly associated with it. Again, part of our intention is to paint back in some of the background against which these two texts originally stood.

1

Both of these texts have now been unavailable in their original form for a considerable time and while they have continued to enjoy some belated reputation (for various contextual reasons, the NWA book more particularly so) this has always been primarily at second hand. At the moment of their first appearance it was ETN which commanded more attention (though largely hostile – see the reviews reprinted in the Appendix). The programme analysis was an early example of a critical engagement with 'ordinary television' and spoke to a then burgeoning debate about the significance of textual analysis, which was developing fast under the influence of the work of the British Film Institute (and most particularly its Education Department) both through its influential annual Summer Schools (at that time a must for anyone teaching in this field) and through the work of the BFI-funded journals *Screen* and *Screen Education*. Indeed, the BFI played a crucial role in this connection. It was through the BFI's investment in Film Studies and its subsequent concern with structural methods of textual analysis that continental work on semiology/semiotics (particularly the work of Guy Gauthier, 1976) was first translated and made available to an English readership, at a time when the world of scholarship associated with the sociology of mass communications had hardly begun to grapple with questions of textual meaning or methods of textual analysis.

Conversely, the NWA book emerged initially to a deafening silence (except for one percipient review by John Corner, 1981). At that time there was very little interest in matters of audience studies. From the perspective of film theory, even to do empirical audience work at all was to be caught in the travails of a low-brow empiricism, by contrast to the giddy heights of 'Theory'. Colin MacCabe, for example, seemed to imagine that the only possible alternative to theoretical work was the banality of 'the counting of heads' (1976: 25). At the same time, political economists still tended to regard audience work as unnecessary (on the grounds that what mattered were structures of ownership: once you knew them, you could predict what kinds of texts would be produced; once you knew that, you could predict their effects). Indeed, the 'common sense' of cultural studies as we have it today, with its taken-for-granted prioritisation of matters of consumption and its recognition of the importance of 'active audiences', simply did not exist at the time of NWA's publication in 1980. Hence the silence. It was only much later in the 1980s, in the wake of the publication of a series of other books with at least a partial focus on the audience – most particularly, in Britain Dorothy Hobson's *'Crossroads': The Drama of a Soap Opera* (1982), in Holland Ien Ang's (1982) *Het Geval 'Dallas'* (published in English as *Watching 'Dallas'*, 1985) and in the USA Janice Radway's *Reading the Romance* (1984/1987) – that NWA began to acquire a significant reputation and to be much discussed, at least at second hand. Unfortunately, by that time, the original texts of both ETN and NWA were out of print, and while some copies remained available for a student audience, at least in British university libraries, most of those who have heard of (or indeed, believe themselves to be familiar with the arguments of) these texts have in fact only been able to know them at second hand. It is in this context that it seemed

useful to republish these materials, so that they will once again be available for students and scholars to consult in their original forms. Here we wish to offer some brief comments on their origins.

The *Nationwide* project in 1975

Over twenty years later, it is perhaps useful to outline some of the contexts in which the *Nationwide* project developed. For it was from the beginning both a contested and a contingent choice of topic. That choice is best understood in both its local and national contexts. The local context was the Centre for Contemporary Cultural Studies (CCCS) at Birmingham University, England, a small and poorly funded graduate research centre, which had for some years struggled to organise intellectual work as a series of collective projects. These projects, some more and some less successful, were organised through topic-based 'sub-groups' such as 'Sub-cultures' (cf. Hall and Jefferson, 1976), 'Language and Ideology' (cf. Coward and Ellis, 1978), 'Women's Studies' (cf. Women's Studies Group, 1978), 'The State' (cf. Langan and Schwarz, 1985). The 1970s project of collective intellectual work is now a distant one, and so it is perhaps worth stressing that this was a widespread feature of critical intellectual life in Britain in the period (see Riley, 1992, for another account). There were Marx reading groups, Freud reading groups, women's reading groups as well as oral history projects, writers' groups and music workshops. Most of these had no institutional basis, but met in living rooms and kitchens, with shared political projects which included tackling theoretical work which might increase understanding of people's conditions of existence and the production of alternative histories and art practices (see, for example, Riley, 1992 and Pollock, 1996).

While the CCCS was an educational institution, much of the research conducted there was strongly influenced by this ethos, particularly in the membership of groups (not limited to Birmingham students), and the widely felt obligation to publish, to make work available. For the *Nationwide* project this history was significant in two ways. First, the research emerged from a history of debate and reading which was much more substantial than might at first glance seem appropriate to the analysis of this avowedly light viewing. Here, it is perhaps most useful to think of both ETN and NWA as snapshots, freeze-framing certain questions about, and approaches to, British television in this period, abstracting these ideas and arguments from a much longer process of research and discussion which involved a great many more people than the named authors. Collective work has both pleasures and perils. The perils are most clearly marked by the uncollated bundles of notes and drafts that all such projects produce. There were certainly many boxes of something labelled 'The Western' in Birmingham in the 1970s, the uncompleted labour of yet another CCCS project (see also Grossberg, 1997: 24–5). So if, on the one hand, it is always more interesting to go on thinking about the project than to write it up, on the other, there is also, nearly always, a problematic sense of appropriation in the writing up of a collective project by

particular individuals. It is partly because of this that we want here to insist on the collective origins of the *Nationwide* project and to point to the contributions of a wide range of people, most particularly Stuart Hall, Ian Connell, Roz Brody, Richard Nice, Bob Lumley and Roy Peters.

The second aspect of local context that is worth recording is that of available technology. The research for ETN was done before domestic video recorders were widely available. At CCCS we had one reel-to-reel machine. The videocassette was as yet unknown. There was thus a substantial problem of how to construct a corpus which included sufficient *Nationwide* programmes to enable us to make any general statements about the programme. Now, in 1997, our solution seems a story from pre-history, but it is worth recalling, precisely for that purpose. For if one of the histories in which the *Nationwide* work has significance is, along with Fiske and Hartley's *Reading Television* (1978) and Heath and Skirrow's 'Television: a world in action' (1977), as an early contribution to what is now known as Television Studies, the phenomenal subsequent growth of this field is unimaginable without its technological infrastructure, the domestic video recorder. In 1975, we took it in turns to go round to each other's houses every night to watch the programme together. While watching, we made a sound tape and took notes about visuals. While the 19/5/76 programme which features in ETN was analysed from video tape, all of the rest of the programmes discussed were watched and recorded in this literal, if very sociable, way. This procedure explains some of the difficulties in which we later found ourselves. For example, when writing up, it later seemed important to know the answers to questions not originally posed, such as whether all the outside broadcast reports were done, as we suspected, by male reporters, or whether Sue Lawley was always inside the studio. Not having anticipated the potential significance of these issues in the periods of collective viewing, these questions could not always be answered unequivocally from the notes we had.

Historical context of the research

As has already been indicated, graduate work at the CCCS in the early 1970s was largely organised (partly through necessity – until 1974 there were only two members of staff to supervise a large body of graduate students – and partly for ideological reasons) into largely self-regulating study groups, defined by subject area. Thus, when David Morley began to transfer his graduate work from the University of Kent (where he was registered, but where little effective supervision could be offered on his topic of research) to the CCCS, in the autumn of 1972, he joined an already preconstituted 'Media Group', whose members at that time included, among others, Ian Connell, Marina de Camargo (later Heck), Stuart Hall, Rachel Powell and Janice Winship.

The focus of the Media Group's work, at that time, which constituted the working agenda for its weekly meetings, was on the role of the TV news and current affairs programmes in the reporting of industrial and political conflict. The

theoretical framework for this analysis was centrally informed by Marxist theories of ideology – derived from Althusser initially, and later from Gramsci. It is worth noting that this period in British political life was very much dominated by large-scale industrial conflicts – notably the miners' strikes of 1972 and 1974. The latter caused a national crisis to the extent that the government of the day (led by Edward Heath) was first provoked into declaring a 'national emergency' by restricting electricity supplies to a three-day working week, in order to conserve fuel, and then was forced into calling an election, in February 1974 (amid panic stricken calls in the media, concerning the need for a coalition 'Government of National Unity'), which the Labour Party subsequently won. In the long history of British politics, all this is perhaps most notable for the extent to which the miners' victories of 1972 and 1974 served mainly to make Mrs Thatcher (then a junior minister) determined to decisively break the unions, should she ever get the chance in government – and which she did, so ruthlessly, in defeating the year-long miners' strike of 1984–5.

For our purposes here, the significance of all this is simply to demonstrate the extent to which, in the early 1970s in Britain, two quite different histories – one external and one internal – combined to affect the work of the CCCS Media Group. The external history is the one recounted above – where national politics was manifestly and visibly in a state of seemingly permanent public crisis and con-flicts, most of which were being fought out noisily in the terrain of industrial relations, with profound consequences for the world of party politics. This imposed a strong sense of political obligation on CCCS graduate students to respond to these events in some way.

The 'internal' history provided the means with which we attempted to do so – this was the point at which the imported mixture of 'continental Marxism' (Althusser, Benjamin and Gramsci) and semiology (Barthes, Eco and Gauthier) was providing what seemed like powerful new theoretical tools with which to address both the general question of the role of ideology in the maintenance and repro-duction of social order and, more particularly, the role of the media in the dissemination of this ideology. For these purposes, Althusser's (1971) essay 'Ideology and ideological state apparatuses' served an almost emblematic function in focusing the work of the Media Group at that time. The essay was both sig-nificant and enabling because of its stress on the significance of what Althusser called ideological state apparatuses (such as the Church, schools and the media), and his argument that these apparatuses – for our purposes, the media – had always to be understood as relatively autonomous from the determination of 'the economic'. This theorisation seemed to legitimate attention to the texts and audi-ences, as well as to the industrial production of media texts.

As noted above, it was thus a quite particular concatenation of factors which produced this focus. The role of the media generally was increasingly coming to be seen as of prime political importance, well beyond the realms of Marxist academia. For example, one of the broadcasting unions, the ACTT (Association of Cinematographic and Television Technicians) had produced *One Week* in

1971, an influential study of media coverage of industrial affairs. Within academia, things were changing as well – in 1972 the (then) Social Science Research Council (SSRC) had funded the Glasgow Media Group to undertake their analyses of TV coverage of industrial conflict – a significant step, in so far as this was one of the largest grants given by the SSRC, up till that time, for media related research.

This then constituted the terrain on which the CCCS Media Group was working in the period from 1972–5: the focus was principally on textual analyses of media coverage of political/industrial conflict – the classic ground of 'hard news'. The further focus was on the development of models of the relationship between the media and the state which would transcend the narrowly 'conspiratorial' Leninist model of the state as simply 'a committee for managing the affairs of the bourgeoisie' which thereby directly controlled the media, as an instrument of state propaganda (cf. Althusser, 1969; Miliband, 1973; Poulantzas, 1975). There is a clear group of CCCS publications arising from this period, all of which share an emphasis on contradiction, negotiation and the 'leakiness' of systems of power. Nonetheless, while offering some conceptual advances, in this respect (see for example Marina de Camargo's (1973) paper on ideology) this work still focused on the traditional terrain of 'hard news', on the whole. Thus, during this period, Stuart Hall produced a number of key papers on broadcasting and politics (see Hall, 1972a, 1972b, 1973a, 1973b). David Morley's own PhD work at this time consisted of a study of media news coverage of industrial conflict (see Morley, 1974) and Ian Connell, Lydia Curti and Stuart Hall's collective work focused on the textual analysis of the BBC's flagship current affairs programme *Panorama* (see Hall, Connell and Curti, 1976).

Towards the audience

However, alongside these developments, there was also another trajectory developing, albeit initially in a minor key. This trajectory was focused on the question of the need to develop a better model of the media audience than seemed to be offered by any of the various media theories on offer at the time. The choice seemed to be split between equally unhelpful (if for opposite reasons) models of either the 'hypodermic effects' of the all-powerful media or liberal models of the sovereignty of the media consumer and their relative imperviousness to media influence. Moreover, while these two models offered symmetrically opposite accounts of the power/limits of media influence, neither paid any attention to the question of how audiences made sense of the media materials with which they found themselves confronted. It was this issue – the need for some semiological theory of audience practices of interpretation of media materials – which Stuart Hall addressed in his paper 'Encoding and decoding in the television discourse', initially written for and presented at a Council of Europe Colloquy on 'Training in the Critical Reading of Television Language' at the Leicester Centre for Mass Communications Research in 1973 and first published in that year as CCCS

Stencilled Paper No. 7 (most widely known through its reprinting, in an abridged and amended form, in S. Hall *et al.* (eds), 1980).

One of Hall's sources in that paper, from whom he drew the model of dominant, negotiated and oppositional belief systems, was the sociologist Frank Parkin (author of *Class Inequality and Political Order*, 1973) who had initially been David Morley's supervisor at the University of Kent and who had, in fact, already suggested that Morley's study of media coverage of industrial conflict should be complemented by a study of its effects – or otherwise – on its audience. In attempting to develop Hall's theoretical model further, Morley drew on work in the sociology of education concerning the relationship between class, race and language, developed in Britain initially by Basil Bernstein (and by his colleague and critic at the Institute of Education in London, Harold Rosen) and in America by William Labov. That work, which addressed the (class or race-based) social determination of linguistic/cultural competence as a determinant of differential educational success or failure, was later to provide a crucial basis for the attempt to theorise audiences' differential decoding of media messages.

Drawing on these shared sources and on work in anthropology (especially Geertz), sociolinguistics (Giglioli) and on the then recently translated work of Bourdieu, Morley then produced a short paper 'Reconceptualising the audience: towards an ethnography of the media audience' (1974) which attempted to advance the model initially offered by Hall's encoding/decoding work, towards the point where it would be capable of empirical application. Hall, Morley and Ian Connell then worked together in the following year to construct a large-scale research proposal to the SSRC for funding for a detailed study of the media audience.

At this stage, the envisaged focus of the work, in line with the media group's previous orientation, was mainstream news and current affairs TV – it was the variety of audience interpretations of media coverage of industrial and political conflict which was to be the focus of the work on the TV audience. In the event, the SSRC rejected this application in the autumn of 1975, and Morley left the CCCS Media Group, in order to concentrate on the completion of his own PhD. This, among other things, left the way clear for the formulation of a new project, based on the interests of the new intake of graduate students to the CCCS that autumn.

The move from News to *Nationwide*

It was the custom of each sub-group at the CCCS to work on a shared project, and (as indicated above) by the autumn of 1975, the Media Group had completed its study of the serious BBC current affairs programme, *Panorama*. As argued earlier, this choice of 'hard' news and current affairs as the preferred object of study and the identification of 'politics' with news and current affairs programming was characteristic of the predominant orientation of media research of the period. The first of the Glasgow Media Group's books, *Bad News*, had been published in 1974,

Stephen Heath and Gillian Skirrow's analysis of *World in Action* in 1977 and Philip Schlesinger's study of the production of news programmes in 1978. At its simplest, these were all studies of obviously 'serious' programmes, using methods ranging from textual and content analysis to participant observation, to interrogate the taken for granted frameworks and values of 'serious' news. The *Nationwide* project differed from these projects in its original conception for it was from the beginning concerned with what was not newsworthy. As an object of study, it was an explicit compromise in the 1975–6 CCCS Media Group between those who wished to continue with the study of 'hard' programming and those who wished to study what was seen as generically its opposite, soap opera. From one point of view, *Nationwide* was a soft topic without being as feminised as soap opera. From another, it still had some reference to the real world, if not the real world of trade union and parliamentary politics. The choice of *Nationwide* was thus, in some ways, a compromise – an object of study in which no one had a deep investment.

However, if contingent as a choice in some ways, *Nationwide* was also extraordinarily apposite theoretically and politically. For the concerns and discourse of *Nationwide*, with its repeated emphasis on everyday life, ordinary people and common sense attitudes, displayed an uncanny proximity to theoretical issues that were beginning to be addressed both in the CCCS and in the wider left culture of the time. The work of the Italian Marxist Antonio Gramsci, first translated into English in 1971, was beginning to have a profound influence on the understanding of the state in terms of power and consent. Particularly influential were Gramsci's notion of hegemony, and his understanding of consent to class dominance as articulated through the common sense of what is taken for granted (1970s CCCS accounts of Gramsci's work can be found in Hall, 1977 and in Hall, Lumley and McLennan, 1977). For our purposes, what is significant is the way in which Gramsci's concerns with common sense provided – for those who needed it – a high theoretical justification for a concern with the trivia of *Nationwide*. This meshed with other theoretical imports, perhaps most notably Roland Barthes's analysis of 'Myth Today', the brilliant set of essays on everyday aspects of French culture, ranging from wrestling to wine (originally published in 1957, but first translated into English in 1972) and Henri Lefebvre's startling account of everyday life (1971). *Nationwide* seemed in some ways an exemplary site to explore the rather more complex understanding of the political articulated in this work, and this in turn permitted a much greater accommodation with another significant influence on the project, feminism.

The definition of the political which characterises the key 1970s analyses of news, documentary and current affairs programming was, as research such as Dorothy Hobson's revealed, a definition from which women repeatedly understood themselves excluded, and one from which they repeatedly excluded themselves. The choice to work on *Nationwide* marked a move away from this definition of the political, if not, in fact, a very big one. For the world of *Nationwide*, as ETN reveals, although addressing the viewer at home, is a world in which

home is the place of leisure. This, as feminist work of the period insisted, is not how the home seems to the domestic labourer. Thus, although the shift to *Nationwide* did involve an interrogation of the constitution of the political, we were perhaps not fully in command of some of the implications of this move.

From programme analysis to audience research

The general analysis of *Nationwide* discourse was produced by the work of the Media Group over the winter of 1975–6, in an intensive collective project involving Roz Brody, Charlotte Brunsdon, Ian Connell, Stuart Hall, Bob Lumley, Richard Nice and Roy Peters. In the late spring of 1976 David Morley rejoined the group, having completed work on his PhD, and discussions were reactivated, this time with the British Film Institute (BFI) about the possibilities of securing funding for the kind of audience research project that Connell, Hall and Morley had been planning for some time previously. In the context of the evident richness of the analysis of the *Nationwide* material, and in the context of the shift in the definition of the important/political into more quotidian terms, it was decided to abandon the initial plan to do audience research on the decoding of news and current affairs and to use, instead, the programme analysis of *Nationwide* as the baseline material to be shown to respondents in the projected audience research. The BFI, in the person of Ed Buscombe, agreed to fund this version of the project, which in fact, by this stage, as we have seen, condensed two different research trajectories.

The imperative then became to complete the programme analysis in time for the beginning of work on the audience, which was scheduled for September of 1976. At this point, the downside of the collective work which had provided the basis for the programme analysis of *Nationwide* became apparent. The summer was coming, members of the Media Group all had a number of other projects and priorities to attend to, and rich as the Media Group's collective work had been, its products only existed in the form of a large number of partial and provisional drafts of different aspects of the programme analysis. With some misgivings it was decided, after consultation with the other members of the Media Group, that Charlotte Brunsdon and David Morley would, in effect, be delegated by the group to write up their work for publication and to prepare the final analysis of the single programme (the 19/5/76 edition) which had been used for the detailed Media Group analysis. It was this programme that was then shown to the majority of the audience groups in the autumn, when the second phase of the work began (see p. 152).

We brought fundamentally different perspectives and abilities to the project – the one of us being trained in textual analysis as a literary scholar, the other a sociologist – but we also shared certain key areas of interest, in the questions of language and class then so much discussed in educational politics and in the significance of what was defined as insignificant (to put it gnomically). This latter question was perhaps best focused by our common interest in Flaubert's project

in his *Dictionary of Accepted Ideas* (published posthumously as a postscript to his unfinished novel *Bouvard and Pécuchet* and as a separate work, in English, for the first time in 1954) – in which he tried to capture, ironically, the platitudes and clichés which made up the 'common sense' of his time. Certainly, the impossible project of Flaubert's scribes, Bouvard and Pécuchet, was one we regarded with considerable affection.

In any event, we worked together to produce the analysis of the programme for use in the audience research and to prepare the programme analysis for publication. However, around the same time, there was also a significant new development on the audience theory side, in the light of which it was necessary for further work to be done on the theoretical model of the audience being used in the second stage of the project. This development concerned the growing impact in the field of the psychoanalytic model of the audience being developed within Film Studies at that time, most influentially by the BFI-supported journal *Screen*. Clearly this model raised all kinds of new issues beyond those formulated by the theories of the audience which Hall and Morley's earlier work had critiqued – especially in relation to issues of the 'construction' of the 'viewing subject' and the 'positioning/construction' of the viewer/subject by the text. Charlotte Brunsdon brought to this question a familiarity with film theory which neither Hall nor Morley possessed. On this basis, working critically with the 'heretical' material that was by then beginning to emerge from inside the *Screen* camp – crucially articles by Steve Neale (1977) and later Paul Willemen (1978) that took issue with the psychoanalytic orthodoxy's presumption that the text necessarily succeeded in positioning the subject viewer – we were able to advance the audience model to the point where we felt it had at least recognised, if not transcended, the issues raised by Screen Theory. For the CCCS Media Group 'Presentation' (an important annual ritual) in the summer of 1978 we wrote up a first draft of our critical response to *Screen*'s work on the viewing subject, an abridged version of which was subsequently written up for publication by David Morley (with substantial revision by Stuart Hall) as 'Texts, readers and subjects' (Morley, 1981a). Morley had begun the empirical audience work, showing the chosen *Nationwide* video to a range of different groups of respondents in the autumn of 1976 – work which went on (on a part-time basis) for three years, until 1979. Our jointly written programme analysis (ETN) was completed in 1977 and published in 1978. The *'Nationwide' Audience* book was then written up by Morley and published in 1980.

The lessons of *Nationwide*

Many commentators have pointed to the peculiar 'nationalness' of broadcast television. John Ellis, in a resonant phrase, characterised television as 'the private life of the nation state' (1982: 5). John Caughie, discussing the experience of watching American television, points to the way in which much writing about television, particularly that which stresses the postmodernity of the medium, is

insensitive to the national specificities of particular broadcasting systems, ignoring 'the extent to which viewing is formed within particular national histories and localised broadcasting systems' (1990: 47). Karen Lury has emphasised the way in which this national viewing is also uniquely formed, for each individual, through generation and domesticity (1995). Each of these arguments points us, in different ways, to the recalcitrant localness of much television, of which *Nationwide* is a prime example. For while there is an enormously significant international trade in television programmes, in which, for example, the USA exports glamour, Britain olde worlde and Mexico passion, there is also the television, like *Nationwide*, which is never exported. If the Media Group was correct, as we would maintain it was, to argue that the key significance of *Nationwide* was to be found not in its defiantly uncategorisable range of items, but in its links – the way in which these items were made sense of for viewers – we would use this argument to posit an homologous structure in national television. It is in the never-to-be-exported channel 'idents' and links, weather forecasts, regional news and continuity announcements that John Ellis's private life of the nation state is to be found. For we would still maintain that it is in what is taken for granted – these seemingly inconsequential matters of 'mere continuity' – that we find the most embedded assumptions about the conduct of social life (cf. Hall, 1977 on the limits of common sense).

This argument, of course, has particular consequences for research that tries to address the peculiarities of any national broadcasting system other than that of the USA. The very non-exportability of the programmes makes any academic discussion of them most unattractive to publishers with an eye always to the lucrative US market. We have certainly both been involved, as editors, in quite protracted arguments with publishers about cases of exemplary scholarship on broadcasting in small European countries which have, in the very specificity and historical detail which makes them so good, been deemed unpublishable – because they will not sell abroad and crucially, not in the USA. Inexorable market logics dictate that publishers prefer three main addresses to television: analyses of widely exported programmes (for example, *Dallas*); analyses of the political economy of these international media flows; or theoretical writing at a relatively high level of abstraction about the nature of television as a medium. While ETN provoked considerable response when first published in Britain (see Responses), in this context, it is perhaps easy to see why it did not 'travel' well. Who anyway, in another country, wants to read about a British magazine programme with a regional emphasis and lots of trivial items about everyday life?

Thus, we would argue that the analysis of *Nationwide* is useful methodologically for what was, at the time, its controversial focus on what was conventionally seen as the unimportant and trivial. Not just the programme as such – although this might explain the vitriol of some of the responses to it, just as analyses of Disney have been castigated for their overpoliticisation of innocent entertainment – but, within the programme, on the transparent discourse of programme watching, of being part of the *Nationwide* family/nation. However, in its analysis of the image

11

of England that *Nationwide* promoted, we would suggest that the Media Group anticipated what has subsequently become a major concern of the critical left, the construction of English heritage. Writing in the mid-1970s, Raymond Williams (1975) was one of the few critics to whom we could refer for an account of the construction of certain images of the English countryside. Since then, Benedict Anderson (1983), in a widely quoted monograph, has defined a nation as 'an imagined community', while writers such as Patrick Wright (1985) and Raphael Samuel (1989) have addressed, in illuminating detail, the elements and attachments of feeling English. Looked at in retrospect, *Nationwide* emerges as an exemplary site, in the 1970s, for the construction of a particular type of white lower middle class national (ethnic?) identity as Englishness. This world of semi-rural hobbies, of enterprising individuals with no time for bureaucrats, and of 'one-of-us' reporters, pre-shadows more than one aspect of 1980s Britain. John Corner and Sylvia Harvey (1991) have suggested that British national life in the 1980s was dominated by the couplet of 'Enterprise and Heritage' – surely a most useful pairing with which to approach that articulation of region and nation, family and individual which characterised the *Nationwide* world. A world of which it could become possible to claim, ironically and appropriately, that there was 'no such thing as society'.

However, it is not just that imagined *Nationwide* community that seems significant in retrospect. There are also many aspects of the programme's format which have become very much more familiar in later years. Here, we would insist that we did and do recognise that, in terms of the history of both the BBC and British television, *Nationwide*'s precursor, *Tonight* (1957–65) was the more significant programme. It was *Tonight* which pioneered the use of the early evening slot as a magazine programme which combined the zany, the humdrum and the serious. With the launch of British Breakfast Television in the 1980s and the subsequent increase in daytime programming, the magazine format, with its distinctively ordinary studio anchors, has become one of the dominant forms of British television. And here *Nationwide* is perhaps more significant than *Tonight*. For the *Tonight* reporters (all journalists) combined hard news training – say Julian Pettifer – with a certain licensed eccentricity – Fyfe Robertson. Not for *Tonight*, except significantly perhaps most noticeably in the key studio anchor, Cliff Michelmore, that aspiration to embody the ordinary that was so significant in *Nationwide*. When Frank Bough's career was subsequently damaged by allegations of cocaine-taking and wild sex in the British tabloid press, the damage was so much the greater for the success of Bough as the ordinary, cardigan-wearing, slightly boring character that we discuss in ETN. It is this heritage of the ordinary that we find in the success of Richard and Judy on *This Morning*, a programme which uncannily reproduces the regional repertoire of *Nationwide* in its phone-in segments. In *This Morning*'s version, a map of England's outline fills the screen, with little illuminated points showing where 'Della from the Isle of Wight' or 'Ray from Upminster' are calling from, linking them in to the central core of Richard and Judy, who had themselves to be relocated from Liverpool to London, apparently because studio guests didn't like

the journey to Liverpool. Unlike *Nationwide*, there is no intermediary regional tele-vision team – just regional individuals checking in to the television nation. *This Morning*, like *Nationwide* and *Tonight* before it, is just one of the sites on which what Anderson (1983) calls the 'horizontal camaraderie' that is national identity is con-structed and reconstituted daily, along with its own patterns of inclusion and exclusion.

Looking back

In some respects we would still defend the value of the programme analysis in ETN as being of significance beyond the life of *Nationwide* as a programme. In formal terms, the emphasis we placed on the – seemingly transparent – 'links' dis-course (later developed in the work of John Morey, 1981) foreshadowed the British television channels' own increasing concern with the impact of their on-screen logos and 'idents' (cf. the marketing of Channel 4 and later BBC2, using these techniques). In substantial terms, *Nationwide* also provided a crucial training ground for people – most notably perhaps Michael Barratt, Frank Bough and Sue Lawley – who have subsequently occupied key positions in contemporary broad-casting. The programme's emphasis on 'ordinary talk' (cf. Livingstone and Lunt, 1994) would seem to foreshadow much of the content and style of contemporary daytime television. Moreover, the BBC itself has never quite given up the attempt to subsequently re-invent *Nationwide* (for example, in the mid-1990s, with *Here and Now*, one of whose reporters offered, in the edition of 10/3/97, a report on homelessness which was trailed in advance as coming '16 years after his first report on this subject for *Nationwide*'). Despite its relatively low status as a pro-gramme at the time, *Nationwide* has come to be seen, retrospectively, as one of the BBC's most unique achievements, in so far as it managed to invent a formula which effectively combined the popular (the 'common touch'), with the quirky, successfully domesticated the 'important' – and in so doing reached a huge early evening audience, all over the country.

However, if we would defend our choice of object of study for these reasons, we must, nonetheless, definitely put our hands up to most charges in John O. Thompson's delicately made, but trenchant critique of ETN (1978, reprinted in this volume, see Responses). The paradox of the position advanced in ETN is to be found in the disjunction between our chosen object of study and, ultimately, our method of analysis. For while *Nationwide* was particularly amenable to an ana-lysis which outlined the contours of the common sense of Middle England in the 1970s, and while, as we have observed, elements of the format are particularly significant for the broader study of television and have had great longevity, we did not rest there. For our approach, much, if unevenly, influenced by Godardian notions of materialist analysis, was committed to the revelation of the real rela-tions beneath the *Nationwide* surface. While we would stand by the argument, which suggested that the celebration of eccentric regional and individual differ-ence stands in for the recognition of structural inequalities of class, nationality,

ethnicity *and* region, we would now recognise that we did not give much thought to what this 'television of real relations' would be like *as television*. Perhaps, specifically, as the sort of television you might flop into a chair and watch at the end – or in the middle – of a day's work. Here, the research is most clearly marked by what is retrospectively a species of 1970s left Puritanism, in which notions of entertainment – in particular – were illegitimate. Which is not at all to suggest that *Nationwide*, as entertainment, did not do much of what we suggested. But perhaps nowadays we would be more sympathetic to the skate-boarding duck.

From *Nationwide* to Rodney King

To conclude with the future – or at least the recent past. Darnell Hunt (1997) has recently published an account of the televising of the 1992 Los Angeles 'riots'. Using some of the methods of programme analysis outlined in ETN, Hunt made a reading of what he calculated to be the key, much repeated 17 minutes of KTTV coverage of the civil disturbances which followed the acquittal of the police officers charged with the beating of Rodney King. Hunt's project was to bring together what he characterises as the two houses of critical media studies and the sociology of race, to examine the extent to which both the televising, and the watching, of those 17 minutes contributed to the differential race-ing of the USA. He then pursued the analysis by showing these 17 minutes of television to 15 differently raced Los Angelino groups (5 Latino-raced, 5 white-raced, 5 black-raced) and recording both the viewing and subsequent discussion. In the analysis of the audience material, Hunt draws particularly on the work of Stuart Hall, NWA and Liebes and Katz (1991). He provides both quantitative and qualitative empirical data to support a sophisticated account of differently raced readings of the news coverage, while at the same time working with a notion of 'race-ing' as, in part, a process made and re-made, for all concerned, in just such broadcasts. Hunt's project was a carefully planned and executed one, in which the decision to investigate audience readings of a controversial news event governed his choice of the textual material for analysis by the groups.

As we have tried to show, the *Nationwide* project lacked this integration, which had particular consequences for the audience research. Morley found himself, on occasion, showing material to groups whose most significant response was that they would not normally have watched the programme. But even without this integration, we would suggest that there is a productive and necessary tension between a text analysed, as Hunt does with the news coverage, or the Media Group did with *Nationwide*, and a text shown and discussed with others. So we would, after all these years, still wish to maintain that most texts do indeed propose a preferred reading, with which most audience members enter some kind of negotiation – and that textual analysis designed to identify the preferred reading of the text in question retains an important place in any audience research project. However, if we have here retrospectively attempted to (re)establish a certain 'preferred reading' of our own texts, we would nonetheless end by endorsing the

wisdom of Janice Radway's comments in her introduction to the British edition of *Reading the Romance*: 'Whatever her intentions, no writer can foresee or prescribe the way her book will develop, be taken up, or read' (1987: 2).

Appendix – print history

ETN was published in 1978. Sections of it were subsequently reprinted in the collection entitled *Popular Film and TV* (1981) edited by Tony Bennett *et al.* and published jointly by the BFI and the Open University Press, in association with the Open University's 'Popular Culture' course. More recently, Chapter 3 of ETN was reprinted in John Corner and Sylvia Harvey's collection *Television Times* (1996).

NWA was published in 1980. A summary version of the research was published as Unit 12 of the Open University's 'Popular Culture' course in 1981. David Morley subsequently published an auto-critique of this work 'The Nationwide Audience: a critical postscript' in *Screen Education* No. 39, 1981b; Sections of the NWA book have subsequently appeared in Parts 1 and 2 of Morley's *Television, Audiences and Cultural Studies* (1992).

Bibliography

ACTT (1971), *One Week: A survey of TV coverage of union and industrial affairs in the week January 8–14 1971*, London: Association of Cinematographic and Television Technicians, TV Commission.

Althusser, L. (1971), 'Ideology and ideological state apparatuses: notes towards an investigation' (1969), in *Lenin and Philosophy and Other Essays*, translated by Ben Brewster, New Left Books, London.

Anderson, B. (1983), *Imagined Communities*, Verso, London.

Ang, I. (1982), *Het Geval 'Dallas'* Amsterdam: Uitgeverij SUA, translated by Della Couling and published as (1985) *Watching 'Dallas'*, Methuen, London.

Barthes, R. (1967), *Elements of Semiology*, Jonathan Cape, London.

Barthes, R. (1972), *Mythologies*, translated by Annette Lavers (first published 1957), Jonathan Cape, London.

Bennett, T., Boyd-Bowman, S., Mercer, C. and Wollacott, J. (eds) (1981), *Popular Television and Film*, London: British Film Institute in association with The Open University.

Benjamin, W. (1973), *Illuminations*, Fontana, London.

Bergstrom, J. and Doane, M. (1990), 'The female spectator: contexts and directions' *Camera Obscura* 20–1: 5–27.

Bernstein, B. (1971), *Class, Codes and Control*, Paladin, London.

Camargo Heck, M. (1974), 'The ideological dimensions of media messages', Stencilled Occasional Papers, No. 10, CCCS, University of Birmingham.

Caughie, J. (1990), 'Playing at being American: games and tactics', in P. Mellencamp (ed.) *Logics of Television*, BFI and Indiana University Press, London and Bloomington.

Church, M. (1977), 'Care, concern and righteous indignation', *The Times*, 29/3/1977: 9.

Corner, J. (1981), '*The Nationwide Audience*: Structure and Decoding' (Book review) in *Media, Culture and Society*, Vol. 3, No. 2, April 1981, 197–200.

Corner, J. and Harvey, S. (eds) (1991), *Enterprise and Heritage*, Routledge, London.

Corner, J. and Harvey, S. (eds) (1996), *Television Times*, Arnold, London.

Coward, R. and Ellis, J. (1978), *Language and Materialism*, Routledge & Kegan Paul, London.

Eco, U. (1973), 'Towards a semiotic inquiry into the TV message', *Working Papers in Cultural Studies*, No. 3, CCCS, University of Birmingham.

Ellis, J. (1982), *Visible Fictions*, Routledge & Kegan Paul, London.

Fiske, J. and Hartley, J. (1978), *Reading Television*, Methuen, London.

Flaubert, G. (1954), *The Dictionary of Accepted Ideas*, translated by J. Barzun, New Directions, New York.

Garnham, N. (1973), *Structures of Television*, Television Monograph 1, British Film Institute, London.

Gauthier, G. (1976), *The Semiology of the Image*, Educational Advisory Service, British Film Institute, London.

Geertz, C. (1973), *The Interpretation of Cultures*, Basic Books, New York.

Giglioli, P. (ed.) (1972), *Language and Social Context*, Penguin, Harmondsworth.

Gillman, P. (1975), 'Nation at large', *Sunday Times Colour Supplement* 2/3/1975: 52–6.

Glasgow Media Group (1974), *Bad News*, Routledge & Kegan Paul, London.

Gramsci, A. (1971), *Antonio Gramsci: Selections from the Prison Notebooks*, (eds) Q. Hoare and G. Nowell-Smith, Lawrence & Wishart, London.

Grossberg, L. (1997), *Bringing It All Back Home*, Duke University Press, Durham, NC.

Hall, S. (1972a) 'The external/internal dialectic in broadcasting', Fourth Symposium on Broadcasting, Department of Extra-Mural Studies, University of Manchester.

Hall, S. (1972b), 'The limitations of broadcasting', *The Listener*, No. 16.

Hall, S. (1973a), 'Deviancy, politics and the media', in P. Rock and M. McIntosh (eds) *Deviance and Social Control*, Tavistock, London.

Hall, S. (1973b), 'The structured communication of events', 'Obstacles to communication' Symposium, UNESCO, Paris.

Hall, S. (1977), 'Culture and the ideological effect', in J. Curran *et al.* (eds) *Mass Communication and Society*, Arnold, London.

Hall, S. (1980), 'Encoding/Decoding', in Hall, S., Hobson, D. Lowe, A. and Willis, P. (eds) *Culture, Media and Language*, Hutchinson, London.

Hall, S., Connell, I. and Curti, L. (1976), 'The "unity" of current affairs television', *Working Papers in Cultural Studies*, no. 9: 51–93.

Hall, S., Lumley, B. and McLennan, G. (1977), 'Politics and ideology: Gramsci', in *Working Papers in Cultural Studies*, no. 10: 45–76.

Hall, S. and Jefferson, T. (eds) (1976) *Resistance Through Rituals*, Hutchinson, London.

Heath, S. and Skirrow, G. (1977), 'Television: a World in Action', *Screen* 18.2: 7–59.

Hoare, Q. and Nowell-Smith, G. (eds) (1971) *Antonio Gramsci: Selections from the Prison Notebooks*, Lawrence & Wishart, London.

Hobson, D. (1982), *'Crossroads': The Drama of a Soap Opera*, Methuen, London.

Hunt, A. (1980), 'Everyday story of studio folk', *New Society* 28/2/1980: 457–8.

Hunt, D. (1997), *Screening the Los Angeles 'riots'*, Cambridge University Press, Cambridge.

Labov, W. (1970), 'The logic on non-standard English', in N. Keddie (ed.) *Tinker Tailor: the Myth of Cultural Deprivation*, Penguin, Harmondsworth.

Langan, M. and Schwarz, B. (eds) (1985), *Crises in the British State*, Hutchinson, London.

Lefebvre, H. (1971), *Everyday Life in the Modern World*, translated by S. Rabinovitch (first published 1968), Allen Lane, London.

Liebes, T. and Katz, E. (1991), *The Export of Meaning*, Oxford University Press, Oxford.

Livingstone, S. and Lunt, P. (1994), *Talk on Television*, Routledge, London.

Lury, K. (1995), 'Television performance: being, acting and "corpsing"', *New Formations* 26: 114–27.

MacCabe, C. (1976), 'Principles of realism and pleasure', *Screen*, Vol. 17, No. 3: 17–27.

Miliband, R. (1973), *The State in Capitalist Society*, Quartet Books, London.

Morey, J. (1981), 'The space between programmes: television continuity', Department of Educational Media, Institute of Education, London University.

Morley, D. (1974), 'Reconceptualising the audience: towards an ethnography of the media audience', Stencilled Paper no. 9, CCCS.

Morley, D. (1981a), 'Texts, readers and subjects', in S. Hall *et al.* (eds) *Culture, Media, Language*, Hutchinson, London.

Morley, D. (1981b), 'The *Nationwide Audience*: a critical postscript', *Screen Education* No. 39.

Morley, D. (1992), *Television, Audiences and Cultural Studies*, Routledge, London.

Neale, S. (1977), 'Propaganda', *Screen*, Vol. 18, No. 3: 9–40.

North, R. (1976), '*Nationwide*: the teatime circus', *The Listener* 30/9/1976: 391.

Parkin, F. (1973), *Class Inequality and Political Order*, Paladin, London.

Pollock, G. (1996), 'The politics of theory', in G. Pollock (ed) *Generations and Geographies*, Routledge, London.

Poulantzas, N. (1975), *Political Power and Social Classes*, New Left Books, London.

Radway, J. (1984), *Reading the Romance*, University of North Carolina Press, Chapel Hill. British edition (with new preface), 1987, Verso, London.

Riley, D. (1992), 'A short history of some preoccupations', in J. Butler and J. W. Scott (eds) *Feminists Theorise the Political*, Routledge, New York.

Samuel, R. (1989), 'Exciting to be English', Introduction to R. Samuel (ed) *Patriotism: The Making and Unmaking of British National Identity*, (Vol. 1), Routledge, London.

Schlesinger, P (1978), *Putting Reality Together*, Constable, London.

Thompson, J. O. (1978), 'A nation wooed', *Screen Education* No. 29: 90–6.

Willemen, P. (1978), 'Notes on subjectivity', *Screen*, Vol. 19, No. 1: 41–69.

Williams, R. (1975, first published 1973), *The Country and the City*, Paladin, London.

Women's Studies Group (ed.) (1978), *Women Take Issue*, Hutchinson, London.

Wright, P. (1985), *On Living in an Old Country*, Verso, London.

Young, H. (1993, 3rd edn 1989), *One of Us*, Macmillan, London.

Part I

EVERYDAY TELEVISION: *NATIONWIDE*

Charlotte Brunsdon
David Morley

produced by
The British Film Institute
Educational Advisory Service

This study of the BBC's *Nationwide* attempts to produce a 'reading' of the pro-gramme which reveals the ways in which it constructs an image of its audience. Specifically, the study details the methods through which the programme addresses itself both to a national audience, united in the diversity of its regions, and an audience of ordinary individuals, grouped in families: everyday television for everyday people.

The authors
Charlotte Brunsdon is a research student and David Morley a research associate at the Centre for Contemporary Cultural Studies, University of Birmingham.

CONTENTS

CONTENTS

ACKNOWLEDGEMENTS

We should like to thank Nadine Cartner for taking the photographs and the BBC for permission to use them. We are also grateful to the BBC and Michael Barratt for permission to publish the transcript in Chapter 3.

PREFACE

The work on which this monograph is based was originally carried out collectively by the Media Group at the Centre for Contemporary Cultural Studies, University of Birmingham, in the period 1975–6. Its members were: Roz Brody, Charlotte Brunsdon, Ian Connell, Stuart Hall, Bob Lumley, Richard Nice, Roy Peters. This work was discussed by the group and individuals wrote up contributions on different aspects of the programme. Since then, we have worked from this material to produce the present monograph, incorporating some of the writing produced at the first stage, although sometimes in relation to different problems from those originally addressed. The Media Group have all read and commented on this work at different stages, and in this context we are particularly grateful to Stuart Hall. We would also like to thank Ed Buscombe for his help.

Our analysis focuses on the ideological themes articulated in the programme, only partially relating these to their material bases in the formal properties of the discourse, and we have not integrated the visual level of the analysis into the central argument – this is one of the most obvious limitations of the work. We have also found ourselves, at times, wanting to make arguments for which we do not have sufficient data because of the different ways in which problems were originally posed. This has happened, for example, in relation to questions concerning women and the family, which were not focused originally as major concerns, but which have come to occupy a more explicit space in the analysis. It has frequently been a case of recognising only at a later stage what questions should have been asked of the material in order to produce satisfactory data.

The *Nationwide* programme examined in some detail in Chapter 3 of this monograph has subsequently been used within a research project, funded by the British Film Institute, on 'the encoding and decoding moments in television discourse and programming': this has been under way at the Centre for Contemporary Cultural Studies since September 1976. This work constitutes an attempt to explore the range of differential decodings of the programme arrived at by individuals and groups in different socio-cultural locations. Within the context of the larger study, then, the programme analysis presented here constitutes the base line against which differential readings may be posed, and our reading of the programme will be open to modification in the light of the audience work.

<div style="text-align: right">

C.B.

D.M.

</div>

1

GOING *NATIONWIDE*

(i) Nation and Regions: the historical development of the programme

Nationwide was started in 1966 as part of a strategy adopted by the BBC to meet three different needs. First, there was the necessity to build on the 'spot' established by *Tonight*, and to produce a programme which would carry through the solid audiences for the early regional news into BBC1's major evening output beginning at 7 p.m. On the other hand, there was the need to meet the criticism that the BBC output was too much dominated by the metropolis and thus failed to express/deal adequately with the needs of 'the regions'. The regionalism of *Nationwide* was seen as a necessary basis for any sense of national unity in the conditions of the late 60s and 70s or, as the BBC evidence to Annan put it:

> local and regional services are an essential part of a truly national broadcasting system.
>
> (BBC Handbook, 1978)

Finally, there were the recommendations made by the McKinsey Report and developed in the BBC policy document, *Broadcasting in the 70s*, that fuller use should be made of the company's regional studios, allowing for regional specialisation and a 'rationalisation' of resources (and cost-effectiveness).

The regional element has always been crucial to *Nationwide* – the idea:

> is to impress on the viewer that this is a programme which is not dominated by London and which embraces every main centre in the UK.
>
> (William Hardcastle reviewing current affairs schedules;
> quoted in Connell, 1975)

So much so that when *Nationwide* 'looked at London' in the film 'Our Secret Capital' (*Nationwide* 16/8/76) Julian Pettifer, the presenter, consciously acknowledged the programme's brief by saying:

> On *Nationwide* we try desperately not to be a metropolitan programme.
> Tonight is an exception. For the next 25 minutes we're looking at life in
> London: but we offer no excuse, because after all, wherever you live in
> the UK, London is your capital . . .

Similarly Stuart Wilkinson (deputy editor of *Nationwide*) claimed that:

> *Nationwide* would not be a nationwide programme without this facility to
> involve our colleagues in the regions. The crosstalk between the regions
> is the very essence of the programme.
>
> (Quoted in Brody, 1976: 20)

The programme attempts to construct a close and 'homely' relationship with its
regionally differentiated audiences: this can be seen clearly in the programme's
self-presentation, or billing, in the *Radio Times*:

> Reporting England: Look North, South Today, Look East, Midlands Today,
> Points West, Spotlight South West.
>
> (*Radio Times* 29/3/77)

> Today's news and views in your corner of England presented by the
> BBC's regional newsrooms. Then . . . take a look at the scene *Nationwide*.
>
> (*Radio Times* 13/1/76)

> . . . present news and views in your region tonight. Then at 6.22 . . .
> present some of the more interesting stories of life in today's Britain . . .
>
> (*Radio Times* 14/1/76)

> News and views in your region tonight. Then the national scene pre-
> sented by . . .
>
> (*Radio Times* 15/1/76)

> . . . present the British scene to the people of Britain . . .
>
> (*Radio Times* 16/1/76)

Nationwide is positively involved in the search for regional variety: of customs and
ways of life. Indeed 'Let's go *Nationwide* . . . and see what the regions think . . .'
becomes the characteristic *Nationwide* form of presentation. Thus the programme is
able to stress regional differences (different dishes, superstitions, competitions), to
present a Nation composed of variety and diversity, but also to unify the regions
in the face of National Crises: 'How is Leeds coping with the drought? What
about the South-West?' (17/8/76).

We see variations in regional responses to issues given by the centre: classically,
regional variations in the celebration of the Jubilee. But the regional is still con-
tained within the national: regionalism is the life-blood of *Nationwide*, but
full-blooded separatist or nationalist movements – such as the Irish Republican

Movement – transgress the limits of the Nationwide discourse, breaking as they do the assumed frame of the 'United Kingdom'.

Similarly, within the programme, the links over to regions are usually from London, and are used to 'fill out' regional aspects of something of national import; the regions do not usually initiate stories. The regions follow, and are linked to the national news – they pick up stories signalled in the national news and flesh out their significance for the region. The input of 'regional stories' – material drawn from the 'life of the region' – is subordinate to this 'national with regional effects' input; the regional variations are orchestrated from the central London studio base. London is the 'absent' region, the invisible bearer of national unity. It is both technologically and ideologically the heart of the programme.

(ii) The world of *Nationwide*: the *Mandala*

During the period in which we viewed the programme, Nationwide regularly opened with the use of a specially designed graphic device – a lengthy sequence in which the basic concentric patterns altered through the superimposition of different images, ending in an abstract which culminated in the programme title. This device was based on the Mandala, an oriental mystical symbol of the universe. In its original form, various aspects of the life of samsara (the cycle of birth and death) or religious representations of the deity were depicted. Mandala is a Sanskrit word meaning 'magic circle' and its basic pattern is a set of concentrically arranged figures with radial or spherical emblems arranged around a central point. It was the term which Frank Bough used to describe the opening sequence of the programme. (See figs. 1–3.)

Deprived of its celestial resonance, the Mandala which heads Nationwide does seem to have a similar function to the Buddhist version. It suggests that 'all human life is there' – tied together at the central point ('the still point of the turning world') which is, of course, Nationwide itself. The device does symbolise something which is essential to the programme – unity in diversity. The form of the device – both the way the images work and the accompanying music – represent something of how the programme sees itself: the whole introduction can be read as a meta-discourse about the programme itself. The wheel suggests constant movement around the country surveying everything of interest. The points of the compass index its outward, regional viewpoint – each wheel being representative of the various Nationwide regions. But the device – like the programme itself – is centred – everything flowing out of and returning to a single source.

The basic pattern of the Nationwide Mandala then, consists of a set of turning wheels whose movement emanates from a central source. The abstract pattern is then followed by a set of tone images, in which are depicted something of the range and variety of topics to be dealt with by the programme. The fact that the screen is occupied at any one time by more than one image produces a split-screen effect – connoting both the simultaneity of 'things going on' at any one time, but also, as the images play off against and between one another, setting up a play of

inter-textuality between the various signs. After the initial sequence, at least one spot is occupied at any one time by a *Nationwide* reporter or presenter, suggesting that these multifarious aspects of our national life are brought to you, the viewers, by 'our' men and women in the field. These reporters are given by *Nationwide*, and signified in the *Mandala* as occupying, a privileged 'overseeing' role in relation to the actuality events depicted in the other wheels. Hence, the attention is also drawn towards the programme's mediating role – we see, know about and participate in events through the crucial intervention in the field of the presenters who act as go-betweens, like 'fences' between us and the world. It is the presence of the reporters, plus the pattern of the device itself, which holds everything together in this opening sequence. The reporters constitute *Nationwide*'s effective repertorial unity. The long arm of the *Nationwide* team is seen to stretch into every corner of our lives to gather material for us and bring it back to the 'home' base.

(iii) Programme format and slot

The magazine format of *Nationwide* – short items (rarely longer than 10 minutes), light relief mixed in with 'heavy fare' to hold the viewers' attention – 'the Postmaster General mixed with a tattooed cat' (quoted in Gillman, 1975) is to some extent determined by the slot that the programme occupies: the break between children's TV and the BBC's major evening output. The programme is usually followed by light entertainment, family shows, quizzes or the like – it is a time of evening when, as Michael Bunce (one-time editor of *Nationwide*) put it:

> people have had a hard day's work and when they sit down they don't want a remorseless, demanding, hard tack diet every night.
>
> (Gillman, 1975)

There is, therefore, a deliberate policy in *Nationwide* to include light items, especially when the programme contains some 'heavy fare'. Barratt argues:

> We need some light relief if we are to hold the viewer's interest: there's a limit to the serious fare they can absorb or want to at this time of evening.
>
> (Quoted in Brody, 1976)

These 'common sense' definitions of the nature of the 'slot' – when people are coming in from work, when the whole family including children will be present, when no sustained attention is possible, etc. – allow us to construct *Nationwide*'s own sense of its responsibilities and its constituency.

The space from 6 to 7 p.m. does tend also to be populated by domestic serials, comedies, panel games, and *Nationwide* is 'contaminated' by, or actively parasitic upon, these alternative genres, as well as aspects of the time zone preceding the early evening news, that reserved for children's programmes. Thus the history of

the time slot makes available a certain range of genres which all have a common sense appropriateness to that hour of the day. This is the basis for some of *Nationwide*'s quality of heterogeneity and also for the oscillations of tone within some of the items.

(iv) The *Nationwide* style of presentation

In his autobiography, Barratt spells out a key element in the 'Nationwide Style':

> The art of communication on any topic – whether it be life itself, or the price of porridge – demands the use of easily understood words, and is greatly heightened by skilful illustration.
>
> (Quoted in Brody, 1976: 24)

The stress is on direct and effective communication – 'simple language, common language if you like' (Michael Barratt) – getting it across to the people. Thus, when 'heavy' items are dealt with, *Nationwide* is primarily concerned to 'establish the point at the heart of the matter' and concentrate on getting that over, unlike, for instance, *Panorama*, which, after 'establishing the topic', will explore the different perspectives and dimensions of it, offering a range of views and definitions for the audience's 'education' (cf. Connell *et al.*, 1976).

The discourse of *Nationwide* then is relatively closed; the stress on 'making the issues comprehensible', translating them into 'real terms', leaves little space for interpretation. The endeavour for *Nationwide* is to establish the time/place/status/immediacy of events and people involved in them – making these, where possible, concrete and personalised – and to get the 'main point' of an item across to the audience.

In *Nationwide* there is a thread almost of anti-intellectualism; 'experts' are held in some value for what they may have to contribute, but it all has to be translatable into the language of immediate issues and everyday concerns.

Thus, while experts expound on 'the causes of inflation', the *Nationwide* team do their best to find out what inflation really means, how it will affect 'our' day-to-day living, whether anything can be done about it ('Yes, minister, but how will that improve the situation here tomorrow . . .'). The team often expresses 'our' exasperation with politicians by asking them 'down to earth' questions. This can be seen in the different interviewing styles of *Nationwide* and *Panorama*; a *Panorama* interview with the Chancellor will tend to probe and challenge his position with reference to the positions of opposing political parties and economic experts. The challenge put by *Nationwide* interviewers will tend much more to be at the level of practical policy making: 'will it help/work?' and will often take the form of a 'common sensical' perspective in terms of which politicians of all parties are likely to be seen as culpable. This style of interviewing is directly in the tradition of *Tonight* and its style of popular journalism – once described as the 'discipline of entertainment':

> We are flippant, irreverent, disbelieving when we feel we should be; we
> refuse to be taken in by pompous spokesmen . . .
>
> (Cliff Michelmore, introducing the programme
> after summer break, 1961)

Implicit in this perspective is a populist ideology which takes for granted the
irrelevance of 'politics' to the real business of everyday life ('Whichever party is
in power I'll still not have a job. Prices will still rise . . .') and also takes for
granted the disillusionment of the electorate with 'politicians' and their promises.

The 'serious issues' – unemployment, inflation, etc. – which are the basis of
most current affairs programming, can therefore only enforce attention within the
Nationwide discourse where they can be shown to have immediate effects on every-
day life; when this happens *Nationwide* can wheel in Robert McKenzie and his
clipboard and graphics to tell us what this 'IMF loan business' is all about. But,
even on such occasions, everyday life and its continuities (nature, sport, enter-
tainment, quirky events) are, within the *Nationwide* world, what 'frame' these
issues, and are called upon (reassuringly) to put them into perspective. ('And on
this gloomy day, a look on the brighter side' . . . 'With all this crisis going on one
could almost have forgotten that today was Shrove Tuesday'. . .)

Barratt, the principal anchorman during the period of viewing, presents him-
self as the embodiment of this 'populist' perspective: a no-nonsense man of the
people, stressing down-to-earth common sense, not only by asking questions he
thinks the public would want to ask but also, unlike many other current affairs
presenters, by adding comments ('Well, they do seem rather daft reasons for
going on strike . . .' *Nationwide* 14/3/73) he assumes the public might make, or
at least agree with.

Interestingly, these comments are not seen to transgress the requirements of
balance and impartiality. They rest on an image of 'the people' outside the struc-
tures of politics and government. Precisely because they are made from a
perspective at odds with that of parliamentary politics – 'the politicians' as such
are suspect from this perspective – these comments do not favour the position of
one party against another within that framework. This 'commonsense' critique of
'politics' presents itself as a-political, despite the obviously political content of
common-sense wisdom about what 'we all know . . .'. The discourse of *Nationwide*,
rooted as it is in this populist 'everyday' perspective on events, undercuts the tra-
ditional discourse of parliamentary politics by basing its criticisms on a set of
assumptions about 'what everybody thinks'. It is a discourse which poses 'or-
dinary people' as its source, and thus represents historically-determined and
necessarily political positions simply as a set of natural, taken-for-granted 'home
truths'.

Moreover, the *Nationwide* perspective is legitimated not only through its identi-
fication with the content of common-sense wisdom, but also through the forms
of discourse in which that perspective is constructed. *Nationwide* employs a kind of
populist 'ventriloquism' (Smith, 1975: 67) which enables the programme to

speak with the voice of the people; i.e., to mirror and reproduce the voice of its own audience. *Nationwide* adopts the language of popular speech – the language is always concrete, direct and punchy, with an assumption of and a reference to always pre-existing 'knowledge'. This populist vocabulary is the language of 'common sense' which the programme adopts and transforms, picking up popular terms of speech (much in the style of the *Daily Mirror*'s 'Come off it Harold . . .'), mimicking phrases and clichés, and putting them to new uses, making them carry the weight of a political message. *Nationwide* often uses, and sometimes inverts, proverbs and clichés, quite self-consciously (the 'postcard shot' of Blackpool; 'when in Rome let the Romans do as you do', 19/5/76; etc.) – grounding its vocabulary in familiar tags and sentence constructions. ('This may look like a load of old rubbish to you . . .', 19/5/76.) The 'persona' of the programme, then, is a professionally formulated reconstruction based in and on 'popular speech' and its sedimented wisdoms. The use of this linguistic register is one of the ways in which *Nationwide* constructs 'ordinary people' as the subject of its particular kind of speech.

This 'populist ventriloquism' is a crucial strand in the way the programme attempts to forge an 'identification' with its audience; its project is to be accepted by the audience as their representative, speaking for them, and speaking to them from a perspective, and in a language, which they share. At the same time, this work of constructing identifications is actively denied in the programme: the presenters appear as 'just like us', just ordinary people – who happen to be 'on telly', doing the talking, while we listen.

The tendency of *Nationwide* to repress the work of producing its own discourse is nowhere so clearly evident as in the way the programme presents itself in the *Radio Times*:

> Britain's nightly mirror to the face of Britain. (29/3/77)
>
> presenting a mirror to the face of Britain. (1/4/77)
>
> Richard Stilgoe reflecting ideas and opinions from the postbag. (1/11/76)

Nationwide, in short, offers us a 'nightly mirror [rather than a window] on the world'. It presents itself as catching in its varied and comprehensive gaze 'everything' which could possibly be of interest to us, and simply 'mirrors' or reflects it back to us. What is more, it 'sees' these events in exactly the same perspective, and speaks of them in exactly the same 'voice', as that of its audience. Everything in *Nationwide* works so as to support this mirror-structure of reflections and recognitions. The ideology of television as a transparent medium – simply showing us 'what is happening' – is raised here to a high pitch of self-reflexivity. The whole of the complex work of the production of *Nationwide*'s version of 'reality', sustained by the practices of recording, selecting, editing, framing and linking, and the identificatory strategies of producing 'the scene, *Nationwide*', is repressed in the

programme's presentation of itself as an unproblematic reflection of 'us' and 'our world' in 'our' programme. *Nationwide* thus naturalises its own practice, while at the same time it is constantly engaged in constituting the audience in its own image. It makes the object of its discourse and practice – the audience – the subject of its speech. The discourse of *Nationwide* thus depends on its ability constantly to reconstruct this imaginary equivalence, this perfect transparency, between the 'us' who are seen and the 'we' who see. What we 'see' and recognise is a reflection of ourselves and our world, caught in the mirror-structure of the screen.

(v) The material of *Nationwide*: specificity of news values

Nationwide is a 'mosaic made up of a variety of interests' where the viewer does not know if s/he will see 'a film of Ulster or a beer-drinking snail' because *Nationwide* has 'no brief other than to be unpredictable, informative and entertaining' (quoted in Gillman, 1975). This is the territory originally 'mapped out' for current affairs TV by *Tonight*:

> *Tonight*'s back . . . the familiar bouncy tune will invite you to look around (with Cliff Michelmore and his team) at the topical, the insignificant, the provocative, and even the sentimental issues of the day. Such is the range of the programme that no string of adjectives will suffice to make a boundary of its activities.
>
> (*Radio Times* 26/8/60)

Nationwide must be topical, but its material is not the same as the material of the national news. While news programming usually acts as a baseline for current affairs TV there is always a selective translation from the domain of news into that of current affairs; current affairs programmes differing according to whether they have a closer or more distant relation to news output. Items usually have to 'pass through' the news before becoming suitable topics for current affairs TV, but not all news items will survive the transition. For instance 'crime', which is routinely 'news', will only become current affairs material if it involves some special feature, or if the crimes are seen to form some significant and problematic social pattern (such as 'mugging').

The differential relations of current affairs TV to news can be seen, for example, by comparing *Tonight* Mark II – which has a close relationship to news, routinely taking up and developing the immediate background to news items – with *Panorama*, which selects only the 'heavy items' (foreign policy, the budget, incomes policy, etc.) from the news.

Nationwide characteristically has a 'distanced' relation to the 'National News', although all the regional programmes carry local news in the traditional format. The 'newsworthy' items that *Nationwide* sets off against an always taken-for-granted reference point of normality are not those like the unexpected 'big bang' (News)

or the world-shattering political development (*Panorama*) nor even the worrying deviant (social problem TV) but the extraordinary, perplexing, various, eccentric quirks of otherwise ordinary people and their lives. *Nationwide* deals in 'human interest' stories. 'Heavy' items like Britain's involvement with the IMF, which are the staple diet of serious current affairs programmes (like *Panorama*), are explicitly featured only sporadically. These problems are, however, routinely recognised, even taken-for-granted, as the familiar background against which more typical *Nationwide* items are foregrounded. *Nationwide* items are often introduced with openers like 'In these days of economic crisis . . .'. When such items are handled, the 'angle' on them will be the search for 'the brighter side', 'what can be done', the 'good news among the bad'.

Nationwide policy in these issues, on the selection and handling of their material, is, at least in part, designed to respond to the fact that, as the BBC Audience Research Dept. Survey put it:

> Four times as many people mentioned politics as mentioned any other subject as the 'most boring'.

What people wanted of a current affairs programme, according to the Survey, was:

> on the spot film, where the action is, to see for themselves . . . to hear the people who are the subjects of the report telling their own story – not debates and discussions between experts in a TV studio.

Nationwide responds to these demands by placing first and foremost the 'discipline of entertainment' – the focus on the quirky, the fascinating, the sensational as a strategy for holding the attention of the audience, in order to lead them to the 'preferred reading' of a given event: the programme aims to produce 'interesting stories' which will 'grab the audience' (*Nationwide* producer, quoted in Gillman, 1975). *Nationwide* doesn't cover areas remote from everyday life (like a *Panorama* special on Vietnam) but visits the places many of us have visited, takes us into the living rooms of ordinary families, shows us people enjoying their leisure time, couples coping with inflation and their new baby. The aim is to be 'a reflection of what you and your family talk about at the end of the day'. *Nationwide* thus occupies a peculiar space in the spectrum of current affairs TV; uniquely, on *Nationwide*, the majority of items are about ordinary people in their everyday lives. These items are always presented with a 'newsy' inflexion, but none the less they overwhelmingly draw their material from the 'normal/everyday' category which usually constitutes the absent baseline against which the 'newsworthiness' of other items is constituted.

It is from this area of 'everyday life' that *Nationwide* routinely produces the bulk of its magazine items: such as the story of the 'man who wrote out the Bible by hand' (*Nationwide* 2/1/76). Such stories could not in any sense become 'news' within the dominant current affairs framework of news values. However, these

items are the specific constituency of *Nationwide*: the dominant perspective is reversed here. The items generated are from a 'grassroots' level: ordinary people's extraordinary habits/hobbies; or the effects of the state/bureaucracy as felt in the lives of 'ordinary folk' as it impinges on the sphere of private life.

Nationwide roots itself in the 'normal' and the everyday, in a 'consensus' based on what it represents as the 'natural' expectations of its audience. A vast proportion of *Nationwide* stories are simply about individuals 'like you or I', with their special skills and interests. Of course, a story about people doing absolutely ordinary things can't trigger an item on its own – even a magazine item – since it would contain no news potential whatsoever. The absolute norm is invisible in the perspective of news: it is what provides the taken-for-granted background to everything else.

Nationwide, then, is grounded in the obvious, the familiar – but in celebrating this area of everyday life, the programme works on and against this 'norm'. *Nationwide* is constantly discovering that appearances are deceptive: the items often spotlight the special things that otherwise 'ordinary people' are doing. Here, *Nationwide* plays off a range of oppositions around the normal/abnormal, ordinary/eccentric polarities, discovering that the 'ordinary' is never as ordinary as it seems; celebrating the life of the people of Britain through the diversity which the programme finds in the activities of its own subjects/audience.

2

THE WORLD OF *NATIONWIDE*
DISCOURSE 1975–7

(i) Introduction: components of the *Nationwide* discourse

The internal organisation of the *Nationwide* discourse can be represented diagrammatically thus:

	Manifest content	Type of item	Dominant thematisation	Function: relation to audience
(a)	NW events/links	NW as its own subject matter	NW self-referential	Identification/framing and contextualisation
(b)	World of home & leisure (i) leisure time (ii) consumers	Magazine story-items: specifically *Nationwide* material	Stories of individuals Family advice	Entertaining, interesting, informing
(c)	People's problems		Concern & care	
(d)	Image of England: town & country		Traditional values	
(e)	National/political news	'Straight' news	'Effects'/practical sense	Reporting

(ii) Description of categories

(a) Nationwide *events/links*

This section is treated first because it is these elements which, we would argue, provide the key to the organisation of the material in other sections. Two different elements are included under this heading. There are those items which have no basis 'outside' the programme and are exclusively generated by *Nationwide* itself. *Nationwide* has a wide range of self-generated items: sponsored competitions,

audience- and presenter-participation events, special trips and tests which the *Nationwide* team undertake – the *Nationwide* horse, the *Nationwide* boat, Michael Barratt's farewell train around the regions, etc., etc. There are also the many places in any one programme where the *Nationwide* team provide the inter-item and inter-region links, the frames and introductions which place and position all the other items within the structure of the programme. Both elements enable the programme to establish a substantial audience-identification with the team itself; this is a basic mechanism of the programme, since the *Nationwide* team is not a team of self-effacing 'objective reporters' but are active *Nationwide* 'personalities' in their own right, and both embody and anchor the programme image. But it is also here that the critical contextualisations and evaluations are made – placing items, providing the links between items, signalling the appropriate treatments for items, giving items their 'preferred reading', towards which the audience is actively directed. This terrain of framing and contextualising is the exclusive preserve of the *Nationwide* team.

(b), (c) and (d) The world of home and leisure; people's problems; the image of England

These constitute the specific area of *Nationwide*'s concerns, which differentiate it from other areas of current affairs. Here the items tend to be inflected through a basic set of thematisations: stories of individuals, in the area of leisure; assumptions about family life, in the sphere of consumption, an orientation towards 'cause for concern' in the 'problem' section; a focus on traditional – often rural – values, in the image of England section.

There does not seem to be any simple correlation between the different areas and their particular thematisations: a 'social problem' story may be thematised through an individual, or a 'political' story through its effect on a family. The thematisations are, to some extent, flexible and variable; moreover, they may be presented in combination – a story may combine the themes of regional and individual variation. The relation of the content-areas to the various thematisations is represented in a linear form in the diagram simply to show the dominant thematisations in each particular area. These elements constitute the basis from which the *Nationwide* discourse is constituted, and, as argued, may appear in variable combinations in concrete instances.

(e) National/political news

This area, in which national issues of importance are dealt with, *Nationwide* shares with other current affairs programmes. *Nationwide*'s particularity here consists to some extent in its emphasis on 'regional news' components (e.g. 'Midlands Today'); dealing with national issues in terms of their local or regional effects, as well as purely 'local' news. As we have said, hard news material is not the staple diet of the programme – indeed it occupies a subordinate position – but it is in

this area that *Nationwide's* style of presentation approximates most to the 'straight report' format, especially in the local news slot. While the 'straight report' is the dominant form of presentation with respect to this area, it is not the only form – where possible *Nationwide* will inflect the presentation of 'the news' through its own dominant themes; that is, it will translate hard news items into stories of individuals and families. (See, for example, the stories on Meehan and the Angolan mercenaries in section (e) below.)

(iii) Analysis of categories

(a) Nationwide *events/links*

I hope you don't mind me coming into your home in shirtsleeves.

(Tom Coyne *Nationwide* 8/6/76)

Nationwide is, above all, a friendly programme, where we're all on Christian name terms ('Over to you Bob . . .'); where we're introduced personally to new members of the *Nationwide* team and regularly given personal news about those of the team we already know. In 'serious current affairs' programming the presenter's personal life/personality does not intrude into his/her professional role. The *Nationwide* team positively exploit their different and highly developed personas – as part of their professional 'style' – commenting on each others' lives, hobbies, attempts to lose weight/give up smoking, etc.; portraying themselves as individuals like us, with their own problems, interests, idiosyncrasies: people who know each other ('Dilys, what about you? Were you a comic freak?') and whom we can know. We get to know 'the team' as personalities – as a family, even, rather like our own: the *Nationwide* family.

The audience is constantly involved in the programme. We are invited to participate through letters, choices, ideas, etc., and our participation is acknowledged; we are asked to help (a poor family is shown on *Nationwide* 9/1/76 with not enough furniture – and our response is recorded – 100 'offers of help pour in'; 'The £ in our pockets may be shrinking, but our hearts are as big as ever'). The team give friendly advice, warnings and reminders (don't drink and drive at Xmas; remember to put your clocks on/back, etc.). The team/audience relationship is presented rather like that of the team as guests in our home, us as visitors to their studio/home.

The team is not at all stuffy, they are willing to mess about and 'have a go' – and we are entertained by their, by no means always successful, attempts to deal in unfamiliar contexts. The East Anglian boat trip on the good yacht *Nationwide* (19/5/76) is a classic example – Barratt and Wellings, two members of the national *Nationwide* team, during *Nationwide's* week in the Norwich studio, are presented 'at sea' on a trip on the Norfolk Broads, skippered by the regional *Nationwide* presenter. The regional presenter is clearly 'at home' in this nautical context, confident and relaxed – our national presenters, though willing to try their best

(Barratt gamely dressed in yachting gear, trying to get it right), cannot cope: Wellings is presented as the original landlubber, about to be seasick, unable to understand seafaring terms. He is the most sympathetic figure, standing in for our own ordinary lack of expertise; and in the end it is he who gently dismisses the specialist exercise:

> All this 'tacking' and 'avast' and 'ahoy' and left hand down and giblets and spinnakers . . . ludicrous performance.

The team are game to try, and they invite the audience to respond in like terms: viewers' competitions are a *Nationwide* speciality – 'Supersave', 'Good Neighbours', 'Citizen '76', etc. The audience are also invited to participate in the construction of the programme – 'What do you think *Nationwide*'s New Year resolution should be?' (17/12/75), and our participation becomes an item in the programme.

Audience response is scanned: we are shown on the programme both 'some of the Xmas Cards we've received from you' and also the more problem-oriented contents of the '*Nationwide* Letter Box' (29/12/75). *Nationwide* constructs an open and accessible relation to events: we watch members of the *Nationwide* team, who are presented in a self-consciously amateurish manner, participating in a *Nationwide* Showjumping Competition, set up as a parallel to the International Showjumping Competition (17/12/75); or we may see the presentation of *Nationwide* medals to Olympic athletes (15/6/76). We meet not only the 'Midlands Today puppy' (3/6/76) but also the '*Nationwide* horse' (19/5/76) – 'Realin', whose name was itself chosen by us the *Nationwide* viewers. Val introduces us to the horse, points out how we may recognise it in a race, and explains the factors relevant to racing success. Here we are invited to participate (as surrogate 'horse-owners') in 'the sport of kings' – an area from which as normal individuals we would be excluded – through the mediation of the *Nationwide* team.

Links and mediations

At many points the *Nationwide* discourse becomes self-referential – *Nationwide* and the *Nationwide* team are not only the mediators who bring the stories to us, but themselves become the subject of the story. This is the 'maximal' development of one consistent thread in the programme – the attempt to establish a close, personalised relationship between the *Nationwide* team and the audience. A 'mystery item' (on *Nationwide* 28/9/76) turns out to be *Nationwide*'s own 'tele-test' with an invited audience who submit themselves to the process of research into their comprehension of *Nationwide* items. Here we have invited 'experts' whose views are elicited, but they are subordinated to the direct relation between *Nationwide* and its audience: it is principally a 'participation' item: we see *Nationwide* in reflection on itself, in dialogue with its own audience.

However, this aspect of the *Nationwide* discourse is not sustained only through the manifest content of those odd items where *Nationwide* and its audience have

become the subject of its own story – it is also sustained through the 'links' between any and every item in a programme. Here the team appear in their capacity as links/mediators – getting out there 'on the spot', bringing us the variety, topical stories, drama of life in Britain today: bringing the regions to each other and to the centre, the parts to the whole. It is the team who must construct a world of shared attitudes and expectations between us all in order to hold the heterogeneous elements of *Nationwide* together.

Links can be made in various ways – through familiar presenters' faces in the studio, through the extraction of some element from the last item ('it may not be the weather for . . .') linked to an extracted element from the next item ('but it's certainly the right day for . . .'), through the establishing of shared ground between commentator and viewer. The central components of these links tend to be references to a level of shared attitudes towards the taken-for-granted world: concern about the weather, holidays, anxiety at rising prices/taxes, exasperation with bureaucracy.

The audience is constantly implicated through the linkperson's discourse by the use of personal pronouns: 'tonight we meet . . .', 'we all of us know that . . .', '. . . can happen to any of us', 'so we asked . . .'. The audience is also implicated by reference to past or coming items, which we have all seen/will see, and (by implication) all interpret in the same way. There is a reiterated assertion of a co-temporality ('nowadays', 'in these times of . . .') which through its continuous present/immediacy transcends the differences between us: 'of course . . .' *Nationwide* assumes we all live in the same social world.

The relations between the team and the viewers are constantly mystified in the discourse of *Nationwide*. There is no credit sequence at the end or beginning of the programme; without reference to the *Radio Times* we can only know them informally and internally, as they refer to each other, people who know each other, so that we too know them like that, like people we already know rather than as presenters/TV personnel. (In their absence, people on the programme are referred to by their full names – 'A report from Luke Casey in Leighton Heath', in the more formal manner of an introduction, but in general these are precisely not the core team.) This already-knowingness, the *Nationwide* team in our living rooms as friends, constantly catches us with them as 'we', in their world, which purports to be nothing more than a reflection of our world.

This can be most clearly seen in the use (*Nationwide* 19/5/76) of 'Let's . . .'. Tom Coyne: 'Let's take a look at our weather picture'; 'Let's go to Norwich'; Michael Barratt: 'Let's hear from another part of East Anglia.' Here, the audience's real separation from the team is represented in the form of a unity or community of interests between team and audience; the construction of this imaginary community appears as a proposition we can't refuse – we are made equal partners in the *Nationwide* venture, while simultaneously our autonomy is denied. This, with its attendant possessive, '*our* weather picture', is the least ambiguous form of the 'co-optive we', which is a major feature of the discourse and linking strategies in *Nationwide*.

Links discourse sometimes seems to be structured in the recognition of the different positions of presenters and audience. Michael Barratt: 'And after *your own* programmes *we* go cruising down the river to bring *you* our third programme from East Anglia.' (Nation/region link.) But this difference is also constantly elided and recuperated:

(1) By reference to a wider, shared context or frame, in which we are all 'we' together: a context which embraces us all, establishing a false equivalence/homogeneity between us, dismantling our real differences of position and power. Here, through this construction, they unashamedly establish us in position in the discourse in a place which enables them to 'speak for us'. For example (19/5/76):

Tomorrow we'll have some sunny intervals . . .

If our society was destroyed, heaven forbid . . .

(2) Through the denial of the inequality of the audience/presenter relationship. Although the form of this relationship is friendly and familiar – conducive to we-ness – it is actually only *they* who can speak and initiate action. Thus, when Michael Barratt says 'so we thought that tonight we'd go racing', although he may strictly be referring only to the studio group, 'we the audience' are implicated because if they go racing, we go racing, unless we switch channels.

This elision, this constant concealing of the one-way nature of the television system in our society, their negotiation of the isolation of their medium, lays the basis for a whole set of ways in which the *Nationwide* audience is implicated in, and identifies with, 'the scene *Nationwide*' (15/6/76).

Identification is also produced and reinforced through the chatty informality of the links. The links themselves are signified as transparent – bearing no substantial meaning of their own, made only of the reference to past or coming items. However, as already discussed, they also signify 'we-ness', which is constantly constructed by both the team and the viewing subject to mean 'nationwideness'. The seemingly neutral links themselves, always carrying this 'other', extra meaning, the 'being-among-friends in one's living room', are constantly contributing to the construction of the meaning of *Nationwide*, which we are always already implicated in, because it is with us, the viewers, that this assumption of intimacy is made.

This can perhaps be seen more clearly, in a slightly more developed form, in *Nationwide*'s presentation of the weather forecast. The weather forecast on BBC television generally takes the standard form of a map of the British Isles, with graphic devices and a commentary over. On 'Midlands Today', the Midlands regional component of *Nationwide*, this standard signifier is replaced by a child's painting, usually showing fairly extreme climatic conditions, with a voice-over commentary. The new signifier is recognised in two ways. The artist's name and age are given, and the linkperson usually makes some comment about the 'content' of the picture, or about the weather at that point:

Tom Coyne: Well with the drizzle coming down, I hardly dare mention it, but let's take a look at our weather picture.

(Nationwide 19/5/76)

What happens here is that the painting, as well as signifying 'weather', also signifies 'children send paintings in to *Nationwide*'. The signifier is emptied of its own meaning (man with umbrella), to mean 'weather' *and* resignified, in the meta-language of the programme's own discourse on itself, as: 'this is a programme which children send in pictures to' – *Nationwide* is our programme. (For a similar point in relation to advertisements, see Williamson, 1978.)

The most elaborate form of this process comes when this 'nationwideness' bursts out of the links and generates its own items, which we have called *Nationwide* events, which don't require reference to the outside world at all, only to the *Nationwide* 'we'. A great deal of the strategic work of the *Nationwide* discourse consists of operations around the construction of this *Nationwide* 'we'. It would be wrong to present these as yielding a fixed and unproblematic structure of positions. In fact, it would be more correct to see the programme as struggling to constitute this set of equivalences around the shifting pronouns – we/us, negotiating this divergence/unity, constantly attempting to secure an identity between these two terms of its speech: an identity it aims for, but cannot guarantee.

Both Roman Jakobson and Roland Barthes have pointed to the critical position of the personal pronouns in discourse, as the location of what Jakobson calls 'duplex structures'. Personal pronouns are *shifters*, in the sense that if, in conversation, A speaks to B in terms of 'I' and 'you', B can only reply coherently by transposing or 'shifting' the terms: A's 'I' and 'you' become B's 'you' and 'I'. Jakobson calls 'shifters' terms of transference, the site of a critical overlapping and circularity in discourse, which thus, through the ambiguity of the 'double structure' of language, can become, at the level of the code, the site of complex ideological work. The shifting of the pronouns of the enunciation and what is enunciated – based on a rule of conversation (cf. Barthes, 1967) – becomes the potential space for the exploitation of an ideological ambiguity which can serve to construct new positions for 'speaker' and 'audience' in relation to the discourse employed. What *Nationwide* seems to represent is not a secured correspondence between speaker and hearer positions such as could sustain an unproblematic equivalence between them – for this would be manifestly an 'imaginary' equivalence in a discourse dominated by the originating practices of the *Nationwide* team, and the structured 'absence' of the audience (the latter may be represented as the imaginary enunciator of *Nationwide*'s speech but in the real relations of TV communication it can only-always be the object of the enunciation). What we find. instead, are multiple strategies designed to secure this 'correspondence' of positions – strategies which seek to exploit the terms of transference; and this results, in the actual discourse of particular programmes, in an unstable fluctuation around and through this double structure:

41

> Tonight we meet . . . and then we join . . . that's us at six . . . After your
> own programme we go cruising. We also meet . . . and we consider . . .
> Our own horse is looking good . . . and we ask . . . What's to be done
> about it *Nationwide*.
>
> (19/5/76)

The mechanisms for the construction of the 'co-optive we' depend on and are realised in language: but they do not operate exclusively at the level of language in the narrow sense. In *Nationwide*, we suggest, they are further secured by and through the 'positioning' of the team – the presenters who represent and 'personify' the programme. And this is a feature, not of *Nationwide* alone (where, however, it is a prominent and characteristic presence) but in the discourses of 'popular TV' more generally. The *Radio Times* observed long ago about *Tonight*, the programme which has a key position in setting the terms and establishing the traditions which structure the practice of 'popular TV':

> the items [were] knitted together into a continuous and comprehensive
> show by a personality, starting off with Cliff Michelmore . . .
>
> (*Radio Times* 26/8/60)

The *Nationwide* presenters attempt to identify as closely as possible with 'you, the viewers'. The team speak on our behalf, mediating the world to us; they assume a position as our representatives. Lord Hill noted, of *Tonight* (but the observation could easily be extended to *Nationwide*), that the first essential of a reporter is:

> not unselfconsciousness or camera presence, but a total conviction that
> he represents the absolute norm, and that any deviation from his way of
> life is suspect.
>
> (Quoted in Connell, 1975)

The team are not stars in the sense of telepersonalities but:

> real people; whole rounded people who ask the sort of questions that are
> sound common-sense – questions that are in the viewers' mind and that
> he would ask if he was in their place.
>
> (Quoted in Connell, 1975)

Thus, the relationships which are established between programme and audience, which set the viewer in place in a certain relation to the discourse – here, a relation of identity and complicity – are sustained in the mechanisms and strategies of the discourses of popular television themselves, but also by the presenters, who have a key role in anchoring those positions and in impersonating – personifying – them. The linking/framing discourse, then, which plays so prominent a part in structuring any sequence of items in *Nationwide*, and guides us between

the variety of heterogeneous contents which constitute *Nationwide* as a unity-in-variety, not only informs us about what the next item is, and maintains the 'naturalism' of smooth flow and easy transitions – bridging, binding, linking items into a programme. It also re-positions 'us' into – inside – the speech of the programme itself, and sets us up in a particular position of 'knowledge' to the programme by (also) positioning us with 'the team'; implicating 'us' in what the team knows, what it assumes, in the team's relationships with each other, and the team's relation to 'that other, vital part of *Nationwide*' – us, the audience. For, as the (one-time) editor Michael Bunce put it, it is not only Michael Barratt, or the *Nationwide* team, who decide what goes on the air, so does the audience:

> Telephone calls, telegrams, 1000 letters a week . . . breathe life into the programme and inspire much of what actually gets on the air . . . [the presenters] do not make *Nationwide*. The viewers make it.
>
> <div align="right">(Quoted in Gillman, 1975)</div>

Identification and preferred readings

However, while our participation as audience may be necessary to the programme, 'we' do not make it in a relationship of equivalence with the 'team'. It is the team who control and define the terms of the discourse, and it is the team who signal to us 'what it's all about'. It is the presenters who 'explain' the very meaning of the images we see on the screen. The 'menu' for the 19/5/76 item on the students:

> Tonight we meet the students who built a new life for themselves out of a load of old rubbish. These may look like a few old plastic bags to you, but actually, for a time it was home to them.

positions viewer, *Nationwide* team and interviewees within a paradox of the programme's own construction.

It is 'we' together who will meet the students, but it is the *Nationwide* team who will offer a privileged reading of the actual significance of the images on the screen, which the audience at home is thus caught into 'reading' as 'a few old plastic bags'. This systematic subversion of the 'obvious' reading an audience might have made of an image, apart from the implications it has for the constantly set-up 'natural' and shared decoding, renders the audience rationally impotent, because the conditions of the paradox are always that it is impossible to know what the image really denotes. The consequent dependence of the audience on the broadcasters' explanation of each little mystery accentuates, in a self-justifying way, the team's role as our 'representatives'.

The presenters and interviewers define for us the status of the extra-programme participants and their views: through these introductions, links and frames the

preferred readings or contextualisations of the items and events portrayed are suggested. In the 19/5/76 programme, for instance, we are 'directed' by Tom Coyne's gruff, fair, but 'no-nonsense' manner towards a rather low estimation of the activities of the students who 'built a new life for themselves out of a load of old rubbish'. After all, they cannot compete with the basically 'sensible' perspective expressed in Coyne's final, indulgently-phrased question:

> Now I can obviously see that a student of your age is going to enjoy an experience like this, even if the weather is rough, because it's a lot of fun, but other people want to know what you actually got out of it from an educational point of view . . .?

Moreover, here Coyne not only invokes our views on the matter but implicates us in his. He does not merely ask a common-sense question, but claims to do so on behalf of us; we are the viewers – those 'other people' who 'want to know'.

(b) The world of home and leisure

Let us begin with an analogy between 'the scene *Nationwide*' and Duckburg:– Dorfman and Mattelart observe of Duckburg:

> In the world of Disney, no one has to work to produce. There is a constant round of buying, selling and consuming, but to all appearances none of the products involved has required any effort whatsoever to make . . . The process of production has been eliminated but the products remain. What for? To be consumed. Of the capitalist process which goes from production to consumption, Disney knows only the second stage . . .
>
> (Dorfman and Mattelart, 1975:64–5)

Foremost among the areas of life from which *Nationwide* draws its material is the world of 'leisure' – the sphere of culture, entertainments and hobbies. Here we meet individuals in their personal capacities, away from the world of social production; we follow their activities in the realms of their personal life. The nation '*Nationwide*', like the inhabitants of Duckburg, seems to be principally concerned with the process of consumption. Unlike Duckburg though, we consume principally in families – entering the Supersave competition (Monday nights 1975) together, and even enlarging our family size together ('Citizen '76' Monday nights 1976).

The world of home and leisure is by far the dominant single element in the *Nationwide* discourse, accounting for 40% of the items in the sample (see figures at the end of this chapter). The first thing to remark is that this 'presence' betokens the almost total absence (except in some local news items) of the world of work, the struggle of and over production. This private leisure-world is a 'free

floating' sphere from which the productive base has been excised. This absence extends to production in the family. Although 'Citizen' 76' focused on pregnancy and the birth of children, and at Christmas we have shared selected hostesses' Christmas menus ('Christmas Round the World' 1975), the day-to-day labour of childcare and housework, which makes the home a sphere of work and not leisure to most women, is invisible in *Nationwide*. *Nationwide* leaves us suspended in the seemingly autonomous spheres of circulation, consumption and exchange: the real relations of productive life, both inside and outside the home, have vanished.

Nationwide addresses itself (cf. *Radio Times* billing) to an audience of individuals and families, the nation, in their personal capacities. Its transmission time allows it to construct itself/constructs it at the bridging point between 'work' and home (for wage workers). Its discourse is structured through the absent present opposition between the 'world' and home. This opposition between the public and the private, we would argue, is partly informed by the sexual division associated with 'world' and 'home' (Rowbotham, 1973). It is the 'masculine' world of work which constructs the home as a place of leisure, a private sphere where the male labourer has some sort of choice and control, which exists quite differently for women (who may well also be wage workers), as it is their responsibility to maintain this 'tent pitched in a world not right'.

As a family show, *Nationwide* addresses itself to the family together, 'caring and sharing' (Thompson, 1977), a close knit group of individuals, among whom the 'obviousness' of the sexual division of labour emerges as simply different responsibilities, specialities and qualities for men and women. Thus *Nationwide* does not, like women's magazines, address itself primarily to the 'woman's world' of the home, with advice about 'coping' and 'managing' which reveal the contradictory tension of maintaining the 'ideal' 'norm' (Winship, 1978). *Nationwide* doesn't have recipes, dress and knitting patterns or household hints, unless there's something special about them: a man who makes his children's clothes ('Supersave'); if we slim, we slim together, *Nationwide* ('Slim and Trim' March 1977, with *Nationwide*'s 'ten guinea-pig slimmers' – *Radio Times* 30/3/77). We meet the family together, usually in their home ('Supersave', 'Citizen' 76', 'Budget' 1977), or its individuals in relation to their own speciality. Sometimes, for women, this is 'being a wife and mother', as in the interview with the Pfleigers in the 'Little Old England' item 19/5/77, which opens with a shot of Mrs. Pfleiger at the kitchen sink, and is cut so that her answer to the question 'Did you find it difficult to settle in here?' is entirely concerned with household equipment, while her husband gives a more general account of the family's history and attitudes. More usually it is being a wife and mother *and also* being fascinated by lions (19/4/77), being a witch (18/6/76), making a tapestry of Bristol's history (15/6/76).

We are concerned, then, with a discourse which, very schematically, and at a general level, has an underlying 'preferred' structure of absences and presences:

ABSENT:	: PRESENT
world	home
work	leisure
production ⎫ reproduction ⎭	consumption
workers (functions)	individuals (bearers)
structural causation	effects

There is a concentration on 'the "real" world of people' (Hoggart, 1957) both as a bulwark against the abstract, alien problems of the outside world, and as a moral baseline through which they are interrogated. The effectivity of the outside world is symbolised for *Nationwide* in 'bureaucracy' – faceless men (non-individuals, but still personalised to the extent that it is 'faceless men', not 'the system'), behind closed doors, who have power over 'us':

> Once again, the key decisions were taken behind closed doors, in this case the small branch meetings up and down the country.
>
> (*Nationwide* 15/6/76)

In relation to these issues *Nationwide* will adopt a 'campaigning' stance – aiming to 'open doors' on our behalf. Thus in Autumn '76 we had the creation of 'Public Eye': a spot in which two team members

> investigate an issue which they feel should be brought under the gaze of the public eye.
>
> (*Radio Times* 3/11/76)

This opposition between we 'ordinary people' and the 'faceless men' of the bureaucracy is close in structure to Hoggart's description of a class sense of 'them' and 'us':

> Towards 'Them' generally, as towards the police, the primary attitude is not so much fear as mistrust; mistrust accompanied by a lack of illusions about what 'They' will do for one, and the complicated way – the apparently unnecessarily complicated way – in which 'They' order one's life when it touches them.
>
> (Hoggart, 1957: 74)

The difference is that the 'us' *Nationwide* speaks for is not class specific, but 'the nation' of consuming individuals, always already in families. In the example above, the decisions taken 'behind closed doors' were made by workers in Trade Union branches. (Cf. Morley, 1976, section 1.b, on presentation of TU decisions as the sole cause of events.)

Classes do not appear in the discourse of *Nationwide*; only individuals, and

these individuals usually appear in relation to the market – in the spheres of exchange and consumption. Thus the image of a group of white male workers with clenched fists standing outside a factory gate (*Nationwide* 19/5/76) is *not* an image of workers victorious in a struggle at the point of production, but that of a group of Pools winners:

> altogether nine people will share the prize money, and for one of the winner's wives, news of the win came as an unexpected but most welcome 44th birthday present.
>
> (19/5/76)

This is not to suggest that *Nationwide* does not, or can never, deal with the worlds of production and hard news, but that when confronted with the need to cover political items, such as the budget or incomes policies, *Nationwide* deals with them where possible by translating them into the context of domestic life; how will such 'political' issues affect the home. The strategy is precisely that of the humanisation/personalisation of 'issues' into their 'effects on people'; or, alternatively, the exploration of the range of people's 'feelings' or reactions to external forces that impinge on them. (For example, the new tax schedule: 'Do you recognise that – one of those nasty PAYE forms . . . an all time grouse . . . along with mothers-in-law' – *Nationwide* 29/3/77.)

Political events then in this discourse have their meaning made comprehensible through their *effects* on 'people', and it is assumed that people are normally grouped in families:

> We . . . look at how this budget affects three typical families . . . 'Ken' feels strongly he's not getting a fair deal at the moment . . . what would you like to see the Chancellor doing for your family and friends? . . .
>
> (*Nationwide* 29/3/77)

Nationwide asks 'home' questions in the world. If we enter into that larger domain, it is to find out what the people in the public world are like – as individuals; for example, that an MP is also a racehorse owner (19/5/76). The structures of ownership and control in society are dissolved into the huge variety of individuals *Nationwide* – it takes all sorts to make a world. Where this type of treatment is not possible, it is because some crisis in that world has made its day-to-day absence no longer tenable in the programme discourse; its effects, at this point, intrude into the concerns of the *Nationwide* World – which at some level involves a recognition of the determinacy of this outside world. But this is precisely registered as intrusion, interruption or inconvenience. (Cf. Morley, 1976, section 5b on the reporting of strikes as a regrettable disruption of 'normal working'.)

The world of home and leisure, then, is the primary space of *Nationwide*'s

concerns. Within this overall field we can differentiate between (b.i) – items drawn from leisure time activities – and (b.ii) – items dealing with consumers and domesticity. The former is the space of 'free time' and individual pursuits, the latter is the largely unstated premise of the *Nationwide* discourse – the predication of the nuclear family as the basic unit of social organisation.

(i) *leisure time*

Items drawn from the 'world of leisure' account for almost 25% ($^{40}/_{182}$) of the items in the sample. Moreover, within these items it is individuals, pursuing their different hobbies and leisure interests (this stress on difference precisely connoting their individuality), who are the principal subjects of the *Nationwide* discourse. Of the 40 items in this category 50% are thematised around the 'story of an individual' ('Tonight we meet the man who . . .'): from the story (9/1/76) of the owner of a card-playing parrot to that of the creator of a strip cartoon of the life of Jesus Christ (17/8/76), or even (*Nationwide* 22/1/76) the story of a man who:

> made a fortune because he has a child-like obsession for a toy – we fly
> a kite with a difference high above the Cotswolds.

This last too is a 'success' story with a 'difference'; the story of 'a simple man' with a 'child-like obsession' – and a bonus: a kite with a difference, which has been bought by a Japanese business man with a keen eye for 'making a yen'.

> Barratt: Whenever/we/can in *Nationwide*/we/try to bring you/the bright side of life to counter all the gloom and the despondency around/us./And tonight we have a success story for you about a Cotswolds man who's turned a childhood delight into a booming business. James Hogg went to meet him . . .
> Hogg: Unbelievable. And if I tell you that Peter Powell has just received a tax demand for £83,000 after one year, you'll get some measure of his outstanding and astounding personal success.

The peculiarly important role of these 'personal' stories is that, despite their particularity, they function principally as counterpoints to 'the normal': the story above infers the normal at the same time as it demonstrates the possibilities of individual 'transcendence' – success = the lucky personal break; but, 'it could happen to anyone'. The little structure represented by this item is worth analysing. It invokes something normal – a 'lowest common denominator': Peter Powell, like the rest of us, is not a 'special person' in the sense of having status or power in the public world. However, this does not submerge him into the invisible average, for that 'ordinariness' depends, in fact, on 'the difference' – something which makes him 'individual and particular', within his ordinariness. What, indeed, is average and normal about everyone is that each person is different, in his or her

unique individuality. And this 'difference' opens the possibility – which can, hypothetically, befall anyone – that an ordinary hobby can become the basis of a raging success story. But even this extraordinary 'turn of events' or 'twist of fate' is coupled back or recuperated for the norm; one person's hobby is presented, not simply in its unique individuality, but as one more example – in a litany of examples – of the extraordinary variety of interesting hobbies that *all* we ordinary people (the audience) have, 'Nationwide'.

This means that items often spotlight one aspect of an 'otherwise ordinary' person's life. *Nationwide* discovers that 'behind' what seems ordinary/normal there is variety and difference. The point is, as Bunce, the programme's ex-editor, put it

> We want to show that individuality hasn't been stamped out. We are not all grey, drab people.
>
> (Quoted in Gillman, 1975)

On *Nationwide* 29/12/75 we meet Miss Evelyn Dainty, who looks just like everybody's Granny; she turns out, in fact, to be exactly that – everybody's Granny. What's special about Miss Dainty is that she's 'adopted 250 kids throughout the world' and she sends every one of them a card at Christmas. She spends 'everything she earns on Christmas cards'. 'This selfless charity has become' – *Nationwide* assures us – 'a complete way of life . . . simple, hardworking and at first sight, very solitary'.

This is in fact a favoured *Nationwide* style of presentation; a narrative technique is used – the item is a 'little story' – and the 'angle' is 'what is it that this place/person which/who looks normal is going to turn out to be/do?' These *Nationwide* stories create a spurious impression of 'investigative journalism' (which informs the reporters' roles); but an investigative journalism that concerns itself with People, not issues – the reporters go out into the world only to discover – reconfirm the existence of – this 'variety in ordinariness'.

One category of individuals for whom there is a special place in the *Nationwide* discourse is precisely that of 'eccentrics' – people so obsessed by their 'specialisms' as to be extra-normal: whether the mildly troublesome 'hermit of the Cotswolds who doesn't want any friends' (1/6/76) or the men who play at World War II in miniature tanks in the woods (30/12/75). But eccentricity itself easily slides into being an 'achievement'; when we meet 'the man who served yakburgers on the roof of the world' (11/6/76: a mountaineering cook) we are interested in him as much for the eccentricity of what he did when he got there as for his achievement in climbing the mountain.

The extreme example of eccentricity was represented by the (1/6/76) multi-millionaire who tired of business and social intercourse, and bought Tony Jacklin's old house and retired there, virtually without friends or contacts, save for the occasional visit of a head gardener; who spends his time indulging bizarre whims, like jumping each day fully clothed into his swimming pool, or feeding model

cars to the fire. This item is given the full Gothic Horror Movie treatment by James Hogg (reporting), complete with unsteady camera making its own way up the overgrown path to the Hammer-style front door, to the sound of barking Baskerville hounds off-stage and the strains of the only record which Mr David keeps permanently on the hi-fi. This truly extra-ordinary, upper-class eccentric – 'the most reclusive multimillionaire since Howard Hughes' – has really so entirely abandoned the land of the ordinary that there is nothing whatsoever left to connect him to us except his eccentricity – a category which, however, in the pantheon of English traditionalism, has, paradoxically, its own 'normal-abnormal' space reserved; indeed, oversubscribed. But he must pay the penalty for his waywardness from the norm. He is – as *Nationwide* itself moralises – the 'rich man who [quite abnormally] doesn't want friends'.

We are concerned, however, with 'serious' individual achievements as well. When *Nationwide* covered the New Years Honours List (2/1/76) it featured precisely not the already famous, but those ordinary members of the public working quietly away at their tasks (a man knighted for fifty years' work in land drainage; a cleaner) whose more mundane achievements had been honoured – ordinary people as 'stars' in their ordinary activities.

News values of a more usual kind reassert themselves from time to time. *Nationwide* specialises in discovering and presenting the really extraordinary achievements of particular individuals. We meet not only the blind person who 'watches' tennis (18/6/76), and the 70 year old part-time art student sculptress: 'I thought I'd have a go . . .'/'My gosh, they're good . . . It's never too late to learn . . . I wonder how many people have got talent like that . . .' (30/3/77), but also 'Mrs D. Louise Dingwall' an '89 year old female racehorse trainer' in a 'tough and masculine world' (29/12/75). Here the value of achievements has a particular resonance: they are individuals who have overcome the handicaps of disability, old age and sex in their chosen spheres of activity.

(ii) consumers and domesticity

Items on domestic life and 'consumers' problems' are the fourth most prominent theme in the sample, accounting for 17% ($^{33}/_{182}$) of the sample. As noted, the material in this category alone exceeds the space given to national political items (15%), and in combination with the other 'natural' elements of the *Nationwide* discourse these kinds of items overshadow the 'serious current affairs' material by a substantial margin.

Family life at times appears directly as an area of concern for *Nationwide* – when threatened for instance by 'politics'; e.g. housing policies which may 'cause families to be split up' (13/2/74) – but also as a cause for celebration. The Christmas 1975 sample is rife with material of this kind, from 'Wilfred Pickles' family Christmas' (19/12/75) – 'Christmas is also a time for families . . .' – to the more down to earth, practically oriented 'food from Christmas leftovers', and even 'remedies for too much Christmas food' (29/12/75).

The predication of Nationwide's discourse on the centrality of the nuclear family emerged most clearly in an item ('Midlands Today' 23/11/76) on some demographic research which showed that 'more married couples each year are deciding to have no children'. The introduction clearly identified the threat posed to the family as we know it.

> Introduction, over family-at-home snapshot: 'A typical family snapshot picture of mum and dad there, surrounded by their happy children, could fade from view the way the population figures are dropping these days.'

The item went on to interview the researchers at some length, itself an indication of the weight Nationwide attributed to this problem, given the noticeable absence of any concern with the results of academic research in 'normal' Nationwide discourse. Indeed the 'relevance' of this research had to be clearly marked out as having general social value:

> You're carrying out this research. Now why? What's the information going to do for us?

The failure to conform to the nuclear pattern was posed as an explicit and threatening problem:

> Now you yourself are married without children . . . why have you decided not to have them?
>
> . . . is it a selfish attitude not to produce that child?

These questions were all premised against a set of equations between

> children = women's work
> parents = married couples
> families = marriages
> birthrate = births to married couples.

which surfaced perhaps most clearly in a slip of the tongue by the interviewer, when he addressed the researchers:

> . . . as parents yourselves without children . . .

Expectations about the nuclear family structure the dialogue so thoroughly that it is impossible, here, for the interviewer even to speak clearly about the breakdown of these norms: the aberration leads only to an uncomfortable blurring of categories.

The dominant tendency in the material in this area, which has made

categorisation particularly difficult (see Appendix: Notes on categorisation) is for the form of the family to be assumed as the baseline experience of the audience. 'The family' is often not so much explicitly present in the discourse as it is precisely an unspecified premise or 'absence' on which the discourse is predicated. Thus *Nationwide*'s 'Supersave' competition had as its competitors not individuals, but families: families who competed to live most economically in these dire times, succeeding through feats like making cot sheets, aprons and an evening skirt out of a double sheet. The families up and down the country were tested in the realms of cooking, shopping, do-it-yourself and money management; and the super-domestic winners were rewarded with four minutes' 'free shopping' in a supermarket which we, the ordinarily domestic audience, were able to watch on speeded up film (2/1/76).

Primarily, then, the items assume the existence of the audience already and necessarily, structured into nuclear family groupings. The discourse adopts a stance of giving 'practical advice' in relation to the problems of consumption experienced by families – this way of thematising the material is the dominant one in this area, accounting for nearly half ($^{16}\!/_{33}$) of the items in this category.

The material that is thematised in this way can be quite diverse – from topical items: 'Grow your own vegetables to beat drought prices'/'Travel to wet places for your holidays' (18/8/76) to issues of perennial concern to us all: 'The need for a will' (6/1/76) or advice to viewers on 'insurance problems' (5/1/76). *Nationwide* here, of course, attempts to be up with our current concerns, able to bring us a timely fog warning from the 'Traffic Unit' (15/12/75) as well as advice on the advantages of laminated windscreens from the 'Consumer Unit' (17/12/75) – a subject on which *Nationwide* had orchestrated a consumer/viewer's campaign against an unresponsive government bureaucracy in the Department of the Environment.

Nationwide thus establishes a predominantly practical relation with the domestic audience – offering advice and warnings on subjects as diverse as the dangerous materials used in some toy pandas (9/1/76) and the necessity of insuring your house against possible subsidence (18/8/76) or storm damage (5/1/76). We must all deal with the changing state of the law where this intrudes into our lives – here again *Nationwide* can help, offering advice on how to deal with the breathalyser, TV licence laws (18/12/75) and the sex discrimination laws (29/12/75 and 9/1/76).

Nationwide is also concerned to play a campaigning/defensive role, protecting the interests of us all as consumers, not only against the abuse of power by monopolistic 'big unions', but also against the inefficiency of state bureaucracies. In a report on a 'price increase coming from the gas board' (31/3/71), the angle was clearly stated in the introductory framing statement: 'What concerns us is that it may be a needless increase' – *Nationwide* here clearly has the viewers' best interests at heart. An interview with the relevant expert then probes the 'necessity' for the increase and points to the hardship it may cause. This meets with a frosty response, and all Michael Barratt can say in conclusion, after trying his best on our behalf, is

So, pay up and try to smile about it.

The centrality of this theme in the programme discourse is also evidenced by the whole role of the 'Consumer Unit' in the development of *Nationwide*. This was the first area where *Nationwide* set up a specialist/regular slot in the programme to deal in 'investigative journalism' in a consistent way (cf. Gillman, 1975).

(c) People's problems

Nationwide is a 'responsible' programme; it will not only amuse and interest us. *Nationwide* is a programme of care and concern and consistently runs stories on 'people's problems': the problems of the lonely, the abnormal, underprivileged and (especially the physically) disabled. These items account for the third largest part of the sample: 16% ($^{30}/_{182}$). The point here is that *Nationwide* deals with these stories in a quite distinctive way; rather than the discussion between experts that we might get on *Panorama* about the background to some 'social problem' *Nationwide* takes us straight to the 'human effects' – the problems and feelings of the 'sufferers', what effect their disability has 'on their everyday lives'.

Nationwide seems to have a penchant for dealing with cases of physical abnormality: where the 'problem' is seen to have natural, not social origins – blindness, handicaps, etc. The angle they take is usually a 'positive' one: 'look what is being done for these people with new technology'. The social role of technology – of inventions and inventors – is stressed here: useful technology is seen to solve social problems by demonstrably improving the quality of people's lives. This is indicative of *Nationwide*'s concern with 'human scale technology' in 'Britain Today', where, as Tom Coyne says (19/5/76), 'Things are changing all the time' – it is the world of 'new developments', such as an invention which enables blind students to produce 3-dimensional drawings (19/5/76).

Physical abnormality, without its social origins or consequences, is very much part of that 'natural human' world on which *Nationwide* frequently reports, and from which it regularly draws its stock of internally-generated reporters' 'stories'. A London region item on the treatment of a thalidomide child, for example, made no reference to the origins of the case, the contentious question of compensation, or the degree of the drug company's responsibility, or the suppression of the *Sunday Times* report. It was concerned, precisely, with finding the means to normalise the life of those affected by thalidomide without reference to the more troublesome question of causes.

The destruction of nature and the effect of natural disability recur again and again: 'Threat to rare birds by egg collectors' (29/3/77); 'Cause for Concern: Christmas pets' (15/12/75); 'Cause for Concern: rare animals' (2/1/76); the problems of 'Hay Fever Sufferers' (9/6/76); the problem of 're-employment of the blind' (3/6/76). But *Nationwide* is also concerned with other kinds of social misfits for whom something must be done. The problems are 'brought home' to us, and in these areas of 'ordinary human concern', *Nationwide* wears its heart on

its sleeve: we see the problem, but we are also shown the positive side – what can be done about it.

Thus we learn of the anguish caused to relatives by 'disappearing people' (1/6/76) but we also meet 'Brigadier Grettin', from a voluntary organisation, who 'devotes his life to trying to find missing people'. We hear of 'old people alone at Christmas' (19/12/75), but also of positive responses: 'six men riding a bike for charity' (19/8/76), people collecting waste, and 'marathon singers' performing for charitable funds (17/6/76).

Nationwide monitors, on our behalf, serious and topical issues – thus not only are there the occasional, 'investigative', reports on the problems of soccer violence (20/1/76) and West Indian children's educational problems (30/3/77), but also responses to 'topical' issues directly affecting us all. So, during the rabies scare, *Nationwide* featured 'rabies remedies' (11/6/76); during the drought, not only an investigation of 'whose responsibility' its problems were (20/8/76), but also practical warnings of 'cuts in our areas' (17/8/76) and of 'diseases from the drought' (20/8/76).

Nationwide's treatment of people's problems is, then, immediate: we are shown 'what it means in human terms'. This 'humanising' emphasis can be seen to have its basis in the specific communicative strategy of the broadcasters – in trying to 'get the issue across' what better way than to concentrate directly on the feelings of those immediately involved? However, the consequent emphasis, being placed almost exclusively on this 'human angle', serves to inflect our awareness of the issue; what is rendered invisible by this style of presentation is the relation of these human problems to the structure of society. The stress on 'immediate effects', on 'people', on getting to the heart of the problem, paradoxically confines *Nationwide* rigidly to the level of 'mere appearances'.

The *Nationwide* discourse in this area is in fact structured by two dimensions of the same 'significant absence'. On the one hand the problems that are dealt with are almost exclusively those with a natural, not social, origin – especially problems arising from physical disability. Here the 'problems' generated by the class structure of our society are largely evaded, through the tendency to naturalise social problems. On the other hand the treatment of these problems consistently evades the social determinations acting on the experience of physical problems: thus the items on people suffering from physical disability do not address themselves to the differential class experience of these problems.

The social dimensions of the problem are consistently excised – they are constantly re-presented as the problems of particular individuals, deprived of their social context. Moreover the horizon of the problem is set in terms of what can be done about it immediately – by charitable work, by individual voluntary effort, or by 'new technology'. The systematic displacement of the discourse to the level of individual effort makes logical, as one of its consequences, this stress on practical, pragmatic remedies. This is not to deny the importance of these matters, but to point to the absence of any awareness of the need for social and structural solutions to structurally generated problems.

We would suggest that in a parallel fashion to the way in which class structure is largely invisible in the Nationwide 'image of England' (see section (d) and conclusion) – and is only presented through the displaced form of 'regional differences' – in this area of Nationwide discourse 'natural disabilities' stand as a similarly displaced 'representation' of the absent level of socially generated inequalities and problems.

(d) The image of England: town and country

The discourse of Nationwide takes as a matter of explicit concern and value our national cultural heritage; the category accounts for 15% $\left(^{31}/_{182}\right)$ of the sample.

The 'culture' in which Nationwide deals is of course the cultural heritage of 'middle Britain'; it is decidedly not the up-to-the-minute culture of the pop world (the Sex Pistols made their breakthrough on Today, not Nationwide) nor the world of 'high culture'. It's the world of the 'Cook Family Circus' (18/6/76) and the anniversary of '30 years since the last ENSA show' (20/8/76). Reunion and anniversary are a recurring thread in the items; it may equally well be 'Pilots in pre-war planes reliving Biggles' (17/8/76), or 'Dakota planes 40 years old today' (17/12/75), or even a Burma P.O.W. reunion (9/1/76). The cultural context is neither the Rainbow nor Covent Garden: it is rather Blackpool (3/3/76) or 'holidays in Spain' (1/6/76). The cultural context is often constructed through the mass of calendar items which punctuate the Nationwide year: from the Glorious 12th, to Hallowe'en, Christmas, Ascot, St. George's Day, Midsummer's Eve, etc.

Even when dealing in other areas Nationwide consistently inflects the story back towards the idea of a national heritage. Thus, Nationwide will not normally deal with MPs' 'campaigns', but they will cover Willie Hamilton when he is attacking the Monarchy (30/12/75) –

> Nobody prompted a bigger response from you than Willie Hamilton . . .
> In January we gave him a chance . . . and asked you to reply . . .

Similarly, Nationwide covers, not our general economic prospects in the export trade, but the particular success of Morgan Car manufacturers – a traditional British make (17/8/76); not the economics of the EEC, but

> the effects on our great British Institutions of joining the EEC.
> (15/12/75)

Here is national(-istic) politics, concern with our craft traditions and national heritage combined in a peculiarly Nationwide inflection: an oddly serious, yet self-parodying chauvinism. Wellings:

> Here I am in an English garden – flowers, rockery . . . and garden
> gnomes, good sturdy English gnomes, moulded and painted by English

craftsmen . . . today their very existence is threatened by imported gnomes – 'gnomeads' . . . from Spain. How will the British gnome stand up to the new threat?

(*Nationwide* 15/6/76)

The dominant theme which orchestrates this material (in over half the items – $^{17}/_{31}$ in this category) is based on a concern with 'traditional values'. Primarily this takes the form of a massive investment in rural nostalgia – a focus on the variety of rural crafts; items on the highways and by-ways of the countryside. Implicitly there is a reference to an 'image of England' which is founded in an earlier, traditional and predominantly rural society – a more settled (even an organic) community. (See Williams, 1975.)

Nationwide's peculiar addiction to the rural customs and traditions of 'Old England' finds an interesting counterpart in the cosmology of Disneyland; Dorfman and Mattelart argue that each great urban civilisation creates its own pastoral myth, an extra-social Eden, chaste and pure, where

The only relation the centre (adult – city folk – bourgeoisie) manages to establish with the periphery (child – noble savage – worker/peasant) is touristic and sensationalist . . . The innocence of this marginal sector is what guarantees the Duckburger his touristic salvation . . . his childish rejuvenation. The primitive infrastructure offered by the Third World Countries [or, in the case of *Nationwide*, 'The Countryside'] becomes the nostalgic echo of a lost primitivism, a world of purity . . . reduced to a picture postcard to be enjoyed by a service-oriented world.

(Dorfman and Mattelart, 1975: 96)

What *Nationwide* presents is not the rural world of agricultural production and its workaday concerns – today's price of animal feed – but the country viewed from the city, a nostalgic concern with the beauties of 'vanishing Britain . . . the threat to our countryside . . . ever since the Industrial Revolution' (31/3/77). Here we meet the Vicar who is concerned with the future of 'one of the Midlands' most beautiful churches' (31/3/77); the army is praised 'in an odd role – as conservationists' (5/1/76); we pay a touristic visit to Evesham and Stonehenge (18/6/76); to the West Midlands Agricultural Show (19/5/76) and the Three Counties Show (15/6/76): we observe the vestiges of the traditional cyclical calendar of rural life.

We are here presented with a very distinct set of concerns – not the workings of the local social security tribunal but of the 'Forest Verdurers Court' in the Forest of Dean (10/6/76); we learn of the work, not of factory farming, but of seaweed collectors (19/8/76); we are entreated with the problems of 'animals threatened by forest fires' (19/8/76) and see the efforts of forest fire-fighters (18/8/76). It is the world of 'Little Old England' (19/5/76) which may be treated in a 'folksy' way – often with deliberate self-parody and irony – but which is nevertheless secure, and the parody leaves the traditionalism intact.

Thus the approach to the soul-searching, investigative item 'Where have all those nice tea-places gone?' (11/6/76) – complete with music from 'An English Country Garden' – may be tongue-in-cheek, but the subject matter is ultimately accorded serious concern. After all, this is a vanishing part of our national heritage; Frank Bough: 'Does the Tradition not continue anywhere at the moment?'

But this is not all that Tradition has to offer. When the pollen count rises (10/6/76) Nationwide sets off the remedies of modern western medicine against the 'traditional hay fever remedies', which are explored in their regional variations around the country. Here the (regionalised) mode of treatment is as important as the subject matter: Nationwide uses the form again in the item on 'the ingenious artist' (5/1/76). We move into the realms of art and craft but more particularly small, home-based craft and craft-industry. We meet individual craftspeople using 'odd materials' and working in 'unusual places' – a painter from Wales who paints family pets on stretched cobwebs, one from Leeds who paints on piano keys and one from Glasgow who paints on the inside of bottles. The Nationwide presentation of these activities – remnants of a craft tradition in an industrialised world – is positively celebratory. Bough sums up:

> There really is no end to the extraordinarily beautiful things people do in this country.
>
> (5/1/76)

The celebration arises directly from the contrasts which the discourse sustains; we celebrate these things because, in this mechanised world, these individuals retain the methods of painstaking individual creation, the mode of production of an earlier, valued, social formation. Nationwide celebrates (16/8/76) the '100th anniversary of woodcarver Robert Thomson's death'; we visit the V & A craft exhibition and meet the leader of a group of women in Bristol who have painstakingly made a giant tapestry to show the town's history:

> The story of Bristol, told in a very imaginative way in needle and thread.
>
> (15/6/76)

(e) National/political news

Items on 'serious'/political issues are not generated from within Nationwide's 'natural repertoire' but are externally imposed from time to time by 'hard news values'. When a dramatic news story breaks, Nationwide can deal with it; thus a whole studio-based Nationwide was devoted to the Balcombe Street siege. Similarly, on 6/1/76, although Nationwide had been advertising an item on compensation for road accidents the whole programme was in fact turned over to an examination of 'the Bessbrook killings' in Ireland, interviewing relatives and friends of the dead.

Thus, we may get an occasional unscheduled dedication of a whole programme to 'serious current affairs' in addition to the local news spot, but this

remains atypical within the discourse of *Nationwide* during our viewing period. The programme does provide routine coverage of 'matters of national importance', but in the sample analysed these items occupy a subsidiary place – accounting for only 15% ($^{28}/_{182}$) – i.e., slightly *less* than the number of items devoted to any of the other four main categories in the discourse.

In the national/political area *Nationwide* is at its closest to the dominant forms of news and current affairs programming, and some reverence is shown towards them. This is the one area in *Nationwide* where items are predominantly dealt with in a 'straight report' format. ($^{15}/_{28}$ national/political items are dealt with in this format. This is even more marked in *Nationwide*'s local news component 'Midlands Today' where a small sample revealed the almost total dominance ($^{8}/_{11}$) of the 'straight report' format among all items.) The specificity of *Nationwide*'s presentation here often takes the form of a more 'personalised' approach by the newsreader (cf. Chapter 3.vii on Mrs Barbara Carter) – stepping out of the more usual 'impartial' role to deliver personal comment on the items.

However, in the determination to 'domesticate' issues, which is the programme's preferred strategy for 'realising' national political events in terms of everyday life, *Nationwide* will 'angle' what is already structured as 'news' through the particular experience of an individual. Thus, on *Nationwide* 5/1/76 we were told that '*Panorama* will be covering the situation on British Rail later tonight'; *Nationwide*, after a brief reference to the Beeching report, went on to deal with the issue through the story of

> Ron Hooper, the ex-Stationmaster of Tavistock North, who continues to live on his now disused station.

Similarly, while other current affairs programmes were analysing the successes and failures of wage controls under the social contract *Nationwide* took us to meet 'Max Quatermain, the plasterers' mate who can earn £400 p.w.' (16/8/76). When Harold Wilson resigned as Prime Minister *Nationwide*'s 'angle' on the story (16/3/76) was to show him on holiday, in his capacity as a train enthusiast.

Political activists do not regularly feature on *Nationwide*, but when there is a story like that of the 14 year old girl 'child protester' who rode into a meeting to protest about the loss of grazing rights on her local common, then it more easily finds a place in the programme. On the other hand, a case like that of Patrick Meehan (*Nationwide* 19/5/76), released from prison after seven years of a life sentence, can be dealt with on *Nationwide* in such a way that the political dimensions of the case – the accusations of framing and the involvement of British Intelligence – all but disappear. In this example *Nationwide* reconstructs the story principally as a 'drama of human suffering' (cf. Morley, 1976, section 6). The political background of the case disappears – all that remains is an 'exclusive interview' in close-up with a man in a highly charged emotional state two hours after being set free from the solitary block of Peterhead prison.

Again, when the story broke of the British mercenaries on trial for their lives

(iv) Appendix: table and notes on categorisation

Nationwide Total Sample: 29 programmes, 182 items

ITEMS	World of Home and Leisure (b)		People's problems (c)	Image of England: town and country (d)	National/political (e)	Sport	ITEM TOTAL
	(i) Leisure	(ii) Consumers					
THEMATISATION TOTALS	40	33	30	31	28	20	182
NW Event 12	2	4	1	0	0	5	
Individual 47	20*	3	5	6	7	7	
Traditional Values 37	10	3	1	17*	4	2	
Advice 27	1	16*	6	2	0	1	
Concern and Care 16	0	0	14*	2	0	0	
Family 13	3	7	0	1	2	0	
Report 30	4	0	3	3	15*	5	
THEME TOTAL 182							

in Angola (10/6/76), after a brief account of the relevant differences between British and Angolan Law, the story was focused primarily onto the feelings of the parents of one of the mercenaries. Similarly, in the context of the budget news (29/3/77) Nationwide, as noted earlier, presented the whole import of the budget through a set of interviews with 'ordinary families'. Experts enter the debate, and have the power to overrule and redefine the ordinary families' interpretations of the budget, but the whole impact of the item is predicated on the mediation of the political story through its effects on the experience of the people portrayed.

Notes on table

(1) Primary combinations of item categories and thematisation are marked * in the table.
(2) 'Nationwide Events' are, of course (see chapter 2(a)), only the tip of an iceberg composed of all inter-item links and self-referential material in the programmes. Only the 'Nationwide Events' were counted in this tabulation.
(3) There was, of course, a substantial difficulty in tabulating, for instance, the 'Family' thematisation (see notes on categorisation below) – here one is tabulating not so much an explicit presence as an implicit but recurring assumption which 'sets the frame' within which specific items are presented.

Notes on categorisation

For the purposes of this analysis the programmes in the sample were disaggregated into the individual items. Each programme item was then classified across both dimensions of the coding grid: stage (1): by reference to the manifest content, it was assigned to an 'item' category; stage (2): by reference to its dominant form of thematisation, it was assigned to a 'theme' category.

Both these categorisations are, of course, dependent on qualitative judgements; an item has to be judged to belong to category x (cf. Kracauer, 1952). The procedure in stage (2) is somewhat more difficult, as one is assigning items to categories not by reference to the presence or absence of a particular kind of manifest content, but by reference to the presence or absence of 'propositions' (cf. Gerbner, 1964) of a more general nature – theoretical constructs which are themselves unobservable. The procedure here is outlined by Gerbner as one where the task is to make explicit the implicit propositions, premises and norms which underlie and make it logically acceptable to advance a particular point of view. In this way, for instance, statements or reports may be reconstructed in terms of the propositions which underpin them; e.g., in terms of interview questions, explicating the assumptions which must be held for it to make sense to ask particular questions.

The relation of particular items to 'thematisations' or 'propositions' is necessarily problematic, and cannot be formulated on a one to one basis; thematisations can 'take as many different forms' and appear in different guises. Moreover, as Mepham argues (in Robey, 1973:108):

messages are likely to be overdetermined and are thus to be analysed in terms of more than one underlying structure or proposition.

Particular items will frequently refer to more than one context, and will be an index, simultaneously, of different themes.

However, the problem of multi-accentuality that we face here is not specific to this form of analysis. It is in fact the same fundamental problem which faces content analysis, proposition analysis or semiological analysis: how should we assign items to categories, statements to propositions or thematisations, and denotations to connotations?

The fundamental problem here is that of making our interpretations systematic (for all these methods rely on interpretation) and explicit; we have therefore attempted to be systematic in our categorisations. If a goes in category x, and b=a in the relevant respect, b must go in category x as well. Moreover, this has meant classifying only by reference to the dominant thematisation items which also contain other, subordinate themes. This is a form of simplification of the material; but it precisely allows us (see the dominant forms of combination, marked * in the table) to establish the basic structure of the discourse in what would otherwise remain an undifferentiated mass of multi-accentual references.

We are aware, of course, that quantification is in many respects a tool of limited use, and that one is forced towards an atomistic categorisation of data in order to provide a basis for quantification. Certainly quantification, in itself, has no scientific value; but if we are to avoid dependence on casual and fleeting impressions, or generalisation from analyses of single instances, then quantification is of some use. While in no sense constituting a final test or 'proof' it does facilitate a measure of check on our interpretations; through quantification we have aimed to establish the basic profile and contours of the distribution of the different elements of the *Nationwide* discourse in our sample. In some respects this procedure has meant simply replicating immediate impressions through laborious means – for instance, the fact that 'stories of individuals' were important to *Nationwide* was immediately obvious on an impressionistic level. However, it is one thing to assert that as an impression, and another to demonstrate that that kind of thematisation in fact accounts for nearly 30% $(^{47}/_{182})$ of the stories in our sample, and that this thematisation is precisely dominant in the 'world of leisure' $(^{20}/_{40}$ items).

Our analysis, in this section, then, has disaggregated items from their individual programme-contexts and treated them as elements in the larger discourse of *Nationwide*, over and above the level of the programme. We would argue that this has precisely allowed us to trace some of the contours of that larger discourse by mapping the dominant and recurrent distribution of the elements and their recurrent forms of combination, over a long period. In the next chapter we move on to complement this analysis of the overall discourse with a partial analysis of the internal structure of one edition.

3

LINKING AND FRAMING

Nationwide in action 19/5/76

(i) Introduction

So far we have been drawing our illustrations from a wide selection of *Nationwide* materials, based on notes made during an extended period of viewing. In this section, we take a closer look at 'Nationwide in Action', concentrating exclusively on the edition of 19th May 1976. The chapter is in two parts. First, we offer a more detailed breakdown and outline of some parts of the *Nationwide* 'script'; secondly, we offer a commentary on certain aspects of the *Nationwide* discourse. We try here to make available the information on which our categorisation of the items in this and other programmes is based, and to explain the way in which we approached the programme. We fully recognise that our analysis fails to examine in detail the 'programme as a whole' at both the visual and verbal levels. A fully adequate analysis would need to provide an account of the structure of the programme at both these levels, and, preferably, a full programme transcript with visual references. This is beyond the scope of our present endeavour – we offer here a schematic outline of the programme which is no more than the beginning of a full analysis.

We begin with a brief description of the 19th May 1976 programme with some of our own comments on items. We then try to deconstruct the common sense notion of *Nationwide* being 'about' its items by printing a descriptive transcript of the programme, 'foregrounding' all the studio links and item introductions, providing full transcript of these, but giving only brief specifications for the items themselves. There are several reasons for this procedure. First, links, introductions and frame make, in our view, a major contribution to holding the programme together, imposing on its varied 'menu' a distinctive identity and unity. Second, the introductions were important for the whole of our analysis because they frequently signal what the main topic or angle of the item is 'for *Nationwide*'. Thus, in introducing an item, *Nationwide* frequently establishes its own 'take' on a topic – it does not simply transmit items, it constructs itself as a very specific kind of discourse by its production of *Nationwide* items, or by the active work of appropriating a topic or item into the characteristic *Nationwide* discourse. Our own assignment of items to categories was made mainly on the basis of how

they were characterised in the 'links discourse'. For example, it seemed to us important that 'local news' – with its regional flavour and inflection – is invariably designated as such; Ralph Nader is introduced as 'America's leading campaigner on consumer affairs' (consumers); Mrs Carter (see below) is introduced as an individual with a special interest (leisure); etc.

Introductions and links also play a key role in the thematising of items. Thematisation is, of course, different from identifying the topic of an item, as the same topic can be 'thematised' in a number of different ways. Thematisation is inevitably a more difficult part of the analysis than the assignment of items to topics, and is less open to examination without reference to a transcript of the whole programme. We saw both the items referred to above as thematised through 'individuals'; in the case of Mrs Carter, through the stress on her individual feelings and experience, in the case of Nader, through the emphasis on his individual role in 'consumer campaigns'.

In general, we adopted this approach, and have chosen to highlight the discourse strategies most directly connected with these aspects of the programme, because of the importance we have come to attach to the 'links discourse' (see Chapter 2.iii(a)). On an initial viewing, the links may seem to carry no meaning in themselves other than their explicit function of 'linking items'. The links proclaim their own transparency: they are reduced to their apparent function of dependency on the items they precede and succeed. But we would argue, in fact, that the links are what centrally structure and constitute the programme discourse. It is in the links that the main strategies of the discourse can be most clearly observed.

The linking/introductory statements are usually made in direct address to the audience, and indeed these are the only sections of the programme discourse which speak (in a kind of meta-dialogue) directly to the audience – explaining what will appear on the programme, who 'we' will meet, etc. – and it is the *Nationwide* team who have exclusive access to this level of discourse. In anticipating and commenting on items, the links assign items to specific contexts of meaning and association. Thus Mrs Carter, through her 'localness', is primarily placed within the programme's continuing search for 'everyday drama':

> I wonder if you remember this dramatic picture we showed you a few weeks ago of Mrs Barbara Carter of Halesowen . . .

It is 'our' memory, as regular members of the *Nationwide* audience, which carries meaning. The links thus constantly produce the meaning of 'Nationwideness', which is, in its turn, grounded in a specific image of the audience-as-nation, sharing with the presenters a common-sense understanding of the social world.

(ii) Programme description and script 19/5/76

(i) Summary

Time (Mins.)	Item	Comments
00	Regional Menu	⎫ Use of identification pronouns:
02	National Menu	⎭ 'we meet'/'the person who' . . .
03	NEWS 'MIDLANDS TODAY' Shop steward at Coventry car plant sacked. Walsall firm cleared of charges of failing to protect their workers. Plessey management give ultimatum to workers in pay dispute.	A 'package' of industrial news. All brief reports except for that on the carpet firm, which includes film, and some 'background'/information.
(06)	Kidderminster carpet firm in danger of closure. Earth tremor in Stoke-on-Trent.	
	Mrs B. Carter goes back to meet the lions who attacked her in a West Midlands Safari Park.	Questioned exclusively about her feelings. C.U. on facial expressions.
	NEWS Cheltenham policeman praised by coroner for bravery. West Midlands Agricultural Show, Shrewsbury. 6 workers at Rolls Royce Coventry win £200,000 on pools.	Photo stereotype of 'striking workers' redefined by commentators as 'individual success'.
13	Interview with Ralph Nader on consumer affairs.	'Devil's advocate' interview probing Nader's credibility.
15	WEATHER REPORT	Use of child's drawing.
	Report on a new invention from a Midlands College which will enable blind students to produce 3-D drawings.	⎫ Both items focus on the role of 'technological development'; visual emphasis on machinery in C.U. Implicit contrast made
	Report on a group of design students from Wolverhampton who've been building a 'Survival Kit' out of rubbish material.	between obvious value of the invention in former item and the ⎭ dubious value of the latter project.
25	NATIONAL *NATIONWIDE* NW team members go on boat trip on the yacht 'Nationwide' on the Norfolk Broads.	Self-reflexive item: the *NW* team become the 'actors' in their own story.
28	A report on American servicemen and their families on a U.S. base in Suffolk.	Extensive use of stereotypes of 'Englishness'/'Americanness' in report on 'invasion' of 'Little Old England'.

Time (Mins.)	Item	Comments
37	Interview with Patrick Meehan, released from jail with a free pardon after being originally convicted of murder.	Focusing on the subject's feelings: C.U. on facial expressions.
40 / 50	What to wear/eat/drink at the races. The *Nationwide* Horse: Realin. Report on the financial problems of English racing. Interview with Clement Freud, a racehorse owner.	The 'Sport of Kings' brought to the NW audience; a highly composite item involving studio mock up, outdoor film, graphics and studio interview.

(ii) Transcript

REGIONAL MENU

Tom Coyne: (See fig. 4.) Good evening. Tonight we meet the students who built a new life for themselves out of a load of rubbish – these might look like a few old plastic bags to you but actually for a time it was home to them. And then we join the lady who was attacked by the lions in the Safari Park as she goes back again to meet the lions. That's us at six.

NATIONAL MENU

Michael Barratt: (See fig. 5.) And after your own programmes we go cruising down the river to bring you our third programme from East Anglia. We also meet the Americans whose home is in Suffolk this bicentennial year and we consider the crisis in racing. Our own horse is looking good, but the sport of kings itself is in trouble and we ask Clement Freud what's to be done about it Nationwide.

'MIDLANDS TODAY' INTRODUCTION

TC: Well you know, isn't it marvellous, every time you come outside the studio the rain seems to come with you. I think that what we've done with this kind of programme is to create a new kind of rain dance ha ha but I'll tell you one thing it certainly isn't going to bother David Stevens because he's back inside waiting to read the news.

Item	Technical Specification	Speaker Status	Categorisation	Thematisation
Shop steward sacked	Studio Report d/a	Newsreader	Local News: Industrial/ Political (e)	'Straight' Report
Walsall firm cleared	Film Report v/o	Newsreader	Local News: Ind./Pol. (e)	'Straight' Report
Report on carpet firm	Film Report v/o	Reporter	Local News: Ind./Pol. (e)	'Straight' Report
Earth tremor	Studio Report	Newsreader	Local News:	'Straight' Report

Item	Technical Specification	Speaker Status	Categorisation	Thematisation
TC: Well there's going to be more news of course later in the programme. I wonder if you remember this dramatic picture we showed you a few weeks ago of Mrs Barbara Carter of Halesowen. She was attacked by lions in the West Midlands Safari Park. Well after an experience like that you'd hardly expect Mrs Carter to be keen on uh seeing lions again. But today she visited a farm near Stratford on Avon to do just that. A report from Alan Towers:				
Lady & Lion (See fig. 6)	Field Interview	Intvwr. & Participant	Leisure (b)	Individual
David Stevens: A much braver and a more determined person than I could ever be.				
Police Constable	Studio Report d/a	Newsreader	Local News (e)	'Straight' Report
DS: Two stories of bravery.				
Agricultural show	Film Report v/o	Newsreader	Rural England (d)	'Straight' Report
Pools winners (See fig. 7.)	Studio Report & still d/a	Newsreader	Leisure (e)	'Straight' Report
TC: I'll tell you something, it's cold out here tonight, just in case you always thought I looked blue like this. You know America's leading campaigner on consumer affairs, Ralph Nader, uh was in the Midlands today, was here to speak to an Industrial Safety Exhibition which was held at the National Exhibition Centre, and it's reported that Mr Nader was paid a fee of £2,000 for speaking. There to meet him was Geoffrey Greene:				
Nader Interview (See fig. 8.)	Field Interview	Intvwr. & Expert (Soc.)	Consumer (b.ii)	Individual
TC: Well with the drizzle coming down, I hardly dare mention it, but let's take a look at our weatherpicture. It comes from Leicester, and from Jane Hickman, who's 15 years of age:				
Weather	Studio d/a	Intvwr. & Expert (Soc.)		Individual
(See fig. 9.) The weather: well, the showers or periods of rain, heavy at times, will gradually die out from the West to give clear intervals later in the night. Minimum temperature 6 degrees Centigrade. Tomorrow we'll have some sunny intervals with further showers developing. There will be winds, the sort you can hear in the microphone now, westerly, light or moderate. And that's it.				
Now one of the things you'd hardly expect a blind person to be able to do is draw a picture like the one we've just seen. But things of course are changing all the time, the new development that is being tried out here in Birmingham could certainly change all that. Here's a report now from Duncan Gibbens:				
DG: The man who's patented the drawing board is Mr Christopher Vincent. As head of the Technical Graphics division of Birmingham Polytechnic, he's adapted the board from a perspective grid. Now he hopes to introduce his device into other colleges for the blind.				

Item		Technical Specification	Speaker Status	Categorisation	Thematisation
Blind students learn to draw (See figs. 10–13.)	Report on invention	Film Report v/o	Reporter		
	Interview with inventor	Field Interview	Interviewer and expert	People's probelms (c)	Concern and care
	Interview with student	Field Interview	Interviewer and participants		
	Report on students' prospects	Film Report v/o	Reporter		

DG: Soon 3-Dimensional braille maps will be developed using drawings from the board. Then blind youngsters like Paul and Martin Sullivan will not only have a better understanding of the way the world looks – they'll be able to find their way around much more easily.

TC: (See fig. 14.) If our society was destroyed, heaven forbid, I wonder if you could pick up the threads of life and build a new one for yourself out of the rubbish lying around? Well, a group of students from the Wolverhampton Polytechnic have just survived that sort of experience in Wales. They're design students and one of the tutors behind it is Mr Wyn Foot. (What's it all about?)

Item	Technical Specification	Speaker Status	Categorisation	Thematisation
Interview with course tutor on project	Field Interview	Intvwr. & Expert	People's problems (c)	Individuals

TC: Good. Well, what I'll do, I'll move across actually to have a word with some of the students over here. As we've just heard from Mr Foot all the objects lying around came from rubbish dumps and places, discarded by industry and householders and all that sort of thing.

Item	Technical Specification	Speaker Status	Categorisation	Thematisation
Interview with female student	Field Interview	Intvwr. & Participant	People's problems (c)	Individuals

TC: Well look, I'll leave you carrying on working there . . . Are you all right in there . . . Good, you look well. Let's move across here now and talk to this erum gentleman.

Item	Technical Specification	Speaker Status	Categorisation	Thematisation
Interview male student (See fig. 15.)	Field Interview	Intvwr. & Participant	People's problems (c)	Individuals

TC: Well thank you very much indeed and thank you all for coming and reconstructing the scene, for it's been a pleasure talking to you, and now let's go to Norwich.

Item	Technical Specification	Speaker Status	Categorisation	Thematisation

NATIONWIDE INTRODUCTION

Michael Barratt: For the third time this week welcome to the Norwich studio of the BBC, the 'LOOK EAST' studio, because for the third time Nationwide is coming to you from East Anglia as indeed it's gonna be all week. Well, we've had a jolly good week so far here and I've enjoyed it immensely; it's my last night of course at the table here. We haven't really had any alarms or er real worries. (Ian Masters: no, no) up to now (very true). Actually let me let the viewers into a secret because this morning Ian and I and Bob Wellings went out onto the Broads, onto the River Ure, is it, that comes into Norwich?

IM: The Yer.

MB: The Yure?

IM: The Yerr.

MB: I See, I see, the River Ure, and we went out on that and we were going to pretend that Nationwide was starting on a boat. Well Nationwide in a way is going to start on a boat in a few minutes because we had some problems with the film. Anyway Ian and Bob and I would like to welcome you a second time to Nationwide.

MB: (See fig. 16.) And er welcome again to East Anglia for the third night this week and in a rather different style this time. Nationwide as you can see is seaborne and this is a very ener . . . Stand by? What do you mean?

IM: Stand by to go about, Mike.

MB: Oh I see

IM: Let that rope go back and hold onto the other one. Come forrard.

MB: Let it go? Right.

(Noise)

IM: That's fine.

MB: I say, where's Bob? Bob, where are you?

BW: Messing about in a boat. Such fun.

IM: The trouble is that when you're sailing in trees . . . it suddenly comes from behind the tree and hits you hard. It's a lot easier to sail to Holland; as a matter of fact the chap, this a pal of mine, does it all the time.

MB: Does he? A bit boring, isn't it?

IM: Yes . . . Well, he enjoys it . . . (Laughter)

MB: (Obscured) Right, do I let go now?

Item	Technical Specification	Speaker Status	Categorisation	Thematisation

IM: Er, listen, we're catching some wind. Bob, where are you? Bob, come on, give us a hand, mate. What are you doing down . . .? Come on, Bob, will you put that main sheet on the cleet?

BW: The cleet?

IM: On the cleet. The mainsheet, yes. Well come on, Bob; no, that's the railing, Bob.

BW: That? This?

IM: That's the railing, No, that's the gibsheet.

BW: Ian . . .

IM: Were you listening to what I was saying?

BW: Wh-wh-wh-what do you want me to do?

IM: I want you to get . . .

MB: Hey, we're going about or tacking or something.

IM: No, No. Keep on holding it in.

MB: Right. My fingers are still sore, you know.

BW: All this 'tacking' and 'avast' and 'ahoy' and left hand down and giblets and spinnakers and god knows what . . . ugh, here we go again – ludicrous performance.

MB: And while we move on with Bob up river to Norwich and the studio let's hear from another part of East Anglia, from Suffolk this time although you might think it was bit of America. In Bicentennial year a report from Luke Casey in Leighton Heath:

LC: This is part of a very polite invasion. Three times a week an American aircraft courteously deposits its cargo of United States citizens onto this seasoned soil of Britain. For most, East Anglia is their first, jet-lagged look at Little Old England, where even the language is different. Soon they'll be happily, if predictably, pitching into the battle between tomatoes and tomătoes, and the mystery of Worcestershire Sauce. But first, they learn of our more pressing eccentricities.

Item	Technical Specification	Speaker Status	Categorisation	Thematisation
Report on Americans' arrival	Film Report v/o	Reporter	England (d)	Traditional Values

LC: Not all the newcomers though, feel they can't live without their instant America kits. This old English farmhouse is home for one family.

Item	Technical Specification	Speaker Status	Categorisation	Thematisation
Interview with Mrs Pat Pfleiger	Field Interview	Interviewer & Participant	England (d)	Traditional Values

LG: Pat Pfleiger; her husband Dave's a major at Mildenhall, and their three children are not the sort of people who'd like to see Coca-Cola on the moon. The breakfast of hot-dogs and French toast is the only recognisable concession to their American-ness. (See fig. 18.)

Item	Technical Specification	Speaker Status	Categorisation	Thematisation
Interview with Dave Pfleiger	Field Interview	Interviewer & Participant	England (d)	Traditional Values
Report on Americans in E. Anglia	Film report v/o	Reporter		

LC: It may not be cricket, but it's sure as hell American.

MB: Luke Casey there, among the nice people in America, or was it Suffolk. This afternoon, as you may have heard, Patrick Meehan was released from Prison in Peterhead, so over now to David Scott in Aberdeen:

DS: Meehan was released from prison after seven years. Most of it had been spent in solitary confinement as a protest against his conviction. It was just under two hours ago that he was released from Peterhead prison, and he was quickly reunited with his former wife Betty, and their son Gary. We recorded this exclusive interview a short time ago.

Item	Technical Specification	Speaker Status	Categorisation	Thematisation
Interview with Meehan (See figs 19–20.)	Field Interview	Interviewer & Participant	National/ Political (e)	Individual

MB: Patrick Meehan filmed exclusively for *Nationwide* by our colleagues in BBC Scotland. Patrick Meehan who of course has served seven years of a life sentence for murder – a conviction based yet again on identification evidence. And now back to our base for this week. East Anglia of course is the home of *Nationwide*'s adopted racehorse Realin, so we thought that tonight we'd go racing.

Item	Technical Specification	Speaker Status	Categorisation	Thematisation
Bob Wellings at the races (See fig. 21.)	Studio d/a	Reporter		
Nationwide Horse (See fig. 22.)	Outdoor d/a	Reporter	Sport	Traditional Values
Problems of English Racing	Film & Graphics v/o	Nat. Presenter		

MB: Well now, Clement Freud in London, that's all a great pity but, er, most people do expect to pay for their sport, why should racehorse owners be different?

Item	Technical Specification	Speaker Status	Categorisation	Thematisation
Interview with Clement Freud (See fig. 23.)	Studio Interview	National Presenter & Institutional Representative	Sport	Traditional Values

MB: Something which clearly makes you, Clement Freud, very sad, but thank you very much for explaining it for me. Well, that's all; as I was saying this is my, er, last night with you, Ian Masters from Norwich here and from East Anglia. I've enjoyed it very much. Frank Bough will be back in this chair tomorrow night, of course (cough) I've got an awful frog in my throat now, anyway from me until tomorrow: Goodnight. (See fig. 24.)

Fig. 1: Nationwide logo

Fig. 4: Tom Coyne introducing menu for 'Midlands Today'

Fig. 2: Nationwide logo

Fig. 5: Michael Barratt introducing menu for *Nationwide*

Fig. 3: Nationwide logo

Fig. 6: Interview with Mrs Carter and lion

Fig. 7: Pools winners

Fig. 10: Blind students in the classroom

Fig. 8: Ralph Nader

Fig. 11: Blind students – the invention at work

Fig. 9: Weather report

Fig. 12: Blind students interviewed

Fig. 13: Blind students – close of item

Fig. 16: Michael Barratt and regional presenter on the *Nationwide* boat

Fig. 14: Students' rubbish project – introduction

Fig. 17: Interview with Mrs Pfleiger

Fig. 15: Students' rubbish project – interview

Fig. 18: The Pfleigers at breakfast

Fig. 19: Interview with Patrick Meehan (i)

Fig. 22: Val Singleton introduces the *Nationwide* horse

Fig. 20: Interview with Patrick Meehan (ii)

Fig. 23: Michael Barratt interviewing Clement Freud

Fig. 21: Bob Wellings at the races

Fig. 24: Michael Barratt closes the programme

KEY TO PROGRAMME OUTLINE

Content Categories

(a)	Nationwide Events/links
(b.i)	Leisure
(b.ii)	Consumers
(c)	People's problems
(d)	Image of England
(e)	National/Political; Sport

Thematisations

Self-Referential/Identification
Individuals
Advice/family
Concern and care
Traditonal values
Straight report

Technical Specifications

Direct address (d/a) $\begin{cases} \text{Studio Report} \\ \text{Outdoor} \end{cases}$

Film Report $\begin{cases} \text{Voiceover (v/o)} \\ \text{Reporter to Camera} \end{cases}$

Interview $\begin{cases} \text{Studio} \\ \text{Field} \end{cases}$

Studio Discussion

Speaker Status Categories

Presenter $\begin{cases} \text{National} \\ \text{Regional} \end{cases}$
Newsreader
Reporter
Interviewer $\Bigg\}$ Programme Internal

Participant
Eyewitness
Institutional
Representation
Politician
Expert $\Bigg\}$ Programme External

(iii) The links

Everything is 'linked in'; an item cannot appear on *Nationwide* without having been firmly set in context. First, it will be introduced by being located in the structure of the programme text (cf. Halliday, 1973: 66); it is made clear what part of the programme we are in (Regional/National *Nationwide*), how the item relates to other parts of the programme. Second, it is made clear how it relates to our concerns in the social world.

This can usefully be seen as a four or five stage strategy:

(1) Linking — performing the textual function, guiding us through the programme discourse ('now, over to . . .').

(2) Framing — establishing the topic and its relevance to the concerns of the audience.

(3) Focusing — establishing the particular angle that the programme is going to take on the topic.

If there are to be extra-programme participants a fourth stage is necessary:

(4) Nominating — clueing the audience in as to the identity of extra-programme participants or interviewees; establishing their 'status' (expert, eyewitness, etc.) and their right/competence to speak on the topic in question – thus establishing their (proposed) degree of 'credibility'/authority within the discourse.

— *Nationwide* members, of course, also have their 'statuses' continually marked and established within the discourse ('our reporter in Lakenheath . . .') but they are also pre-given as established figures, with an established competence (e.g. Barratt) and role in the programme.

Customarily there is a fifth stage of the process:

(5) Summing-up — drawing together the main threads of the item, its relevance and the context in which it is to be placed; done by the interviewer at the end of the item (internally), and/or by the linkman, before going on to introduce the next item.

If we look at the item on the blind students who have been able to learn to draw because of a new invention we can see this process in operation:

(1) Link:	'One of the things you wouldn't expect a blind person to be able to do is draw . . . a picture like the one we've just seen but things of course are	The link is given by the regional presenter; he links its relevance back to the previous item (a child's, drawing of the weather) and frames/connects it with
(2) Frame:	changing all the time, and a new invention . . . could change all that.'	our social concern for the blind.

He then introduces/nominates the reporter who is going to do the story:

'. . . a report now from Duncan Gibbons.'

who moves on to phase (3) of the process:

(3) Focusing:	'A class at . . . College for the Blind . . . these youngsters are working with a new device . . . giving them a remarkable insight into the world of the sighted person. The device is a new drawing board . . .'	He focuses our concern with the topic onto the specific role of a new invention in helping blind people to produce 3-D drawings.

He goes on to explain a little how the device works and then moves to phase (4):

(4) Nominating: 'The man who invented the drawing board is Mr Christopher Vincent, head of technical graphics at Birmingham Polytechnic . . . he adapted it from a perspective grid . . . hopes to introduce the device into other colleges for the blind . . .' He thus nominates the first extra-programme participant – he introduces him and explains his status as expert/inventor, and thus his competence to speak on the topic.

The inventor is then interviewed, and afterwards two of the students who are using the invention. At the end of the interview with the students we move out to a film report of them walking cumbersomely out of the college, arm in arm, and the reporter, in voice-over, sums up:

(5) Summing-up: 'Soon 3-D maps will be developed using drawings from the board. Then blind youngsters like . . . [these] will be able to find their way around much more easily.' The summing up contextualises the item in terms of its social use-value; the invention will help to produce maps which will practically improve the lives of the blind students.

This item, then, displays a recurring *Nationwide* structure:

(L	F	(N)	Fo	N	(. . . .)	F)
(Link	Frame	(Nominate)	Focus	Nominate	(. . . .)	Frame)

The structure contains (in both senses: includes, and holds within its limits) the independent-authentic contributions of the extra-programme participants. That is, it defines and determines the structure of how, where and what the extra-programme participants can contribute. Of course, the items appear to ground, witness and authenticate themselves, outside the programme, in the 'real world' through these 'extra-programme' contributions. This process of authentication is supported and realised by the forms in which the participants' accounts are signified: that is, participants are shown 'in their own person' on film; what they are said to be doing is witnessed to by our seeing, in the visuals, that they are indeed doing it; and they are shown and heard, speaking 'in their own voice'. But this apparent transcribed reality is itself framed by the encoding structure of the item, which establishes its own over-determining 'reality'; and, through the visual and

verbal commentary, encodes, as its privileged reading, a specific interpretation of what they are saying and doing. The discursive work of linking and framing items binds the divergent realities of these different items into the 'reality' of the programme itself – reconstitutes them in terms of their reality-for-the-programme. Over against the divergent times, histories and locations of these different items, the linking work establishes its own privileged continuity – incorporates them into the 'natural' Nationwide flow, into Nationwide time. Essentially, Nationwide as a programme is articulated through these two axes: the axis of *difference* (different items, different topics, different participants – each with its own register, its own point of interest, contributing to the panoramic *variety* which is Nationwide's manifest stock-in-trade, its claim to be a magazine topicality programme); the axis of *continuity and combination* – which binds, links and frames these differences into a continuous, connected, flowing 'unity'. But the linking discourse has a determining primacy in the hierarchy over the other discourses, which are actively subordinated to it through certain specific discursive strategies.

It would be perhaps more appropriate to define the linking and framing discourse as the *meta-language* of the programme – that which comments on and places the other discourses in a hierarchy of significance, and which therefore actively constitutes the programme as a 'structure in dominance'.

As we move through any one item – from direct address, through filmed report and interview, to studio discussion – we move from that level of the discourse at which control is most directly in the presenter's hands, to that at which the structure is more 'open'. This movement, however, is paralleled by an increasing restriction of access as we move up the scale: only the Nationwide team have access to the level of the discourse in which frames and contextualisations for all the elements of an item are given. Extra-programme participants only have access to the lower levels of the discourse; and their contributions are always framed by the presenter's statements.

(iv) Verbal and visual discourses: combinations and closures

The framing of items is also set by the relations of hierarchy established between the visual and verbal levels of discourse. The use of voice-over film reports – where the commentary 'explains' the meaning and significance of the images shown – is the most tightly-controlled form in which the 'actuality' material is presented: here, the verbal discourse is positively privileged over the visual. It is important, analytically, to hold a distinction between these two, distinct, signifying chains. The visuals could, potentially, be 'read' by some section of the audience outside of or against the interpretive work which the commentary (voice-over) or meta-language suggests. But the dominant tendency – which the specific work of combination accomplishes here – is for the visual images to be 'resolved' into those dominant meanings and interpretations which the commentary is providing. This interpretive work is, however, repressed or occluded

by the synchronisation of voice-over with images, which makes it appear as if the images 'speak for themselves' – declare their own transparent meaning, without exterior intervention. This synchronisation of discourses is the work of *coupling* – the accomplishment of a particular combination of discourses which has the effect of *fixing* certain privileged meanings to the images, binding the two signifying chains together in a specific relation of 'dominance'. Specifically, film used on *Nationwide*, although it may have its own faint sound-track (naturalistic background sound, for example), is invariably *voiced-over* for some part of an item, except where the *Nationwide* team itself (e.g. the East Anglia boat trip) is the 'subject' of the item, providing both the content of, as well as the commentary on, the report. In that situation, sound is relayed direct.

Thus, there is a repeating structure which (to take examples from the 19 May programme) is used for both the 'Blind' and the 'American' items:

(introduction – v/o film report)

(interview(s))

(conclusion – v/o film report)

As in the case of framing by direct address, v/o introductions set the frame and dominant meaning within which the content of an item or interview is set.

This structure can be seen at work if we look at the item on 'Blind students' – now with special attention to the visual discourse. Visually, this item has a complex form: we begin with v/o film report, showing the invention in use in a classroom – we see and hear students performing operations which we do not yet understand. The indeterminacy or unresolved nature of this visual 'clue' is sustained in the v/o commentary:

> Reporter: 'This/mysterious/clicking noise makes this a very special classroom.'

This temporary 'suspense-effect' is quickly resolved, as the commentary begins to explain the meaning of these unintelligible visual messages. We then see film without commentary (in direct sound) of an obviously authoritative figure (this much is signified by his manner, dress, age, style of addressing and directing the students), moving around the classroom. After a few seconds – in which the visual resolution is, once again, temporarily suspended – the reporter's commentary identifies him:

> Reporter: 'The man who's patented the drawing board is Mr . . .'

We then move on to more film of the invention in use, with v/o commentary – this time, an internal commentary, provided by the inventor himself – and then to a shot of the inventor being interviewed, speaking now direct to camera.

In these sections of the item, visual sequencing reinforces (and also constitutes) the force of the meaning of the images: while the inventor is talking, explaining how the invention works and how he derived the idea for it, the camera gives us

detailed close-ups of the use and workings of the invention: shots of hands moving along T-squares, etc.

When we move, however, to speak to the students themselves, the camera zooms in to a facial close-up, as soon as they begin to speak of the difference the invention has made to their personal lives. Here the emphasis is fixed, visually, on one student (on his facial expression) as he explains how the invention has changed his life. The use of visual close-up on the face – expressing in personal terms the essential-human 'point' of the item – supports the displacement of focus from the technical to the experiential register.

For the final section of the item (third move in the structure), as we watch the blind students leaving the college, the students walk away from us out of the door, the camera moving back to allow us a more distanced/'objective' perspective – a concluding, rounding-out, closing shot. The reporter sums up and contextualises the significance of the item *as a whole*, in v/o commentary, over the 'closing' filmed images.

(v) Setting the spectator in place: positions of knowledge

It is clear from this brief analysis that no permanent dominance is given to the visual in the hierarchy of discourses established in this item. Rather, we would have to say that, at the key points of transition in the item, a dominant interpretation is, if anything, 'privileged' by the signifying discourse of the commentary and v/o meta-language. However, certain key transitions *are* principally realised through the shift from one visual register to another – for example, the *technical* aspect of the item is 'shown' by the close-ups of hands manipulating the apparatus, before its 'workings' are explained by an internal commentary; the transition from the technical to the *experiential* register is principally accomplished by the camera movement to full-face visual close-up; the 'closure' of the item, and its 'human significance', is pointed principally by the camera pulling back to give us a more 'overall' view of what has been accomplished for the blind students coupled, of course, with a framing commentary. What matters, then, is not the permanent primacy of the visual discourse, but rather the way the verbal-visual hierarchy of combinations is differently established at different moments or points in the item – the discursive work which each on its own and both together accomplishes and sustains.

The visual discourse, however, has a special significance in *positioning* the spectator, setting him/her in place in a set of shifting positions-of-knowledge with respect to the item. Even here, positioning ought not to be reduced to the specific technical movements of camera shot and angle, but must rather be understood as the result of the combined visual-verbal 'work' – sustained by and realised through the programme's discursive operations.

Thus, when we first 'look' at the invention being used in the classroom, we look at this scene with and through the 'eye' of the presenter. It is his 'gaze'

which we follow, from a position – a perspective on the filmed scene – outside the frame, looking in on it. Here, paradoxically, we 'see' from an absent but marked position, which is where the presenter's *voice* appears to come from: 'this mysterious clicking noise . . .'.

It is the 'gaze' of the presenter/spectator, outside the programme, which 'finds' the inventor, within the frame; which then picks up and follows (as the camera does) his 'glance'. The spectator's position is now, through a mirror-reciprocation, identified with that of the inventor's as we look at what he looks at – and he can now directly address 'us'; an identical line of vision, from inside the frame to 'us' outside the frame, has been established. This privileged giving-of-the-commentary over to a representative figure within the frame (operating along this line of vision) is sustained by the specific work of designation, pre-senter-to-inventor. That is, it is sustained by the *process* through which, progressively, the various positions of the viewer are established: the overseeing 'look' at the film, from a position outside its system of significations; the 'find-ing' of a position of identification for the spectator (outside), inside the film-space; the mirror-effect, which, having established 'us' at the centre of the film – seeing what is to be seen, through its glance – then enables the recipro-cating look, back at us, through direct address, eye-to-eye. Our 'look' is now identical with 'his' (the inventor's). Hence, while, as he speaks, he looks down and around at the operations which he is explicating, 'we' follow his glance; we have been inscribed in it, and take the perspective of his look: close-ups of the invention, hands moving along T-squares, feeling their way . . .

The transition to the students speaking and imaged 'as themselves' returns us to a position outside the frame – but a privileged one; a point emphasised by the camera zoom, manipulating the distances, which 'takes us closer in' – but which is also a shift of focus in the other sense, obliterating the technical details of the classroom, and 'focusing' (or re-focusing) our 'look' on what is now the most important element – the expressive signifier of the face of the subject, in what has been abstracted/emphasised (by the zoom) as the essence, the truth, the human point, of the item: technology changes lives; it enables the blind to 'see'; we 'see' that it does, because we see the intense (i.e., intensified, by the close angle) meaning-for-the-subject of what has already been shown.

The point once made, in its most intensified moment/point of registration, we are ready for the closure. Closure is signified here by re-positioning the spectator in the place of a now more-inclusive knowledge – in the enclosing, framing, gathering-together plenitude of our 'sense of a sufficient and necessary ending'. 'They' – the subjects of the item – are seen moving away from us, from our posi-tion of knowledge/vision; we, in turn, move back from this involvement (i.e., are moved back, as the camera retreats, from the point of intensity), to get a retro-spective-circumscribing 'over-look' of the item: what it *all* means . . .

What we 'know' about the 'Blind' item is inscribed through the process of *how* we come to know – that is, the positions from which we see and hear what there is to be known about this item. That knowledge is constructed in part through the

inscription of the spectator-as-subject in a series of positions – positions of vision, positions of knowledge – sustained by and realised in the discursive operations. These operations set us in place in a process of knowledge – from perplexed ignorance ('this mysterious clicking noise . . .') to completed, circumscribed understanding (what the item was *really* all about). The ideological effect of this item is not in any sense completed by this process of positioning – it includes, for example, what we 'come to know' about humane technology, about how lives are changed; but it depends, in part, on how the process of 'coming to know' is sustained through the programme's discursive work – constituting the spectator actively in the unity of the places in which 'we' are successively fixed and positioned.

(vi) Speaker status and the structure of access: subject and experts

Access to the discourse is controlled by the programme team. The question is 'access on what terms for whom' and the crucial variable here is the extra-programme status of participants. Participants of 'low' status will tend (a) to be questioned only about their 'feelings' and responses to issues whose terms have already been defined (cf. Cardiff, 1974) and (b) will tend also to be quickly cut short if they move 'off the point'. Those of 'higher' status will conversely tend to be (a) questioned about their 'ideas' rather than their 'feelings' and (b) will be allowed much more leeway to define issues in their own terms.

This distinction is formally supported by the tendency to move in for bigger close-ups of subjects who are revealing their feelings, whereas the set-up for the 'expert' is usually the same as that for the interviewer – the breast pocket shot. Both kinds of statused participants are 'nominated' by the reporters into the discourse, questioned by a member of the team, and have their contributions framed and 'summed-up'.

Thus, there is a clear differentiation in the discourse between those participants who appear, principally, as 'subjects' – something newsworthy has happened to them – and those who appear as 'expert' in some particular field. The distinction between the two types of participants is constructed through the interview questions.

Thus, in the case of those who appear as newsworthy subjects it is their feelings and experiences which are explored:

(1) to lady attacked by lion: 'How did you feel . . . when this attack took place? You must have literally thought it was your end, did you?'

(2) to blind students learning to draw: '. . . what sort of difference has this drawing system made to your everyday life?'

When we meet 'experts' of various kinds it is their ideas and explanations that are of interest, not their feelings as 'human subjects':

(1) to inventor of drawing system: 'Did it come as a surprise to you to learn that blind people had a perspective?'

(2) to Nader: 'What are your ideas, for instance, on industrial safety?'

Interviewees whose status is constructed as being low (either – in the case of Patrick Meehan – because of his background or – in the case of the lecturer who organised the 'rubbish/survival kit' project – because of a lack of clear legitimacy in their particular (in this case educational) field of practice) can be easily cut short if they go 'off the point'.

In the case of the lecturer, Tom Coyne as interviewer feels able to demand that he give an account of himself in a way that forces him to comply. Thus after a brief introduction to the item Coyne asks crisply:

What's it all about?

to which the lecturer feels bound to respond, half-apologetically:

Lecturer: 'Um, I think I should explain . . .'

However, he fails to provide an explanation which meets Coyne's fundamental questioning of the validity of the project, and is cut short in favour of interviews with the students who 'actually went to the rubbish dump'.

When an interviewee is considered to have some more considerable status – as in the case of Ralph Nader in this programme – he will be allowed more time to develop his answers to questions; he cannot be cut short so brusquely and may even be allowed the 'space' to redefine the questions asked into his own terms. Greene questions Nader quite sharply on the legitimacy of his campaigning activity. Obviously Nader presents something of a troublesome figure for *Nationwide*; on the one hand he claims to stand for the 'rights of the consumer' much in the way that *Nationwide* does, on the other hand his activities have a 'maverick' quality. But, even when Greene presses the point, invoking what 'many people' think:

Greene: 'Would you be unhappy if you were described, as many people have described you, as an agitator?'

Nader is granted the space in his reply to redefine Greene's question and to answer it in his own terms:

Nader: 'Well you see any change involves agitation, King George found this out two hundred years ago and . . . of course, by definition, any improvement requires a change of the prior status quo, or displacement of it, and so I think that's a very important role for people to play because there's a lot of change needed in our world today.'

(vii) Controlling the discourse: the work of nomination

'Tonight we meet the person who . . .' is a characteristic *Nationwide* introduction, but the point is that although we may 'meet' a host of individuals in the course of the programme, we never meet them direct. The 'meeting' is carefully set up by the *Nationwide* team. Thus, we are told in the regional menu that we will:

> TC (direct address) to camera: 'join the lady who was attacked by the lions in the Safari park as she goes back again to meet the lions.'

After the first section of local news we cut again to Tom Coyne in his role as out-door linkman. He first supplies the textual link, situating this item in the flow of the programme:

> TC: 'Well there's going to be more news of course later in the programme.'

Then he moves on to introduce and frame this particular item, first linking it back to an earlier story covered by the programme:

> TC: 'I wonder if you remember this dramatic picture we showed you a few weeks ago of Mrs Barbara Carter of Halesowen. She was attacked by lions in the West Midlands Safari Park. Well after an experience like that you'd hardly expect Mrs Carter to be keen on seeing lions again. But today she visited a farm near Stratford on Avon to do just that . . .'

Mrs Carter's status and identity as a newsworthy person are established; her actions are situated in our frame of expectations – the focus is placed on her doing something 'you'd hardly expect' – breaking the frame of our everyday expectations and therefore being newsworthy (cf. introduction to 'Americans in England': 'let's hear from another part of East Anglia, from Suffolk this time although you *might think* it was a bit of America.') Coyne then nominates the reporter for the story:

> TC: 'A report from Alan Towers.'

At the end of the interview the newsreader moves momentarily out of his impartial role, to add a personal comment:

> A much braver and a more determined person than I could ever be.

before moving on to the next story – a report of a policeman attempting to rescue a woman from a fire. At the end of that item the newsreader's comment links it back to Mrs Carter's story:

> Two stories of bravery.

Similarly, the interview with Ralph Nader is introduced by a statement which clearly 'statuses' the interviewee:

> Coyne (d/a to camera): 'You know America's leading campaigner on consumer affairs, Ralph Nader . . .'

followed by a framing/introductory question:

> . . . we hear of you on all sorts of controversial topics . . . what motivates you to get into all these different fields?

The introduction and the question thus tell us Nader's status and competence and establish the topic on which he is to speak; again in the interview with Patrick Meehan we find the two stage introductory frame at work:

> Barratt (d/a to camera): 'This afternoon, as you may have heard, Patrick Meehan was released from prison in Peterhead, so over now to David Scott in Aberdeen.'

Barratt thus nominates the reporter, who continues:

> Scott (d/a to camera): 'Meehan was released from prison after seven years. Most of it had been spent in solitary confinement as a protest against his conviction . . .'

The chain of nomination passes from Barratt, as presenter, to the regional reporter, and only then to Meehan – his appearance is by no means a direct access or meeting with the audience: it has been 'framed', we have been told who he is, what is remarkable about him and how long ago (two hours) he got out of jail. His status for-the-programme is pre-established.

At the end of the interview Barratt (speaking d/a to camera again) sums up the item in a way that contextualises it and thus attempts to encode it within a preferred interpretation:

> Barratt: 'Patrick Meehan, who of course has served seven years of a life sentence for murder – a conviction based *yet again* on identification evidence' [his emphasis].

Here Barratt proposes a dominant framework for the interpretation of the events portrayed and retrospectively inserts the item into the frame; only he, as presenter, can authoritatively lay claim to the right to privilege one interpretation in this way. Meehan, on the other hand, can only speak within the frame set by the interviewer, which itself is within the frame set by the presenter.

Within the interview itself, *Nationwide* has a lesser degree of control over the

discourse: thus Meehan repeatedly tries to 'break the frame' that has been set up for him – talking about the political issues behind the case rather than about his feelings while in prison:

> Meehan: '. . . I think it's wrong that, er, when things happen in places like America that people over here should become all sanctimonious and criticise, little do they know that the same things are happening here and the whole system is geared to prevent these things coming to the surface . . .'

Indeed, at the point where he claims that he was framed by British Intelligence *Nationwide* has to resort to the ultimate level of control (cutting the film) in order to maintain the dominant direction of the discourse.

Control, then, is not simply 'given' by the structure of the discourse; it has to be maintained, at times through an ongoing struggle, by specific discursive strategies, on the studio floor. In this interview Meehan repeatedly attempts to answer the questions that he would have liked to have been asked rather than those he is asked: that is, he attempts to gloss or inflect the discourse in his favour (cf. the 'yes, but . . .' strategy identified in Connell *et al.*, 1976):

> . . . the first thing I want to do is pursue the matter further, er, for a public enquiry, and, er, I hope that within the next few days I'll be back in court applying . . . for permission to bring an action against, er, certain, witnesses shall we call them, for perjury.

The interviewer is then faced with the difficulty of steering the discussion back to the realms of feelings and personal experience:

> You sound quite bitter . . .
> What was your daily routine in prison?

In this interview, then, we see a struggle being conducted over the very terms of the discourse. This is not a struggle about what 'answers' are acceptable – since, strictly speaking, the interviewer cannot precisely prescribe what his respondent will say; and he cannot directly contradict, counter, or break off the interview after an 'unacceptable' reply without prejudicing or rupturing the protocol within which this type of interview operates. These interviews are based on an apparent equivalence between interviewer and respondent – equal parties to the conversation – and they are governed by the protocols which provide the 'rule' in all current affairs TV – the protocols of 'objectivity' (of the interviewer) and 'balance' (between interviewer and interviewee). But it is a struggle over the way items are framed – over which 'frame' is operating or dominant. The frame is the device which, though it cannot absolutely prescribe the content of a reply, does prescribe and delimit the *range* of 'acceptable' replies. It is an ideological strategy, in the

precise sense that, when it works, it sustains a certain spontaneous circularity – the form of the answers being already presupposed in the form of the questions. It is also ideological in the sense that it sustains an apparent equality in the exchange, whilst being founded on an unequal relationship – since the respondent must reply to a question within a frame he/she does not construct.

In sustaining, through the exchange, the tendency to reply within this restricted limit, much depends on the 'rule' of acceptability: a reply must appear to be relevant to the question, while sustaining the sense of 'natural following-on', good conversational practice, flow, natural continuity. To make an 'unacceptable' reply, whilst maintaining coherence, relevance, continuity and flow, entails a very special kind of work – a struggle in conversational practice: first, to re-frame or re-phrase (e.g. to break the 'personal experience' frame, and to replace it with an alternative, 'political' frame); second, then to reply within the reconstituted framework. It is in this sense that interviewing and responding, within the dominant discursive strategies of this kind of programme, entail the work (for the presenters) of securing the dominant frame (for it cannot be taken for granted as unproblematically given), and sometimes also (for the respondents) of struggling against or countering the dominant frame (though these counterpositions are by no means always taken up).

4

'A NATION OF FAMILIES . . .'

Nationwide, in its regular weekday concern to bring its audience 'some of the more interesting stories of life in today's Britain', constantly 'makes new' the understanding of national individuality which is its premise. Heath and Skirrow argue:

> television is an apparatus used for the production-reproduction of the novelistic; it seems to address the problem of the definition of forms of individual meaning within the limits of existing social representations and their determining social relations, the provision and maintenance of terms of social intelligibility for the individual.
>
> (Heath and Skirrow, 1977: 58)

We are concerned here with the production of a specific televisual discourse:

> little dramas of making sense in which the viewer as subject is carried along – in which, indeed, the individual becomes 'the viewer', the point of view of the sense of the programme.
>
> (Ibid.)

Nationwide's discourse is specific – both to the medium in which it is constituted (television) and to a specific area of discourse within television (topical current affairs). But it is also specific in terms of the field of 'existing social representations and their determining social relations' on which it draws. We attempt in this section to delineate this field. We attempt to provide here some of the grounds on which to argue that *Nationwide's* ideological specificity lies in its orchestration, through regions, of individuals (in their families – see below) into the *televisual* coherence of 'the nation now'. To risk a general characterisation of that kind may appear to run counter to the diverse content and aims of the programme. But this heterogeneity must be seen in relation to Barthes' comment in discussing 'Myth Today':

> To the quantitative abundance of the forms there corresponds a small number of concepts.
>
> (Barthes, 1972: 120)

In *Nationwide*, we would argue, the abundance of newsworthy items which the programme produces nightly 'corresponds' to a small number of core ideological concepts. That is, items are produced through, and overdetermined by, a particular set of understandings of the social world (and the viewer's and England's place in it) which we have attempted to specify (see Chapter 2) as the programme's basic 'themes'.

(i) *Nationwide* at home: pictures of everyday life

If *Panorama* articulates the sphere of institutional politics, foreign policies and affairs of state, *Nationwide* by contrast clearly focuses away from the public, institutional world, onto the domestic sphere. The focus is on the realm of family life and 'leisure', the sphere of 'freedom' where individuals can express their individualities: the world of hobbies, of regional traditions and differences, the domain of everyday life.

This has led us to speak of the *Nationwide* discourse as articulated, above all, through the sphere of *domesticity*. Several different aspects of the programme are gathered under this designation of *Nationwide*'s principal ideological field. It relates to the programme's explicit focus on issues affecting 'family life'. In this respect, it is crucial to note that whereas *Panorama* or *This Week* treat individuals in their public-institutional social roles, *Nationwide* treats individuals as members of *families*. In the *Nationwide* discourse 'individuals' and 'families' are coterminous. This focus is reinforced by the programme's orientation to the 'family audience' as a target group, by its timing in the evening schedule for exactly that moment when individuals are reconstituted once again, from their different and varied tasks and occupations, into the 'unity' of the family scene. But domesticity also accounts for the programme's mode of presentation: its emphasis on the ordinary, everyday aspects of issues, on the effects of general issues and problems on particular individuals and families. It is sustained in the very jigsaw nature of the 'menu' of a typical *Nationwide* evening – 'something for everyone'; above all, in its preoccupation with topics of 'human interest', the 'infinite variety of ordinary life'. Domesticity also is sustained through the recurring cycle of familiar topics, through the *Titbits/Daily Mirror* style of reporting, through the 'everyday' angle of the questions posed, the 'bringing it all back to common sense' thrust of the items: the 'normalising' impetus. Even when *Nationwide* is not explicitly dealing with 'the family', its dominant mode of representation is defined through its domestication of the world.

Nationwide focuses here on 'what we all share' (or are assumed to share); in many respects the programme displays our regional and individual differences and heterogeneity, but the domestic field in which these items are routinely situated acts as a frame to these differences. There is a concern here for what we have in common, beyond the level of our individual differences: the family home and its problems. This concern is evidenced at many levels (choice of items, style of treatment, etc.), but is also given an interesting stress by the

programme's main figurehead and anchorman during the period of our viewing, Michael Barratt.

In his autobiography Barratt stresses the importance of family life; not only how his job interferes with it, but also how he dashed back from Berlin to be with the 'wife and kids' on Christmas Eve. Just as Barratt stresses them here, *Nationwide* observes the rituals of the domestic calendar: Christmas, Shrove Tuesday, Bank Holidays, etc. Also, for *Nationwide* fame is no substitute for the joys of family life, clearly; in the programme people who have achieved 'success' but are without friends and family ('the rich man who doesn't want any friends', 'the hermit of the Cotswolds' (1/6/76)) are portrayed as either unhappy or eccentric.

Barratt negotiates the difficult situation of being 'just an ordinary family man' and being famous too, by defining his priorities clearly with the former. After describing various travels, exciting adventures, meetings with Zsa Zsa Gabor and Albert Schweitzer, he writes:

> And outside the studio, how good is the good life? The posh restaurants and the plush hotels. The fast cars, the fat cheques. Another myth. I enjoy eating out with Joan or with close friends (who are more likely to be country men than 'personalities') in restaurants not too far from home, preferably where it is not necessary to wear a jacket or tie. Cod and chips out of paper is my delight. Its only rival is roast lamb at home for Sunday lunch.
>
> (Barratt, 1973: 27)

Like Michael Barratt, *Nationwide* is 'at home' even when it appears to be 'out in the world'. 'Home' is the – sometimes marked, sometimes unmarked, but always 'present' – centre of the *Nationwide* world. In this sense, the whole of *Nationwide*'s discourse is predicated on a particular way of structuring the world, and on the complex matrix of imagery and social relations through which this structure is sustained. It depends, essentially, on the contrasting couple of the world/the home and thus it is predicated, however invisibly (in terms of the manifest references of the programme), on the sexual division of labour, which

> . . . under capitalism takes the extreme form of separation of the general economic process into a domestic and an industrial unit.
>
> (Coulson, Magas and Wainwright, 1975: 60)

Behind the taken-for-granted form of this separation of social life into two distinct, contrasted 'spheres', there lies the long historical process through which the household has gradually been separated (as a distinct world of its own) from the relations of production and exchange, its transformation into a private sphere, concerned exclusively with the essential functions of maintaining and reproducing the labourer and his family (cf. Engels, 1975; Zaretsky, 1976). This separation has been accompanied by, and constructed through, the development of what were,

originally, class specific ideologies of domesticity, of personal and family life (Davidoff *et al.*, 1976; C. Hall, 1974). The 'domestic' world has been signified, ideologically, as the sphere which is separated and protected from the nasty business of making, doing and producing. It is where 'people' are produced; it is thus also where 'people' can be most 'themselves'. It is not only where we become 'individuals' but the domain in which we can most fully and satisfyingly express our individuality. The domain of domesticity thus has the effect of abstracting individuals from the network of social relations 'outside', and of reconstituting them into the unity of the family, the domestic. Against the divisions, distinctions and complexities of 'the outside' is set this privileged centre of familiar relations which becomes, even in its literal absence, the measure of all that is worthwhile.

This 'domestication' of the world can be related to more general ideological effects; Hall, for example, has argued that:

> One way of thinking the general function of ideology . . . is in terms of what Poulantzas (1975) calls 'separation' and 'uniting'. In the sphere of market relations and of 'egoistic private interest' (the sphere pre-eminently of civil society) the productive classes appear or are represented as (a) individual economic units driven by private and egoistic interests alone, which are (b) bound by the multitude of invisible contracts – the 'hidden hand' of capitalist exchange relations . . . this representation has the effect, first, of shifting emphasis from production to exchange, second of fragmenting classes into individuals, third of binding individuals into that 'passive community' of consumers. Likewise, in the sphere of the state and of juridico-political ideology, the political classes and class relations are represented as individual subjects (citizens, the voter, the sovereign individual in the eyes of the law and the representative system, etc.) and these individual political-legal subjects are then 'bound together' as members of a nation, united by the 'social contract', and by their common and mutual 'general interest'. Once again, the class nature of the State is masked: classes are redistributed into individual subjects: and these individuals are united within the imaginary coherence of the State, the nation and the national interest.
>
> (Hall, 1977: 336–7)

Connell *et al.* (1977: 116) point out that it is wrong to imagine that the agents of production appear as individuals only in superstructural relations and not within the structure of the relations of production itself. The individualisation of agents really occurs in the process of the exchange of commodities, and in the sale of labour power as a commodity.

> Out of the act of exchange itself, the individual, each one of them, is reflected in himself as its exclusive and dominant (determinant) subject . . .
>
> (Marx, 1973: 244–5)

The point here is that the 'noisy sphere' of exchange relations in the market

> provides the basis for those superstructural practices and ideological
> forms in which men are forced to 'live an imaginary relation' of equiv-
> alence and individualism to their real (non-equivalent, collective)
> conditions of existence . . . [Civil Society] is no longer the seat and
> source of individualism. It is simply the individualising sphere of the cir-
> cuit of capital's path to expanded reproduction. Individualism is not the
> origin of the system . . . it is what capital produces as one of its neces-
> sary phenomenal forms – one of its necessary but dependent effects.
>
> (Hall, Lumley, McLellan, 1977: 62)

'Individualism' is, therefore, sited within those social relations which are spe-
cific to the relations of exchange and consumption. In our culture, the individual
is, therefore, given a special, privileged position in the relations of civil society
(the sphere, classically, of 'egoistic impulses and exchange'), and in the relations
and ideologies which fill out and sustain the juridical (the 'legal subject', equal
to all other subjects in the eyes of the law) and the political domains (the 'polit-
ical subject', equally represented with all other citizens). But the attention to the
juridical and political aspects has tended to disguise and mask the equally impor-
tant source and foundation of the ideologies of 'individualism' in the domestic
and familial sphere.

(ii) Labourers in their private lives

The reproduction and maintenance of the working class, which as Marx argues is
a precondition of the reproduction of capital (Marx, 1961: 572), has historically
taken place in the family, and been the concern primarily of women. Increasing
state intervention has left women morally responsible for this work, although
some of its burden (differently at different periods; CSE, 1976; Wilson, 1977) has
been shifted from paid to unpaid work, and the penetration of the home by com-
modities has transformed its nature. It is, historically, in the family that the
individual who engages in the act of exchange as 'its exclusive and dominant
(determinant) subject' is reproduced and maintained.

The home, as a separate and 'naturalised' sphere, apparently undetermined by
the mode of production, is itself structured by the labourer's relation to the
moment of exchange in which he

> manages both to alienate his labour power and to avoid renouncing his
> rights of ownership over it.
>
> (Marx, 1976: 717)

This structure effects a crucial separation:

The worker's productive consumption and his individual consumption are therefore totally distinct. In the former, he acts as the motive power of capital, and belongs to the capitalist. In the latter, he belongs to himself, and performs his necessary vital functions outside the production process.

(Marx, 1976: 717)

It is in this 'private sphere', structured through the sexual division of labour, where individuals are interpellated as sexed subjects, that individuality is understood to express itself outside the determinations of the mode of production and juridico-political constraints. Perceived as outside 'the system', the family, as site of the material practices of procreation and the maintenance and reproduction of the labour force, is also the site of the most elaborated articulation of the ideology of 'individualism' as 'origin of the system'.

Thus the increasingly elaborated distinctions between 'home' and 'work' (which have contributed to the invisibility of work done by women in the home), have to be understood at a theoretical level in relation to both the reproduction of capital and women's subordination.

Zaretsky summarises the historical process as one whereby:

Work, in the form of wage labour, was removed from the centre of family life, to become the means by which family life was maintained. Society divided and the family became the realm of 'private life' . . . (Zaretsky, 1976: 57). 'Work' and 'life' were separated; proletarianisation split off the outer world of alienated labour from an inner world of personal feeling . . . it created a separate sphere of personal life, seemingly divorced from the mode of production.

(Ibid.: 30)

The workings and ideological articulation of this separate sphere cannot be understood without attention to women's special place within it. There is a type of collapse; the woman somehow is the home, the woman and the home seem to become each other's attributes. Thus Ruskin's famous description in 1868:

This is the true nature of home, it is the place of peace; the shelter, not only from all injury, but from all terror, doubt and division . . . So far as the anxieties of the outer life penetrate into it . . . it ceases to be a home; it is then only a part of the outer world which you have roofed over and lighted a fire in . . . *And whenever a true wife comes, this home is always round her.*

(Quoted in Millett, 1971: 98–9. Our emphasis)

This is an image from a masculine point of view:

> The underlying imagery is the unacknowledged master of the household, looking in, so to speak, at the household he has 'created'. The 'domestic interior' awaits his coming, his return.
>
> (Davidoff, L'Esperance, Newby, 1976: 159)

This image is premised on an understanding of women as being 'themselves' exclusively when they are 'wives and mothers': that is, it is an image predicated on their socio-economic inequality and dependence, as well as on their psycho-sexual subordination. Historically, this 'image' first became the dominant one within the bourgeois household; but it has been generalised outside the bourgeois family, extended to many women who, though they may well now be wage-workers themselves, nevertheless subscribe to it as 'norm' and 'ideal'. Few women 'live' this ideology without some deep sense of its contradictions – the so-called 'rewards' of being 'special' as wives and mothers constantly co-existing with the reality of their isolation, exploitation and subordination. But, in so far as this variant of the 'familial' ideology remains the dominant one, it serves to perpetuate and sustain the oppression of women, both inside and outside the home:

> Consciously or unconsciously, the world has been conceived in the image of the bourgeois family – the husband is the breadwinner and the wife remains at home attending to housework and childcare. Both the household itself and women's domestic labour within it are presented as the unchanging backcloth to the world of real historical activity.
>
> (Alexander, 1976: 59)

Davidoff, L'Esperance and Newby argue:

> In their suburban homes, wives are still expected to create a miniature version of the domestic idyll, set in subtopian pseudo-rural estate surroundings while their male counterparts swarm into central city offices and factories. Wives remain protectors of the true community, the 'still point'; a basic moral force to which the workers, travellers and seekers can return. In the archetypal portrayal of everyday life they still wait, albeit with less resignation as well as less hope, for the hand upon the latch.
>
> (p. 175)

This is the image of the home upon which *Nationwide* bases (and times) itself. The family home is 'provided' for, in material terms, through the waged work of men and women: it is maintained as an economic unit through women's unwaged work, through their continuing subordination. Without these material supports, it would not exist. Yet in its archetypal portrayal as the centre of 'everyday life', it is re-presented as the refuge from the world of material constraints, the true measure of individuality, and thus as the last repository of

essential 'human values' elsewhere crushed by the forces and pressures of 'modern life'. *Nationwide* rarely deals with the first but it constantly traffics in the second of these aspects: thus it constantly articulates the real relations of the social and sexual division of labour through this displacement into the space of the 'domestic'. In this space – and the realms of leisure and recreation, hobbies and personal tastes, consumption and 'personal relations' which especially belong to it and fill it out as a 'lived' domain – people (especially men) can exercise that 'freedom' denied them within the sphere of alienated labour. This is *Nationwide's* primary sphere of operation: 'reflecting' the activities of the individuals and families which comprise the nation, in their personal capacities: in their domestic lives.

Nationwide's discourse is, then, founded on a very specific mode of representing individuals and families which is so taken-for-granted within the programme that it requires to be made explicit here, making visible what *Nationwide* makes invisible, but constantly assumes. It is through these assumptions that *Nationwide* produces and reproduces, in its selection and presentation of items, a particular image of England, which is unremittingly grounded in its own obviousness ('Many people would say . . . '), in the construction of which its audience is both constitutive and constituted. The stream of 'subjects' interviewed gives authenticity to this 'real world of people', which then appears as the 'guarantee' of its reality – as does the audience itself – through both its implication and participation in, for example, such exercises as the *Nationwide* slimming campaign.

In an attempt to delineate the connotative image of England through which the nation is constructed, we produced a sentence in which we seemed able to locate the whole range of *Nationwide* items, in a way which allowed some ordering of the connotations in which the programme deals. In a modified form, this sentence also underlies the categorisation of items we have used:

ENGLAND, A COUNTRY WHICH IS ALSO A NATION, IN THE MODERN WORLD,

Regions	of Families	Technological Advance
Localism	of Individuals	Fast-moving
Town and		Alienating
Country		

WITH OUR OWN SPECIAL HERITAGE AND . . . PROBLEMS

Traditions	Bureaucracy
Calendar	Prices
Eccentricities	Unions
Patriotism	Balance of Payments

(iii) Regionalism and nationalism *Nationwide*

Within the discourse of *Nationwide* the concept of the nation is not presented as a monolithic entity, immediately embracing us all – rather the unity of the nation is constructed out of the sum of our regional differences and variations. As argued earlier, *Nationwide's* history was specifically informed by the attempt to break away from the idea of a blanket metropolitan dominance and bias; indeed the 'life of the regions' is a crucial ingredient in the *Nationwide* formula, as well as being integral to how the programme is constructed technically.

Over a long period Britain has experienced a tendency towards the destruction of regional differentiation – the result of many factors, including the effects of the educational system, and of television itself. At the present time, however, there is of course a countervailing movement towards regional separatism, manifested in the 'nationalism' of Wales and Scotland, the revival of the movement towards national independence in Northern Ireland, and some forms of regional devolution. When *Nationwide* was first established it had enough on its plate to rake up the dying embers of 'regional' consciousness, but this is now doubly problematic. Firstly because of the weakening of English regionalism, and secondly, ironically, because of the vitality of a regional 'awakening' on the Celtic fringes. In the present context *Nationwide* has both to rub the lamp to conjure up the dead spirits in the counties, and to try and control the wild spirits beyond them.

Within this context, the programme adopts a range of different strategies: on the one hand, *Nationwide* through its reporters (who are themselves established as having their own close regional links) can bring the news of the regions' activities to the attention of the nation: reporting the activities of the peripheries to the metropolis. But the stress is also on bringing you 'your own news and programmes from your own corner of England', local news for a local audience, concretising national issues by dealing with them as they appear 'on your doorstep'; e.g. in 'Midlands Today', dealing with a national issue (the future of British Leyland) as it affects the immediate prospects of the local workforce. Alternatively, issues of immediate local concern can be presented as important news (the future of a well known local building), or local issues can be given national status (e.g. the lions of Cradley Heath achieve national notoriety; Princess Anne opens a local hospital).

The *Nationwide* enactment of 'regionality' then, involves both:

(1) The invention of regional differentiation via *Nationwide's* own internal processes of regional cultural manufacture; e.g. *Nationwide* events like the boat-race in which each region had its own yacht.

(2) The adoption and transformation of real differences between the regions; e.g. Mike Neville's continuous play on Geordie 'sub culture', which is made into the symbolic/representative dialect and stock-in-trade for the whole of the North-East, although in reality it is only a feature of a particular part.

The 'regional' character of *Nationwide* is clearly pivotal to its identity, to what makes the programme distinctive. The way the items are put together into a unified programme has a great deal to do with the way it is articulated between the

two poles – 'region' and 'nationwide'. It is as if the programme, first, locates 'you' in your local-regional place; and, from that point of identification, it can survey for you (enable you to construct) a view of the nation as a whole – nationwide. These axes are clearly evident in the very way the programme is billed in the *Radio Times*. (See Chapter 1.) The national scene is usually presented as seen from the vantage point of 'your corner of England'. If *Nationwide* constructs the 'nation' as a representative or imaginary whole, it does so through the construction of regional viewpoints. This articulation is then, of course, constantly realised in the programme itself, which not only combines regional news (different for and specific to each region) with national news, but also, in its feature items, constantly stresses the 'regional' origin of particular items, or nominates a topic and then takes a 'round-up' of regional views, reactions, experiences. If the principal anchoring role is that provided by the central figure in the London studio (in our viewing period, Michael Barratt), the programme nevertheless is constantly 'going out' to the regions from this point and 'returning' to home base: the 'nation' is always 'dropping in' on the regions. One of the favourite visual shots peculiar to *Nationwide* is Barratt shown facing the bank of screens, each with a 'regional' presenter's face, all 'regionally' available to him, to be called on, each piped in (as the *Mandala* represents graphically) from the regional corners of England to 'the centre'. Without this complex set of oscillations – centre/periphery, region/nation – *Nationwide* could not adequately construct that representation of what 'the nation' consists of, a representation which is – in the whole range of current affairs programmes on all channels – quite peculiarly specific to it.

If we ask, what is the ideological effect of constructing 'the nation' in this way, we would suggest that it is a representation which constructs England as a complex of regionalisms, as an entity marked principally by its spatial 'unity-in-difference'. These regional differences and variations do not, within the discourse of the programme, conflict with one another, cancel or contradict one another. In the 'hard news' items the growing problem of regional economic underdevelopment sometimes surfaces. But it is not a pertinent theme in the items which *Nationwide* characteristically generates for itself. In the latter parts of the programme, the differences are each to be savoured and enjoyed for their own peculiarities and distinctive flavours; the nation is the sum of these distinctive regional characteristics. The nation becomes 'one' by the simple addition of all the regions – a form of unity through juxtaposition. This represents England as a nation which is a complex but non-contradictory unity.

Nationwide's regions are almost exclusively *cultural*. It is their cultural traditions, peculiarities, characteristics, distinctive identities which establish them, all equally 'English' in their difference. The regionalism of the programme therefore forges close connections with the whole domain of tradition – regional crafts, pastimes, etc. – which is discussed in the following section. But it can be said here that the culture of regionalism on *Nationwide* is massively linked with the *rural* aspects of regional life (cf. Chapter 2.iii(d)) and hence with the 'past', and with a kind of cultural nostalgia for 'old folkways, values and customs', which it is *Nationwide*'s

privilege to rediscover and indeed celebrate, against all the other 'modern' tendencies which are fast obliterating these critical cultural differences.

But the regions are also 'regional' in a technical sense; i.e., the BBC is 'regionalised' by its transmitting grid, which is in turn determined by technical factors: the siting of transmitters, boosters and studios. The cultural and common sense map of regional identities which segments the world of *Nationwide* is, in fact, based on and supported by a technical and material system. And it is the technical links between regional centres of television production, across the country, which enables *Nationwide* to operate 'regionally' – a fact which dictates many aspects of the visual forms of the programme, and of its organisational features (drawing more widely than any other single TV programme on the BBC's regional news and feature facilities). There is a 'regional' staff employed on *Nationwide* in each of the major regions. In Birmingham, for example, the technical staff and apparatus for the region's contribution includes three cameras and cameramen, a floor manager, one or two scene hands, a producer, producer's assistant/secretary and a director.

Each region is responsible for its own *Nationwide* budget. There are *Nationwide* researchers attached to each region to scan the area for possible feature items. In addition to the great concentration of resources and manpower needed to sustain *Nationwide* at its nerve centre in London, there are smaller *Nationwide* units replicated throughout the broadcasting regions.

Technically, however, London is very much in control. There are three systems for locking in, *Nationwide*:

General Lock: Regions – London

National Lock: London – Regions

ICE Lock: London – Regions (Insertion Communications Equipment)
This latter form of the lock is that which combines regional inputs to the programme with London through the device of Colour Separation Overlay (see below).

The regional-centre articulation of the programme, based on these complex forms of technical coupling, requires very careful synchronisation between London and the regions. This includes – apart from extremely careful timing (as the programme moves between regions/centre especially in the opening parts) – matching of line, frame and colour phase. The regions are connected to London by GPO land cable. When London receives a 'message' from a region, it has to transmit back information about the degree of matching, to enable the correct adjustments to be made (line, frame, colour). This 'information' is in fact carried in the top seven lines of the TV image, which each region magnifies in order to decode and adjust accordingly. Hence, there are complex and specialised technical means which enable the shifts and transitions – region-to-'nation' – to be made *naturally* – i.e., without the viewer registering the shifts through manifest lacks of synchronisation.

One of the most widely used techniques in *Nationwide* is Colour Separation Overlay. This enables an image from one region to be 'overlaid' on to a space in the frame from another region, so that two images with different regional sources

appear, not only within a single frame, but with both images on a single plane. This is achieved by placing the subject to be isolated against a blue backdrop; this backdrop will not be registered by the master camera, thus leaving a space in the picture which is filled by an image from a second camera. This second camera can, of course, be piping the second image down the line from another region. The effect of CSO will be to combine these two images into a single composite picture. Thus – though this is not usually allowed by the BBC's professional code – the transmitted picture could be made to signify that two people, who were in fact in different rooms, miles away from each other, were sitting in the same room, having a conversation. The use of CSO in *Nationwide* therefore not only considerably extends the degree to which different regional images can be 'composited', but also sustains the illusion of the many 'natural' links which bind the regions together.

The unity which composes the nation in *Nationwide*'s terms may be said to find some homology of structure with the character of the links between items, discussed earlier. It is implicit in the *Nationwide* representation of 'the nation' that the programme must constantly move, not only from one sort of item to a very different one (one of its main virtues being its variety, its heterogeneity) but also from one place to another. As we have argued, this heterogeneity has to be woven into a coherent programme: the distinctive *Nationwide* 'mix' of items, usually signalled at the start of the programme by the giving of the evening's 'menu' of items and the links which create smooth transitions between wildly different items and themes. But, like the 'nation' which the sum of these items constructs, this unity of approach is of an 'open' kind – allowing the different items, stories and places to *coexist*. Hence, the 'menu' is usually permissive rather than directive and obligatory, stressing variety rather than imposing a strict hierarchy of stories. Accordingly, the connections signalled in the 'menus' are loose connections, conjunctural in form: 'and another thing . . .' The discourse of the typical *Nationwide* menu stresses the element of *contingency* – as if it just happens, by chance, that this evening's dip into what the editor of the *Daily Mirror*, Hugh Cudlipp, once called 'the rich, full bran-tub of life' produces this miscellany of interesting things: each different from the other, each in its own way as interesting as the other.

The power of the *Nationwide* presentation, then, derives from, and is relayed through, its localised, concretised character; moreover, it is relayed through a further identification with the localised audience. In contrast to other, metropolitan-dominated current affairs programmes, *Nationwide* reporters and presenters will often speak in the regional dialect of their area. The programme celebrates its televisual regionalism; thus the play on regional pronunciations:

The River Ure? The Yer. The Yure? The Yerr.
<div style="text-align:right">(Nationwide from East Anglia, 19/5/76)</div>

Significantly the *Nationwide* reporter on the item covering the anniversary of the Jarrow hunger march was accredited as 'knowing' the particular area of Lancashire which the march had reached at that point: being familiar with those local conditions and therefore qualified to 'report it back' to the centre. This is a crucial condition of *Nationwide*'s sphere of operations. The issues are concretised, localised by familiar place-name tags: indeed they are formulated as local/regional issues. John Downing (1976) argues that this kind of localised presentation is particularly powerful precisely in so far as it works by grounding itself in the reproduction of familiar concrete sense-impressions, thus reproducing and reinforcing the spontaneous forms of localised, sectional class-consciousness. (Cf. Beynon, 1976; Lane, 1974; Nicholls and Armstrong, 1976 on factory class consciousness.)

It has recently been argued that in the case of a 'populist' TV series, such as *The Sweeney*, there is a crucial emphasis on making this kind of 'identification' with the programme's audience both at the level of vocabulary, where:

> the use of a certain kind of demotic speech . . . defines the programme as being 'of the people' if not exactly working class . . .'

and at the visual level where the programme:

> uses not the tourists' London of Big Ben and Buckingham Palace, but the London 'of the people': Ladbroke Grove, the docks, Shepherd's Bush . . .
> (Buscombe, 1976: 68)

While *Nationwide* speaks more clearly to a petit bourgeois (and older) audience than does *The Sweeney*, the programme's project is aimed in a parallel direction: to present a 'popular' perspective, to speak in the 'language of the people', through the code of localised/regional presentation. In adopting the forms of regional speech the programme lays claim to 'our/insiders'' local-authoritative knowledge and understanding of events.

(iv) The myth of the nation

Fragmentation by regional difference is, however, framed in *Nationwide* by the idea of our 'special national heritage': a tradition and a set of values which we are all as individuals assumed to share.

This material is focused in the 'country' and 'conservationist' range of *Nationwide*'s repertoire (see Chapter 2.iii(d)). Here *Nationwide*'s regional/populist orientation picks up on the activities of revivalists concerned with maintaining 'traditional' customs and institutions, or the programme itself performs this function, searching out surviving practitioners of older crafts 'in your corner of England'. As Raymond Williams points out:

All traditions are selective; the pastoral tradition quite as much as any other.

(Williams, 1976: 28)

Nationwide situates 'the tradition', a national heritage of customs and values, threatened and eroded by modern industrial society, in an image of England dominated by the 'rural past'. What is elided here is both the class basis of 'traditional culture' as it existed historically – it is simply 'our tradition', as members of the nation – and the political content of that culture as it exists today. (Cf. Lloyd, 1969 on 'traditional' culture in an urban industrial setting.)

This, then, is an always-already nostalgic perspective on a tradition rooted in the past – but *Nationwide* also clearly marks out the value of progress. Some aspects of the past we are well rid of; fundamental among these is the notion of class, which is situated as belonging to the 'bad old days'. In its presentation of the anniversary of the Jarrow march *Nationwide* displayed a double inflection of the material. On the one hand the events were translated out of their foundation in a specific class history and experience; the march was presented as the 'plight' of a town or region, not of a class or a system. Here 'regionality' becomes a code of social organisation through which class forces are represented. But, secondly, the very class structure was situated in the past in an image of the 'Northern Community' which itself belongs to the past – the days of the

futile slogans of a cloth-cap, class-conscious nineteenth century socialism.

(*Nationwide* 22/3/73)

Interestingly, Nicholls and Armstrong found a similar 'blurring' of categories among some of the foremen in their 'Chemco' plant – who, they noted were

given to use any of the terms 'the North', 'the working class', or 'the past' as a shorthand for the others.

(Nicholls and Armstrong, 1976: 130)

This 'blurring' is precisely significant in its negotiation of a contradictory image of the trade union movement, which *Nationwide* also shares; the unions are seen to have a positive social role ('a lot of people would agree you're in need of more money' – Barratt to striking trade union representative, *Nationwide* 13/3/73), coexisting uneasily with a negative industrial role ('They do seem rather daft reasons for going on strike . . .' – Barratt, *Nationwide* 14/3/73). This contradiction is characteristic of the form of sectional/negotiated consciousness outlined by Parkin (1972, Chapter 3), which frequently includes both accommodation and oppositional elements. But in *Nationwide* the contradiction is elided by situating the positive role of the unions *in the past*:

101

because the 'social' good was achieved in the past, whereas the 'industrial' harm is taking place in the present . . . however necessary past struggles may have been, social justice [has] now been more or less achieved. To go on, as some militants want to, would be to go too far.

(Nicholls and Armstrong, 1976: 182)

The image of 'nowadays' which is constructed in opposition to this image of the past is one which contains diversity but not structural difference; communities and regions are present in the discourse but classes, except in the past, are absent. If the 'contradictory unity' in which *Panorama* traffics is the construction of the 'idea of general interest', *Nationwide* is clearly operating some 'idea of the nation and its regions' as its imaginary coherence.

In the discourse of *Nationwide* the social structure of the nation is denied; spatial difference replaces social structure and the nation is seen to be composed not of social units in any relation of exploitation or antagonism but of geographical units often reduced to regional stereotypes or 'characters'.

This recomposition of the nation, from a set of elements that have been displaced out of their structural relations with one another, is performed, then, at what Roland Barthes would describe as a 'mythical' level, as in his analysis of the treatment of Paris:

> . . . the displaced parts are then rearranged into a mythical meta-language. Thus the swirling lights around the Arc de Triomphe, displaced from the real relations of Paris, the historico-commercial city, are then, as 'empty but spectacular forms', reorganised, in a second system or meta-language, into the 'myth of the city at night . . .'
>
> (Barthes, 1972)

What the discourse of *Nationwide* produces, from the elements which have been displaced out of their structural relations with each other, is a myth of 'the nation, now'.

(v) It's only common sense

Nationwide, we have argued, is a programme of common sense, speaking to and from the 'ordinary viewer'. Thus, Barratt:

> I can do any programme they ask me to do because I ask the naïve questions that everyone wants the answers to.
>
> (*Daily Mirror* 11/7/77)

We may usefully follow Nowell-Smith (1974) in distinguishing two meanings in the 'inherently ambiguous' concept of common sense:

(1) A form of pragmatic reasoning based on direct perception of the world and

opposed to all forms of thought that lack this direct link with experience. (2) Whatever understanding of the world happens to be generally held.

We would argue that common sense in both these meanings can be found to both construct and constitute this programme at several levels. Firstly we would suggest that Nowell-Smith's first sense can be used to approach both the verbal and visual discourse of the programme. To suggest that the programme's visual discourse is 'common-sensical' is obviously to draw heavily on, and summarise very crudely, a great deal of the work on realism and transparency in the cinema produced in recent years in *Screen* and elsewhere.

We have not established this here in a fuller analysis of the visual discourse. However, we would suggest that the programme relies on a practice and an ideology of television as a medium which allows a 'direct perception of the world', and provides an immediate and direct 'link with experience'. The programme's own productive work is rendered invisible.

The signification of a great many of the visual images of *Nationwide* is not, as Barthes described the photograph, in its 'having-been-there', (cf. Hall, 1972: 'The Determinations of News Photographs') but rather, the 'being-thereness' of the reporter, interwiewee or participants. Thus Michael Barratt writes, distinguishing between newspaper and television journalism:

> for television, you have to produce evidence of being on the spot.
>
> (Barratt, 1973: 110)

So in the 19 May programme, in the 'lady with the lion' sequence, Honeybunch's 'camera nerves' are commented on when she paws the camera lens, but this 'interruption' in transparency precisely guarantees the actuality of the report. The most complex articulation of this 'common sense' about television is found in the regional 'link-up', where the technology which allows simultaneous images to be transmitted from the different regions is positively celebrated – the bank of screens appears – but celebrated as a technology which allows a direct-link with the experience of the regions.

We have already commented to some extent on *Nationwide*'s common sense verbal discourse, and examined the way in which it interrelates with Nowell-Smith's second meaning: 'whatever understanding of the world happens to be generally held'. In relation to this second definition, we would argue that *Nationwide* constructs a particular 'understanding of the world' which is both specific to the programme and its production of 'the nation, nationwide', but which also draws on, and is read in the context of, already existing social representations. This production (connotatively paralleled in some ways in local newspapers and Radio 4) is distinguished by its dissolution of contradiction into difference and diversity, and self-legitimating in its populism, its claim to be the 'understanding of the world that is generally held'. *Nationwide*'s cast of thousands signifies thousands of individual endorsements of the generality of this 'world view', the contours of which we have already attempted to sketch in Chapter 2. We now

need to relate these common-sense effects in the Nationwide discourse more directly to the ideological work of Nationwide as a programme.

Althusser describes the elementary ideological effect as that of 'obviousness' (Althusser, 1971: 161), and it is in relation to this conceptualisation of ideology that the ahistoricity, the naturalness, of common sense, should be considered. The immediate obviousness of common sense, its in-built rationale of reference to 'the real', its structure of *recognition*, forecloses historical and structural examination of its conclusions. The instant reference which contemporary common sense makes to a massively present and unalterable reality – simply, what is there, what every-body knows – denies both its own history and its specific content, the *bricolage* of more developed and sometimes archaic ideological systems which inform its empiricism (Nowell-Smith, 1974). Stuart Hall comments that common sense *feels* 'as if it has always been there, the sedimented, bedrock wisdom of "the race", a form of "natural" wisdom, the content of which has changed hardly at all with time'. He continues:

> You cannot learn, through common sense, how things are; you can only discover *where they* fit into the existing scheme of things. In this way, its very taken-for-grantedness is what establishes it as a medium in which its own premises and presuppositions are being rendered invisible by its apparent transparency.
>
> (Hall, 1977: 325–6)

As noted earlier (Chapter 1.iv) Nationwide's verbal discourse is always con-structed *as* the 'ordinary language' of its audience. The programme speaks in terms which have a resonance in popular thinking, utilising particularly in its 'links' the forms of everyday speech and popular 'wisdom':

> orally transmitted tags, enshrining generalisations, prejudices and half-truths, elevated by epigrammatic phrasing into the status of maxims.
>
> (Hoggart, 1957: 103)

This 'common-sense' perspective of the programme has a particular force. In it 'feeling', 'personal experience' and immediate empirical perception are dom-inant; it is grounded in 'the personal and the concrete'; in particular, in local experiences. It is practical, opposed to abstraction and theorising; it

> identifies the exact cause, simple and to hand, and does not let itself be distracted by fancy quibbles and pseudo-profound, pseudo-scientific metaphysical mumbo-jumbo.
>
> (Gramsci, 1971: 348)

Through its televisual common sense, 'based on direct perception of the world', the programme offers a direct picture of 'how things seem' Nationwide, and how

the people involved in events feel about them. *Nationwide*'s common sense must be understood in relation to the adequacy of commonsense explanations as lived:

> Common sense is neither straightforwardly the class ideology of the bourgeoisie nor the spontaneous thinking of the masses. It is the way a subordinate class in class society lives its subordination. It is the acceptance by the subordinate class of the reality of class society, as seen from below.
>
> (Nowell-Smith, 1974)

Williams argues that common sense must be understood in relation to the concept of hegemony:

> Hegemony . . . is also different from ideology in that it is seen to depend for its hold not only on its expression of the interests of a ruling class, but also its acceptance as 'normal reality' or 'common sense' by those in practice subordinated to it.
>
> (Williams, 1975: 118)

Common sense must be related to another aspect of hegemony:

> It is a set of meanings and values which as they are experienced as practices appear as reciprocally confirming.
>
> (Williams, 1973: 9)

This 'reciprocal confirmation' points to, at one level, the 'undeniableness' of common-sense ideas. They must have, as Mepham argues:

> a sufficient degree of effectiveness both in rendering social reality intelligible and in guiding practice within it for them to be apparently acceptable.
>
> (Mepham, 1974: 100)

In our view 'hegemony' cannot be understood solely in terms of class (or class fractions). As we have argued earlier, we are concerned in *Nationwide* with an image of the home constructed in masculine hegemony. The 'naturalness' of common sense cannot be separated from the commonsensical definition of women through their 'natural' and 'timeless' roles of wife and mother, roles which correspondingly define them as the 'bearers' and repository of a basic/natural wisdom, which is founded on their taken-for-granted separation from political life. Mattelart (1975) raises interesting points about the way in which the Chilean Right was precisely able to exploit the activity of women against the Allende regime by presenting their demonstrations

as the spontaneous reaction of the most a-political sector of public opinion, brought together and activated by a natural survival instinct . . . behind demands which appeared unrelated to class strategy because they encompassed areas traditionally marginalised from the political sphere such as the home, family organisation . . .

(Mattelart, 1975: 19)

We thus confront in *Nationwide* the contradictory nature of common sense. Its very strength, its concrete, particular character also constitute a crucial ideological limit; the always-local, concretised form of presentation of issues in the discourse of *Nationwide* precisely excludes the awareness of wider structural factors. As Harris argues of British Conservatism:

The particular is its own justification, justified by its own existence (it *is* the real).

(Harris, 1971: 128.)

We are provided with an understanding of the world which is always:

more or less limited and provincial, which is fossilised and anachronistic . . . corporate or economistic.

(Gramsci, 1971: 325)

From this perspective it is impossible to grasp either the social formation as a whole or the role, for instance, of 'political' institutions, or of the sexual division of labour within this complex whole. Gramsci characterises aspects of this type of 'understanding' as a 'negative' class response in speaking of the peasantry, where:

Not only does that people have no precise consciousness of its own historical identity, it is not even conscious of the . . . exact limits of its adversary. There is a dislike of 'officialdom', the only form in which the State is perceived.

(Gramsci, 1971: 272–3)

This is precisely the level at which the State is presented on *Nationwide*. The State 'appears' as the unwelcome intrusion of officialdom and bureaucracy, infringing on private freedoms. We are advised by the presenters on how to deal with the demands of this bureaucracy (advice on breathaliser laws, etc.); similarly the presenters represent us against the bureaucracy, against the inefficient gas board or local authority. What the discourse of *Nationwide* excludes is any awareness of dominance or subordination in relationships of class, race and gender. Politics is not presented in terms of power and control but in terms of bureaucracy, inefficiency, interference with the individual's rights.

Nationwide's characteristic style of presentation is to deal with 'issues' through

'individuals', dealing with an individual example of a problem, concentrating on the level of individual experience and felt 'effects'. Through this style of presentation the programme contracts a relationship with forms of common-sense thought which have deep roots in our spontaneous experience of society.

> Precisely, common sense does not require reasoning argument, logic, thought; it is spontaneously available, thoroughly recognisable, widely shared.
>
> (Hall, 1977: 325)

Moreover this perspective has a profound 'purchase' on the 'facts of common sense', precisely because these 'facts' have a certain validity in experience as a mirror of the way society really operates.

The *Nationwide* presentation, then, is concerned with immediacy, reflection; presenting pictures of 'the nation now'. *Nationwide*'s discourse always moves within the limits of what Marx described as 'the religion of everyday life' (Marx, 1961: 384), in its exclusive attention to the level of 'appearances', and consequent neglect of their determining social relations. While the immediate appearances and 'forms of appearance' of capitalist society 'contain some part of the essential content of the relations which they mediate' (Hall, 1973: 9) they represent this content in a distorted form. The distortion consists principally in taking (i.e., mistaking, mis-recognising) the part or the surface forms (appearances) for the whole (the 'real relations' which produce and structure the level of appearances). This is not to suggest that these levels do not have their own materiality, practices and relative autonomy (cf. Althusser, 1977). We would argue with Geras (1972: 301) that capitalist society is necessarily characterised by a quality of opacity, and that ideology arises from the opacity of this reality, where the forms in which reality 'presents itself', or the forms of its appearance, conceal those real relations which themselves produce the appearances.

> The origin of ideological illusions is in the phenomenal forms of reality itself . . . the invisibility of real relations derives from the visibility of outward appearances or forms . . . this is the mechanism by which capitalist society necessarily appears to its agents as something other than it really is.
>
> (Mepham, 1974: 103)

The strength of ideology at a common-sense level, then, lies in its apparent justification by the perceived forms and practices of empirical social reality: Williams' 'reciprocal confirmation'. It is surely in this 'closed circle' of 'instant recognition' that *Nationwide*'s discourse moves. Its very project is 'presenting a nightly mirror to the face of Britain'. This discourse

does not just distract attention away from real social relations, nor does it explain them away, nor does it even directly deny them; it structurally excludes them from thought – because of the very immediacy and 'visibility' of the 'natural, self-understood meanings' encountered in social life, the 'spontaneous' modes of speech and thought under capitalism . . .

<div align="right">(Mepham, 1974: 107)</div>

This network of 'given' meanings, embedded in the structure of language and common sense, is the field of discourse in and on which *Nationwide* operates – constituting and constituted by the contours of this map of dominant or preferred meanings.

Ideology then is to be understood here

not as what is hidden and concealed but precisely as what is most open, apparent, manifest; what 'takes place in the surface and in view of all men' . . . the most obvious and 'transparent' forms of consciousness which operate in our everyday experience and ordinary language: common sense.

<div align="right">(Hall, 1977: 325)</div>

Thus the most immediately 'appearance-like' level of all – the form of spontaneous appropriation of lived relations in immediate consciousness – is itself the product of specific ideological 'work': the labour of the production of common sense.

Nationwide produces a discourse based on and in these 'spontaneous' forms of experience and it is a discourse in which the structures of class, gender and race are absent. What we see is a cast of individual characters through whose activities *Nationwide* constructs a picture of 'the British people', in their diversity. We are constituted together as members of the regional communities which make up the nation and as members of families, and in our shared concern with this domestic life is grounded *Nationwide*'s common-sense discourse. The domestic sphere, presented as a realm of leisure, is both the explicit focus of *Nationwide* discourse and the perspective from which *Nationwide* will approach other areas of concern. Given the taken-for-granted separation of the domestic from the economic/political spheres, *Nationwide* is thus able to present its own particular 'domestic' perspective as both a-political and natural: 'it's only common sense.'

BIBLIOGRAPHY

Alexander, S. (1976), 'Women's work in 19th century London', in Mitchell and Oakley 1976.

Althusser, L. (1971), *Lenin and Philosophy*, New Left Books, London.

Althusser, L. (1977) *Essays in Self-Criticism*, New Left Books, London.

Barratt, M. (1973), *Michael Barratt*, Wolfe Publishing, London.

Barthes, R. (1967), *Elements of Semiology*, Jonathan Cape, London.

Barthes, R. (1972), *Mythologies*, Paladin, London.

Beynon, H. (1976), *Working For Ford*, EP Publishing, London.

Beynon, H. and Nicholls, T. (1977), *Living with Capitalism*, Routledge and Kegan Paul, London.

Brody, R. (1976), '*Nationwide's* contribution to the construction of the reality of everyday life', M.A. Thesis, Centre for Contemporary Cultural Studies.

Buscombe, E. (1976), '*The Sweeney*', *Screen Education* n.20, SEFT, London.

Cardiff, D. (1974), 'The broadcast interview', Polytechnic of Central London mimeo.

Conference of Socialist Economists (1976), *The Political Economy of Women*, Stage 1, London.

Connell, I. (1975), 'London town: a kind of television down your way', CCCS mimeo.

Connell, I., Clarke, J. and McDonough, R. (1977), 'Ideology in political power and social classes', *Working Papers in Cultural Studies*, n.10.

Connell, I., Hall, S. and Curti, L. (1976), 'The unity of current affairs TV', *Working Papers in Cultural Studies*, n.9.

Coulson, M., Magas, B. and Wainwright, H. (1975), 'Women and the class struggle', *New Left Review*, n.89.

Davidoff, L., L'Esperance, J. and Newby, H. (1976), 'Landscape with figures', in Mitchell and Oakley 1976.

Dorfman, A. and Mattelart, A. (1975), *How to Read Donald Duck*, International General, New York.

Downing, J. (1976), 'Gravediggers' difficulties . . . ', in Scase (ed.), *Industrial Society: Class, Cleavage, Control*, Arnold, London, 1976.

Engels, F. (1975), *Origin of the Family*, Pathfinder, London.

Geras, N. (1972), 'Marx and the critique of political economy', in Blackburn (ed.), *Ideology in Social Science*, Fontana, London, 1972.

Gerbner, G. (1964), 'Ideological tendencies in political reporting', in *Journalism Quarterly*, Vol. 41, n.4.

Gillman, P. (1975), 'Nation at large', *Sunday Times*, 2/3/75.

Gramsci, A. (1971), *Prison Notebooks*, Lawrence and Wishart, London.

Hall, C. (1974), 'The history of the housewife', *Spare Rib*, n.26.

Hall, S. (1972), 'The determinations of news photographs', *Working Papers in Cultural Studies*, n.3.

Hall, S. (1973), 'Signification and ideologies', CCCS mimeo.

Hall, S. (1977), 'Culture and the ideological effect', in Curran *et al.* (eds), *Mass Communication and Society*, Arnold, 1977.

Hall, S., Lumley, B. and McLellan, G. (1977), 'Politics & ideology: Gramsci', *Working Papers in Cultural Studies*, n.10.

Halliday, M. (1973), *Explorations in the Function of Language*, Arnold, London.

Harris, N. (1971), *Beliefs in Society*, Penguin, Harmondsworth.

Heath, S. and Skirrow, G. (1977), 'Television: a world in action', *Screen*, Vol. 18, n.2.

Hoggart, R. (1957), *The Uses of Literacy*, Penguin, Harmondsworth.

Kracauer, S. (1952), 'The challenge of qualitative analysis', *Public Opinion Quarterly*, Winter 1952.

Lane, T. (1974), *The Union Makes us Strong*. Arrow, London.

Lloyd, A. L. (1969), *Folk Song in England*, Panther, London.

Marx, K. (1961), *Capital* Vol. 3, Lawrence and Wishart, London.

Marx, K. (1973), *Grundrisse*, Penguin, Harmondsworth.

Marx, K. (1976), *Capital* Vol. 1, Penguin, Harmondsworth.

Mattelart, M. (1975), 'Chile: the feminist side of the coup – when bourgeois women take to the streets', *Casa de las Americas*, Jan. 1975.

Mepham, J. (1974), 'The theory of ideology in *Capital*', *Working Papers in Cultural Studies*, n.6.

Millett, K. (1971), *Sexual Politics*, Hart Davis, London.

Mitchell, J. and Oakley, A. (1976), *The Rights and Wrongs of Women*, Penguin, Harmondsworth.

Morley, D. (1976), 'Industrial conflict and the mass media', *Sociological Review*, May 1976.

Nicholls, T. and Armstrong, P. (1976), *Workers Divided*, Fontana, London.

Nowell-Smith, G. (1974), 'Common sense', *Radical Philosophy*, Spring 1974.

Parkin, F. (1972), *Class Inequality and Political Order*, Paladin, London.

Poulantzas, N. (1975), *Political Power and Social Classes*, New Left Books, London.

Robey, D. (ed.) (1973), *Structuralism*, Oxford University Press, London.

Rowbotham, S. (1973), *Woman's Consciousness, Man's World*, Penguin, Harmondsworth.

Smith, A. (1975), *Paper Voices*, Chatto and Windus, London.

Thompson, E. (1977), 'Happy families', *New Society*, 8/9/77.

Williams, R. (1973), 'Base and superstructure', *New Left Review*, n.82.

Williams, R. (1975), *Keywords*, Fontana, London.

Williams, R. (1976), *The Country and the City*, Fontana, London.

Williamson, J. (1978), *Decoding Advertisements*, Boyars, London.

Wilson, E. (1977), *Women and the Welfare State*, Tavistock, London.

Winship, J. (1978), 'Woman', in *Women Take Issue*, CCCS/Hutchinson, London, 1978.

Zaretsky, E. (1976), *Capitalism, the Family and Personal Life*, Pluto Press, London.

Part II

THE *NATIONWIDE* AUDIENCE
Structure and Decoding

David Morley

Television Monograph No. 10, *Everyday Television: 'Nationwide'*, was a 'reading' of the programme which attempted to reveal the ways in which *Nationwide* constructs for itself an image of its audience. The present volume is an extension of that study, this time showing through detailed empirical work how different audiences actually 'decoded' some *Nationwide* programmes. The analysis is set in the context of a substantial critique of previous audience research.

The author

David Morley is Lecturer in Communications at Lanchester Polytechnic.

CONTENTS

PREFACE

The use of the first person singular to refer to the author of this work should not be taken to imply that 'I' am the originator of the perspectives developed here. I must, of course, take sole responsibility for the particular formulations employed, and for the errors of fact and argument which no doubt remain in the text. However, any credit for this work is due not so much to me as to the wider circle of those who have been involved in planning, organising and discussing this project over the last five years. Members of the Media Group of the Centre for Contemporary Cultural Studies at the University of Birmingham have helped in various ways, but the project would not have been possible without the involvement of Charlotte Brunsdon, Ian Connell and Stuart Hall. I owe them an enormous debt.

D.M.

1

AUDIENCE RESEARCH

The traditional paradigms

It is not my purpose to provide an exhaustive account of mainstream sociological research in mass communications. I do, however, offer a resumé of the main trends and of the different emphases within that broad research strategy, essentially for two reasons: first because this project is framed by a theoretical perspective which represents, at many points, a different research paradigm from that which has dominated the field to date. Second, because there are points where this approach connects with certain important 'breaks' in that previous body of work, or else attempts to develop, in a different theoretical framework, lines of inquiry which mainstream research opened up but did not follow through.

Mainstream research can be said to have been dominated by one basic conceptual paradigm, constructed in response to the 'pessimistic mass society thesis' elaborated by the Frankfurt School. That thesis reflected the breakdown of modern German society into fascism, a breakdown which was attributed, in part, to the loosening of traditional ties and structures and seen as leaving people atomised and exposed to external influences, and especially to the pressure of the mass propaganda of powerful leaders, the most effective agency of which was the mass media. This 'pessimistic mass society thesis' stressed the conservative and reconciliatory role of 'mass culture' for the audience. Mass culture suppressed 'potentialities' and denied awareness of contradictions in a 'one-dimensional world'; only art, in fictional and dramatic form, could preserve the qualities of negation and transcendence.

Implicit here was a 'hypodermic' model of the media which were seen as having the power to 'inject' a repressive ideology directly into the consciousness of the masses. Katz and Lazarsfeld (1955), writing of this thesis, noted that:

> The image of the mass communication process entertained by researchers had been, firstly, one of 'an atomistic mass' of millions of readers, listeners and movie-goers, prepared to receive the message; and secondly . . . every Message [was conceived of] as a direct and powerful stimulus to action which would elicit immediate response.
>
> (p. 16)

The emigration of the leading members of the Frankfurt School (Adorno, Marcuse, Horkheimer) to America during the 1930s led to the development of a specifically 'American' school of research in the forties and fifties. The Frankfurt School's 'pessimistic' thesis, of the link between 'mass society' and fascism, and the role of the media in cementing it, proved unacceptable to American researchers. The 'pessimistic' thesis proposed, they argued, too direct and unmediated an impact by the media on its audiences; it took too far the thesis that all intermediary social structures between leaders/media and the 'masses' had broken down; it didn't accurately reflect the 'pluralistic' nature of American society; it was – to put it shortly – sociologically naive. Clearly, the media had social effects; these must be examined, researched. But, equally clearly, these 'effects' were neither all-powerful, simple, nor even direct. The nature of this complexity and indirectness too had to be demonstrated and researched. Thus, in reaction to the Frankfurt School's predilection for 'critical' social theory and qualitative and philosophical analysis, the American researchers developed what began as a quantitative and positivist methodology for empirical radio audience research into the 'Sociology of Mass Persuasion'.

It must be noted that both the 'optimistic' and 'pessimistic' paradigms embodied a shared implicit theory of the dimensions of power and 'influence' through which the powerful (leaders and communicators) were connected to the powerless (ordinary people, audiences). Broadly speaking, operating within this paradigm, the different styles and strategies of research may then be characterised as a series of oscillations between two different, sometimes opposed, points in this 'chain' of communication and command. On the one hand, message-based studies, which moved from an analysis of the content of messages to their 'effects' on audiences; and, on the other, audience-based studies, which focused on the social characteristics, environment and, subsequently, 'needs' which audiences derived from, or brought to, the 'message'.

Many of the most characteristic developments within this paradigm have consisted either of refinements in the way in which the message-effect link has been conceptualised and studied; or of developments in the ways in which the audience and its needs have been examined. Research following the first strategy (message-effects) has been, until recently, predominantly behaviourist in general orientation: how the behaviour of audiences reflects the influences on them of the messages they receive. When a concern with 'cognitive' factors was introduced into the research it modified, without replacing, this behavioural orientation: messages could be seen to have effects only if a change of mind was followed by a change in behaviour (e.g. advertising campaigns leading to a change in commodity-choices). Research of the second type (audience-based) has been largely structural-functional in orientation, focusing on the social characteristics of different audiences, reflecting their different degrees of 'openness' to the messages they received. When a 'cognitive' element was introduced here, it modified without replacing this functional perspective: differences in audience response were related to differences in individual needs and 'uses'.

We will look in a moment at the diverse strategies through which this basic conceptual paradigm was developed in mainstream research. It is not until recently that a conceptual break with this paradigm has been mounted in the research field, one which has attempted to grasp communication in terms neither of societal functions nor of behavioural effects, but in terms of social meanings. This latter work is described here as the 'interpretative' as against the more dominant 'normative' paradigm, and it does constitute a significant break with the traditional mainstream approach. The approach adopted in this project shares more with the 'interpretative' than with the traditional paradigm, but I wish to offer a critique, and to propose a departure from, both the 'normative' and 'interpretative' paradigms, as currently practised.

The 'normative' paradigm

Post-war American mass communications research made a three-dimensional critique of the 'pessimistic' mass society thesis: refuting the arguments that informal communication played only a minor role in modern society, that the audience was a 'mass' in the simple sense of an aggregation of socially-atomised individuals, and that it was possible to equate directly content and effect.

In an early work which was conceptually highly sophisticated, Robert Merton (1946) first advanced this challenge with his case study (*Mass Persuasion*) of the Kate Smith war bond broadcasts in America. Though this work was occasionally referred to in later programmatic reviews of the field, the seminal leads it offered have never been fully followed through. Merton argued that research had previously been concerned almost wholly with the 'content rather than the effects of propaganda'. Merton granted that this work had delivered much that had been of use, in so far as it had focused on the 'appeals and rhetorical devices, the stereotypes and emotive language which made up the propaganda material'. But the 'actual processes of persuasion' had gone unexamined, and as a consequence 'the effect' of the materials studied had typically been assumed or inferred, particularly by those who were concerned with the malevolent effect of 'violent' content. Merton challenged this exclusive reliance on inference from content to predicted effects.

This early work of Merton is singular in several respects, not least for the attempt it made to connect together the analysis of the message with the analysis of its effects. Social psychology had pointed to 'trigger phrases which suggest to us values we desire to realise'. But, Merton asked, 'Which trigger phrases prove persuasive and which do not? Further, which people are persuaded and which are not? And what are the processes involved in such persuasion and in resistance to persuasive arguments?' To answer these questions Merton correctly argued that we had to 'analyse both the content of propaganda and the responses of the audience. The analysis of content . . . gives us clues to what might be effective in it. The analysis of responses to it enables us to check those clues.' Merton thus retained the notion that the message played a determining role for the character of the

responses that were recorded, but argued against the notion that this was the only determination and that it connected to response in a simple cause and effect relationship; indeed, he insisted that the message 'cannot adequately be interpreted if it is severed from the cultural context in which it occurred'.

Merton's criticisms did not lead to any widespread reforms in the way in which messages were analysed as such. Instead, by a kind of reversal, it opened the road to an almost exclusive pre-occupation with receivers and reception situations. The emphasis shifted to the consideration of small groups and opinion leaders, an emphasis first developed in Merton's own work on 'influentials' and 'reference groups', and later by Katz and Lazarsfeld. Like Merton, they rejected the notion that influence flowed directly from the media to the individual; indeed, in *Personal Influence* (1955) they developed the notions of a 'two-step flow of communication' and of the importance of 'opinion leaders' within the framework of implications raised by small group research. From several studies in this area it had become obvious, according to Katz and Lazarsfeld, that 'the influence of mass media are not only paralleled by the influence of people . . . [but also] . . . refracted by the personal environment of the ultimate consumer'.

The 'hypodermic model' – of the straight, unmediated effect of the message – was decisively rejected in the wake of this 'rediscovery of the primary group' and its role in determining the individual's response to communication. In *The People's Choice* it was argued that there was little evidence of people changing their political behaviour as a result of the influence of the media: the group was seen to form a 'protective screen' around the individual. This was the background against which Klapper (1960) summed up: 'persuasive communications function far more frequently as an agent of reinforcement than as an agent of change . . . reinforcement, or at least constancy of opinion, is typically found to be the dominant effect . . .'

From 'Effects' to 'Functions' . . . and back again

The work outlined above, especially that of Merton, marks a watershed in the field. I have discussed it in some detail because, though there have been many subsequent initiatives in the field, they have largely neglected the possible points of development which this early work touched on.

The intervening period is, in many ways, both more dismal and less fruitful for our purposes. The analysis of content became more quantitative, in the effort to tailor the description of vast amounts of 'message material' for the purposes of effects analysis. The dominant conception of the message here was that of a simple 'manifest' message, conceived on the model of the presidential or advertising campaign, and the analysis of its content tended to be reduced, in Berelson's (1952) memorable phrase, to the 'quantitative description of the manifest content of communication'. The complexity of Merton's Kate Smith study had altogether disappeared. Similarly, the study of 'effects' was made both more quantitative and more routine. In this climate Berelson and others predicted the end of the road for mass communications research.

A variety of new perspectives were suggested, but the more prominent were based on the 'social systems' approach and its cousin, 'functional analysis' (Riley and Riley, 1959), concerning themselves with the general functions of the media for the society as a whole (see Wright's (1960) attempt to draw up a 'functional inventory'). A different thread of the functionalist approach was more concerned with the subjective motives and interpretations of individual users. In this connection Katz (1959) argued that the approach crucially assumed that 'even the most potent of mass media content cannot ordinarily influence an individual who has no "use" for it in the social and psychological context in which he lives. The "uses" approach assumes that people's values, their interests . . . associations . . . social roles, are pre-potent, and that people selectively fashion what they see and hear.' This strand of the research work has, of course, recently re-emerged in the work of the British 'uses and gratifications' approach, and has been hailed, after its long submergence, as the road forward for mass communications research.

These various functionalist approaches were promulgated as an alternative to the 'effects' orientation; nonetheless, a concern for effects remained, not least among media critics and the general public. This concern with the harmful effects or 'dysfunctions' of the media was developed in a spate of laboratory-based social-psychological studies which, in fact, followed this functionalist interlude. This, rather than the attempt to 'operationalise' either of the competing functionalist models, was the approach which dominated mass media research in the 1960s: the attempt to pin down, by way of stimulus-response, imitation and learning theory psychology approaches, applied under laboratory conditions, the small but quantifiable effects which had survived the 'optimistic' critique.

Bandura (1961) and Berkowitz (1962) were among the foremost exponents of this style of research, with their focus on the message as a simple, visual stimulus to imitation or 'acting out', and their attention to the consequences, in terms of violent behaviour and delinquency, of the individual's exposure to media portrayals of violence of 'filmed aggressive role models'. Halloran's study of television and violence in this country took its point of departure from this body of work.

During the mid to late sixties research on the effects of television portrayals of violence was revitalised and its focus altered, in the face of the student rebellion and rioting by blacks in the slum ghettoes of America (see *National Commission on Causes and Prevention of Violence: the Surgeon-General's Report*). Many of the researchers and representatives of the state who were involved in this work, in their concluding remarks, suggested that TV was not a principal cause of violence but rather, a contributing factor. They acknowledged, as did the authors of the *National Commission Report*, that 'television, of course, operates in social settings and its effects are undoubtedly mitigated by other social influences'. But despite this gesture to mitigating or intervening social influences, the conviction remained that a medium saturated with violence must have some direct effects. The problem was that researchers operating within the mainstream paradigm still could not form any

decisive conclusions about the impact of the media. The intense controversy following the attempt of the Surgeon-General to quantify a 'measurable effect' of media violence on the public indicated how controversial and inconclusive the attempt to 'prove' direct behavioural effect remained.

Mick Counihan (1972), in a review of the field, summarised the development of mass communications research up to this point as follows:

> Once upon a time . . . worried commentators imputed an eternal omnipotence to the newly emerging media of mass communication. In the 'Marxist' version of this model of their role, the media were seen as entirely manipulated by a shrewd ruling class in a bread and circuses strategy to transmit a corrupt culture and neofascist values – violence, dehumanised sex, consumer brainwashing, political passivity, etc. – to the masses. . .
>
> These instruments of persuasion on the one hand, and the atomised, homogenised, susceptible masses on the other, were conjoined in a simple stimulus-response model. However, as empirical research progressed, survey and experimental methods were used to measure the capacity of the media to change 'attitude', 'opinions', and 'behaviour'. In turn, the media-audience relationship was found to be not simple and direct, but complex and mediated. 'Effects' could only be gauged by taking account of the 'primary groups', opinion leaders and other factors intervening between the media and the audience member (hence the notion of 'two-step' or 'multiple-step' flow of information) . . .
>
> Further emphasis shifted from 'what the media do to people' to 'what people do to the media', for audiences were found to 'attend to' and 'perceive' media messages in a selective way, to tend to ignore or to subtly interpret those messages hostile to their particular viewpoints. Far from possessing ominous persuasive and other anti-social power, the media were now found to have a more limited and, implicitly, more benign role in society: not changing, but 'reinforcing' prior dispositions, not cultivating 'escapism' or passivity, but capable of satisfying a great diversity of 'uses and gratifications', not instruments of a levelling of culture, but of its democratisation.

(p. 43)

The interpretative paradigm

In the same period, a revised sociological perspective was beginning to make inroads on communications research. What had always been assumed was a shared and stable system of values among all the members of a society; this was precisely what the 'interpretative' paradigm put into question, by its assertion that

the meaning of a particular action could not be taken for granted, but must be seen as problematic for the actors involved. Interaction was thus conceptualised as a process of interpretation and of 'mutual typification' by and of the actors involved in a given situation.

The advances made with the advent of this paradigm were to be found in its emphasis on the role of language and symbols, everyday communication, the interpretation of action, and an emphasis on the process of 'making sense' in interaction. However, the development of the interpretative paradigm in its ethno-methodological form (which turned the 'normative' paradigm on its head) revealed its weaknesses. Whereas the normative approach had focused individual actions exclusively as the reproduction of shared stable norms, the interpretative model, in its ethno-methodological form, conceived each interaction as the 'production' anew of reality. The problem here was often that although ethno-methodology could shed an interesting light on micro-processes of inter-personal communications, this was disconnected from any notion of institutional power or of structural relations of class and politics.

Aspects of the interactionist perspective were later taken over by the Centre for Mass Communications Research at Leicester University, and the terms in which its Director, James Halloran (1970a), discussed the social effects of television gave some idea of its distance from the normative paradigm; he spoke of the 'trend away from . . . the emphasis on the viewer as tabula-rasa . . . just waiting to soak up all that is beamed at him. Now we think in terms of interaction or exchange between the medium and audience, and it is recognised that the viewer approaches every viewing situation with a complicated piece of filtering equipment.'

This article also underlined the need to take account of 'subjective definitions of situations and events', without going over fully to the 'uses and gratifications' position. Halloran recast the problematic of the 'effects of television' in terms of 'pictures of the world, the definitions of the situation and problems, the explanations, alternative remedies and solutions which are made available to us . . .'. The empirical work of the Leicester Centre at this time marked an important shift in research from forms of behavioural analysis to forms of cognitive analysis. *Demonstrations and Communications* (1970b) attempted to develop an analysis of 'the communication process as a whole', studying 'the production process, presentation and media content as well as the reactions of the viewing and reading public'. This latter aspect of the research was further developed by Elliott in his study *The Making of a Television Series* (1972), especially the notion of public communication as a circuit relaying messages from 'the society as source' to 'the society as audience'.

The developing emphasis on the levels of cognitive and interpretative analysis made it possible for the whole question of the 'influence of the media' to be reopened and developed. As Hartmann and Husband noted (1972), part of the problem with the theories of 'media impotence' was that their inadequate methodological orientations predisposed them to this conclusion, for:

to look for effects in terms of simple changes of attitude may be to look in the wrong place . . . part of the high incidence of null results in attempts to demonstrate the effects of mass communications lies in the nature of the research questions asked . . .

. . . it may be that the media have little immediate impact on attitudes as commonly assessed by social scientists but it seems likely that they have other important effects. In particular they would seem to play a major part in defining for people what the important issues are and the terms in which they should be discussed.

(p. 439)

This perspective allows for a re-evaluation of 'effects' studies such, for instance, as that of Nordenstreng (1972). Nordenstreng has argued, on the basis of his research on Finnish TV audiences, that watching TV news is a 'mere ritual' for the audience which has 'no effect'. His research showed that, while 80 per cent of Finns watched at least one news broadcast per day, when interviewed the next day they could remember hardly anything of the specific information given by the news; the main impression retained was that 'nothing much had happened'. On this basis Nordenstreng argued that the 'content of the news is indifferent to them'.

Hartmann and Husband's argument leads beyond this difficulty in so far as it clarifies the point that one cannot argue that just because an audience cannot remember specific content – names of ministers, etc. – that therefore a news broadcast has had 'no effect'. The interpretative paradigm led to a focus on the level of 'definitions' and 'agendas' of issues, rather than on specific content items. The important point is that while an audience may retain little, in terms of specific information, they may well retain general 'definitions of the order of things', ideological categories embedded in the structure of the specific content. Indeed Hartmann and Husband's research on race and the media precisely focused the impact of the media on definitional frameworks, rather than on specific attitudes or levels of information.

However, despite these important conceptual advances, the Centre's work has been marred by an inadequate conception of the message. Following Gerbner's work, this was conceived of as the 'coin of communicative exchanges', but at the same time, it was thought to have only one 'real meaning'. This notion is also evident in the more recent audience research project *Understanding TV* (O. Linné and K. Marossi; Danish Radio Research Report, 1976) on which Halloran collaborated. Here again the principal concern of the research was to check whether the real/intended message of the communicators had 'got through' to the audience. In short, the framework was effectively that of a 'comprehension' study – as to whether the audience had 'understood' the (pre-defined) meaning of the programme (a documentary on Vietnam) – rather than one concerned with the various possible kinds of meanings and understandings that were generated from the programme by the different sections of its audience. The implications of this misconception of the message can best be assessed by situating it in relation to the overall model of the communication process proposed here.

The communication circuit: breaks and oppositions

Much of the work of the Centre for Contemporary Cultural Studies Media Group over the last few years represents an attempt to fill out and elaborate a model of the 'communication process as a whole' of the kind called for by Halloran (1970a). Necessarily, this has involved detailed work on particular moments in that process, or on the links in the communication chain between such 'moments'. This project was intended to refine certain hypotheses about one such privileged moment: that which links the production of the TV message to its reception by certain kinds of audiences. It is not necessary to spell this general model out in detail here, but it may be worthwhile to specify some general theoretical outlines about how such a model must be 'thought'. Though conceived as a communication chain or 'flow', the TV discourse is *not* a flow between equivalent elements. Thus the chain must be conceived as one which exhibits breaks and discontinuities. It connects 'elements' or moments which are not identical, and which have a different position in the hierarchy of communication and an identifiable structure of their own. Hence, the flow between one point and another in the communication chain depends *a*) on two points (sender and receiver) which have their own internal structure (the structure of TV production, the structures of reception); which *b*) being different, and yet linked, therefore require *c*) specific mechanisms or forms to articulate them into a unity. That unity is necessarily *d*) a complex not a simple unity; that is, *e*) one where the articulations, though they will *tend* to flow in a certain way, and to exhibit a certain logic, are neither closed nor finally determined (cf. Hall, 1973).

In the first place this is to reject those theories which 'collapse' the specificity of the media's mode of operation by picturing the media as totally controlled and manipulated by the state (Althusser, 1971; Garnham, 1973), or by arguing directly from the economic structure of media institutions (concentration of ownership) to the 'effects' of this structure at the level of power and ideology (cf. Murdock and Golding, 1973 *et seq.*) − the production of cultural artefacts which legitimate the consensus − without giving specific weight in the analysis to the process of symbolisation itself.

However, to take account of these 'breaks' in the communications chain is not, in itself, enough; we must allow for the break at the reception end of the chain, and *not* presume that audiences are bound to programming in a transparent relationship, in which all messages are read 'straight'. That the broadcaster will attempt to establish this relationship of 'complicity' with the audience is undoubtedly true (as argued in *Everyday Television: 'Nationwide'*, for instance, via the provision of 'points of identification' within-the programme), but to assume the success of these attempts is to assume away the crucial problem.

The message: encoding and decoding

The premises on which this approach is based can be outlined as follows: 1) The production of a meaningful message in the TV discourse is always problematic

'work'. The same event can be encoded in more than one way. The study here is, then, of how and why certain production practices and structures tend to produce certain messages, which embody their meanings in certain recurring forms. 2) The message in social communication is always complex in structure and form. It always contains more than one potential 'reading'. Messages propose and prefer certain readings over others, but they can never become wholly closed around one reading. They remain polysemic. 3) The activity of 'getting meaning' from the message is also a problematic practice, however transparent and 'natural' it may seem. Messages encoded one way can always be read in a different way.

In this approach, then, the message is treated neither as a unilateral sign, without ideological 'flux' (cf. Woolfson, 1976), nor, as in 'uses and gratifications', as a disparate sign which can be read any way, according to the need-gratification structure of the decoder. The TV message is treated as a complex sign, in which a preferred reading has been inscribed, but which retains the potential, if decoded in a manner different from the way in which it has been encoded, of communicating a different meaning. The message is thus a structured polysemy. It is central to the argument that all meanings do not exist 'equally' in the message: it has been structured in dominance, although its meaning can never be totally fixed or 'closed'. Further, the 'preferred reading' is itself part of the message, and can be identified within its linguistic and communicative structure.

Thus, when analysis shifts to the 'moment' of the encoded message itself, the communicative form and structure can be analysed in terms of what is the preferred reading; what are the mechanisms which prefer one, dominant reading over the other readings; what are the means which the encoder uses to try to 'win the assent of the audience' to his/her preferred reading of the message? Special attention can be given here to the control exercised over meaning and to the 'points of identification' within the message which transmit the preferred reading to the audience.

The presentational or interviewing styles employed will also be critical for winning the assent of the audience to the encoder's reading of the message. Here we can attempt to reintegrate into the analysis some of the insights relating to the congruence between the internal structure of the message and the objective form of the audience's understanding and responses which were, in many ways, first empirically pursued in Merton's early study discussed above. Krishan Kumar (1977) has pointed to the key role of the 'professional broadcasters', the linkmen and presenters who from the public's point of view 'constitute the BBC'; as Kumar argues, these men 'map out for the public the points of identification with the BBC'; they are the 'familiar broadcasting figures with whom the audience can identify'.

It is precisely the aim of the presenter to achieve this kind of audience-identification. The point is that it is through these identification mechanisms, I would suggest, in so far as they do gain the audience's 'complicity', that the preferred readings are 'suggested' to the audience. It is when these identificatory

mechanisms are attenuated or broken that the message will be decoded in a different framework of meaning from that in which it was encoded.

We can now turn to the moment in the communicative chain where these encoded messages are received. Here I would want to insist that audiences, like the producers of messages, must also undertake a specific kind of 'work' in order to read meaningfully what is transmitted. Before messages can have 'effects' on audiences, they must be decoded. 'Effects' is thus a shorthand, and inadequate, way of marking the point where audiences differentially read and make sense of messages which have been transmitted, and act on those meanings within the context of the rest of their situation and experience. Moreover, we must assume that there will be no necessary 'fit' or transparency between the encoding and decoding ends of the communication chain (cf. Hall, 1973). It is precisely this lack of transparency and its consequences for communication which this project has attempted to investigate. It is the problem of conceptualising the media audience to which we must now turn.

Undoubtedly, the dominant perspective in audience research, certainly in this country, in recent years has been the 'uses and gratifications' perspective developed by Blumler *et al*. It may therefore be best to attempt to define the perspective employed in this project by way of a critique of the limitations of the 'uses and gratifications' problematic.

2

'WHAT PEOPLE DO WITH THE MEDIA'

Uses, gratifications, meanings

The realisation within mass media research that one cannot approach the problem of the 'effects' of the media on the audience as if contents impinged directly onto passive minds; that people in fact assimilate, select from and reject communications from the media, led to the development of the 'uses and gratifications' model; Halloran advising us that:

> We must get away from the habit of thinking in terms of what the media do to people and substitute for it the idea of what people do with the media.

This approach highlighted the important fact that different members of the mass media audience may use and interpret any particular programme in a quite different way from how the communicator intended it, and in quite different ways from other members of the audience. Rightly it stressed the role of the audience in the construction of meaning.

However, this 'uses and gratifications' model suffers from fundamental defects in at least two respects.

1) As Hall (1973) argues, in terms of its overestimation of the 'openness' of the message:

> Polysemy must not be confused with pluralism. Connotative codes are not equal among themselves. Any society/culture tends, with varying degrees of closure, to impose its segmentations . . . its classifications of the . . . world upon its members. There remains a dominant cultural order, though it is neither univocal or uncontested.

While messages can sustain, potentially, more than one reading, and:

> there can be no law to ensure that the receiver will 'take' the preferred or dominant reading of an episode . . . in precisely the way in which it has been encoded by the producer.

(op. cit.: 13)

126

yet still the message is 'structured in dominance' by the preferred reading. The moment of 'encoding' thus exerts, from the production end, an 'over-determining' effect (though not a fully determined closure) on the succeeding moments in the communicative chain.

As Elliott (1973) rightly argues, one fundamental flaw in the 'uses and gratifications' approach is that its implicit model of the communication process fails to take into account the fact that television consumption is:

> more a matter of availability than of selection . . . [In this sense] availability depends on familiarity . . . The audience has easier access to familiar genres partly because they understand the language and conventions and also because they already know the social meaning of this type of output with some certainty.
>
> (p. 21)

Similarly Downing (1974) has pointed to the limitations of the assumption (built into the 'uses and gratifications' perspective) of an unstructured mass of 'differential interpretations' of media messages. As he points out, while in principle a given 'content' may be interpreted by the audience in a variety of ways:

> In practice a very few of these views will be distributed throughout the vast majority of the population, with the remainder to be found only in a small minority. [For] given a set of cultural norms and values which are very dominant in the society as a whole (say the general undesirability of strikes) and given certain stereotypes (say that workers and/or unions initiate strikes) only a very sustained and carefully argued and documented presentation of any given strike is likely to challenge these values and norms.
>
> (p. 111)

2) The second limitation of the 'uses and gratifications' perspective lies in its insufficiently sociological nature. Uses and gratifications is an essentially psychologistic problematic, relying as it does on mental states, needs and processes abstracted from the social situation of the individuals concerned – and in this sense the 'modern' uses and gratifications approach is less 'sociological' than earlier attempts to apply this framework in the USA. The earlier studies dealt with specific types of content and specific audiences, whereas 'modern' uses and gratifications tends to look for underlying structures of need and gratification of psychological origin, without effectively situating these within any socio-historical framework.

As Elliott (1973) argues, the 'intra-individual' processes with which uses and gratifications research deals:

can be generalised to aggregates of individuals, but they cannot be converted in any meaningful way into social structure and process . . .

(p. 6)

because the audience is still here conceived of as an atomised mass of individuals (just as in the earlier 'stimulus-response' model) abstracted from the groups and subcultures which provide a framework of meaning for their activities.

Graham Murdock (1974) rightly argues that:

> In order to provide anything like a satisfactory account of the relationship between people's mass media involvements and their overall social situation and meaning system, it is necessary to start from the social setting rather than the individual: to replace the idea of personal 'needs' with the notion of structural contradiction; and to introduce the notion of subculture . . . Subcultures are the meaning systems and modes of expression developed by groups in particular parts of the social structure in the course of their collective attempt to come to terms with the contradictions in their shared social situation . . . They therefore provide a pool of available symbolic resources which particular individuals or groups can draw on in their attempt to make sense of their own specific situation and construct a viable identity.
>
> (p. 213)

This is to argue for the essentially social nature of consciousness as it is formed through language much in the way that Voloshinov does (quoted in Woolfson, 1976):

> Signs emerge after all, only in the process of interaction between one individual consciousness and another. And the individual consciousness itself is filled with signs. Consciousness becomes consciousness only once it has been filled with ideological (semiotic) content, consequently only in the process of social interaction.
>
> (p. 168)

As Woolfson remarks of this, the sign is here seen as vehicle of social communication, and as permeating the individual consciousness, so that consciousness is seen as a socio-ideological fact. From this position Woolfson argues that:

> speech utterances are entirely sociological in nature. The utterance is always in some degree a response to something else. It is a product of inter-relationship and its centre of gravity therefore lies outside the individual speaker him/herself.
>
> (p. 172)

Thus utterances are to be examined not as individual, idiosyncratic expressions of a psychological kind, but as sociologically regulated both by the immediate social situation and by the surrounding socio-historical context; utterances form a:

> ceaseless stream of dialogic inter-change [which is the] generative process of a given social collective.
>
> (Woolfson, op. cit.)

What Woolfson argues here in relation to the need to redefine the analysis of 'individual' speech utterances – as the analysis of the communicative utterances of 'social individuals' – I would argue in relation to the analysis of 'individual' viewing patterns and responses. We need to break fundamentally with the 'uses and gratifications' approach, its psychologistic problematic and its emphasis on individual differences of interpretation. Of course, there will always be individual, private readings, but we need to investigate the extent to which these individual readings are patterned into cultural structures and clusters. What is needed here is an approach which links differential interpretations back to the socio-economic structure of society, showing how members of different groups and classes, sharing different 'culture codes', will interpret a given message differently, not just at the personal, idiosyncratic level, but in a way 'systematically related' to their socio-economic position. In short we need to see how the different sub-cultural structures and formations within the audience, and the sharing of different cultural codes and competencies amongst different groups and classes, 'determine' the decoding of the message for different sections of the audience.

Halloran (1975) has argued that the:

> real task for the mass communications researcher is . . . to identify and map out the different sub-cultures and ascertain the significance of the various sub-codes in selected areas governed by specific broadcasting or cultural policies.

This is necessary, Halloran argues, because we must see that:

> the TV message . . . is not so much a message . . . [but] more like a message-vehicle containing several messages which take on meanings in terms of available codes or subcodes. We need to know the potential of each vehicle with regard to all the relevant sub-cultures.
>
> (p. 6)

This is to propose a model of the audience, not as an atomised mass of individuals, but as a number of sub-cultural formations or groupings of 'members' who will, as members of those groups, share a cultural orientation towards decoding messages in particular ways. The audience must be conceived of as composed of clusters of socially situated individual readers, whose individual readings

will be framed by shared cultural formations and practices pre-existent to the individual: shared 'orientations' which will in turn be determined by factors derived from the objective position of the individual reader in the class structure. These objective factors must be seen as setting parameters to individual experience, although not 'determining' consciousness in a mechanistic way; people understand their situation and react to it through the level of subcultures and meaning systems.

This brings us, in the first instance, to the problem of the relationship between social structure and ideology. The work of Basil Bernstein (1971) and others in the field of educational sociology is of obvious relevance here and some extrapolations on the possible significance of that work for media audience research are made in Morley (1975), 'Reconceptualising the media audience'. Rather than rehearse that argument in detail I will attempt in the next chapter simply to outline the notorious problem of the relation of classes and codes and its significance for this audience research project.

3

CLASSES, CODES, CORRESPONDENCES

Autonomy: relative or total?

In recent years one of the most significant interventions in the debate about the problem of 'determination', or the relation of class structure and ideology, has been that made by Paul Hirst and his associates. They have argued that the attempt to specify this determination is doomed to incoherence, on the grounds that either the determination must be total, in which case the specificity of the ideological or the 'level of signifying practices' is denied; or alternatively that the proper recognition of this autonomy precludes the specification of any such form of determination of the ideological. The argument is, of course, premised on the rejection of the concept of 'relative autonomy' derived from Althusser, and in particular on the rejection of the use of that concept within the field of cultural studies (cf. Coward, 1977).

John Ellis (1977) takes up this problem, basing his position on Hirst's arguments in *Economy and Society*, November 1976. He denies the sense of attempting to derive expectations as to ideological/political practices from class position, and denies the validity of any model of 'typical positions' (such as those embedded in the encoding/decoding model derived from Parkin). He argues that this is illegitimate, since: 'According to the conjuncture, shopkeepers, for example, can be voting communist, believing in collective endeavour.' ('The Institution of the Cinema': p. 58) So presumably, according to the 'conjuncture', shopkeepers can be decoding programmes in any number of different frameworks/codes, in an unstructured way.

This 'radical' formulation of the autonomy of signifying/ideological practices seems inadequate in two respects. Firstly, by denying the relevance of cultural contexts in providing for individuals in different positions in the social structure a differential range of options, the argument is reduced, by default, to a concern with the (random) actions (voting, decoding) of individuals abstracted from any socio-historical context except that of the (unspecified) conjuncture.

This return to methodological individualism must be rejected if we are to retain any sense of the audience as a structured complex of social collectivities of different kinds. It is the sense of Voloshinov's conception of the 'social individual'

131

which must be retained if we are not to return to a conception of the individual who is (*contra* Marx) simply 'in society as an object is in a box'.

Secondly, and more importantly, the Ellis/Hirst approach simply seems to throw out the baby with the bathwater. The argument against a mechanistic interpretation in which:

> it is assumed that the census of employment category carries with it both political and ideological reflections
>
> (Ellis, op. cit.: 65)

is of course, perfectly correct, precisely because this approach

> eliminates the need for real exploration of ideological representations in their specificity

by assuming that members of category X hold beliefs of type Y 'as a function of their economic situation'.

However, there is no licence for moving from this position, as Ellis and Hirst do, to an argument that therefore *all* attempts to specify determination by class structure are misconceived. The argument here becomes polarised into an either/or, both poles of which are absurd: either total determination or total autonomy.

The problem is that shopkeepers do not act as Ellis hypothesises. The reason that bourgeois political science makes any kind of sense at all, even to itself, is precisely because it is exploring a structured field in which class determinations do, simply on a level of statistical probability, produce correlations and patterns. Now, simply to count these patterns may be a fairly banal exercise, but to deny their existence is ludicrous; the patterns are precisely what are to be explored, in their relation to class structures.

It is interesting to compare the Ellis/Hirst intervention with that of Harold Rosen (1972) in *Language and Class*, who begins to provide precisely the kind of non-mechanistic, non-economistic account of the determination of language by class and the action of language on class formation that Ellis and Hirst seem to consider impossible. Rosen attacks Basil Bernstein exactly for providing a mechanistic, economistic analysis. The working class is, in Bernstein's work, an undifferentiated whole, defined simply by economic position. Factors at the level of ideological and political practice which 'distinguish the language of Liverpool dockers from that of . . . Coventry car workers' (Rosen, 1972: 9) are ignored. However, Rosen precisely aims to extend the terms of the analysis by inserting these factors as determinate. He rejects the argument that linguistic code can be simply determined by 'common occupational function' and sees the need to differentiate within and across class categories in terms of ideological practice:

history, traditions, job experience, ethnic origins, residential patterns, level of organisation . . .

(p. 6)

Yet the central concern remains. The intervention is called *Language and Class* and its force is produced directly by the attention paid (as against Bernstein's mechanistic/economistic account) to the levels of ideological, discursive, and political practice. These factors are here inserted with that of class determination, and their extension into the field of decoding is long overdue – but the relative autonomy of signifying practices does not mean that decodings are not structured by class. How they are so structured, in what combinations for different sections of the audience, the relation of language, class and code, is 'a question which must be ethnographically investigated' (Giglioli, 1972:10).

The question is really whether this is an irretrievably essentialist or mechanistic problematic. I would argue that a charge of mechanism cannot be substantiated. Indeed the formulation of structures, cultures and biographies (outlined in Critcher, 1978) clearly evades the polarity of either total determination or total autonomy, through the notion of structures setting parameters, determining the availability of cultural options and responses, not directly determining other levels and practices. This problematic, then, clearly is concerned with some form of determination of cultural competencies, codes and decodings by the class structure, while avoiding mechanistic notions.

The problem which this project was designed to explore was that of the extent to which decodings take place within the limits of the preferred (or dominant) manner in which the message has been initially encoded. However, the complementary aspect of this problem is that of the extent to which these interpretations or decodings are inflected by other codes and discourses which different sections of the audience inhabit. We are concerned here with the ways in which decoding is determined by the socially governed distribution of cultural codes between and across different sections of the audience: that is, the range of different decoding strategies and competencies in the audience.

To raise this as a problem for research is already to argue that the meaning produced by the encounter of text and subject cannot be 'read off' straight from textual characteristics; rather:

> what has to be identified is the use to which a particular text is put, its function within a particular conjuncture, in particular institutional spaces, and in relation to particular audiences.
>
> (Neale, 1977: 39–40)

The text cannot be considered in isolation from its historical conditions of production and consumption.

Thus the meaning of the text must be thought of in terms of which set of discourses it encounters in any particular set of circumstances, and how this

encounter may re-structure both the meaning of the text and the discourses which it meets. The meaning of the text will be constructed differently according to the discourses (knowledges, prejudices, resistances, etc.) brought to bear on the text by the reader and the crucial factor in the encounter of audience/subject and text will be the range of discourses at the disposal of the audience.

Here, of course, 'individuals do have different relations to sets of discourses in that their position in the social formation, their positioning in the real, will determine which sets of discourses a given subject is likely to encounter and in what ways it will do so' (Willemen, 1978: 66–7).

Clearly Willemen is here returning to the agenda a set of issues about the relation between social position and discursive formation which were at the core of the work in educational sociology generated by Bernstein's intervention, and developed in France by Bourdieu, Baudelot and Establet. Moreover, Willemen's work can be seen as a vital element in the development of such a theory. As he argues, determination is not to be conceived as a closed and final process:

> Having recognised the determining power of the real, it is equally necessary to recognise that the real is never in its place, to borrow a phrase from Lacan, in that it is always and only grasped as reality, that is to say, through discourse . . . the real determines to a large extent the encounter of/with discourses, while these encounters structure, produce reality, and consequently in their turn affect the subject's trajectory through the real.
>
> (op. cit.: 67–8)

or as Neale (1977) would have it:

> audiences are determined economically, politically *and ideologically*. [my emphasis]
>
> (p. 20)

Sociologisms

The emphasis given in the Neale quotation above is intended to highlight the chief problem with the other main body of theory which has attempted to deal with the question of the relation between ideology and social structure – or, in its own terms, between a dominant normative order, roles and individuals. This, of course, is that substantial body of work in sociology variously addressed as the problem of order, the problem of class consciousness, and so on.

The inadequacy of this work is that of its sociologism in so far as it attempts to immediately convert social categories (e.g. class) into meanings (e.g. ideological positions) without attention to the specific factors necessarily governing this conversion. Thus, it is of course inadequate to present demographic/sociological factors – age, sex, race, class position – as objective correlates or determinants of

THE *NATIONWIDE* AUDIENCE

differential decoding positions without any attempt to specify how they intervene in the process of communication. The problem, I would suggest, is how to think the relative autonomy of signifying practices (which most of the sociological theory neglects) in combination with the operation of class/gender/race, etc., as determinations.

Those who have followed Hirst and others in their development of a theory of the autonomy and specificity of 'signification' repeatedly warn against the dangers of a reductionist form of analysis, which is concerned with the level of ideology and signification only for as long as it takes to discover which ideologies are being worn as the 'number plates' of which classes. We must take due note of Laclau's (1977) strictures against the 'metaphysical assignment to classes of certain ideological elements' (p. 99) and against a mode of analysis in which 'the discrimination of "elements" in terms of their class belonging and the abstract postulation of pure ideologies are mutually dependent aspects' (p. 94). On this basis we can proceed to attempt to specify complex modes of determination which precisely start from the presupposition that 'ideological elements, taken in isolation, have no necessary class connotation, and that this connotation is only the result of the articulation of those elements in a concrete ideological discourse' (ibid.: 99).

The object of analysis is, then, the specificity of communication and signifying practices, not as a wholly autonomous field, but in its complex articulations with questions of class, ideology and power, where social structures are conceived as also the social foundations of language, consciousness and meaning. This is to return to prominence, along with specifically textual analysis, the questions raised by Bernstein and Bourdieu (and readdressed by Willemen) as to the structural conditions which generate different cultural and ideological competencies.

Exactly what is the nature of the 'fit' between, say, class, socio-economic or educational position and cultural/interpretative code is the key question at issue. Parkin's (1973) treatment of class structures as the basis of different meaning systems is a fruitful if crude point of departure in this respect, and provided some of the ground work for the characterisation of hypothetical/typical decoding positions as developed by Stuart Hall. I am, of course, aware of the limitations of the conceptual framework outlined by Parkin; as I have argued in 'Reconceptualising the media audience', his framework constitutes, in fact, only 'a logical rather than a sociological statement of the problem . . . providing us with the notion that a given section of the audience either shares, partly shares, or does not share the dominant code in which the message has been transmitted'.

The crucial development from this perspective has been the attempt to translate Parkin's three broad 'ideal types' of ideological frameworks (dominant, negotiated and oppositional) into a more adequately differentiated model of actual decoding positions within the media audience. Much of the important work in this respect consists in differentiating Parkin's catchall category of 'negotiated code' into a set of empirically grounded sub-variants of this basic category, which can illuminate the sociological work on different forms of sectional and

corporate consciousness (cf. Beynon, 1973; Parkin, (op. cit.); Mann, 1973; Moorhouse and Chamberlain, 1974a and 1974b; Nicholls and Armstrong, 1976; see also Hall and Jefferson, 1978, for a 'repertoire of negotiations and responses').

Parkin's schema is, in fact, inadequate in so far as:

a) it over-simplifies the number of 'meaning-systems' in play. He locates only three: dominant, negotiated, oppositional.
b) for each 'meaning-system' he locates only one source of origin.
c) these sources of origin are derived, in each case, from different levels of the social formation.

In respect of a) it simply needs to be stated that any adequate schema will need to address itself to the multiplicity of discourses at play within the social formation; or at least, to provide systematic differentiations within the categories provided by Parkin, locating different 'versions' or inflections of each major discourse.

In respect of b) we must admit of the varied possible origins of discourses and of the contradictions within these discourses. Thus, for example, Parkin's category of a 'dominant meaning system', much in the manner of Althusser's (1971) ISAs essay, neglects the problem of contradictions within any dominant ideology. Moreover such an ideology, or rather different versions of it, may originate in a number of different places: from the media (is this what is implied by Parkin's abstract concept of the 'dominant normative order'?), from a political party, an industrial organisation, a consumer association, and so on.

In respect of c) we must put into question the 'necessity' implied by the links Parkin makes between these meaning systems and their points of origin. Thus, as argued, versions of a dominant ideology do not only originate in the media; nor do the media produce exclusively such an ideology. A 'negotiated' or subordinate meaning system can arise out of a trade union just as easily as out of a 'local working class community'; nor do such 'communities' only produce 'subordinate' ideologies, but also, on occasion (*pace* Parkin's Leninist assumptions) spontaneously radical ideologies. Thus 'oppositional' ideologies are not produced only by the 'mass political party based on the working class' but also elsewhere in the social formation. Moreover we must attend, as Parkin fails to do, to the multiplicity of ideologies produced by the range of political parties and organisations within civil society. This is precisely to focus on the relation of social and economic structure to ideology, and on the forms of articulation of the one through the other. These questions of social structure are fundamentally interlinked with the question of the differential interpretation, or decoding, of texts.

We would stress here that, whatever shortcomings Parkin's schema may have, it does allow us to conceive of a socially structured audience, and as such constitutes a considerable advance on any model which conceives of the audience as an unstructured aggregate of 'individuals' (or 'subjects'). How actual readings correspond to various types of class consciousness and social position remains to

be elucidated. This is a matter for concrete investigation. What is assumed here is the viability of the attempt to relate (in however complex a form) social or class positions and decoding frameworks.

PROBLEMS OF TECHNIQUE AND METHOD

There has been a tendency in Britain for the single-minded and extremely important investigation of concepts like 'film language' – and the question of the mode of production of meaning specific to the cinema . . . to be accompanied by an ill-considered and unhelpful assumption that all attempts at sociological research into the conditions of reception or consumption of filmic texts can only be manifestations of the rashest empiricism. The baby (the study of the conditions of consumption) has too often been thrown out with the bathwater (the inadequacy of many of the methods employed).

(S. Harvey, *May '68 and Film Culture*, p. 78)

The above text is quoted by way of acknowledging the problems of method that remain unresolved in this work. As is evident, we are committed to a position that insists on the necessity of the 'empirical dialogue', rather than the attempt to deduce audience positions or decodings from the text in an *a priori* fashion (see E.P. Thompson (1978) p. 196, on the confusion of empirical with empiricist). However, serious problems remain in the attempt to develop an adequate methodology for the investigation of these issues – problems which have only been dealt with here in a provisional fashion. What follows is an outline of the makeshift strategies which have been adopted in the course of this project in an attempt to pursue these problems.

Bearing these points in mind, the overall plan of the research project can be seen to have been adapted from that proposed by Umberto Eco (1972).

Phases of research

1) Theoretical clarification and definition of the concepts and methods to be used on the research.

2) Analysis of messages attempting to elucidate the basic codes of meaning to which they refer, the recurrent patterns and structures in the messages, the

ideology implicit in the concepts and categories via which the messages are transmitted. (An account of the substantive products of these phases of the research can be found in Everyday Television: 'Nationwide', along with a discussion of some of the problems of programme analysis. Space only allows a brief indication of the main outline of the methods of analysis employed there. The programmes were analysed principally in terms of the way they are constructed: how topics are articulated; how background and explanatory frameworks are mobilised, visually and verbally; how expert commentary is integrated and how discussions and interviews are monitored and conducted. The aim was not to provide a single, definitive reading of the programmes, but to establish provisional readings of their main communicative and ideological structures. Points of specific concern were those communicative devices and strategies aimed at making the programmes' topics 'intelligible' and filling out their ramifications for the programmes' intended audiences.)

3) Field research by interview to establish how the messages previously analysed have in fact been received and interpreted by sections of the media audience in different structural positions, using as a framework for analysis the three basic ideal-typical possibilities:
a) where the audience interprets the message in terms of the same code employed by the transmitter – e.g. where both 'inhabit' the dominant ideology.
b) where the audience employs a 'negotiated' version of the code employed by the transmitter – e.g. receiver employs a negotiated version of the dominant ideology used by the transmitter to encode the message.
c) where the audience employs an 'oppositional' code to interpret the message and therefore interprets its meaning through a different code from that employed by the transmitter.

4) All the data on how the messages were received having been collected, these were compared with the analyses previously carried out on the messages, to see:
a) if some receptions showed levels of meaning in the messages which had completely escaped the notice of our analysis.
b) how the 'visibility' of different meanings related to respondents' socio-economic positions.
c) to what extent different sections of the audience did interpret the messages in different ways and to what extent they projected freely onto the message meanings they would want to find there. We might discover, for instance, that the community of users has such freedom in decoding the message as to make the influencing power of the media much weaker than one might have thought. Or just the opposite.

The Nationwide Audience Project: Research Procedure
The project aims were defined as being:
To construct a typology of the range of decodings made.
To analyse how and why they vary.
To demonstrate how different interpretations are generated.

To relate these variations to other cultural factors: what is the nature of the 'fit' between class, socio-economic or educational position and cultural or interpretative competencies/discourses/codes?

The first priority was to determine whether different sections of the audience shared, modified or rejected the ways in which topics had been encoded by the broadcasters. This involved the attempt to identify the 'lexico-referential systems' employed by broadcasters and respondents following Mills' (1939) proposals for an indexical analysis of vocabularies. He assumes that we can:

> locate a thinker among political and social co-ordinates by ascertaining what words his functioning vocabulary contains and what nuances of meaning and value they embody. In studying vocabularies we detect implicit evaluations and the collective patterns behind them, cues for social behaviour. A thinker's social and political rationale is implicit in his choice and use of words. Vocabularies socially canalise thought.
>
> (pp. 434–5)

Thus, the kind of questions to be asked were: do audiences use the same words in the same ways as broadcasters when talking about aspects of the topic? Do respondents rank these aspects in the same order of priority as the broadcasters? Are there aspects of the topic not discussed by broadcasters which are specifically mentioned by respondents?

Moreover, beyond the level of vocabularies, the crucial questions are: to what extent does the audience identify with the image of itself presented to it via vox pop material (and via other, more implicit, definitions and assumptions about what the common sense/ordinary person's viewpoint on X is)? How far do the different presenters secure the popular identification to which they (implicitly) lay claim? Which sections of the audience accept which presenter styles as 'appropriate' points of identification for them? And, does acceptance or identification mean that the audience will then take over the meta-messages and frameworks of understanding within which the presenters encapsulate the reports? How much weight do Michael Barratt's 'summing up' comments on reports in *Nationwide* carry for the audience in terms of what code of connotation they then map the report onto? How far, for events of different degrees of 'distance' from their immediate situation and interests, do which sections of the audience align themselves with the 'we' assumed by the presenter/interviewer? To what extent do different sections of the audience identify with an interviewer and feel that they are 'lending' him/her their authority to interrogate figures in public life on their behalf?

Investigating decodings: the problem of language

I have elsewhere argued that language must be conceived of as exercising a determining influence on the problems of individual thought and action. As MacIntyre puts it:

The limits of what I can do intentionally are set by the limits of the descriptions available to me; and the descriptions available to me are those current in the social groups to which I belong. If the limits of action are the limits of description, then to analyse the ideas current in a society (or subgroup of it) is also to discern the limits within which rational, intended action necessarily moves in that society (or subgroup).

(quoted in Morley, 1975)

In these terms, thinking is the selection and manipulation of 'available' symbolic material, and what is available to which groups is a question of the socially structured distribution of differential cultural options and competences.

As Mills argues:

It is only by utilising the symbols common to his group that a thinker can think and communicate. Language, socially built and maintained, embodies implicit exhortations and social evaluations.

(op. cit.: 433)

Mills goes on to quote Kenneth Burke:

the names for things and operations smuggle in connotations of good and bad − a noun tends to carry with it a kind of invisible adjective, and a verb an invisible adverb.

He continues:

By acquiring the categories of a language, we acquire the structured 'ways' of a group, and along with language, the value-implications of those 'ways'. Our behaviour and perception, our logic and thought, come within the control of a system of language. Along with language, we acquire a set of social norms and values. A vocabulary is not merely a string of words; immanent within it are societal textures − institutional and political coordinates.

Mills premises his argument about the social determination of thought on a modified version of Mead's concept of the 'generalised other', which is:

the internalised audience with which the thinker converses: a focalised and abstracted organisation of attitudes of those implicated in the social field of behaviour and experience . . . which is socially limited and limiting . . . The audience conditions the talker; the other conditions the thinker.

(pp. 426−7)

However, Mills goes on to make the central qualification (and this is a point that would apply equally as a criticism of a concept of the Other derived from Lacan) that:

> I do not believe (as Mead does . . .) that the generalised other incorporates 'the whole society', but rather that it stands for selected societal segments.

<div align="right">(p. 427)</div>

This then is to propose a theory not only of the social and psychological, but also of the political, determinations of language and thought.

Problems of hypothesis and sample

I attempted to construct a sample of groups who might be expected to vary from 'dominant' through 'negotiated' to 'oppositional' frameworks of decoding. I aimed, with this sample, not only to identify the key points of difference, but also the points at which the interpretations of the different groups might overlap one with another – given that I did not assume that there was a direct and exclusive correspondence so that one group would inhabit only one code. Obviously, a crucial point here is that members of a group may inhabit areas of different codes which they operationalise in different situations and conversely, different groups may have access to the same codes, though perhaps in different forms.

The research project was designed to explore the hypotheses that decodings might be expected to vary with:

1) *Basic socio-demographic factors*: position in the structures of age, sex, race and class.

2) *Involvement in various forms of cultural frameworks and identifications*, either at the level of formal structures and institutions such as trade unions, political parties, or different sections of the educational system; or at an informal level in terms of involvements in different sub-cultures such as youth or student cultures or those based on racial and cultural minorities.

Evidently, given a rejection of forms of mechanistic determination, it is at this second level that the main concerns are focused. However, the investigation of the relations between levels 1) and 2), and their relations to patterns of decoding, remains important in so far as it allows one to examine, or at least outline, the extent to which these basic socio-demographic factors can be seen to structure and pattern, if not straightforwardly determine, the patterns of access to the second level of cultural and ideological frameworks.

Further, it was necessary to investigate the extent to which decodings varied with:

3) *Topic*: principally in terms of whether the topics treated are distant or 'abstract' in relation to particular groups' own experience and alternative sources of information and perspective, as opposed to those which are situated for them

more concretely. Here the project aimed to develop the work of Parkin (1973), Mann (1973) and others, on 'abstract' and 'situated' levels of consciousness. The thesis of these writers is that working class consciousness is often characterised by an 'acceptance' of dominant ideological frameworks at an abstract level, combined with a tendency at a concrete, situated level to modify and re-interpret the abstractly dominant frameworks in line with localised meaning systems erected on the basis of specific social experiences. In short, this oscillation in consciousness or conception of contradictions between levels of consciousness is the grounding of the notion of a 'negotiated' code or ideology, which is subordinated, but not fully incorporated, by a dominant ideological framework.

What we need to know is precisely what kind of difference it makes to the decoding of messages when the decoder has direct experience of the events being portrayed by the media, as compared to a situation in which the media account is the audience's only contact with the event. Does direct experience, or access to an alternative account to that presented by the media, lead to a tendency towards a negotiated or oppositional decoding of the message? If so, might any such tendencies be only short lived, or apply only to the decoding of some kinds of messages – for instance messages about events directly concerning the decoders' own interests – or might there be some kind of 'spread' effect such that the tendency towards a negotiated or oppositional decoding applies to all, or to a wide range of messages? (In the project the clearest areas in which it became possible to explore these issues were in relation to the different student groups' interpretations of the 'students' item in Phase 1, and in the different trade union groups' interpretations of the 'unions' item in Phase 2.)

A further level of variation which it had originally been hoped to explore, but from which time and lack of resources ultimately precluded me, was the level of contextual factors – that is, for instance, the extent to which decodings might vary with:

4) *Context*: of particular concern here were the differences which might arise from a situation in which a programme is decoded in an educational or work context, as compared with its decoding by the same respondents in the context of the family and home.

The absence of this dimension in the study is to be regretted and one can only hope that further research might be able to take it up; in particular, in the investigation of the process by which programmes are, for instance, initially decoded and discussed in the family and then re-discussed and re-interpreted in other contexts.

However, I would argue that this absence does not vitiate my results, in so far as I would hypothesise a more fundamental level of consistency of decodings across contexts. The difference between watching a programme in the home, as opposed to in a group at an educational institution, is a situational difference. But the question of which cultural and linguistic codes a person has available to them is a more fundamental question than the situational one. The situational variables will produce differences within the field of interpretations. But the limits of that

field are determined at a deeper level, at the level of what language/codes people have available to them – which is not fundamentally changed by differences of situation. As Voloshinov (1973) puts it:

> The immediate social situation and its immediate social participants determine the 'occasional' form and style of an utterance. The deeper layers of its structure are determined by more sustained and more basic social connections with which the speaker is in contact.
>
> (p. 87)

A connected but more serious absence in the research concerns the question of differential decodings, within the family context, between men and women. This is to move away from the traditional assumptions of the family as a non-antagonistic context of decoding and 'unit of consumption' of messages. Interest in this area had originally been stimulated by the results of a project investigating the decoding of media presentation of the Saltley Gate pickets of 1972 (results kindly made available to me by Charles Parker). That investigation showed a vast discrepancy between the accounts of the situation developed by miners who were at the Saltley picket and those of their wives who viewed the events at home on TV, and considerable difficulties for husband and wife in reconciling their respective understandings of the events. This material suggested the necessity of exploring the position of the 'housewife' as a viewer; in so far, for instance, as her position outside the wage labour economy, and her position in the family, predispose her to decodings in line with what I have defined (Morley, 1976) as the media's 'consumerist' presentation of industrial conflict.

Again, time and scarce resources prevented me from following up these important problems (indeed problems of particular relevance given the concentration of women within *Nationwide*'s audience). We can only hope that the research currently being conducted by Dorothy Hobson of the Centre for Contemporary Cultural Studies and others on the situation of women in the media audience will allow some clarification of these issues.

Notes on recent audience research

The most significant work done in this area from the point of view of this project is firstly the study by Piepe *et al.* (1978), *Mass Media and Cultural Relationships* and secondly, Blumler and Ewbank's study (1969), 'Trade unionists, the mass media, and unofficial strikes'. In my view these projects, while focusing attention on some important issues, are critically flawed at both the theoretical and methodological levels.

Piepe's study is, from the point of view adopted here, flawed by its proclaimed concern with 'the question of "normative integration" and the manner of its attainment' (p. ix). This is an adherence to what I have described in Chapter 1 as a 'normative' rather than an 'interpretative' model of the communicative process,

which, despite the authors' later disclaimers, cannot deal effectively with the question of meanings. Indeed this is a lacuna perhaps reflected in the authors' decision not to analyse the interpretation of any specific media texts, but to concern themselves solely with their respondents' views on the media at a general level.

The study does raise important issues about the relation between patterns of differential decoding and patterns of social structure, in terms of class position, position in the housing market and community, etc. (pp. 34–5 *et seq.*). It insists on the necessity to relate psychologically based theories of media consumption – such as 'selective perception' – to social factors:

> to locate people's selective responses to media in collective contexts relating to class and community structures.
>
> (p. 7)

Moreover the study confirms the findings here of a dimension of working class relationships to the media (and particularly to ITV) which is concerned with the questions both of localism and sectional consciousness among that class, and also with the extent to which the media are looked to for a subversive form of entertainment – a 'bit of fun' – which the BBC with its dominant paradigm of 'serious television' is seen as failing to provide.

However, the project is structured by a framework seemingly derived unproblematically from Bernstein's concepts of elaborated and restricted code, which are taken, too simply, to characterise the predominant decoding practices of the middle class and the working class respectively. Thus we are told that the:

> middle class use of television [is] selective and inner-directed, the working class pattern relatively more indiscriminate and other-directed.
>
> (p. 44)

And while the middle class is characterised as having:

> selective perception. The ability to reject dissonant messages . . .
> Cognitive orientation to medium.

the working class is characterised by:

> Blanket perception. Acceptance of dissonant messages . . . media orientation to reality.
>
> (p. 46)

I would simply argue that not only are the class stereotypes invoked here too crude (cf. Rosen's critique of Bernstein) but that my own research shows plenty of examples of selective perception, rejection of dissonant messages and a distinctively cognitive orientation to the medium on the part of working class

groups, with an equally complex set of responses and interpretations on the part of the middle class groups in the sample.

Blumler and Ewbank's research project is locked within the problematic of the media's 'effects'. The authors 'sought evidence of significant correlations between . . . respondents' opinions about certain trade union questions and the degree of their exposure to TV, radio and the press' (p. 41). The questions at issue for them were those of 'the impact of the mass media in matters of concern to trade unions' (p. 33), and the degree of trade unionists' 'susceptibility or imperviousness to what they have seen, heard and read' (p. 36). Their conclusion was that 'among all the forces that had helped in recent years to arouse trade unionists' concern about unofficial strikes, radio and TV had played a slight but significant part' (p. 51).

The authors certainly do not see the media as providing any 'hypodermic effect; they are aware that the audience may be resistant to persuasion and are also aware of the way that the message is mediated to the individual through his/her social context. Far from seeing the audience as an atomised mass of individuals they explicitly recognise that 'trade unionists do not face the barrage of media comment about their social situation in isolation', and that 'group ties can act as mediating variables, blocking or facilitating the impact of mass communicated messages' (p. 34).

Nonetheless it is still a question of the degree of 'effect' on an audience of a 'message': the audience is seen to 'accept' or 'reject' given messages; selective perception and attendance only to 'sympathetic' communications are recognised as 'defence mechanisms' which the audience has at its disposal. But what is not recognised is the necessarily active role of the audience in the construction of the very meaning of the messages in question. The message is still seen here as a stimulus which may or may not produce a response at the level of attitudinal change, rather than as a meaningful sign vehicle (see Hall, 1973), which must be 'decoded' by the audience before it can 'have an effect' or 'be put to a use'. The level at which the decoding operates is not explored.

Further, although audience members are recognised to be members of various groupings, the membership of which is seen to affect their relation to the message, the process of discussion and debate, implicit and explicit evaluation and counter-evaluation, is not explored. This is the collective process through which understandings and decodings are produced by an individual as a part of one or a number of critically significant groupings. Indeed, the authors go so far as to deny the possibility of investigating this process, declaring that 'media effects cannot be detected as they occur'. I would argue that without the analysis of this as a process, the 'recognition' of the significance of occupational family or subcultural groupings in the audience remains little more than a ritual bow to a problem.

The work in question is defined as a survey of individual opinions and attitudes, and the media are seen as having effect at the level of attitude and opinion confirmation or change. Marina de Camargo (1973) has written of this kind of research:

In current political science, the sociologist who examines ideological material works with opinions, usually those given in interviews, which are responses to very precise questions, such as: what party do you vote for? why? etc.

(in the case of Blumler and Ewbank: 'do you think newspapers/TV are pro-union, pro-employers, fair to both sides? Do you think they give too much, too little, about right, attention to strikes?') Camargo goes on:

These opinion researchers have moved from the comprehensive concept of ideology to a far more limited concept of 'opinion' . . . this appears as more 'operational' and it can certainly be more easily specified; but it tends to take the whole framework of ideas within which the individuals express 'opinions' as given and neutral, and unproblematic; all that requires pin-pointing is where individuals position themselves inside this framework, or how their position has changed as a result of exposure to certain 'stimuli'.

She makes the further, and from our perspective crucial, point that most of this kind of research 'measures merely the degree of acceptance or refusal of the ideological content of particular messages, with respect to quite specific beliefs or issues' while failing to touch on the level at which the ideology transmitted by the media may more effectively operate – through the structuring of discourses and the provision of frameworks of interpretation and meaning. It is at this latter level – of frameworks and structures – rather than at the level of the 'attitudes' or 'opinions' expressed within them that we have attempted to investigate the operation of ideology in this project.

It was this theoretical perspective that informed the methodological decision not to use fixed-choice questionnaires, as Blumler and Ewbank had done, nor to use formally structured individual interviews. Blumler and Ewbank presented their respondents with fixed-choice questions and recorded the 'substance' of their views (e.g. 'Yes I think TV pays too much attention to strikes') as the quantifiable data on which their conclusions could be based. I would argue that this separation of the content (a 'Yes') from the form in which it is expressed (the actual words used by the respondent to formulate his/her answer) is a crucial mistake: for it is not simply the 'substance' of the answer which is important, it is also the form of its expression which constitutes its meaning; not simply the number of 'yesses' or 'noes' to particular questions. To deal only with quantifiable content/substance is to substitute the logic of statistical correlations for the situated logic of actual responses. To be sure, quantitative procedures may be applicable to a later stage – once the 'logics in use' have been mapped – but quantitative analysis cannot, of itself, provide the analysis of these 'logics'.

Subsequent work by Blumler, on the actual words used by politicians in the course of the 1974 General Election, would suggest a recognition of these

limitations and a revision of his earlier position. However, even in that study he concentrates on charting the frequency of appearance of particular words, rather than the preferred meanings suggested by their use in certain contexts, and the way forms and structures 'prefer' some meanings over others. Here the appropriate focus of study is surely to be placed on the scope of the available definitional frameworks, the logics-in-use, which assign particular topics to particular meaningful contexts.

'Different languages': project methods

The inadequacy of a purely substantive approach, which assumes that it makes sense to add up all the 'yesses' and 'noes' given to a particular question by different respondents, is highlighted once we question the assumption that all these responses mean the same thing. As Deutscher (1977) puts it:

> Should we assume that a response of 'yah', 'da', 'si', 'oui', or 'yes' all really mean the same thing in response to the same question? Or may there be different kinds of affirmative connotations in different languages?
>
> (p. 244)

He goes on to make the point that:

> A simple English 'no' tends to be interpreted by members of an Arabic culture as meaning 'yes'. A real 'no' would need to be emphasised; the simple 'no' indicates a desire for further negotiation. Likewise a non-emphasised 'yes' will often be interpreted as a polite refusal.
>
> (p. 244)

However, he argues, these are not simply points which relate to gross lingual differences; these same differences also exist between groups inhabiting different sections and versions of what we normally refer to as the 'same language'. As Mills puts it:

> writings get reinterpreted as they are diffused across audiences with different nuances of meaning . . . A symbol has a different meaning when interpreted by persons actualising different cultures or strata within a culture.
>
> (Mills, op. cit.: 435)

Dell Hymes makes the point that:

> The case is clear in bilingualism; we do not expect a Bengali using English as a fourth language for certain purposes of commerce to be

148

influenced deeply in world view by its syntax . . . What is necessary is to realise that the monolingual situation is problematic as well. People do not all everywhere use language to the same degree, in the same situations, or for the same things.

(quoted in Deutscher, op. cit.: 246)

Thus, in the first instance, I have worked with tapes of respondents' actual speech, rather than simply the substance of their responses, in an attempt to begin to deal with the level of forms of expression and of the degrees of 'fit' between respondents' vocabularies and forms of speech and those of the media (though this aspect of the research is still underdeveloped). For similar reasons I have dealt with open discussions rather than pre-sequenced interview schedules, attempting to impose an order of response as little as possible and indeed taking the premise that the order in which respondents ranked and spoke of issues would itself be a significant finding of the research.

The focused interview

The key methodological technique used has been the focused interview – designed, as Merton and Kendall (1955) noted:

to determine responses to particular communications . . . which have been previously analysed by the investigator.

and crucially providing a means of focusing on:

the subjective experiences of persons exposed to the pre-analysed situation in an effort to ascertain their definition of the situation.

The initial stages of interviewing were non-directive; only in subsequent stages of an interview, having attempted to establish the 'frames of reference' and 'functioning vocabulary' with which respondents defined the situation, did I begin to introduce questions about the programme material based on earlier analysis of it. Again, following Merton, I attempted to do this in such a way that the specific questions introduced did not 'cut across the flow of the conversation' but rather engaged with, and tried to develop, points already raised by the respondents. The movement of the discussion was thus from open-ended prompting: e.g. 'What did you make oi that item?' to more specifically structured questions: e.g. 'Did you think the use of that word to describe X was right?' The initial stages of the discussions enabled the respondents to elaborate, by way of discussing among themselves, their reconstruction of the programme, while the later stages enabled a more direct check on the impact of what, in the programme analysis, had been taken to be the significant points. In short, the strategy was to begin with the most 'naturalistic' responses, and to move progressively towards a more structured probing of hypotheses.

149

Group interviews

The choice to work with groups rather than individuals (given that limitations of resources did not allow us the luxury of both) was made on the grounds that much individually based interview research is flawed by a focus on individuals as social atoms divorced from their social context.

This project's results confirm the findings of Piepe *et al.* (op. cit.: 163) that while 'people's uses of newspapers, radio and television is varied, it is fairly uniform within subgroups'. While there is some disagreement and argument within the different groups over the decoding of particular items, the differences in decodings between the groups from the different categories is far greater than the level of difference and variation within the groups. This seems to confirm the validity of the original decision to use group discussions – feeling that the aim was to discover how interpretations were collectively constructed through talk and the interchange between respondents in the group situation – rather than to treat individuals as the autonomous repositories of a fixed set of individual 'opinions' isolated from their social context.

Here I would agree with Pollock (1976), 'Empirical research into public opinion' (in Connerton (ed.), *Critical Sociology*) that it would be mistaken:

> to think of every individual as a monad, whose opinions crystallise and take on permanent existence in isolation, in a vacuum as it were. Realistic opinion research [has] to come as close as possible in its methods of research to those conditions in which actual opinions are formed, held and modified.
>
> (p. 229)

Where I would part company with Pollock is in his slide from the rejection of a naive empiricism towards a position in which an abstracted (Hegelian?) concept of 'public opinion' is proposed as the object of research as against the actual 'opinions' of individuals, and the method of investigation becomes correspondingly philosophical rather than empirical.

Analysing interview tapes

My concern has been to examine the actual speech-forms, the working vocabulary, implicit conceptual frameworks, strategies of formulation and their underlying logics, through which interpretations, or decodings, are constructed – in short, the mechanisms of 'cultural competences'. Since there is as yet no one adequate methodology for the analysis of complex, informal discourse I have employed a number of related strategies for the analysis of responses. At the first level I have attempted to establish the visible particularities in the lexical repertoires of the different groups – where particular terms and patterns of phrase mark off the discourses of the different groups one from another. Here it has been of particular interest to establish where, because of differences in overall perspective,

the same terms can function in distinct ways within the discourses of the different groups.

At a second level I have been concerned to identify the patterns of argumentation and the manner of referring to evidence or of formulating viewpoints which different groups predominantly employ. Here, for instance, an attempt has been made to establish how the central topic areas identified in the programme analysis ('common sense', 'individuality', 'the family', 'the nation', etc.) are formulated by the different groups. Particularly important here has been the attempt to establish the differential definitions of, on the one hand, 'common sense', and on the other, 'good television' which are operated by the different groups as the points of reference from which evaluations of particular items or aspects of the programme are made. The difficulty here has been that of producing explications of such 'taken-for-granted' concepts. The attempt to directly probe such areas often meets with a resistance on the part of respondents, who presumably feel, along with Cicourel, that such attempts at precise definition of 'obvious' terms strip them of:

> the kind of vague or taken-for-granted terms and phrases they characteristically use as competent members of that group.
>
> (quoted in Deutscher, op. cit.)

At a third level I have been concerned with the underlying cognitive or ideological premises which structure the argument and its logic. Here Gerbner's work on proposition analysis (1964) has provided the main guide. As Gerbner defines it, the aim of this form of analysis is to make explicit the implicit propositions, assumptions or norms which underlie and make it logically acceptable to advance a particular opinion or point of view. In this way, declarative statements may be reconstructed in terms of the simple propositions which support or underpin them (e.g. in terms of a question in an interview, explicating the assumptions which are probably being held in order for it to make sense to ask that question). Thus, the implied premise of the following question (*Nationwide: Midlands Today*):

Q: 'But how will this research help us? What is it going to do for us?'

would be reconstructed as:

> 'Everyone knows most academic research is pointless. Can you establish your credentials as actually doing research which will have practical use-value?'

5

RESPONSES TO *NATIONWIDE*

The project used as its 'baseline' the analyses of two *Nationwide* programmes, one broadcast in May 1976 (an extended analysis of which is to be found in *Everyday Television: 'Nationwide'*) covering a fairly representative sample of *Nationwide*'s characteristic topics, and a second programme, broadcast in March 1977 (a briefer outline of which can be found below: pp. 218–19), which was a 'Nationwide Special' on the Budget and its economic consequences.

The first programme was shown to eighteen groups drawn from different levels of the educational system, with different social and cultural backgrounds, some in the Midlands region where the programme was broadcast, some in London. These were school-children, part-time and full-time students, in different levels of further and higher education.

The second programme was shown to eleven groups, some from different levels of the education system, but others from both trade union and management training centres, this time mainly in London. These were full- and part-time students in further and higher education, full- and part-time trade union officials and managers from banking institutions.

Our procedure was to gain entry to a situation where the group already had some existence as a social entity – at least for the duration of a course. We then arranged the discussions to slot into their respective courses and showed the videotape of the appropriate programme in the context of their established institutional setting.

The groups were mainly of between five and ten people. After the viewing of the tape, we tape-recorded the subsequent discussion (usually of about 30 minutes duration) and this was later transcribed to provide the basic data for the analysis.

Groups Interviewed

Phase 1: Nationwide 19/5/76

Group No.	Institution	Profile of Group	Size of Group
1	Birmingham Polytechnic	Apprentice Engineers, Block Release HND Course. Mainly white, all male, aged 20–26; Working Class (WC)	10
2	Birmingham Polytechnic	Apprentice Metallurgists, Day Release HNC Course. All white/male, 21–25; WC	6
3	Birmingham Polytechnic	Apprentice Telephone Engineers, Block Release (City & Guilds). All white/male, 18–20; WC	13
4	Birmingham Polytechnic	Apprentice Electricians, Block Release HNC. All white/male, 21–29; WC	13
5	Matthew Bolton Technical College	Apprentice Telecommunications Engineers, Block Release HNC. All white/male, 17–19; WC	12
6	Matthew Bolton Technical College	Apprentice Lab Technicians, Block Release ONC. 4 women, 9 men, all white, 17–19; WC	13
7	Birmingham University	Arts Degree Students. 3 men, 3 women, all white, 20–24; Middle Class (MC)	6
8	London College of Printing	Film/Photography Diploma Students. White/male, 24–26; MC	2
9*	Hackney College of Further Education	Full-time 'A' level Sociology Students. 8 men, 4 women, 6 white, 6 black, 17–29; WC	12
10	Christopher Wren School	Schoolboys (3rd year) studying for 'O' levels. 8 white, 5 black, 14–15; WC	13
11	Hackney College of Further Education	Full-time Commercial Studies Students. All women, mainly black, 17–26; WC	9
12	Christopher Wren School	Schoolboys (4th year) studying for 'O' levels. 3 white, 3 black, 15–16; WC	6
13	City College (E. London)	Full-time CSE General (Literacy) Students. 5 women, 2 men, all black, 17–18; WC	7
14	Philippa Fawcett College	Teacher Training Course Students. Mainly white, all women, 19–20; MC	12
15	Philippa Fawcett College	Teacher Training Course Students. All white, mainly women, 21–46; MC	6
16	Hackney College of Further Education	Full-time Community Studies Students. All women, all black, 17–19; WC	9
17	Hackney College of Further Education	Full-time Community Studies Students. All women, 3 white, 5 black, 17–19; WC	8
18	London College of Printing	Photography Diploma Students. 8 men, 3 women, all white, 19–26; MC	11

*Owing to a fault in the tape recording this group had later to be omitted from the analysis.

Phase 2: Nationwide *Budget Special* 29/3/77

19	Birmingham University	Arts Degree Students. All white, 2 women, 1 man, 19–21; MC	3
20	TUC Training College	Full-time TU Officials on in-service training. All white/male, 29–47; WC	6
21	Midland Bank Training College	Bank Managers on in-service training. 6 men, 1 woman, all white, 29–52; MC	7
22	TUC Training College	Full-time TU Officials on in-service training. All white/male, 24–64; WC	5
23	Polytechnic of Central London	Shop stewards on part-time Labour Studies Diploma Course. All white, 5 men, 2 women, 23–40; WC	7
24*	Hammersmith College of Further Education	Part-time students on TU Studies course. 2 women, 1 man, all white, 24–32; MC	3
25	Hackney College of Further Education	Full-time 'A' level Sociology students. 6 women, 2 men, mainly black, 18–37; WC	8
26	London College of Printing	Print Management Trainees. All men, 3 white, one black, 22–39; MC	4
27	London College of Printing	Apprentice Printers. Both white/male, 18–19, WC	2
28	London College of Printing	Print Management Trainees. All male/black, 22–39; MC	5
29*	Midland Bank Training College	Bank Managers on in-service training. All white/male, 35–53; MC	9

*Owing to a fault in the tape recording these groups had later to be omitted from the analysis.

A BBC Audience Research Department Survey (1974) gave the composition of *Nationwide's* audience as follows:

	Audience	Composition	Population as a whole
	000's	%	%
Total	5,899	100.0	100.0
u-mc	321	5.4	6.0
l-mc	2,140	36.3	24.0
WC	3,438	58.3	70.0
Total			
males	2,772	46.1	
females	3,177	53.9	

Programme Description 19/5/76

Summary

Time	Item	Comments
00	Regional Menu	Use of identification pronouns;
02	National Menu	'we meet'/'the person who'.
03 (06)	NEWS 'MIDLANDS TODAY' Shop steward at Coventry car plant sacked. Walsall firm cleared of charges of failure to protect their workers. Plessey management give ultimatum to workers on pay dispute. Kidderminster carpet firm in danger of closure. Earth tremor in Stoke-on-Trent.	A package of industrial news. All brief reports except for that on the carpet firm, which includes film, and some 'background' information,
	Mrs B. Carter goes back to meet the lions who attacked her in West Midlands Safari Park.	Questioned exclusively about her feelings. C.U. on facial expressions.
	NEWS Cheltenham policeman praised by coroner for bravery. West Midlands Agricultural Show, Shrewsbury. 6 workers at Rolls-Royce Coventry win £200,000 on pools.	Photo stereotype of 'striking workers' redefined by commentators as 'individual success'.
13	Interview with Ralph Nader on consumer affairs.	'Devil's advocate' interview probing Nader's credibility.
15	WEATHER REPORT	Use of child's drawing.
	Report on a new invention from a Midlands College which will enable blind students to produce 3-D drawings. Report on a group of design students from Wolverhampton who've been building a 'Survival Kit' out of rubbish material.	Both items focus on the role of 'technological development': visual emphasis on machinery in C.U. Implicit contrast made between obvious value of the invention in former item and the dubious value of the latter project.
	NATIONAL *NATIONWIDE*	
25	NW team members go on boat trip on the yacht 'Nationwide' on the Norfolk Broads.	Self-reflexive item: the NW team become the 'actors' in their own story.
28	A report on American servicemen and their families on a US base in Suffolk.	Extensive use of stereotypes of 'Englishness'/'Americanness' in report on 'invasion' of 'Little Old England'.

37	Interview with Patrick Meehan, released from jail with a free pardon after being originally convicted for murder.	Focusing on the subject's feelings. C.U. on facial expressions.
40	What to wear/eat/drink at the races. The *Nationwide* horse: Realin. Report on the financial problems of English racing. Interview with Clement Freud, a racehorse owner.	The 'Sport of Kings' brought to NW audience: a highly composite item involving studio mock up, outdoor film, graphics and studio interview.

Group 1

A group of mainly white, male apprentice engineers; non-unionised, with a skilled working class background, aged 20–26. Studying part-time in a Midlands polytechnic; predominantly 'don't know' or Conservative in political orientation.

The decoding of the programme material made by this group exhibits a number of contradictory tendencies. On the one hand, they at times identify and are able to articulate some of the presentational codes of the discourse which structure it in the direction of a preferred/dominant reading:

> 'People like Barratt must have some kind of controlling influence. They seem to be in command of the situation . . . he puts the last word in . . . it's like a summing-up sentence.'
> 'They're experts at looking average . . .'
> 'They go deeper than the impression they try to put over of themselves. They try to identify with the viewer.'

They recognise the operation of control in the interview situation:

> 'The interviewer was trying to guide him on the lines towards the . . . happiness of being out of jail . . . but when he goes back to saying he's going to try to get this grudge out of his system that's when the interviewer wasn't looking for that sort of aspect . . .'
> 'I think they were trying to get his feelings . . . but his opinions kept coming through, which was what threw the interviewer, he didn't want it . . .'

And they express a view of the programme as not really 'theirs':

> 'They tend to pitch the tone of the programme at about the 40 year old "normal man's approach" . . .'

Their basic attitude towards the programme is one of cynicism and disbelief:

> 'I couldn't understand why the chap was sitting down in the pouring

rain – he complained to the programme about being cold – I mean there's nothing to stop him going and sitting in his nice cosy armchair like everybody else.'

'I thought personally that interviewer was an idiot . . . he just kept repeating himself . . . silly questions . . .'

But despite their expressed cynicism and 'distance' they fundamentally share many of the cultural orientations and assumptions that underlie the discourse. They criticise the presentation – 'I think the interviewer was a bit of an idiot' – they are equivocal about the programme's 'neutrality': 'I think they stand fairly neutral . . . I think they try to appear to stand fairly neutral at times . . .' and they see that the programme embodies attitudes and orientations pre-given to the viewer:

'I don't think the interviewer likes him very much . . .'

But still, the codes and assumptions that they share lead them nonetheless to accept many of the interpretations of events and issues offered by the programme. They feel that the treatment of Nader is hostile, but:

'They're not in it for the money . . . Nader is extremely high-paid . . . *Nationwide* are doing it as a service . . . and they're willing to draw the line . . . say we must accept some change . . . but Nader, his attitude is, if you don't do it my way, you don't do it at all . . . he's powerful enough to close firms down . . .'

To this extent then, whatever their reservations about the programme's presentation of Nader, they accept the programme's definition of him as something of a 'maverick' figure – again returning to the question of monetary self-interest:

'Nader's in it for the money . . . it's a kind of racket . . . he says the consumer needs protecting, but the consumer will pay for it in the end . . . he goes to different extremes and causes more money to be spent, and the consumer pays the bill – does this community really need him?'

Interestingly, they reject the idea that *Nationwide* are to be seen as taking up a 'fourth-estate' position of 'defending' the audience/consumer against such pretensions as Nader's: they define *Nationwide*'s role as much more 'natural' and 'transparent':

'It's not so much defending us against people like Nader as showing . . . what people like him are like.'

They sense that the treatment of the students' design project on waste materials has been trivialised in the presentation:

'They could have put a completely different slant on that . . . they could have made it seem like a scientific breakthrough.'
'Looking at it that way it can seem quite funny and it brushes any kind of importance it might have developed out of the window . . .'

But yet, despite these reservations about the treatment, their own position as part-time students on a practical/vocational training course and a strong suspicion of 'education' for its own sake, and 'arty-crafty' students, leads them to accept the perspective that *Nationwide* offers: they identify with the perspective offered by the interviewer.

Q: 'Do you think he's expressing your opinions?'
'Yeah – what the hell *were* they doing?'
Q: 'Is he asking the kind of question you would want to ask?'
'Yeah . . . because those students are obviously living on taxpayers' and ratepayers' money for some kind of educational purpose and it's a fairly obvious question, "well, what the hell are they doing it for? Why are we throwing money into rubbish dumps?"'

Indeed, the item is remarkable to them for its uselessness:

'a bunch of students . . . living in Wales on a bunch of old rubbish – it was incredible.'

And they felt that in the interview the student representative totally failed to account for the project:

'A load of rubbish . . . and he couldn't answer . . .' 'Yeah he didn't answer . . .' 'He didn't give an answer . . . it's not an answer.'

As far as this group is concerned the students' project, in clear distinction from that of the 'blind' item, is precisely not useful or practical in any sense; and for this group practicality is an overriding consideration:

'If you ask me, they've got their priorities wrong – they spend far too much time with those students . . . I mean that's going to be *really useful*, isn't it?! I mean that thing with the blind people – they could possibly hold down a job if they've got a piece of equipment like that . . . the one is useful, and the other isn't.'

This perspective, shared between them and the programme, seems so natural to

them that it hardly qualifies, in their view, as any particular perspective at all.

'They just said the obvious comment, didn't they . . .'
'. . . he would have thought about the obvious questions that people are going to ask after seeing it, then ask them himself.'

The one section of the programme which their confidently commonsensical approach cannot accommodate is the Meehan interview. They validate the dramatic form of the presentation, the close-up interview:

'It tends to enhance the sincerity of the situation, because you can see the expression.'

and they argue that this is better than a conventional 'serious current affairs' presentation of such issues where because of the distanciation of the 'round table' discussion 'it becomes less real'.

Something has come over strongly through this highly charged interview, but it is unclear to them how to interpret it:

'They gave the impression that he, em, I don't know how to explain it, y'know, he was obviously cut up about it, em . . . it was the grudge that was prominent . . .'
Q: 'What was the item about?'
'. . . the injustice of the system' [laughter] . . . 'the fact that a guy had spent seven years of his life . . . through no fault of his own . . . but through misidentification . . . and what he was saying about those things going on in America, and also going on over here, I mean, you don't know, whether that's true or not . . .'
'It didn't come over strongly, because he only said it once [the reference to British Intelligence – DM] and it was only in passing, but it was certainly there, wasn't it, *something* . . .'

Group 2

A group of white, male, trainee metallurgists, aged 21–25, with a skilled upper working class background, studying on day-release for HNC qualifications in a Midlands polytechnic; predominantly 'don't know' or Conservative.

This group strongly state their preference for *ATV Today* over Nationwide:

ATV Today – oh yes, that's better.'

The preference is explained in terms of what they see as the more humorous approach of the ITV programme which is also seen as less 'reverent' than the *Nationwide*/BBC mode:

'On *ATV Today* Chris Tarrant [presenter] – he's the sort of "laughing type", the "mucker" . . . it's a great laugh . . . and he sort of always tries to bring the person down, or give them a question they can't answer, and make them look, you know, as if they're wrong . . .'

It is a preference for a different mode of presentation and also a different type of item, one more squarely within the 'Sunday dreadful'/popular tradition of the working class press – the strange and miraculous. It is expressed with an acknowledgement that it's not 'news', but it is after all, 'a bit of a laugh':

'the sort of news they get on ATV – a bloody woman's being fired across a river like a cannon ball . . . every time she went straight into the river, that was great [laughter] . . . it's strange isn't it? What the bloody hell they call it news for I don't know . . .'

But the reservation is without weight: those items on *Nationwide* which the group pick out as the best are those that came closest to this mode – like the item with Mrs Carter and the lion:

'It has more local interest. She's not really important but it's a nicer thing to put on, isn't it? Have everybody looking – you know, nobody wants to know Scotland's problems in the Midlands . . . it has got to be Midlands, hasn't it? Like Mrs Brown's cat, stuff like that . . . it's the sort of thing that appeals, isn't it? Everybody in her street's going to sit and watch the programme . . .'

Here the sense of location (cf. the London working class groups on *London Today*) is the crucial thread – the point from which identification is possible. Thus the role of Tom Coyne:

'It's as though he's part of us . . . from Birmingham.'

and the significance of the item on the invention for the blind:

'Because it was a Midland invention – it shows the Midlands doing something for the blind.'

The Meehan item cannot be accommodated within these terms – all that comes over is a very negative reading:

'His back's up . . . he was bitter and he wants revenge . . .'
'underneath it all it appeared that he just wanted revenge of some sort . . .'

– a position which is simply reduced to the commonplace:

'After all, everybody's got some grudge against the system . . .'

Given their lack of purchase on the item, they are necessarily dependent on the presenter's framing of it:

'I didn't know what he [Meehan] was on about and . . . well, Barratt's a national figure, so what he says, you know . . .'

The role of the presenters is accepted, if diffidently, as the best representative point of identification available:

'and they're [presenters] supposed to be sort of unbiased, take a back seat sort of view . . . in one respect it's similar to appealing to the authority, y'know, because he's such a well known person . . . the presenters have got to be the most authoritative 'cause you see most of them, they're sort of, the control . . . you mistrust the person they're interviewing, straight away, don't you? I mean, you don't know them, you're suspicious, you know, they're out for themselves, the interviewer isn't, he's only presenting the programme . . .'

Yet in some instances the presenters/interviewers are seen to 'step out of line' – which is how this group interpret the Nader interview:

'With the Nader interview he [interviewer] was putting the point of view of the people Nader was really fighting against. He wasn't putting the questions that the taxpayer and the, em, consumer groups would have asked him . . . he was really on the industrialist's side, you know . . . You know, he more or less asked him, do you think you're "an expert" and he pushed him on that point . . . you know, virtually called him an agitator . . . Nader was just defending himself . . .'
'. . . he [interviewer] made a point of mentioning that Nader was being paid £2000 for the appearance, which seemed to give you the wrong impression of him being a consumer protection person to start off with – you distrust him before the item comes on!'

But the emphasis on money can also operate in another direction. Like group 1 there is an articulation of a certain cynical attitude to the whole programme – precisely in terms of money:

'It seems that people, well I don't know, that they . . . a lot of people seem as if they're in it for the money, more than anything else . . . a lot

of those . . . even like the bloke who designed a T-square for blind people, you know, he'd patented it, so, you know. . . .'

Thus, when the programme is seen to provide a similarly hard-headed, cynical approach to the value of the students' 'rubbish' project, the group definitely endorse it. They, unlike some of the full-time student groups, regard the presentation of the students' project as 'fairly open-minded' and feel that the 'lack of sense' is a quality of the project, rather than of the presentation of it:

'he [the tutor] looked a bit of a nutter, didn't he . . . I was sort of . . . wondering – what the hell – we're paying! I've just paid for that, you know!'
'that's a reasonable question, you see – well, you know, what a waste of time and money!'

Similarly, the group have no hesitation in assuming as soon as the picture of the group of pools winners (six men with raised fists, in working clothes, outside a factory) is shown, that this is, of course:

'about a strike – it had a Rover sign in the back! It's usually what they're doing, isn't it? [laughter] . . . – first thing you think, whenever you hear of British Leyland is "who's on strike this time?"'

This is, simply, common sense.

In contrast with the shop stewards' (group 23) sense of themselves as a co-hesive group of socially located 'decoders' this group return the argument to the level of the individual: there can be no general perspective, only a random col-lection of individual ones, because:

'They say they ask the questions that you'd like to know, but then again everybody's got different questions they'd like to ask. They say they try and ask things which will be general to everyone. When they say "some people would like to know . . ." it's probably, you know, it's, er, the bloke he's been for a drink with dinnertime and things like that – it's got to be all personal, hasn't it . . . he has to think, well, what would I like to know, and what would Fred like to know . . .'

Although there is, in terms of sexual difference, one categorisation of perspectives and decodings which they are aware of the programme working on:

'That blind one . . . you know, it gets the . . . [note heavily edited speech – DM], you know . . . the . . . women into it as well, you know . . . "ooh, isn't that nice", you know – "the blind can actually do things like that" . . . especially when you saw them walking out of the

place, I thought that was really trying to get at people, you know, arm in arm . . . tears trickling down . . . you know, I really thought they were aiming at that . . .'

Group 3

An all white, all male group of trainee telephone engineers with an upper working class background, members of the Post Office Engineering Union, studying part-time in a Midlands polytechnic; predominantly 'don't know' politically, which is extended to a rejection of party politics.

The group, like group 2, express a marked preference for ATV Today over Nationwide, on the grounds that it is 'a bit more sort of informal', 'it's not so, sort of . . . formal' '. . . – that [Meehan item] seemed too formal, that interview with him' and, importantly for this group, on ATV Today 'the interviewers are younger', a point expanded on as they try to explain their disidentification with Nationwide:

'On this programme, they're all sort of middle aged people . . . there's ten years age difference . . . they're like 1950s sort of thing . . . but with those of us of our age . . . you know . . . times have changed that quickly that within ten years it can't be the same – what they think and what we think . . .'

The 'informality' of ATV Today is also associated for them with a sense of a greater realism – expressed in terms of 'seeing' how things 'actually are' for yourself – as distinct from what they see as Nationwide's 'over-planned' and rehearsed style of presentation:

'. . . the Americans: if that had been on ATV Today they'd always have one of their interviewers sort of on the camp – you'd see . . . you see nobody here . . . they didn't ask the people in Suffolk what they thought about it.'

They explain what they see as a model of acceptable/realistic presentation, as exemplified by ATV Today:

'There was a programme on ATV Today . . . a school . . . and the interviewer was going round, he was talking to them . . . as they were at work . . . so you sort of associated yourself with that interviewer as though you were talking to them . . .'
'And you actually saw the people at work rather than at home.'
'– but here [blind item] that could have been planned.'
'– what you see there . . . that way they were sitting . . . they could have been going round a script – whereas on ATV Today that thing is, like, informal, you know, just take things as they are . . .'

In contrast with groups 13 and 14, who single out the Meehan interview as the best/most interesting item in the programme, this group's view is that:

'it's quite boring really . . . about him being in jail for seven years.'

– a judgement informed by their very different sense of what constitutes 'good TV'. Their judgement is informed by the sense that this is the closest *Nationwide* comes to a 'serious' current affairs item.

For this group the Meehan interview makes little or no sense in itself; they are just confused:

'I'm not even sure if he was innocent . . . you know . . . it could be just him saying he was . . .'

and their confusion makes them dependent on the programme's framing of the item as the only way to make any sense of it:

'When he [Barratt] explained, at the end, you know, the full details . . . I mean . . . I could see, obviously, what had sort of happened . . . before that . . . I didn't really feel anything about it, because . . . I didn't know enough of the details to say whether he was in the right, or wrong.'

Indeed, the category which Barratt provides, in which to 'place' the item, is reproduced as an explanation:

'It was, like, a "mistaken identity", wasn't it . . . ?'

– a 'mistaken identity' being a category only very recently, in the wake of the George Davis case, established in the discourse of popular common sense.
As this group put it, when speaking of the presenters:

'You take what they say to be fact because they're generally . . . they generally say the news – like the news roundup at the end . . . the others you just . . . they give you all their personal opinions.'

Although this power is not monolithic in its operation – in the case of the Nader interview, while they feel that 'it's the bloke who interviews him who has more power because you never see him . . .' (incidentally an equation between 'invisibility' and 'power' made by several groups) – they still go on to reject the preferred, negative reading of Nader; as they put it:

'The chap's agitating . . . but it's a good thing – a lot needs changing [a paraphrase of Nader's own words] really – he's onto a good thing.'

When it comes to that section of the programme on the students' rubbish project and the invention for the blind students, they clearly pick up and endorse the contrasting evaluations signalled by the presenters – within the terms, again, of their respective practicality/use-value. The students on the rubbish project:

> 'They're misers . . . and they didn't really put over why they were doing it. Why do you wanna survive out of rubbish? Why do you wanna make knives and forks out of coathangers . . . especially when you can pinch 'em from the college canteen!'

The lack of rationale of the project is seen as a quality of the project itself, not of the programme's presentation of it. Most crucially though, in this group's view, the project is damned because 'they didn't seem sort of applied to anything.'

In striking contrast, the item on the invention for the blind students is seen as thoroughly rational and sensible – and again this is seen as a quality of the project, rather than of the presentation of it:

> 'They tell you . . . they express what it's doing for them.' 'I think you learn more from that interview . . .'
> '. . . That one with the blind was about the most interesting . . .'
> '– yeah, the blind.'
> 'The other one [students] was a waste of time: with the blind they've more or less got it for life, haven't they? Whereas with the students they've got a choice – they could go out and get a job, instead of roaming round rubbish dumps.'
> (cf. group 1: 'they could hold down a job . . .')

But, while accepting and endorsing the dominant reading of the relative value of these two projects they go on to make a broader statement of qualification as to how relevant this discourse is to their lives, in general:

> 'Neither of them was really relevant to us though, you know, were they? You could say they were both vaguely interesting, but that's it, once it's finished, it's finished, it's finished, you know . . . you can think about it afterwards, and that . . . you know what I mean – you say "very good", and that's it.'

This perhaps is an instance of the kind of response to which Harris (1970) is referring when he speaks of the rational basis of working class alienation from the dominant forms of political and educational discourse. That is to say, in so far as the groups feel there is nothing they can do with the information which the media supply to them, it is hardly worth their while to have any opinion about it.

Group 4

A group of white, male, trainee electricians, with an upper working class background, studying part-time for HNC qualifications in a Midlands polytechnic; predominantly 'don't know' in political orientation.

The group are immediately able to 'deconstruct' Nationwide's self-presentation. They see the presenters as:

> 'people who try to put over the view that they're, you know, sort of next door neighbours . . .'
> 'It's to create the impression that Tom Coyne sort of is your local mate from up the road that's in there on your behalf . . .'
> 'Do you feel that he is?'
> 'I think he's on the level myself.'
> 'I think it's easy to forget that he is, in the end, employed by the BBC . . .'

Although they are equivocal about the extent to which they accept Nationwide's self-presentation they see it as a different issue for their parents:

> '. . . he's had that effect on my father – I mean my dad calls him "Tom": "Tom's on the telly". When Tom says about the students, my dad thinks they're all layabouts, long hair, greasy and all this . . . when Tom says something, our dad says "he's right, you know, Tom is."'
> 'I mean I'm forever telling myself, when I see them . . . hold on though, they're only doing it for the money . . . so I'm a bit cynical that way . . . but I know that . . . my mother is always sort of laughing about how he's [Tom Coyne] on a diet and he's not achieved this and that, you know.'

The group are thoroughly familiar with the programme's discourse and role structure:

> 'Bob Wellings always seems to be the one who not to believe on Nationwide . . . he's always the one with the funny sketches . . . the one who plays the fool . . .'
> 'It's producing Tom Coyne as a personality . . . and you know what Tom Coyne is going to act like . . .'

Moreover, they can also deconstruct Nationwide's dominant mode of presentation:

> 'You're never just presented with something "bang" on the screen, you've always had something beforehand that prepares you for it, you

know . . . anticipation is set up, and you're waiting for something to happen . . .'

Their overall orientation towards the programme remains distanced and cynical – as far as they are concerned:

'There was absolutely no point whatsoever in them spending half a day filming on the boat, you know. But they wanted to show us that they were definitely in the, er, East, because otherwise it could have been a studio with 'East' written on it . . . But you know what the Norfolk Broads are associated with, what they convey – so that was brought in . . .'
'. . . and they like to show that they'll have a go at anything . . .'
'. . . and they all get the expenses in!'

The cynicism at points becomes hostile: 'Barratt – he doesn't seem very well-informed . . .' 'he breaks into some sick smiles . . .' 'bit "smart" isn't he? . . .' while they recognise that, as a presenter, he does have a considerable power within the structure of the programme.

The Meehan item leaves them confused: 'He said he was innocent . . . you don't know why . . .' '. . . it was just about "six years in solitary" . . .' '. . . you get no answer' and within this confusion they are dependent on Barratt's framing statement for clarification, about which they rather resentfully admit:

'Yeah . . . it makes a difference . . . the way that Barratt bloke winds you up and says this is another example of British justice . . . going wrong that we've shown on *Nationwide* . . .'

The Nader item they read fully within the preferred terms set up by the programme, with a particular emphasis on the chauvinistic nature of the reading. Nader is interpreted as a stereotypically 'big-shot American':

'He tends to be like most Americans – they have the gift of the gab . . . they tend to hold the microphone . . . he conveyed what he wanted to convey . . . obviously he was asked the right questions . . .'

They even interpret the questions (which most groups saw as evidently antagonistic towards Nader) as positively biased in his favour (cf. group 3):

'He wanted that question about the antagonism so that he could say, "no, I'm not" . . . I thought that question was specifically tailored to give him that space . . .'

With the students' 'rubbish' item they are well aware of the effect of the presentation:

'[the presenter was] setting up the students . . . into a separate category of people . . . he's got all the respectable people . . . sitting at home, just got home from work, and it's . . . "look at that yob on the telly", it's obvious what he's [the presenter] on about, "he's a yob". . .'

However, despite this recognition there is a vital qualification:

'But that's what you pay for . . . if that's where the rates have gone . . .'

Again the project is seen as lacking any sense:

'I don't think any of those students actually answered why they did it . . .'
'they were just doing it, sort of thing . . . I still don't know why they did it . . .'

and this is seen as a quality of the project, rather than of the presentation, although there is in this group an undeveloped and solitary attempt to 'read sense' into the item:

'. . . perhaps it was to see if they could use their imagination and put it into practice . . . out of the classroom . . .'

The 'Americans' item is, like Nader, interpreted through a militantly chauvinistic version of the preferred reading, one which is resolved into a thoroughly xenophobic 'them/us' model:

'They don't change much . . .'
'They're all creeps . . .'
'They seem to be very, very false . . . so very "easy-going" . . .'
'sick . . . basically sick . . .'
'. . . about three times they said how "pleasant" they were . . . how good natured they were to people.'

They are confident about the interviewer's own stance:

'The interviewer was saying how "nice" the Americans were, but really, he meant, well, you know, they're not really nice . . . the interviewer was looking down on the Americans, while outwardly trying to look up at them, you know . . .'

The interpretation is premised on the construction of a sense of 'we' which is shared between the group and the interviewer, constructed by 'what we know', as distinct from these outsiders:

Q: 'Do you think he [the presenter] thinks the Queen and the police are wonderful?'

'No . . .'

'He was being sarkie, wasn't he!' Q: 'How do you tell that?'

'Simply 'cos none of us think that way, do we?'

'. . . we, being a cynical race, know that . . .'

'. . . you were on the same wavelength as him . . .'

'The Englishman thinks of the Queen . . . sort of majestic . . . something like that, you know – that's the illusion he's trying to create of what we think but we know what we really think . . .'

However, while this identification is firmly secured at the level of national cultural identity, it is to some extent undercut by the group's distanciation from the image of *Nationwide* at the level of class:

'I think most people on *Nationwide* . . . the people we see presenting, they all seem to be snobs to me . . . I wouldn't say upper class, but getting on that way . . . the people who go to Newmarket and this sort of place . . . they are at the top, pretending they are at the bottom and trying to project the image that they think the people at the bottom ought to have . . .'

Here there is a clear distinction at the level of mode of address. The group endorse the preferred readings of particular items – Nader, students, Americans. But at the level of presentation they reject the image of the audience (and the tone 'appropriate' to that audience) which they see inscribed in the programme. In a class sense it is simply not 'for them':

'You wouldn't think anyone actually worked in factories – at that time of night: to them, teatime's at 5 o'clock and everyone's at home . . . a real middle class kind of attitude . . . things they cover like that boat, you know, sailing . . .'

'. . . it's a middle class attitude, the sort of things they cover are what middle class people do.'

'. . . the audience you can imagine are all office workers . . . commuters.'

Although the group do then go on to debate their relation to class and to middle class values in a way that shows the contradictions and instabilities within the group's perspective:

'But aren't the majority of working class aspiring to the middle class anyway . . .? Isn't it them they're aiming at?'

'I never actually go to the races . . . I don't expect many of us in here do, you know . . .'

'But you *want* to . . .'

'And they present it as if you could. They present it like how you want it. You *can* really if you . . . you can do if you want to . . .'

'But . . . you know . . . deep down inside you know . . . you can have a good go at it but you never actually get there . . .'

Finally, the group make an important qualification about their responses, one which, of course, without this particular emphasis, applies potentially to all the groups:

'There is one thing though . . . going back to that point about being too critical . . . I mean I was being critical . . . I was being asked to watch it and answer questions . . . but at home as a rule . . . when *Nationwide* is on . . . it's on all the time, I'm there just watching it, having me tea, like . . .'

Group 5

A group of white, male apprentice telecommunications engineers, with an upper working class background, mainly non-union, aged 17–18, studying part-time in a Midlands Technical College; predominantly 'don't knows' who again extend this to a rejection of party politics.

The group begin by distancing themselves from the programme:

'It's more trivial news, nothing very important . . . most of the programmes are made up of waffle.'

And they later remark of the 'boat trip' item:

'Anybody with any sense knows they've got to be messing about . . . the one who's supposed to be seasick: you wouldn't expect that to be true.'

As far as they are concerned *Nationwide* is not for them – it's for:

'the family sitting around watching . . . nobody in particular, just the whole family together . . .'

They resist the notion of the structuring power of the presenter's discourse, reducing the role to one of providing 'humour':

'They're there more as a personality, to add a bit of humour to it . . . Tom Coyne's there to be tongue in cheek . . .'

While they in fact retain verbatim Barratt's frame statement on the Meehan interview:

'He was on about "yet another case of wrong conviction".'

Yet the effect of the frame is reduced/denied:

'In an earlier programme they were going into the subject of wrongful convictions . . . and what he said afterwards just tied in with that . . . it came back to what had already gone before . . .'

After all, to ask questions about the effects of 'frame' statements is to raise questions outside the 'normal' discourse of TV discussion and the responses quickly close down the space and (re)treat the problem/issue as a technical one:

'He just sums up.' 'Tidies it up.'

The problem is acknowledged only, and purely, as a *textual* problem of 'linking', producing a 'good'/coherent programme:

'I think they're just doing a job like everyone else. They've got a job to do so they do it. I think it's only now and then when they feel strongly about something, they might just change it round a bit to try and influence people. Generally I think they've just got a job to do and they do it . . .'

This seems to me to be crucially overdetermined by the programme-makers' own technical/professional ideology, bracketing out all other considerations and working with the notions of 'good television/effective communication/interest'. These terms seem to be taken over in large part by the respondents and are both the ground on which attempts to raise other questions are denied/evaded and, further, set the terms of reference for what critical comment there is – thus criticisms are couched in terms of 'boring' ('not very skilful/silly/stupid questions/amateurish').

'The other programmes are better produced . . . *Nationwide* looks so amateurish . . . not very skilful . . . like that "blind" bit would have been done better in *Tomorrow's World*: they'd have made something of it . . .'
(cf. groups 1 and 4: 'the interviewer wasn't very skilful . . .')

Again, like group 4, Nader is seen to be very much in control of his own interview:

'They let him say what he wanted . . . though he [presenter] didn't agree with him . . . I mean, he was giving long answers which usually means that he's got the upper hand . . .'

whereas:

> 'with the students, Tom Coyne, he was running the show, he was asking
> the questions, they were giving short answers. He was getting them on
> whatever he wanted to, whereas this Nader bloke was taking as much
> time as he wanted.'

This is seen quite simply as a result of Nader's personal skills:

> 'This Nader bloke has probably been in this situation many times
> before . . . if they'd had a better interviewer . . . he might not have got
> on so well . . . like, Robin Day would probably have shot him down . . .'

– an outcome they would have preferred, as they basically accept *Nationwide*'s neg-
ative characterisation of Nader.

With the students' 'rubbish' item *Nationwide*'s 'common-sensical' dismissal of
their project is endorsed:

> 'You could see that the people sitting at home would say, "what was the
> good of that? What's everyone paying for, the kids are there to learn:
> what have they learnt from that" . . . well, you couldn't see much point
> in it . . .'

This is so, notwithstanding their recognition of how the students' item has been
constructed by the programme:

> 'On that programme you can't take it seriously . . . it seems a total waste
> of time! . . . Tom Coyne treats it as a kind of joke, tries to show it up
> as a joke, as a complete waste of time, to go to Wales to make plastic
> tents . . . he [Tom Coyne] was laughing at it . . .'

They can see that the students have been 'set-up' for a joke – and they agree with
Coyne about them.

The sense of the obvious 'appropriateness' of *Nationwide*'s perspective is
brought out oddly in relation to their presentation of the family in the
'Americans' item. When asked why Mrs Pflieger is interviewed in the kitchen
they first reply that:

> 'That's how a housewife is supposed to look.'

But they go on to turn the programme's construction of her upside down: her
placing in the domestic context is so naturalised for them that they see the pro-
gramme as simply showing where she 'is', rather than placing her somewhere.
She is shown in the kitchen, they argue, 'because she was going on about a

dishwasher and things' and the programme's specific role in articulating this cultural location is taken as a reflection of a natural fact.

Again, like the other apprentice groups, they discriminate between the 'rubbish' item and the item on the blind students on the basis of practicality: they see that the blind item had a specific appeal because of its location:

'I think it was probably on mainly because it had been done in Birmingham . . . it was specifically from Birmingham.'

But, most importantly:

'because the students are blind . . . in a bad situation . . . and in the second one where they're messing about with plastic bags . . . it's just wasting their time like, nothing . . . beneficial . . .'

The American item is read firmly within the dominant chauvinistic perspective:

'Terrible [laughter]. They speak with a funny language.' 'Plenty of money . . .'
'Whenever they go to a foreign country, like Japan . . . they've brought baseball there, and Coca Cola, and they just sort of invade it . . .'
'. . . you're safe sending up Americans . . .'

and the implied chauvinism is of an obviously common-sensical nature.

Group 6

A group of mainly male, all white trainee laboratory technicians studying part-time in a Midlands Technical College; skilled working class background, mainly members of Association of Scientific, Technical and Managerial Staffs; predominantly 'don't know' or Labour.

The group are not at all enthusiastic about Nationwide:

'They state the obvious all the time . . . there was no point . . .'
'It would have been a lot more interesting with a blind interviewer and a blind cameraman.'
'I tell you what was a complete waste of time – Barratt messing about on that boat.'

They express a definite preference for ATV as more in tune with their interests: a preference in terms of its humorous, irreverent approach, as against what they see as the 'middle class', 'serious' nature of Nationwide as a BBC current affairs programme. The response is evidently overdetermined here by the educational context of this viewing dimension, but Nationwide is characterised as a 'general studies programme.'

By contrast, *ATV Today* is seen as:

'Not as false as that programme.' 'You have a good laugh . . .'
'Their sport is a lot better . . .'
'They're more human I reckon . . .'
[= more like me?]
'. . . it's a lot more realistic . . .'
'. . . they put the odd bit in and make it interesting and humorous instead of serious and boring.'

ATV Today is praised for being 'local'; for covering the 'ridiculous but interesting':

'stuff like world record marrows growing . . . it's more relaxing . . . it's things that affect everyone . . . at least they tell you about his [i.e. the marrow grower] family background, how old he is, things like that, and his dad did it before him and his dad . . . what he used to do . . . what he's going to do with it when he's grown it . . .'

They at times criticise the inadequacies of *Nationwide* from a point of view which seems close to the criteria of serious current affairs:

'The students were only asked questions that, you know, had no real relevance; yet again, that bloke . . . [Meehan] no real relevance . . . they didn't ask the type of questions that an enquiry would ask, you know who was the bloke who framed you? Why do you think he did it . . . and all that . . .'

Here the criticism is articulated in terms of *Nationwide* being too 'safe' and unchallenging:

'These interviewers, they want to keep their jobs . . . it's an early evening programme and they don't want to offend too many people . . . they can be too diplomatic in the way they approach things, especially Tom Coyne.'

But this does not mean that they would therefore endorse the 'serious/current affairs' approach. When asked to imagine the Meehan item on *Panorama* they say:

'They'd give us a case history of why he's in prison and you'd probably switch off.'

The Meehan interview is identified as 'serious' material; as such:

'That was the most boring thing in the programme.'

The group seem puzzled and frustrated by the item's combination of intensity

and opaqueness – producing a very contradictory reading of it. The significance of the visuals (permanent close-up on face) is entirely denied:

> '. . . it didn't matter if you saw his face, they completely wasted the man's time, filming him, talking to him. A telephone conversation would have been just as effective.'

The point of Nationwide's presentation of Meehan in this way (as 'suffering subject') is explicitly denied:

> 'I can't see at all what you got from that interview that couldn't have been summed up in five minutes of words . . .'

But at this point the precise effect of the Nationwide presentation, concentrating on the visual/subjective aspect, exerts its force:

> '. . . but there he was, sat on a sofa, shirt down to his navel, smoking a cigarette, probably had a can of beer in the other hand!'

This impression of Meehan is, in fact, largely constructed on the basis of the visuals supplied – extrapolated into visual stereotype (uncouth criminal?) despite the fact that the explicit 'message' of the respondent is that the visuals were entirely redundant. The repression of the sense of this item – because the political background of the case is crudely edited out – leaves the group asking:

> 'Why? Did they say why?'
> 'Why had he been in?'
> 'I understand he claimed he was innocent – why was he innocent?'

The confusion here contrasts strongly with the reading of the 'blind' item where, because there is no similar repression of background/coherence the group can articulate the structure of the item in perfect clarity:

> 'The reporter explained how to use it, and the bloke who invented it explained why he invented it, and the kids . . . how they use it.'

The group are well aware of the role of the presenter:

> 'It's Barratt, he holds it together . . . a witty remark here and there, thrown in, this and that [i.e. a style, not a particular content?] . . . he's a well-known face . . . the news changes from day to day and you're glad to see something that doesn't . . .'
> '. . . it's so that you . . . walk into the room, you think "what's this?" – kind of, someone's fallen in the canal, and then you see Tom Coyne and say "Oh, it's Nationwide!"'

Moreover, they are aware of the structuring role of the presenters' 'frames' and questions – with the students' project:

> 'They were structuring the questions . . . They only wanted you to
> believe what the commentator, what the scriptwriter was thinking. They
> don't want you to make your own ideas on the subject . . .'
> 'They tried to channel you up in one direction.'

Indeed, as they can see:

> 'They humoured the students – because that's a good laugh. Tom Coyne
> asked him what the jumper was made of and he already knew.'

which does not imply a critical attitude to the programme's position, rather a tolerant benevolence:

> 'Yes, he's like that Tom, a bit thick.'

in which Coyne and the other presenters are redeemed because the group share their estimation of the student's project, which means that they endorse the preferred reading, despite seeing the mechanism of its construction:

> 'It's a joke . . . they didn't survive – because they took their own
> food . . . they just made a couple of shelters for the evening.'
> 'They did manage to make a new axe out of an old one!'
> 'It was just a chance to get on the telly, I suppose!'
> '. . . I mean, they [Nationwide] simply said – this is a load of kids – look
> at what they've done!'

Similarly with Nader: although they are perfectly aware that the programme 'had him set up as a bad guy', despite their awareness of this structure they endorse the preferred reading because, in their terms, Nader is:

> 'out to make himself seem bigger and better . . . he's too smooth . . .
> and he's in the money too. I mean the statement they paid him £2,000 –
> I'd like to do that for £2,000!!'

They accept *Nationwide*'s definition of the situation, they share the same cultural world, and what is common-sensically 'obvious' to *Nationwide* is, by and large, obvious to them too. The decoding, in line with the dominant structure embedded in the message, follows from the complementarity between their ideological problematic and that of *Nationwide*.

The Americans item is interpreted within the dominant chauvinist framework of the programme. Like the other apprentice groups the chauvinism seems to be

reinforced by, or act as a displaced expression of, a form of class-based resentment at the Americans' affluence:

'They're used to a higher standard of living . . . so her husband didn't like it . . . and she'd got "dishpan hands"!! – like we're that "behind" in this country . . .'

At this point a subordinate thread of oppositional reading appears, taking off from the chauvinist form of opposition to the Americans towards an articulation of this opposition in a class perspective:

'They think we're all backward because we haven't all got three cars and two dishwashers and what have you, whereas their country is far more backward [opposition: redefinition] because they've got a higher percentage of unemployment and all the rest of it . . .'

This is extended to a criticism of the item's absences:

'They didn't tell you why the Americans were here though . . . you just see their social life: you don't see them loading up fighter bombers . . .'
'. . . they were trying to convey how they tried to live just how the locals live . . .'

But this is not the group's dominant perspective, which is again (as in groups 4, 12, etc.) constructed around an identification with the 'we' articulated by the programme as against the American 'them':

Q: 'What do you think the *Nationwide* people doing the programme think of Americans?'
'Probably hate them as much as we do . . .'

a perspective which takes up and endorses the programme's ironic presentation of the Americans as a 'simple race':

'They're saying the Americans are naive . . . thinking the police are wonderful and the royal family . . . we know our police aren't that good.'
(cf. group 12: 'we know the other side'.)

The group share *Nationwide*'s 'common sense'. When asked to define their picture of 'England now' it fits closely with that of the programme; they speak of:

'Inflation . . . they're going way ahead – leaping wages – I think *everybody* agrees that sort of thing because *everybody knows* what a bad state we're in.'

And although this perspective does not go unchallenged:

> 'Yeah. But it's not true is it – that's not everyone. No . . . sooner or later there's going to be a day of reckoning.'
> 'No . . . there isn't though . . . there's the chance for a few in America . . .'
> 'No. There'll be a reckoning – some will feel the bite rather than others: and that will be that . . .'

the whole of this closing exchange is accompanied by a bored chorusing of:

> 'Ding-a-Ding . . . Ding-a-Ding . . . Ding-a-Ding . . .'

which is the group's final comment on this emerging moment of political radicalism.

Group 7

A mixed group of white students, with a middle class background, studying drama at a Midlands University, aged 19–25.

Like groups 14 and 15, this group identify *Nationwide* as a programme made for an audience which is clearly 'other':

> 'It's obviously directed at people with little concentration . . . it's got a kind of "easy" form . . . it's "variety", isn't it.'

They feel that the programme:

> 'tries to give you the impression of the presenters – that "Michael Barratt's a very nice guy" . . .'
> 'It's a way of treating it . . . they go in to be chatty . . . a lot of what you're watching is these same characters behaving in the same way . . .'
> 'It's meant to give the impression that we're all in this together. We're a great big happy family as a nation and we're all doing these things together . . . they've got this very personal approach . . . and they all chat to each other . . .'

But, they feel, *Nationwide* is 'about':

> 'what individuals are doing . . . something that's happened to the typical lower middle class or upper working class person . . . but in fact, if you watch it, you don't get to know any more about those individuals or what they are actually doing.'

So, assessed according to educational/informational criteria, Nationwide clearly fails to achieve what they see as the important goals for this kind of TV programme.

The group are, in fact, very critical of Nationwide's chosen project – indeed of the programme's very claim to be 'nationwide':

> 'It really is very narrow. Even this excuse of going to East Anglia . . . there was nothing which dealt with East Anglian culture . . . I didn't hear an East Anglian accent . . . you've got American culture, under the guise of being in East Anglia. They go out and say "we're in East Anglia": so what? . . . that bloke could have been anywhere.'

But it is not only Nationwide's claim to represent regional diversity which is rejected; the programme is also seen to represent a singular class perspective:

> 'There's all sorts of things in that programme . . . from a middle class point of view . . . the language used by all the interviewers . . . there was very little dialect, very little accent . . . most of the people had middle class accents . . . [they're] taking a middle class point of view, and it's basically for middle class people, that's how things fit in, like their view of the police . . .'

Again, like the teacher training college groups, the adherence to criteria derived from current affairs programming leads them to choose the Meehan interview as:

> 'the best part of the programme . . . on an interesting subject . . .'

in that it most closely resembles a 'proper' current affairs item in its subject matter. However, the group are, on that basis, very critical of Nationwide's mode of presentation of the case:

> 'They kept fending him off . . . he was clearly quite ready to talk about it, and all they wanted to know was . . . they were emphasising the bitterness and the anger, because that's more sensational, more digestible than the "deep" . . . Yes it's "the man, the human surface" . . . "I saw it" . . . "what does the man feel like" . . . "Is that how a man looks after seven years solitary confinement" . . . if you see his face, it's as if he's talking to you individually . . .'
> '. . . they ask him how he feels . . . but they don't ask him how he came to be convicted – none of what it's theoretically about. . .'

For them clearly its 'theoretical' status is of vital importance. However, they also negotiate their response to the item by reference to how they imagine the item might appear to that vast 'other' audience:

'What I was getting round to, this sort of interview, this sort of tone is perhaps what people, what the general public, like, that sort of TV, at that time during the day. That's more important than you or I who are not satisfied with that sort of depth!! . . .'
'Just because we don't like it . . . doesn't mean anyone out there doesn't like it, I mean they love it. Why shouldn't they?'

The Nader item is decoded in a directly oppositional fashion; they feel that the programme:

'set him up as a sophist to start with . . . he's coming over here for £2,000 . . . they're in fact saying, "Nader does this for money" – so it colours your impression of the fellow before you even see him.'

But despite this attempted 'closure':

'He came out very well actually. He answered him very well and turned it round. He kept it quite light and answered the question.'

With the 'rubbish' and blind items they feel that the programme suggests an implicit, contrasting valuation:

'One's saying, "this is a great advantage, made the life of the blind boys better", the other one was saying, "well you *can* do this. . ." but there were questions whether there was any advantage in it: "they're living off the state/we pay them grants to do that" is the kind of response that item is asking for.'

While they feel that this presentation aims to 'fit in with' a stereotype, 'a popular idea about students wasting time and money', their response is complex, because:

'There is in fact the sort of reality thing behind that – that this is maybe a questionable thing to do with public money – because that's what kids do when you're eight or nine . . . making a camp . . . maybe there's a point there . . . you mustn't forget that altogether.'
'This is comical in that context – the students *do* actually go and build these sorts of useless things.'

Thus their own evaluation of the respective worth of the two projects is, in fact, in line with that of the programme, despite being resistant to the programme's manipulation of the student stereotype:

'To me the blind thing came across quite well . . . I thought it

worthwhile . . . you don't get the same sort of thing about the students. You got a load of rubbish, and what you can do with a plastic bag, there's no really worthwhile thing to me about it.'
'Whereas the blind kids . . . it came over very well, it was very intelligently justified.'

They also make the point that it is the highly organised clarity of the blind item that makes for its impact:

'You know who the anonymous voice belongs to [the commentator] so you can relate to that . . . it brings you in and it takes you out . . . and the guy who designed it, he's the expert, he's telling you what it's about . . . and you've got the two kids who give you the human interest . . . telling you that it's useful. And then this voice sums up for us, "well this is what you should have gained from this item".'
'And the voice prepares you before you start, "this is what you're going to see, and this is what it's about . . ."'

The response to the 'Americans' item is contradictory; on the one hand they regard the item as 'so patronising' for presenting an image of 'Americanness' which consists of:

'having rubbish disposers . . . women who don't wash up.'
'it's so absurd. . . I mean, this woman to say that they've got two refrigerators and a dishwasher. How typical is that of American life? Essentially atypical. It may be typical of the kind of media image we get of Americans . . .'

On the other hand the programme's chauvinistic picture of the Americans does find some resonance:

'But there is this thing amongst Americans, it's the "quaintness" about England, about the police, they ask the time, they love the Queen, they come over and stand outside Buckingham Palace and so forth . . .'

They are aware of the 'absences' in the item:

'They don't say what the Americans think of the Rolls Royce factory or the environment, they say the Queen and the police.'

And they inhabit rather uneasily the 'we' which the programme constructs to include itself and the British audience, as against the 'invaders':

Q. 'What do you think *Nationwide* thinks about the Queen and policemen?'

'You don't know because if the Americans are really rather silly people, are really rather naive about Britain, which is at one level what they come across as, then you could say if the Americans say the Queen is a nice lady and British policemen are nice, then they're idiots and they're naive because they're not like that. But there's no way *Nationwide* will actually put across that point of view . . .'

But the response is also negotiated from a position which grants some reality to the image which *Nationwide* has presented:

'I can't at this stage raise many objections against that . . . I thought it was quite a good portrayal of how Americans view England and how they feel actually when they first come here . . . They probably change their ideas about the police . . .'

Nationwide's claim to 'represent' its audience is not altogether rejected. In identifying *Nationwide*'s own 'values' the group are situated uneasily in relation to them, only partly being able to endorse them:

'They can't be sceptical about everything . . . even in this programme . . . they did tend to praise some things . . . the blind drawing thing . . . things like that . . . they are serious about anything like old ladies, people who can't . . . can't drive or walk or something. That kind of thing . . . and probably someone hitting an old lady across the head, muggers, that he takes seriously. He comes across with a strong line . . .'
'. . . work doing anything with the blind is good, the students were rather silly in their waste of taxpayers' money, horse-racing would be a great loss to the British . . . "Social value for money" . . . "Practical groups in society . . ."'

But yet they give some credence to *Nationwide*'s claims:

'They've got Callaghan on next week and they're asking him our questions and they actually *are* our questions, because you have to send them in on a postcard, and they say "another man from such and such", and then answer it . . .'

Indeed, despite their criticisms, *Nationwide* remains, in part, an attractive programme:

'To me actually, you know, I think it's a very successful programme and I think it's very entertaining and I've never actually analysed why I like it but it is a good thing to watch, that's all.'

Group 8

A group of white male students at a college in London, studying full-time for a diploma in photography.

The group firmly reject the programme's presentational strategy, which they see as operating:

> 'by making it "jolly", which I find extremely creepy . . . "well, let's see what's going on in Norwich this week" . . . all very sort of matey . . . "old chap" . . . they all seem depressingly similar . . . they're all smiles . . .'
> 'I find I get a peculiar reaction against those individuals, those presenters, in that they tend to be particularly repellent, no matter what they say . . .'

It is a programme not for them, but, perhaps, for:

> 'teenagers . . . mothers putting kids to bed . . .'
> 'I don't think anyone really watches it for its news values . . . it's like *Titbits*, it really is, a magazine . . . *Weekend* sort of thing . . .'
> 'They're just like a tidied up version of the *News of the World* – lots of bits and pieces – and they don't want to risk offence.'

They are very aware of the structure of control in the programme, that it is Barratt who is:

> 'the one who puts the final – gives his opinion after a piece of film, and has, obviously, link sentences . . . so he puts *Nationwide*'s stand . . . on what we've just seen.'

But the programme's preferred readings are largely rejected by the group. In the case of the Meehan item they feel that the programme frames the item in such a way that it is presented simply as:

> 'a minor difficulty here in the judicial system . . . sort of, "I'm sorry about that, audience, but really it's nothing very important, it's just a little misidentification."'

Like some of the other groups in higher education, they regard the Meehan item, in so far as it qualifies on the criteria of serious current affairs, as potentially the most interesting thing in the whole programme – and as such to have been quite inadequately dealt with:

> '. . . I found it very insipid anyway.'
> 'The interviews are sort of prearranged; everybody's got something

separate to say . . . when they did have something which could have been interesting – like Meehan . . . they shied away from the things he was saying . . . so that at the end you get the announcer saying, "well, there's another case of a man wrongly convicted on identification" – which wasn't the case at all, according to, y'know, Meehan was trying to say something . . . very different from that.'

'That's putting . . . it into a nice careful protest . . . putting it into a situation where the audience won't be too alarmed by it . . . they won't feel the judicial system, the British Intelligence agents, are into . . . activities . . . that . . .'

The group feel that the sense of the political background to the case, which Meehan is clearly most concerned about, is simply repressed by the item:

'When Meehan's trying to question . . . making allegations . . . and the interviewer refuses to press it . . . he's almost ignoring what Meehan's saying . . . he almost said, "there you are, old chap, are you bitter?" . . . this is very serious – if he really isn't treating them seriously, we should want to know, we should want to know what it is Meehan's getting at . . .'

The group in fact interpret the problem posed for Nationwide by the Meehan item precisely in the terms of its 'inappropriateness' for the kind of genre/slot which Nationwide is:

'In a way, what Meehan thinks is completely foreign to their set-up . . . just by accident they just found that it's what they cheerfully term "an exclusive" . . . and they didn't really know what the hell to do with it.'

As they put it, all Nationwide could do was:

'to concentrate on the . . . "gosh, what a lucky chap you are, you've just been pardoned" . . . you know . . . "perhaps you're a little bit bitter" . . . understatement of the year!'

'I just feel the questions were blank . . . and his answers were trying to bring out something to the questions which were not permitting him to do that . . .'

The Nader item they read in an oppositional sense: they see and reject the implied evaluation of Nader supplied by the framing of the item, and go on to redefine the terms of the discussion to make sense of Nader's project:

'Well, before the Nader interview they very carefully slipped in some snide comment about how he'd received £2,000 . . . if they bothered to

think, that's an individual like me, who's got to live, I mean . . . you don't sort of live by sort of . . . charity . . . you've got to . . . I dunno . . . you don't live on charity . . . he's running . . . a service . . . I mean . . . you can't just . . . sort of . . . I mean it's not some sort of holy guru . . . he's a practical . . . y'know . . . working man, who's just come across the Atlantic . . . as part of a service really . . . he's got to be paid for it . . .'
(cf. apprentice groups' rejection of Nader, in terms of it being precisely *Nationwide*, and not him, who's providing 'a service'.)

They see the contrast between the way Nader and Meehan came over in their respective interviews as very much a product of Nader's professional skill and expertise:

'Nader himself is capable of manipulating interview time . . . he's a very fluent individual . . . and very coherent . . . presents his views . . .; with Meehan . . . the interviewer was coping with a man who for six years has been virtually in solitary confinement . . . but I don't think that exactly develops your . . . y'know . . . your coherence . . .'

And they see Nader as successfully defeating the hostile interviewer's strategy:

'Yes he does . . . I thought he did . . .'
'He more or less said . . . he said exactly what he felt agitation meant, then he answered the question . . . I mean he's really very careful . . . I mean he's . . . issued about five disclaimers and then accepted the deal . . .'

The Americans item is unhesitatingly dismissed, precisely because of its stereotyped chauvinism:

'I couldn't believe it when we got to the Americans . . . that could have come straight from 1952 or something – you know, "there are these strange people . . . called Americans . . . with strange customs; and gosh, they must find us strange too!" It was so weird to see them still put out that stuff.'
'It didn't do anything, you know, to destroy your preconceptions that have been floating around since the war . . . before that.'
'. . . and then you get some housewife talking about all her consumer luxuries . . . Christ knows how many American people are like that! It's just . . . trying to reinforce our view of . . . or misview of Americans and Americanism, you know, having those children sing "God Bless America"! This is an air-force family and they are a race apart virtually . . . I mean, I've met them in various countries throughout the world

and they are very different from many other Americans . . .'

And the one aspect of the item which they feel has any real substance is, they feel, evaded:

> 'I mean, they come across one controversial issue . . . the Black Market, you know, which in fact is a very serious concern — the American Forces Black Market — the way it operates has the most extraordinary effects upon the communities in which it's set up . . .'

With the students' 'rubbish' item they feel that, because of the form of the questions and the presentation:

> '"some students wasting the taxpayers' money" is the message that got across . . .'

But at the same time they endorse the programme's message:

> 'That's a weird item of no interest to anybody . . . I would have thought . . . it's a "curiosity item" . . .'

Whereas the blind students' item:

> 'That would find a lot of interest . . . I don't know about you, but I've sat on a bus and thought, Christ, what does he [a blind person] see inside his head . . . and really it is quite surprising . . . those drawings were extraordinarily interesting . . .'
> 'To me, the most interesting thing was those two blind guys saying what they got out of it . . .'

They regard their position, as students themselves, in relation to the 'rubbish' project as, indeed, raising complex questions about 'identification':

> 'A lot of students don't identify as such, because if you're not something different . . . not a race apart, often you would be thinking of yourself as "them" rather than "us". I mean, do you go around thinking "Christ, I'm a student!" . . . so the student audience can sit there thinking, "God, they're wasting the taxpayers' money" — forgetting the fact that he himself is a student.'

The group go further; rather than 'forgetting' their student status they, while acknowledging it, still endorse the item's valuation of this particular project:

> 'But still, that student item — I am a student — but it is rather a waste of time . . .'

Group 9

Owing to a fault in the tape recording this group had later to be omitted from the analysis.

Group 10

A group of mainly white schoolboys, aged 14, with a working class background, in a West London Comprehensive; predominantly 'don't know' or Labour.

The group take up and endorse many of Nationwide's own criteria of what is a 'good programme'; they say approvingly of Nationwide that it has:

> 'more breadth to it . . . it has different kinds of items, lots of different reports on different stories . . . things you don't read about in the news or the paper and they tell you all about it . . .'
> 'They move around a bit . . . go outside as well as inside . . . makes it more interesting . . . they've got studios all over the country . . . gives them a better scope . . .'
> 'Makes it different . . . more interesting for a change.'

This is in clear distinction to how they see 'serious' current affairs, which is rejected as:

> 'It's all politics. And things like that. For grown-ups . . . Nationwide's more or less of a children's just as well as the adult's programme.'
> 'Panorama's about, more or less, the adult's . . . Grown-up politics – things like that . . .'
> 'It's boring, we don't understand that . . .'

Similarly the news is not appreciated as much as Nationwide. About the news, this group say:

> '. . . they're not interested in everyday life and things like that . . . they just wanna know about Politics. The World Cup . . . they really look *above* it. It's Politics, Politics . . .'

Whereas, they see Nationwide as:

> 'a person's programme . . . a people's programme . . . and so it's more interesting . . . like the facts of what you can do . . .'

From this point of view they appreciate Nationwide's presentation of Meehan for its immediacy and accessibility:

'You can *see* the expressions on his face.'
'You *see* the emotional state.'

This is a valued form of experience, as against that provided by the news, in which:

'you just sort of *know* the case, what's going on.'

They comment that 'on *Nationwide* you only see the man himself' – i.e. the human subject extracted from his social/political context.
 They see that this is because the interviewer only wanted him to:

'talk about "inside". . . what his day was like.'
'What he did while he was in there . . .'
'They weren't talking about the case . . . just . . . about what it was like in there . . .'
'He didn't talk about what he was put in there for.'

And they are aware that this was not what Meehan wanted to discuss, that for him 'the case was the important thing', even that, on *Panorama* perhaps:

'They'd give you more information . . . they'd let him speak up, wouldn't they . . . let him speak his mind.'

But, despite these qualifications, they feel that *Nationwide* has enabled them to grasp something of what is at issue, whereas *Panorama* or the News would have alienated them. They resolve the opacity of the item into a story of a 'mistake', which they feel they have grasped:

'They put him in the wrong prison.'
'He didn't really do it, but he was in there and he was telling about how bad it was when he wasn't really meant to be in there.'

Indeed, later in the context of discussion about the shortcomings of the police force they became more definite:

'He wants justice, doesn't he?'
'He was a "pawn" wasn't he? 'Cos he was put up to making him do it . . .'
'Yeah . . . but he couldn't do nothing . . .'

The Nader interview produces a clearly oppositional reading: while they see that the interviewer:

'tends to be questioning . . . his work . . . trying to put him off . . . trying to catch him out all the while.'

this does not prejudice their own response to Nader, who they characterise as:

'Serious. A serious guy.'
'He's trying to put across certain things . . . he looks serious.'
'He's trying to stop it happening to others . . .'
'He wanted to keep it clean . . .'
'They didn't want to build a power-station, nuclear waste . . .'

The items on the blind and the students' 'rubbish' project they read within the terms of the programme's dominant problematic. As far as they are concerned the 'rubbish' project was:

'just something that came up . . . they wanted to do something . . . so they did it . . .'
'. . . it wasn't really all that clever.'
'They just want to do it – they can walk home, you know.'

And *Nationwide*'s more sympathetic presentation of the blind students' project is seen as entirely justified, precisely:

' 'Cos they're blind . . . they've not got their five senses.'
'[But] the students, they've got their limbs, they've got all their senses, they could go out and work and they can find time to mess about with rubbish . . .'

Similarly the 'Americans' item is interpreted in line with the dominant reading. They endorse (verbatim; cf. group 7) the programme's definition of them as:

'Invaders . . .'
'They're invaders . . .'
'Yeah, like a big DaDa . . .'

And they are certainly seen as naive in their attitude to the British police – here the group enter into the programme's construction of a 'we' of informed knowledge about these matters, though qualifying it by their reservations about *Nationwide*'s ability to express what they see as the truth of the situation. The police:

'They're just, you know, like, something we've got to learn to live with . . .'
'He couldn't really come out and say . . . if they didn't like the police . . . they couldn't really say . . . you know . . . the English police

are doing wrong things, you know, and they're rubbish – they could bleep him, bleep him out . . .'
(cf. groups 2 and 6)

Group 11

A group of black (mainly West Indian/African) women, aged 18–26, working class background, studying English as part of a commercial course, full-time in an F.E. College; predominantly 'don't knows' politically.

To this group Nationwide is all but completely irrelevant:

'It's boring . . . Nationwide or anything like that's too boring.'
'Once was enough.'
'It's for older folks, not for young people.'

The programme simply does not connect with their cultural world:

'We're not interested in things like that.'
'I just didn't think while I was watching it . . .'
'I'd have liked a nice film to watch – Love Story . . .'

This cultural distance means that the premise of Nationwide – the reflection of the ordinary lives of the members of the dominant white culture, which is what gives the programme 'appeal' for large sections of that audience – is what damns it for this group:

'Nationwide's a bit boring . . . it's so ordinary, not like ITV . . .'
'Nationwide show you things about ordinary people, what they're doing, what Today left out.'

Like some of the white working class groups they too express some preference for the ITV equivalent as closer to their interests:

'It's mainly on Saturdays I watch. Sale of the Century, University Challenge. Today is more lively. It's the way they present it. And it's shorter. You're probably looking forward to Crossroads.'
'[Today] they really do tell you what it's all about . . . and you do understand it even after seeing it for a short time.'
'They bring the population into it . . . it's not all serious . . . it's a bit of fun.'
(cf. apprentices)

In the terms of Bourdieu (1972) the group simply do not possess the appropriate cultural capital to make sense of the programme; or from another angle, the

programme does not possess the appropriate cultural capital to make sense to them – although the articulation of *what* it is that constitutes the 'lack', the terms in which their distance from the dominant culture is set, are themselves contradictory:

> 'I don't watch it, it's not interesting . . .'
> 'It's the way they put things over . . .'
> 'They should have more politics on *Nationwide*.'
> Q: 'When you say "politics" what do you mean?'
> 'Things what happen in this country.'
> 'This isn't really it, is it, *Nationwide*'s just not what you think about, is it?'
> 'It is going on . . . it is happening.'
> 'Closer to home, I mean . . .' 'Oh no, I don't like politics.'
> 'I don't understand it, that's why I don't like it.'

Interestingly the disjunction between their cultural world and that of *Nationwide* makes them immune to the presenter's framing statements, to the point where they cease to have any bearing beyond their simple 'textual' function:

> Q: 'Do you take much notice of the "frames"?'
> 'Not really, they're just there to introduce things . . . they don't really make remarks after them . . .'

Their response to most of the items is one of blank indifference:

Nader

> 'I couldn't understand a thing he was saying . . . I don't know how much he's on the level . . .'
> 'I don't really know what he's done . . . anything he's done.'

Students/'rubbish'

> 'I didn't really think about it.'

Meehan

> 'I think you'd have to be interested in things like that before you think about them.'

However, in the case of Meehan they do pick up on the suppression of the political aspects of the case, and the suggestion of police malpractice:

> 'They put him in jail for seven years and – he didn't do anything.'

'You don't really know what happened . . .'
'They don't want to hear about it . . .'
'They don't want the public to really know, do they.'

And in the 'Americans' item they are aware of, and reject, the chauvinism of the presentation:

'They tried to put them down – they tried to put them down and say the Americans were silly . . .'
'That couple . . . they made them seem quite silly.'

Interestingly, in comparison with the white apprentice groups, this group are ambiguously situated in relation to the British 'we' which the programme constructs in contradistinction to the Americans. To the apprentices it was clear that the programme was 'calling' the Americans naive for thinking that all British policemen are wonderful (as against the reality known by that 'we'). This group are not at all sure what the white British 'we' does know about the police, as against what they know:

Q: 'Do *Nationwide* think the police are wonderful?' 'No.'
Q: 'Is he taking the mickey out of that?' 'Yeah . . .'
'Lots of English people don't think so, do they?' 'They don't think the police are so good.'
'They think the police are good.'
'Do they? I wonder . . .'

The other aspect of the programme which they pick up on, besides the issues relating to the police, is that dimension of the programme's chauvinism constituted by its exclusive attention to Britain – which they resent; the total absence of foreign or third world news:

Q: 'Why do you like *Panorama?*'
'They go abroad, it's very interesting . . . you see things that happen abroad . . .'
'*Nationwide* is just this country . . .'
'I watch the news . . . if there's something interesting to see . . . like the news on Amin.'
'I like to hear what these nuts get up to . . .'
'*Nationwide* is OK for people who are interested in what's going on in this country only, but there are others who like to know what's going on in the countries outside.'
'They were quite excited about going as far as East Anglia . . .'

Group 12

A group of 15 year old schoolboys, 50:50 white/West Indian, all with a working class background, in a West London Comprehensive; predominantly 'don't know' politically.

Like the apprentice groups this group frames its comments on *Nationwide* by an expressed preference for the ITV equivalent – *London Today* - as more relevant to them:

'*Today's* better than *Nationwide* because *Today* worries about things that actually happen on the actual day they show 'em . . .'
'*Today* . . . the London programme is better for news – because *Nationwide* goes all over the place . . . but *Today* generally deals with London – that's why it's better.'

This sense of greater local identification with *Today* is also a matter of the programme's mode of address; its irreverence and 'realism' is what appeals to this group:

'*Nationwide* should have a [studio] audience . . . *Today* is better . . .'
'They keep backing off . . .'
'They should let the audience ask questions, not just the interviewer bloke . . .'
'On *Today* – take someone Royal comes on . . . they don't just talk about the things they done . . . like say they done something wrong, they talk about that, they don't try and cover them up. That's what I like about *Today* . . . it talks about the more interesting . . . like housing in London, how bad it is . . . like the punk rockers . . . the Sex Pistols, that was live – you wouldn't get that on *Nationwide*, nothing like that . . . *Nationwide* try to keep it too clean . . .'
'*Today*, you get bad stuff and things like that; *Today's* more reality and *Nationwide's* more like what they would like the public to hear, rather than what the public should hear . . .'

This is the hard edge of their criticism; in another sense they can also appreciate *Nationwide* as against the drier styles of 'serious television', current affairs and news:

'*Nationwide*, they bring the camera to more faces . . .'
'*Nationwide* do the more mixed sort of thing. *Nationwide* has more variety . . .'
'They're more sort of tales and myths and things like that.'
'*Nationwide's* more for your pleasure, and the news is whatever it is . . .'
'*Nationwide*, they seem to go into more detail and historic and everything else . . .'

Thus the Meehan item is appreciated because of its immediacy/accessibility to them:

> 'It's better than when you're watching something like Panorama because you can see where it was.'
> 'You get all the detail.'
> 'You get the idea of what he went through . . . rubbish, isn't it?'
> (cf. group 15)
> 'You can see his reactions . . . see what he reacts like . . .'

Unlike many of the groups, who see the construction of the Meehan interview as obviously controlled, this group feel that far from consciously dictating the pace, the interviewer is:

> 'just there doing his job, isn't he?'

The interview is clear to them:

> 'He was just talking about . . . what happens next . . . what actions he was going to take . . . what was going to happen . . . How he was going to do it . . . what he was going to do . . .'

And they make their own sense of Meehan's statements precisely by extrapolating them to connect with their own forms of experience of the 'criminal arena', making a factually incorrect reading which retains, however, the basic point:

> 'Some old man got killed or some old woman, I can't remember.'
> 'Some break-in or something.'
> '. . . he got framed up . . .'

On the other hand, they are aware that their own sympathy with Meehan may be atypical – they hypothesise at a general level a much more negotiated reading:

> 'After all, most people don't watch it like that – they just say, "Oh well, it's just hard luck innit?" . . .'

They are aware of the way in which the programme allocates Meehan a particular kind of 'role' – to which certain questions and not others are relevant – but they justify the 'naturalness' of the relation between the role and the questions:

> Q: 'Could they interview a politician like that?'
> 'No, not with questions like that.'
> 'Because big names . . . more powerful . . . they've got to watch the questions.'

'They've got to have a bigger answer, they're not just going to stand there and say a little bit of the answer.'
Q: 'Would they ask a politician about his feelings in that way?'
'No. Obviously . . . there's no *need* to, is there?'
'. . . you're not going to do that, are you?'

Similarly the programme's presentation of Nader is clearly seen to denigrate him in a particular way – and this is justified by how 'well known' or not he is:

Q: 'Do they give him [Nader] a lot of respect?'
'No . . . they didn't, did they, because he's not known, you see . . . I doubt if many people know that lawyer, not as many as would know an MP, so they didn't treat him . . .'
'If it's someone big they couldn't, you know, give him any old questions like that . . . got to treat them, you know . . .'
'When they interview a Prime Minister or someone, they sit them in the swivel chairs, with a round table and glass of water . . . but when they interview that man they were out in the cold, and the wind was blowing, and they were standing up – they don't care about him so much . . . he isn't popular is he? If it was someone like Harold Wilson they'd treat him good wouldn't they, you know, big bloke . . .'

With the students' item they feel that the presenter's attitude to the 'rubbish' project is that:

'Well, he doesn't take it serious, the reporter doesn't take it serious . . .'
'He just shows them walking about.'
'That woman was talking about a coat, he couldn't care less about that, he just went on to something else.'
'He rushed everything, rushed through that.'
'He just went through it all and went off . . .'

And they clearly see the contrast with the presentation of the blind students:

'That was more serious.'
'Yeah . . . they did that more serious.'
'They asked more serious questions and all that.'
'It was the way they done it. They talked to the people how they felt about it . . .'

However, they go on to endorse the programme's implied valuation of the 'rubbish' project:

'They didn't say why they did it, they just said what they were made out

of and all that. Didn't say the point of it all.'
Q: 'Do you think it's a serious project?'
'No, it's not important really.'
'It is if you're out in Wales on a mountain.'
'Yeah. But most people aren't though, are they?!'

The group extend their critical reading of the students' project to the point of disbelieving the factual content of the item:

'Mad. Dangerous that is . . .'
'I don't believe half of that's true – you don't find great big plastic bags in a rubbish dump . . . and where did that thread come from . . ?'

The 'Americans' item is again read squarely within the dominant/chauvinistic framework:

'They're "friendly" . . .'
'. . . they have better homes, they're nice.'
'. . . they were proud of where they were born.' '. . . they got luxury.'
'. . . they stuck to their own culture and they never changed their way of life.'
'. . . they're bigheads and they're lazy, but then they did it by earning it, by working for it . . .'
'. . . it was showing that what they had in America was better than what they got here. Yes, they got better luxuries all round . . .'
'They seem to be a bit . . . don't they . . . they just got big wallets, that's all! Everything's big over there . . .'

And again, the group enter into and identify with the 'we' constructed by the programme, which includes team and audience as members of a community of knowledge about the realities of British life – such as the Queen and the police force – and which precisely excludes the Americans and designates them as naive:

'We have the lot . . . we know the other side of them [the police].'
'He [presenter] – knows the other side of it, he knows what they're like . . .'
(cf. groups 6 and 13)

This again is simply common sense, as is their attitude to industrial relations; the pools winners photo is again assumed at first to be a story about a strike:

' 'Cos it's outside Rolls Royce and people are always striking over there.
'There's always strikes going on . . . there's always disputes.'

'There's always strikes going on, isn't there . . .'
'There's no point, is there – 'cos if they're going to keep striking this country's just going to go down and down . . .'

Group 13

A group of mainly female West Indian literacy students, aged 17–18, with a working class back-ground, studying full-time in a London F.E. College.

Like group 11, this group are confused and alienated by the discourse of *Nationwide*: even the 'blind' item, which could be argued to be the clearest, most highly organised item in the programme, is seen as confusing. Although it was a rela-tively long item the group say that:

'There wasn't enough time to take it all in . . .'
'You don't know what they were doing . . .'
'It clicks . . . I don't really know . . . we know it clicks.' [i.e. the inven-tion on the drawing board.]
'I still don't understand why those drawings were useful.'

However, one point does come over, perhaps the main one:

'I thought it was a bit amazing.'

Similarly, the Meehan item leaves the group quite confused, arguing that the missing 'key' to the item is 'a Russian bloke, some Russian bloke' who presum-ably is a relative of Meehan's oblique and edited reference to 'British Intelligence'. However, again, despite the confusion as to the substance of the material the 'point' – at the level of professional code values, anyway – does come over:

Q: 'So what did come out of it?'
'An "exclusive interview" . . .'

The fact that this is a London group, watching a programme made in the Midlands – in the context of a course in literacy – raises the question of dialect/accent in relation to decodings, and the extent to which 'clarity' at the technical level of hearing the words interlinks with the structure of power of the discourses in the programme. They remark of Mrs Carter (the lady interviewed with the lion):

'She had an accent . . . you couldn't understand her.'

The regional accents of the contributors are, then, mediated by the standard accent of the national presenter. Barratt is said to be:

'just making it clear to me what the guy's already said . . .'

and this is seen as an exercise of power, beyond the technical level, for:

'that can be dangerous actually . . . 'cos I think, "Oh, that's what it was about . . ."'
'. . . the clearest voice presumably comes over . . . you take that as what's going on . . .'

But this sense of dependence on the presenters is mediated by a distinct lack of 'identification' with them. The presenters on the boat trip, displaying their willingness to 'have a go', are dismissed as not at all funny but rather:

'like a very poor Blue Peter item.'

Indeed, the group suggest in relation to Barratt that the programme would be:

'better off showing him eating his breakfast and shouting at his wife.'

They reject *Nationwide*'s characterisation of 'students' in the 'rubbish' item. They are well aware of the programme's construction of it, but unlike the apprentice groups, go on to reject it:

'I thought he [presenter] was awful to him [student interviewed] actually . . .'
'. . . the guy started talking and he just said "Thank you very much, that was very interesting", and he walked off . . .'
'. . . and it doesn't matter what the guy was saying but it did sound like he wasn't actually interested himself . . .'

Similarly, they reject the 'Americans' item:

'I thought the bit about the Americans was really nasty actually . . .'
'All this stuff about "nice people" . . . the way they say "nice people" made you think they were nasty people . . . it's the tone of words, isn't it?'

In particular they reject the portrayal of the family sex-roles in that item; they feel that the programme has constructed, rather than reflected, a particular image of the family and as an image of that sphere, in their experience it simply fails to fit:

Q: 'Why do they do it like that?'
'Because the wife's supposed to be in the kitchen . . .'
'But most men are in the kitchen . . . I mean they do . . .'

'It's like they're showing you a very traditional picture of how the family works: this is the woman in her place and this is the man . It's like those, what-do-you-call-it books . . . Jill and whatsisname . . .'

Group 14

This is a group of white women students, with an upper middle class background, aged 19–20, in a London Teacher Training College; predominantly 'don't know' or Conservative.

They see Nationwide as simply not for them. They identify it as situated in a range of domestic programming for an older, family audience:

'Nationwide is more for . . . general family viewing . . . like the mother rushing around getting the evening meal ready.'

The Nationwide audience are seen, crucially, as:

'Older . . . they're an older age . . .'
'That's the sort of programme it is – it's that time of day isn't it?'

A 'typical' Nationwide is seen as one where:

'they link it in with things like, I don't know, things like sort of cookery . . . and all over the country.'

It is a programme which 'I only watch with my parents.'
The programme's mode of address is alien to them, although they supply a somewhat elitist rationale for why the programme is as it is:

'I suppose at that time of day and that sort of audience, they don't want to give them anything that might force them to think or anything . . .'

The programme simply fails to 'fit' with the educational discourses in which they are situated:

'It's individually that it appeals – to people who want TV to talk to them particularly rather than a general thing like Panorama . . . like people on their own . . . they appeal to individuals . . . though it is a family programme as well.'

For this audience Nationwide:

'gives them a bit of the news – national news – and it brings it home to them . . .'

'I think the local thing is very important to whoever did the programme . . .'

The dominant criteria of evaluation are derived from that area of current affairs which does 'fit' with the discourses of their educational context. The news elements of the programme are criticised because:

'there was no detail, was there?'

In the same way the programme's presentation of Meehan is criticised by comparison with a hypothetical *Panorama* in which, they predict:

'They'd re-enact some of the case . . . and it'd be very, very detailed . . .'
'Lots of detail . . .'
'Absolutely detailed.'

– clearly a discourse in which they would feel more at home.
 The personal, emotive aspects of the Meehan item, which for some groups are the best thing about it, are here seen as a poor substitute for a 'proper' treatment of the issues:

'The news is more factual . . . whereas *Nationwide*'s more personalised.'
'. . . they're more relaxed . . . they try to get over more of his personality, showing him smoking a cig and emphasising if he touches his head or something, you know, displaying all the tension being built up . . . made you aware of his feelings . . .'

The substance of the Meehan item raises little comment in itself – except to the extent that it raises the question of *Nationwide*'s previous coverage of the George Davis case – which was seen as 'biased' in Davis' favour:

'They're biased . . . aren't they . . . when they were doing the George Davis case . . . well he's a real crook . . . and everybody got the opinion that he was so nice and everything . . . it was very biased . . .'

The presenter is seen to be in a position of power in the discourse:

'I suppose it's Michael Barratt popping up afterwards. If he grins then it's supposed to have been funny . . . if he has a straight face you're supposed to have taken it seriously.'
'They try to make their own personalities, or what they want you to see of it, show through, so that you identify with them, and more or less see what they see as the interview.'

But the strategy is less than successful; the presenters on the boat trip are found to be:

> 'embarrassing . . . just embarrassing . . . they went too far – it was so ridiculous.'

and Barratt himself:

> 'Personally, no, I don't like him . . . he can be so crushing to some people that he interviews. I find him horrible, a horrible person.'

The Nader interview is seen as misplaced in *Nationwide*, an element of 'serious broadcasting' sitting unhappily in this context:

> 'That was a bit too heavy for that programme.'

They clearly see *Nationwide*'s 'framing' of Nader as being quite hostile:

> 'They said something about him, "what would you say, because people call you the agitator?" The interviewer said that . . . You felt he was, you know . . . He couldn't defend himself very well in such a short time . . . he started off saying he got paid so much every time he talked . . . you know – he just works up a subject to get some money . . .'

But they read against the grain of the presentation and feel that Nader comes over well – because, after all:

> 'Well, he's a professional.'
> 'He's an expert. He's probably said it loads of times . . .'

Similarly with the students' 'rubbish' project, they see that the programme presents them in an unflattering way, that the interviewer:

> 'seemed to brush them off . . . I'm sure a lot of people watching would say "well, what a waste of time . . . I wonder how much it costs . . ."'

They reject this stereotypical picture of students, extrapolating what they see as the interviewer's attitude into actual dialogue:

> 'He made the remark – "this is all very jolly, but I'm looking down on you."'

And they do attempt to read 'sense' into the project; they comment that the project could have been to do with:

'the educational value they'd get out of this . . .'
'the imagination.'

although this is qualified later as a more guarded form of support for the students:

'. . . though . . . I felt it was pretty much a waste of time . . . I mean
the chap that organised it didn't come over very well . . .'

But still in the end, it is the presentation, rather than the project, which they see
as at fault:

'There weren't enough technical questions in that at all.'
'. . . silly questions, like why didn't you go and buy an axe, when the
whole point is the destruction of society . . . that was ridiculous . . .'

Interestingly, as opposed, for instance, to the apprentice groups (who wholeheart-
edly take up and endorse *Nationwide*'s implied evaluation of the blind students item
as much more important − because practical, useful − than the 'rubbish' project),
this group reread the respective valuations. They can see that the 'rubbish' project
has an 'idea' behind it and as such is of educational interest. The very practicality
of the 'blind' item, its immediate, seen, usefulness is of limited interest to them:

'I still don't understand how that device works . . . I got the feeling . . .
you don't need to understand it . . . you, just need to feel sorry for
them . . .'
'. . . it was something to do with it being useful, to them, and them talk-
ing about it. That seemed to be what they were after . . . Not an actual
explanation of why or how it works.'

The preferred reading of the 'Americans' item is also rejected. While they are
aware that it:

'tends to reinforce some British attitudes − you become very British!'

they reject the chauvinist undertones of the item. They feel that it is meant to:

'give you the impression that he thought the English were superior intel-
lectually, even if they haven't got the equipment and the luxury . . .'

They find the presentation objectionable:

'The "nice people" . . . and it's just his whole way of speaking . . .'
'. . . he stands on the line. He's not prepared to go over it. He wants to
sort of annoy people . . .'

'In a way they were laughing. When they interviewed the woman in the department store or wherever it was . . . and she was saying she respected those things . . . and I felt . . . he was laughing at the . . .'
' "Poor American Woman."'
'Yeah, and she herself was being very fair, she was being straight, and he was letting her hang herself with her own rope . . .'

Finally, they reject what they take to be the item's implied message:

'Like "what a disgraceful thing to have for breakfast". None of his business, really, what she eats for breakfast . . . Why should they blame the Americans for playing baseball in England? I mean, we go over there and play cricket! Like . . . they shouldn't be allowed to bring anything of America over with them.'

Group 15

A group of white students, predominantly women, aged between 21–46, with a middle class background, in a London Teacher Training College; predominantly Conservative.

Like group 14 this group too find *Nationwide*'s whole mode of address out of key with their own educational context: they describe the programme as:

'A muddle . . . very amateurish . . . it hopped about . . .'
'A magazine programme designed to put a smile on your face.'
'Maybe that's supposed to relieve you of any depression.'
'. . . that business on the boat . . . that was supposed to be funny . . . I thought it was really silly.'
'. . . there didn't seem to be a good reason, a valid reason, for half the things they showed . . . like that stupid thing on Americans . . .'

Here they clearly stand at the opposite end of the spectrum from those working class groups (e.g. the apprentices) who endorse *Nationwide*, but more particularly *ATV/London Today* precisely for providing variety, 'a bit of a laugh', rather than items which require 'valid reasons' for being on.

The programme's lack of coherence is problematic for them:

'The number of participants . . . from one place to another . . .'

They evaluate the programme with criteria again derived from the standards of 'serious' current affairs broadcasting; thus:

'There's nothing really there to . . . capture your imagination – it's not very thought provoking.'
'I think [it was] put out just for not the kind of people who would be

interested in the "in-depth" . . . The TV equivaient of the *Sun or Mirror*.'
'It didn't feel like me . . . an older audience . . . but it's not just that.'
'I would have thought that Patrick Meehan and Ralph Nader were the type of people who would have been far more interesting to listen to than silly women getting mauled by lions . . .'

The programme clearly fails to achieve any sense of audience identification; as far as they are concerned the audience is clearly 'not them' – it is other people:

'Don't you think that those sort of people don't listen to current affairs programmes really, and if *Panorama*'s on they switch over to *Starsky and Hutch* or something . . .'

The questions the programme asks are not their questions:

'Perhaps they think those are the typical kind of questions that people expect . . . in which case I feel quite insulted.'

They identify and reject the programme's strategy:

'They're trying to bring them into your home . . . bringing the person-
alities into the home . . . a friendlier air, Barratt . . . and that sort of "ha,
ha" . . . we're supposed to side with him . . . they're trying to get the
audience more involved. Unfortunately, it does tend to have rather the
adverse affect on me, because it irritates the life out of me . . . gets on
your nerves after a while . . .'

From the perspective of current affairs the Meehan item is picked out as the only one meeting the appropriate criteria of substantive interest:

'That's the only thing it had to offer, the Patrick Meehan thing . . . really
newsy . . . and interesting.'

Though they immediately go on to criticise the inadequacies of *Nationwide*'s pre-
sentation of the case:

'. . . there could have been a lot of potential – when he said "I know
they framed me, British Intelligence" that was the only bit that could
have made it; if they'd gone into that . . . it was the only bit that was
interesting . . . they were skirting around the subject when there's
something – the bit you really want . . .'

They reject *Nationwide*'s focus on the 'human' angle:

'They asked, "what was your daily routine" – it was superficial but nothing was said about what it was really.'

They speculate that the reason for this is that:

'Perhaps his daily routine is interesting to the masses.'
Q: 'What did you get out of it?'
'Very uninformed opinions. Just an ex-con who's come out of prison . . .'
'They're trying to make it a sort of . . . human profile of a guy . . .'
'They made a big thing of it . . . exclusive . . . two hours out of prison . . . and our *Nationwide* team has been right in there . . .'

They are galled because they are aware of a missing point of coherence, something repressed in the item:

'I think Meehan really wanted to get to grips with something, didn't he? . . . keeps on saying, "But . . ." He really wanted to get onto his own thing . . . and he couldn't . . .'

 The criteria of 'serious issues' taken over from current affairs is even applied by this group to the interview with Mrs. Carter about the lion . Here again the group are dissatisfied with *Nationwide's* focus on the 'human experience' angle and sense the absence of an 'issue':

'What we wanted was somebody to ask the question how she came to be mauled by a lion – because at those Safari Parks you're definitely told not, on any account, to get out of the car. That wasn't taken up, was it?'

 The group make a straightforward oppositional reading of the Nader interview, noting how the presentation is 'biased' against him:

'They say . . . "Nader was paid £2,000 to speak" – that's a condemnation . . . a bit of sly digging . . .'
'They asked him a funny question about what did he think of the horrible things people said about him . . .'

And this characterisation fails to fit with their own perspective on Nader:

'. . . they're undermining him, aren't they. After all, he's a very interesting man.'
Q: 'How are they undermining him?'
'By not allowing for all this good work and all the work he does put into things. They're bringing it down a bit by asking him that kind of silly question . . .'

'. . . they're always criticising him for sort of having a bash against the system, of which they are an integral part.'

The group interpret *Nationwide*'s perspective on the 'rubbish' and blind items in an unusual way:

'Both those things are really . . . optimistic . . . I think they were trying to say that our hope lies in our youth.'

But they also see an implied contrast in the evaluation of the two projects and they themselves are more hesitant than group 14 in rejecting the implied contrast. Their own response to the 'rubbish' item is a mixture of rejection of the programme's presentation:

'the guy almost accused him of being a waste to the taxpayer.'
'like "are you wasting our money?!"'

and, at the same time, a hesitancy about the actual value of the project:

'I couldn't really see what it was they were supposed to be building . . .'
'. . . it seemed to be all play . . .'
'You couldn't really think of that as being working.'

On the other hand the response to the blind item is far less equivocal, and they endorse the programme's implied evaluation:

'Oh I think they had a different attitude to that, didn't they. They seemed to take a very serious attitude to that . . .'
'It struck me that was one of the few things on the programme that does get explained a bit. You do understand.'
'You can see the relevance of it . . . the interviewer asked the blind student . . . and he actually has a reason or a need for doing that, whereas the others don't – or it doesn't come across . . .'
'Here they get to the end and they say "Oh, here's a very worthwhile thing."'

Still, like group 14 their involvement in serious/educational discourse leads them to suggest that the item would have been better had it focused more on the 'issue' and less on the 'human' angle:

'It'd probably be best in *Tomorrow's World* – more of the machinery and less of the students – concentrate on the actual invention . . . on *Tomorrow's World* you might have a better understanding . . .'
(cf. groups 10 and 12)

In the 'Americans' item they see the programme's chauvinist orientation:

> 'It was very condescending . . . about their being "nice people" . . . a
> simple race. I think it bases the whole thing on "what are we doing with
> Americans in this country anyway."'

But their reading of the item negotiates uneasily between the awareness of this
'angle' and their actual response to the Americans interviewed, particularly Mrs
Pflieger:

> 'I think the intention was to make us feel inferior against them . . .'
> 'She condescends to live in a two hundred year old house. I mean, this
> is partly our heritage, sod it. I mean I'd like to live in places like
> that . . . but I know darn well I could never afford it. But she's gonna
> condescend to live in it . . . made me very uptight . . .'

Group 16

A group of West Indian women students, aged 18–19, with a working class background, on a com-
munity studies course full-time in a London F. E. College; predominantly 'don't know' or Labour.

To this group *Nationwide* is totally irrelevant and inaccessible:

> 'As soon as I see that man [Barratt] I just turn it over.'

They are so totally alienated from the discourse of the programme as a whole that
they do not discriminate between the items. In the case of the blind students' and
the 'rubbish' projects, which most of the white groups see as clearly contrasted
within the structure of the programme, they treat both as equal:

> Q: 'Were both items treated as serious stories?'
> 'Yeah.'
> 'No, it was a joke.'
> Q: 'Which one?'
> 'Everything.'
> 'It's so boring, it's not interesting at all.'
> 'It should be banned, it's so boring.'
> '. . . I think it's just like fun really watching it . . . it doesn't really inter-
> est you . . . it's like a joke or something.'
> '. . . I don't see how anybody could watch it . . .'
> '. . . I think I'd be asleep.'
> '. . . they make it sound so serious . . . but actually to me, that was noth-
> ing . . . nothing at all . . . just crap . . .'
> 'I've never seen anything like that . . . I can never understand why
> people just sit and look at that; if I had that on my telly I'd just bang it

off . . .' 'If I'd just come in . . . and that was on the telly I'd smash it
up . . .' 'A really long bit of rubbish . . . rubbish . . . just telling you
things you've heard already . . .'
'You watch Nationwide and somebody says to you – "what happened?" –
and you don't know!'

The presenter's strategy of achieving an identification with the audience is less
than fully successful:

'That man [Tom Coyne] sitting down around that table . . . with an
umbrella . . . there was no rain and he went and opened it . . . and they
show you some picture of some drops of rain [i.e. the weather report as
a child's drawing] . . . I think that's really silly, that's stupid . . .'

Clearly they see Nationwide as a programme for a different audience, not relevant
to themselves:

Q: 'Who is it for, Nationwide?'
'Older people – like you.'
'Middle class people . . .'
'Parents who've come in from work, especially fathers who've got noth-
ing to eat yet.'

They are aware of the other areas of programming, however, which they see as
much more relevant to themselves:

Q: 'Is there a programme meant for people like you?'
'Yes, Today . . .'
'Today isn't so bad . . .'
'This Week . . .'
'World in Action . . .'
'Crossroads – (Yeah).'

Their enthusiasm for this range of ITV programming is quite marked, and they see
it in clear contrast to Nationwide:

'Those programmes bore me . . . I can't watch it – 'cos I like to watch
Crossroads, y'know . . .'
'Today's shorter . . . less boring . . . and then there's Crossroads on after . . .'

The style of the Today programme in particular is much preferred:

'Today's just what happened during the day . . . one day . . . just that day,
so you know exactly what has happened.'

THE *NATIONWIDE* AUDIENCE

'. . . and sometimes it has some really nice things on that you can watch . . .'

The crucial contrast between *Nationwide* and *Today* is the extent to which they fall into the category of boring, detailed, 'serious' current affairs:

'*Today* . . . they tell you what's happening and what they think about it . . .'
'*Nationwide* gets down more into detail . . . makes it more boring . . .'
'*Nationwide* . . . they go into the background – that makes it worse, 'cos it's going down further into it . . . *Nationwide* it goes right down into detail.'
'. . . *Nationwide* – they beat about the bush . . . they say it and then repeat it . . . I was so bored with it.'
(cf. teacher training groups 14, 15 for a differently accentuated use of the term 'detail' in evaluating the programme.)

The group are here not simply rejecting *Nationwide* in particular, but *Nationwide* as a part of a whole range of, largely, BBC broadcasting including the News:

'. . . when I stay and listen to the news I fall asleep.' '. . . I can't watch it.'
'. . . I don't like the news.'
'. . . there's too much of it, you get it everywhere, in the papers, on every station on the telly . . .'

The range rejected also includes things:

'like them party political broadcasts . . . God, that's rubbish . . . those things bore me – I turn it off!'

and indeed extends to the BBC as a whole:

'I think BBC is boring.'
'BBC is really, really boring . . . they should ban one of the stations – BBC 1 or BBC 2.'

As far as this group is concerned:

'All those sort of things should be banned.'

In the absence of the power to ban the programmes, evidently the next best strategy is simply to ignore them:

Q: 'What about the interview with Nader?'
'I can't remember seeing that bit . . .'
'. . . he was there, the thing was on, so I looked . . . and I sort of lis-
tened, but it just went in and went out . . .'
Q: 'What about the Meehan interview?'
'No idea . . . not very much . . . not really . . . All I heard was that he
just came out of prison . . . some murder . . . something he didn't do:
that's all I heard.'

In this case, though, possibly because of a connection with their own experiences
of the police, there is sufficient engagement for criticism of the item to be
voiced, in some mildly oppositional sense:

'That's silliness . . . they should tell you what happened, why he was in
prison, and things like that . . .'
'Anyway, he [Meehan] didn't look suspicious to me . . .'

Somewhat surprisingly, one of their most developed oppositional readings,
redefining the terms of *Nationwide*'s presentation, is reserved for the piece on Mrs
Carter and the lion:

Q: 'Is everyone presented equal?'
'No: for one, that woman who went back to the tiger, I think she was
an idiot.'
Q: 'Was she presented like that? Did they treat her as an idiot?' 'No,
but . . .'
'. . . they did present her like . . . they took it as a joke . . .'
'But . . . he said she was a very determined person, she was very brave:
"she's braver than me."'
'I don't think she was really brave, she was stupid.'

In the blind/students' 'rubbish' section they read both items as equivalent,
ignoring again the programme's structuration of the contrast:

'I think it was amazing . . . those people should take the chance and
make all those knives and forks, you know . . .'
'All the things they made.'
''And the blind, yeah . . . really interesting . . . making something . . .
they were blind but they were actually drawing like that . . .'

However, they are suspicious that these items might be there precisely to engage
their interest in an underhand way:

'I think that students thing had nothing to do with education . . .'

'. . . it was interesting, though . . .'
Q: 'But do you think *Nationwide* thought it was interesting?'
'No – . . . I think they thought it was a pisstake.'
'. . . maybe they thought "oh, young people".'
'. . . it's nothing really, they sort of push that in for us – "youngsters".'

If so, they clearly see it as an inadequate 'sop' to their interest; if the programme wanted seriously to engage them:

'Why didn't they never interview Bob Marley?'

When asked what the programme would need to be about in order to interest them they reply, rather blandly:

'About everyday life . . .'
'– something that goes on.'

using the terms which *Nationwide* would indeed claim for itself: focusing precisely on their definition of the everyday. But the 'everyday life' of *Nationwide*'s mainstream culture is simply seen as irrelevant to that life as viewed by these members of a working class, black, inner city community.

Group 17

A mixed group of West Indian and white women students, aged 17–18, all with a working class background, on a full-time community studies course at a London F.E. College; predominantly Labour or Socialist.

To some extent this group respond to and validate *Nationwide*'s presentation of the domestic world:

'You get some good things on *Nationwide* . . . like they run competitions and things like that.'
'They do handyman of the year competition; nurse of the year . . . best neighbour of the year and all that . . . they're more interesting, those kind of things . . . like *Coronation Street* . . . at least to me.'

Moreover, they find no fault with *Nationwide*'s construction of differential 'spaces' for different statuses of contributor. They accept as common-sensical that:

'it seems more proper to ask a politician his views than his feelings. A politician . . . they'll ask him the practical things . . . they wouldn't ask about his feelings . . . it's what you're supposed to get, what you're trying to get from the man . . .'

They are aware of the structure of the programme, in terms of the presenter's dominance:

> 'Barratt seems to be the one most important . . . seems to do a lot of . . . the "direction changing" during the programme . . .'
> 'Always goes back to Barratt . . . one goes through him . . .' 'Camera always goes back to him.'

This 'dominance' is seen only as a necessary, textual function, producing order in the discourse:

> 'I think he's got to say something short, which is roughly the centre of what it's about − something that slightly interests you − and then you're ready to watch it . . .'

This is not seen as a form of political and ideological dominance, for they say that if you happened to 'disagree' with the presenter's specific comments:

> 'if you were interested, then the things he said wouldn't worry you at all . . .'

Indeed:

> 'I don't think they do influence you.'

The presentation of Meehan is seen to focus on the subjective, emotional angle, but this is seen as a quite appropriate choice, and the suppression of the political background to the case is not taken to be a problem:

> 'I think the interviewer was interested in the feelings of the man . . . you know . . . where he'd been . . . the effects of what being inside in solitary could do to him . . . they were trying to put over how he felt, other people were shown what it would be like to be in prison . . . what prison does to people . . .'
> 'You could see the man . . . and tell how he's really feeling by the way he's sitting and the way his face reacts . . .'

In a similar vein *Nationwide's* treatment of Nader is not taken to be problematic. They feel that the programme has helped him to come over sympathetically:

> 'He was like . . . someone doing something he feels is right . . . caring . . . caring for people.'

clearly articulating with their understanding of the community studies course perspective.

They articulate their concerns in terms of 'youth'; this is both the sense in which they express some preference for *ATV Today*:

'I prefer *Today* . . . there's a lot more . . . it's got more things for the youth, you know.'

and the perspective from which they pick out one section of the *Nationwide* programme as particularly relevant to them:

Q: 'So is there a bit of *Nationwide* that feels like it's for you?'
'Yeah, about the students, about the lion . . .'
'The fact that they're trying to do it on their own . . .'
'Yeah . . . that was really good . . .'

Here they make their clearest break with *Nationwide*'s perspective; in so far as they see sense in the students' project:

'It was to show people that rubbish is useful – stuff can be made out of it.'

They can see clearly that the presenter is dismissive of it:

'You can see when [the interviewer] is interested in something and when he's not, 'cos when he speaks, and the type of question he asks . . . that man interviewing those people making things out of rubbish . . . you could see he wasn't interested . . . the studio had just sent him along to do it and he did it . . .'
'I know for one thing, I wouldn't have asked them [students] "what did you get from an educational point of view", I wouldn't have dreamt to ask it. I'd have said . . . you know, "did you enjoy it?" I would have said, "do you think this has got practical uses . . ."'

They see the programme's implied contrast between the 'rubbish' project and the blind students' invention as inappropriate:

'This attitude towards the rubbish is "it's nasty, dirty stuff" . . . while the blind students . . . they were really interested in that . . .'

– a sharp contrast with the apprentice groups' strong endorsement of the implied opposition between the two items.

They read the 'Americans' item within the terms of the dominant/chauvinist problematic, seeing that the programme is being ironic about the Americans but accepting this on the grounds that they do feel themselves to belong, with *Nationwide*, to a 'we' which excludes these 'invaders':

'That woman [Mrs Pfleiger] she was like a fish out of water . . .'
Q: 'Were they taking the mickey out of the Americans?'
'Yeah – course they were . . . the way they phrase things . . .'
'*Nationwide* thinks that maybe the British police and the Queen ain't that wonderful.'

– clearly an insider's knowledge that the Americans are naive not to share:

'I think even showing that the things we know naturally, what we accept as normal, they've got to learn, so because they do things differently, they're daft. They show them as backward – they presented them as if they were backward – dummies or something . . . he said "uncomplicated Americans", and things like that . . .'

although this identification between the group and the *Nationwide* team, as members of a community of 'natural knowledge', is to some extent qualified:

'I think they try and present that picture . . . but they're not really [representing us] . . .'
'I don't think that they could know a wide range enough of feelings, of people's feelings to be able to represent us . . .'

– a question, though, of an imperfect 'sample', or lack of comprehensiveness, not a problem of opposition of perspectives. (cf. group 2: 'it's all down to the bloke he drinks with at lunchtime . . .')

Finally, the group reject a criticism of *Nationwide* as failing to deal with serious issues like the workplace. This is seen as a form of middle-class 'serious' TV which is inappropriate. What is endorsed, as in the apprentice groups, is a notion of 'good TV' as that which gives you 'a bit of a laugh . . . variety and that.'

'Don't you think though, it shouldn't carry anything about work, because people do enough work during the day . . . when they come home in the evening they don't want to watch work because they do it so many hours a day . . . When they come home they want to see a bit of variety, a bit of difference . . . those extra things . . . changes from their normal life, working. If they was to show . . . Fords you'd get all the people that work for them saying, "Oh, well I've seen this – twelve hours a day already."'

Group 18

A group of mainly white, predominantly male students with a middle class background, on a full-time photography diploma course at a college in London; mainly 'don't know' politically.

The group's professional training leads them to criticise the programme from a technical point of view:

> 'I couldn't understand that bit about that guy sitting out in that tent . . . and what was the reason for having the wind in the soundtrack – that would have been easy to avoid . . .'
>
> '. . . I always get the feeling with *Nationwide* that somehow they never quite get it together . . . nearly every programme there's two or three mistakes . . . the next piece isn't quite ready or whatever . . .'
>
> 'Unless it's to make it more relaxed, watching TV make mistakes, so it's "human" . . .'

The group argue that the presenters have considerable power:

> 'They claim to speak for the viewer . . . but in doing that they're actually telling you what to think . . .'
>
> '. . . It's trying to be about "people", isn't it? . . . for people . . . ordinary people . . . and by saying, "a lot of people think" they're telling you what a lot of people ought to think, according to them . . . or suggesting things to people . . .'

Though the programme may not necessarily have this power in relation to them:

> 'Unfortunately, I would say that the majority of people who watch *Nationwide* accept it, accept Barratt's viewpoint, because it's easier than not . . . particularly if the audience . . . the major audience is women . . . who are probably quite hassled . . . and as they're not in any position to discuss it . . . in any other way . . . the only viewpoint they can take is the one in the programme – there's a chance it's the first time they've been presented with a particular argument.'

Moreover, this is an argument they apply to their own position in some cases, for instance in the discussion of the Meehan item:

> 'I don't know anything about the case, so the only interpretation I can make is that it was what Barratt says – "identification" . . .'

Because, after all:

> 'He's the voice of authority . . . he's the bloke that you see every night, sitting there telling you things.'

This power, in the case of the Meehan item, is because of the condensed and opaque form that it takes. They feel that the presentation of Meehan:

'keeps it very personal . . . just showing his face . . . his personal ex-
perience . . . just on the guy's face . . . I think they are strong visual
effects . . . there's a sort of emotive series of questions . . .'
'All they want to show is how the bloke feels emotionally.'

This leaves them quite confused as to the facts of the case:

'I thought he said someone got mugged.'

and precisely because of this confusion, unwillingly dependent for whatever
sense they can make of the item on the presenter's 'framing' statements.
 They feel that it is the presenters who provide the cues as to the hierarchy of
credibility and status of the participants; after all:

'You do it [meet the contributors] through the presenters . . .'
'Some are used for "human" stories . . . like the lions or the Americans
in Suffolk and some things are "social" issues – like inventions for the
blind kids.'

However, this is not to say that they necessarily accept the programme team's
'classifications' of the participants. In the case of the Nader item they feel that the
programme:

'Doesn't give him much of a build-up.'

Further, that:

'. . . they make him sound a little bit eccentric.'
'I think it's significant they interviewed him outside . . . it seems less
controlled and serious in approach – as opposed to if they brought him
into the studios.'
'. . . they were implying that his presence [wasn't] that important – they
could just go out and do a sort of "street interview".'

This is a presentation which is simply unacceptable on the basis of their prior
knowledge of Nader from other sources:

'. . . and the questions too: he's a pretty important figure as far as the
protection of consumers' rights is concerned. But the way they were
speaking to him they were kind of cynical as to what he was going to
get out of it. That was the line of questioning: "What are you doing it
for?"'

And they feel that in fact, despite the hostile presentation:

'. . . he answers quite well, quite fully . . . because he could cope with that sort of situation – he's . . . been in those . . . situations very often . . .'

The group reject what they see as the chauvinism of the 'Americans' item, reading it within an oppositional framework:

'. . . the American one seems like a blatant piece of propaganda . . . for sort of . . . British Patriotism . . . laughing at the Americans . . . patronising . . . the Americans look even sillier . . . the big technology and that, they ridicule it . . . and "ho, ho, fancy having that for breakfast".'
'. . . it's ironical about the Americans . . . "they may be weird but they've got the right values . . ."'
'. . . poking fun at the Americans . . . "if they're going to live over here they ought to make the effort to be British . . . instead of playing baseball . . ."'

The group reject the programme's characterisation of the students' project, which they see as simply:

'implying that taxpayers' money is being wasted.'
'They treated it as frivolous.'
'It sort of voices the popular attitude towards students . . . you know, they said, "you all had a very exciting time" and there was a shot of this guy lying in a sleeping bag . . .'
'The interviewer also seemed to cut everybody off . . . each student, he seemed to cut them off.'

This last point – the way in which the discussion is cut about and therefore incoherent – they take to be, in fact, the most crucial one:

'The rubbish thing . . . I couldn't work out what it was meant to be.'

and they contrast that very clearly with the coherence of the 'blind' item:

'In the interview with the blind, it worked to a complete conclusion . . . you saw them walking out of the building together . . . it was more structured and planned out . . . more together . . . taking more pains to make it into a finished piece . . .'

The point here seems to be that coherence, as a prerequisite of comprehension or memorability, is only produced within the programme for some discourses, or some items, and not for others. This is to suggest a 'politics of comprehension' where 'balance' allows that other, subordinate perspectives and discourses, beyond

that of the preferred reading, will 'appear' in the programme – but not in coherent form – and the dominance of the preferred reading is established, at least in part, through its greater coherence.

Phase 2: *Nationwide* 'Budget Special' 29/3/77

Phase 2 of the project, using a *Nationwide* programme on the March 1977 Budget, was designed to focus more clearly on the decoding of political and economic issues, as opposed to the coverage of 'individuals' and 'social oddities' represented in the programme used in Phase 1. In particular this sample of groups was chosen so as to highlight the effects of involvement in the discourse and practice of trade unionism on decoding patterns. The groups chosen were managers, university and F.E. students, full-time TU officials and one group of shop stewards.

The programme was introduced by Frank Bough, as follows:

> 'And at 6.20, what this "some now, some later" Budget will mean to you. Halma Hudson and I will be looking at how three typical families across the country will be affected. We'll be asking . . . union leader Hugh Scanlon and industrialist Ian Fraser about what the Budget will mean for the economy.'

Three main sections from the programme were selected for showing to the various groups:

1) A set of vox pop interviews with afternoon shoppers in Birmingham city centre on the question of the tax system and whether:
a) taxes are too high, and
b) the tax system is too complicated.
These interviews are then followed by an extensive interview with Mr Eric Worthington, who is introduced as 'a taxation expert'. Mr Worthington moves from technical discussion of taxation to expound a philosophy of individualism and free enterprise and the need for tax cuts to increase 'incentives', combined with the need for cuts in public expenditure. It is notable here that the interviewer hardly interrupts the speaker at all; the interview functions as a long monologue in which the speaker is prompted rather than questioned.

2) The main section of the programme, in which *Nationwide* enquires into:

> 'how this Budget will affect three typical families . . . and generally speaking most people in Britain fall into one of the three broad categories represented by our families here . . . the fortunate 10% of managers and professionals who earn over £7,000 p.a., the less fortunate bottom fifth of the population who are the low paid, earning less than £2,250 p.a., and the vast majority somewhere in the middle, earning around £3,500 p.a.'

The three families are then dealt with one at a time. Each 'case study' begins with a film report that includes a profile of the family and their economic situation, and an interview which concludes with the husbands being asked what they would like to see the Chancellor do in his Budget. Following the film report, the account then passes back to the studio where Bough and Hudson work out by how much each family is 'better off' as a result of the Budget. Each family (the husband and the wife) is then asked for its comments.

The families chosen are those of an agricultural labourer, Ken Ball, a skilled toolroom fitter, Ken Dallason, and a personnel manager, John Tufnall. The general theme of the programme is that the Budget has simply 'failed to do much' for anyone, though the plight of the personnel manager (as representative of the category of middle management) is dealt with most sympathetically.

3) The third section is again introduced by Bough:

> 'Well now, with one billion pounds' worth of Mr Healey's tax cuts depending upon a further round of pay agreement, we are all now, whether we are members of trade unions or not, actually in the hands of the trade unions.'

There follows a discussion between Hugh Scanlon (Associated Union of Engineering Workers) and Ian Fraser (Rolls Royce), chaired by Frank Bough, which concentrates on the question of the power of the unions to dictate pay policy to the government. Here Scanlon is put on the spot by direct questions from both Ian Fraser and Frank Bough in combination, whereas Fraser is asked 'open' questions which allow him the space to define how he sees 'the responsibility of business'.

Group 19

A mixed group of white, upper middle class drama students at a Midlands University, aged 19–21; no predominant political orientation.

This group judge Nationwide by the criteria of 'serious' current affairs, and find the programme's whole mode of presentation inappropriate to their interests, and out of key with the educational discourses within which they are situated:

> 'It's like Blue Peter . . . it's vaguely entertaining . . . basically un- demanding . . . doesn't require much concentration . . . stories that have absolutely no implications apart from the actual story itself . . .' ' . . . sort of dramatic . . . teatime stuff, isn't it? . . .'
> ' . . . it's all very obvious . . . here's a big board with a big chart – it's like being in a classroom: very simplified.'
> ' . . . just novelty . . . they almost send them up by their mock serious- ness . . . they'd make a story out of nothing . . . someone who collects

something very boring, making models out of matchsticks or some-
thing . . .'

In contradiction, however, they do later argue (contrary, for instance, to group
21, who reject this personalised mode) that the *Nationwide* form of presentation
does have the advantage that:

'You remember a personality easier than you can a table of figures . . .
I can remember those three people . . . whereas, if they'd talked about
"three average families", you'd just forget all the particulars.'

The 'three families' section of the programme is seen to be aimed at getting over:

'what it means to these three families – trying to put a "human interest"
on it . . .'
'. . . it tends to neaten it up, makes it very accessible in a way . . . Britain
is divided into three categories and you slot yourself into one of the
three . . .'

However, it is a form of identification which they are not happy about making:

'Well I suppose you should be able to slot yourself into one of those cat-
egories, just by the amount of money your parents earn . . . em . . .
whether or not you'd say they're social categories as well . . .'

However, unlike the TU groups, they do not feel that the item proposed a par-
ticular class perspective; rather:

'Really, it's three ways of saying that none of them are satisfied . . . just
three examples that it wasn't a very good Budget to anyone.'

Indeed they remark that:

'The whole thing was biased against the Budget . . . they didn't have a
single government spokesman sticking up for it at all, which I thought
was a bit naughty.'

But, crucially, as far as they are concerned:

'Everybody's bound to have a different say.'

It is a question, for them, of individual rather than class perspectives. Thus, the
vox pop interviews, which the TU groups (e.g. group 22) comment on as being
exclusively middle class, are for them:

'seven different individuals.'

although 'class' re-emerges here in a displaced way, as indexed by 'coherence' or 'thickness':

'I was amazed how coherent those people were, you didn't have anyone saying, "Yer what?" You often get that.'
'. . . if they'd have picked somebody who was terribly incoherent, a bit thick and that, we'd have criticised it for that . . .'

They reject any idea that the programme's complementarity or perspective with a particular class group leads them to communicate differently with the different families. Rather, at a general level:

'I felt they were all a bit patronising.'
'I wouldn't have said he communicated in a different way to the three families, actually.'

As they put it, class is simply a 'fact of life':

'Surely he's already accepting, maybe wrongly, that there are, obviously, differences in income . . . different classes, different educations, and he's not trying to say . . . you're all equal, he's presupposing . . . it's a fact of life. You've got three different people there, and £1 to that one is . . . all right, it's callous, but it's going to make more difference than £1 to another set. So yes, OK, in a way he's . . . it's being discriminating . . . when you analyse it down . . . but it's a fact of life . . .'

They do see some partiality in *Nationwide*'s presentation, to the extent that the programme is seen to focus on the themes of:

'Incentive to work . . .'
'Middle management . . . they kept on talking about middle management.'

and to present the respective cases in such a way that:

'They do it as if he's [i.e. the personnel manager] hard done by, because he's got his mortgage to pay, but he's also living in a nicer area . . .'

and moreover to display an important lacuna in that:

'They try to give a wide spectrum by showing those three families, but in fact they left out the fourth lot – which is anything over £7,000 . . .'

However, the strongest criticism of the programme's presentation of this item comes not from a class but from a feminist perspective, especially important as they feel that the programme is designed principally for an audience of:

'Women . . . they're the only people home at 6 o'clock.'
'The budget approach . . . all those bits about budgeting, how much housekeeping . . .'
'It's surely all directed towards women . . .'
'. . . this is very heavily guided towards just how much money the woman is going to get. In all of those cases, it was always Mrs X – there was the wife not affording this and not affording that.'
'Even the woman who goes to work . . . they say, how do you spend his money . . . but she's earning . . .'
'And they ask that woman "what's your husband's line of business" and she breaks in, "and I am also . . ."'

Despite these criticisms, and the fact that they feel that the discourse of the programme is:

'. . . all middle . . . sort of very generalised thing . . . especially the national part . . . whereas *Midlands Today* seems a bit more . . . more . . . well . . . because there's masses of factory workers watching it . . .'
'. . . on a general level it goes back to a BBC audience . . . general, bland . . . middle class presentation . . .'

they are unwilling to reject the overall discourse, which they feel retains its validity, for instance, in the case of the linking thread provided by the 'expert' who assesses the three families' tax/budget situations; because:

'You can't really distrust those figures, unless the guy just makes up things . . . he did have a reason for each figure, and it wasn't, em, an *opinion*, it was a *fact*.'

In the case of the tax expert interviewed at length at the beginning of the programme (Mr Worthington), although they see him at a formal level as 'out of control' they do not see him as presenting a particular political economic perspective:

'Well, he was just let loose . . . at least . . . he had no-one against him . . . all the time, you thought, God, this is amazing . . . he was allowing him to run riot . . . he was saying absolutely anything . . . I mean he could have blasted out "Buy Ryvitas" and all trade names . . . the chap was out of control . . . just giving a very personal point of view, saying I, I think . . .'

In commenting on the trade union/employer discussion they justify Bough's attack on Scanlon as reasonable 'in the situation':

'Considering the weight of the responsibility *was* with the trade union – I mean it was dependent on the trade union vote so he can't be sort of completely equal because one question is really more important in the discussion than the other question.'

This, I would argue (see Morley, 1976), is to accept the media's construction of the situation as one in which the trades unions bear principal responsibility for inflation, etc., and to fail to see that this is a constructed view. Indeed, they deny the process of its construction:

'I don't think they have done anything to bias us one way or another there, there's nothing they can do . . .'
'Scanlon's passing the buck . . .'

Indeed, they feel that Bough:

'was a lot more friendly towards Hugh Scanlon than he was towards Fraser.'
(a view shared by one of the most right wing groups, group 26)

and that Scanlon is evasive, rather than persuasive:

'He's pretty quick with his tongue, he can get out of any situation.'

They identify with the 'responsible' perspective preferred by Fraser, especially when he demands of Scanlon point blank that he 'tell us whether or not he wants another phase of pay restraint':

'The best question that was asked that I wanted to ask was that put by Ian Fraser . . .'

They validate the *Nationwide* team's claim to simply represent 'our' views:

'Bough was just picking up on the implications of what everyone was . . . asking in their own mind . . . I don't think it was him personally.'

and reduce the signifying mechanisms of the programme to a question of personalities:

'It was just a question of personalities rather than the way it was set up.'

in which the form of the treatment (an attack on a trade unionist) is nat-uralised/legitimated as 'given' by the nature of the situation (trades unions are responsible) and the role of the media in constructing this definition of the situation is obliterated:

> 'It's quite right, surely there's nothing that Fraser, try as he might, or any of the others, can do about the situation until he knows what Scanlon is going to do. I would say the weight, definitely, is on Scanlon . . .'

Group 20

An all male group of white, full-time, trade union officials (National Union of Hosiery and Knitwear Workers, National Union of Public Employees, Confederation of Health Service Employees) aged 29–47, with a working class background, on TUC training course; predominantly Labour.

This group inhabit a dominant/populist-inflected version of negotiated code, espousing a right-wing Labour perspective. They are regular *Nationwide* watchers and approve both the programme's mode of address and ideological problematic.

They take up and endorse *Nationwide's* own 'programme values', they approve of the programme in so far as it is:

> 'Slightly lighthearted . . . takes it straight away . . . it's more spon-taneous . . . as it happens, on that day . . . more personal . . .' 'I find that quite interesting . . . there's something in that programme for everyone to have a look at . . .'
> 'It seems to be a programme acceptable to the vast majority of people.'

To a large extent they do identify with the presenters and accept them as their 'enquiring representatives'. They remark of Bough that he was:

> 'basically saying what many of us thought last year . . .'
> 'Probably he was asking the questions millions of other people want to ask as well . . .'

The only fully oppositional element in this group's decoding comes in relation to the identifiably right-wing Conservative tax expert who bemoans the high level of public expenditure:

> 'You've got to look at the fact that in this country you've got ser-vices . . . hospitals, social security for those people who can't work or there is no work for them and it's got to be paid for. Now . . . if you've got that position . . . people like him who knock it should say what they would do . . .'

But it is a rejection of *a particular* position within an overall acceptance of the

224

Nationwide framework − a classic structure of negotiated code (cf. Parkin 1973).

They feel that an unusual amount of 'space' is allowed to Mr Worthington and that this is different from the kind of treatment they can expect from the media:

> 'I was surprised the interviewer never asked him other questions . . . a trade unionist would never get away with that . . . unless it was Jimmy Reid . . .'

They sympathise with the farm worker portrayed:

> 'Who is more emotive than the farm worker who does his best . . . but can't have his fags now . . . ?'
> '. . . anyone who lives in a rural area knows the problems of the agricultural worker . . .'

but feel that in this respect it is an open question whether the Chancellor has treated the farm worker unfairly, for, as far as they can see from the programme:

> 'The bloke that does the best out of it is the farm worker . . .'

They are critical of the middle manager's complaints:

> 'The point is you know, with us, we know, that middle management are not getting all that bad a deal . . . where they're not picking up in wages they're picking up in other areas . . . I mean let's face it . . . let's take the company car . . . I mean, he doesn't have his own car, "poor lad!" . . . they didn't . . . say that car's probably worth £20/30 per week . . .'

However, at the same time, they accept the individualistic, anti-tax theme of the programme:

> 'The only ideal situation is to have as much as you can to earn . . . and they find some way of taking it off you.'

and to this extent identify with the programme's construction of the plight of middle management, because if:

> 'we're talking about incentives . . . it's going to come to us as well . . .'

The 'we' constructed by the programme is something with which they do identify. Further, they accept the programme's construction of an undifferentiated national community which is suffering economic hardship:

> 'There's a sort of pathos in each of those cases . . .'

'It's not even the rich get richer and the poor get poorer . . . any more . . . it's *we* get poorer.'

Their involvement in right-wing union politics is evidenced by their acceptance that in the trade union/employer discussion Bough is simply representing our interests; and moreover that, much in the same way as the issue is presented by the programme, it is the unions, and not the employers, who are 'responsible' for the problem. They accept Fraser's self-presentation as a disinterested and objective onlooker who cannot 'do anything' himself:

'The things Fraser was saying . . . basically there's nothing sticking on what he says. . .'

They accept the programme's perspective on the unions, arguing that this is simply 'realistic':

'. . . let's face it, it's the TUC that's going to make or break any kind of deal . . . basically what the interviewer was doing was saying, on behalf of you and me and everyone else in the country, are you going to play ball so we can have our [tax reduction] . . .'

and they accept the terms of the *Nationwide* problematic:

'I thought this was a programme that was fair. It was saying there isn't any incentive to try and advance . . . yourself.'

The sense of 'realism' goes further and is expressed as a Labour version of 'Realpolitik' unionism; this is how they characterise their own position as union officials:

'We're sitting here, in this place [TUC College] this week . . . learning basically to put other people out of work . . . this is basically what we do and when we boil it down this is what we do because we know that [for] a vast majority of [our] productivity schemes . . . the only way is by putting people on the dole . . .'

Group 21

A group of white, mainly male bank managers, with an upper middle class background, on a two-week in-service training course at a private college run by the Midland bank; aged 29–52; predominantly Conservative.

The predominant focus of concern for this group is the mode of address or presentation of the programme. This is so out of key with the relatively academic/serious forms of discourse, in TV and the press, to which they are

attuned that their experience is one of radical disjuncture at this level. This is a level of discourse with which they make no connections:

> 'Well, speaking for myself, if I'd wanted to find out about the Budget I'd probably rely on the next day's newspaper . . . something like the *Telegraph* . . . or the *Money Programme* . . .'

(From a quite different perspective, they repeat the comments of the predominantly black F.E. groups; cf. group 12: 'If I'd been watching at home I'd have switched off, honestly . . .')

Further, when asked:

> Q: 'How did that come across as a message about the Budget?'

They replied:

> 'It wasn't sufficient, to be quite frank . . .'
> '. . . it didn't do anything for me . . .'
> '. . . I find that kind of plot embarrassing . . .'
> '. . . I just squirm in embarrassment for them.'
> '. . . I'd far rather have a discussion between three or four opposing views . . .'
> '. . . I mean it's much more rewarding . . . more ideas . . . they are articulate . . .'

It is *ideas*, not 'people', which are important to them:

> Q: 'What about the actuality sequences – going into people's homes?' 'I don't think you need it – if we're talking about ideas.'

Rather than the immediacy of 'seeing for yourself' someone's experiences, which many of the working class groups (e.g. 1–6) take as at least a partial definition of what 'good TV' is, for this group it has to be about considered judgements and facts:

> 'In that programme, what have we heard? We've heard opinions from various people which don't necessarily relate to facts . . . some of the information . . . or background . . . all you've picked up are people's reactions . . . not considered . . .'
> 'I mean . . . the point was made [by Ian Fraser of Rolls Royce] "I'm not prepared to comment on the Budget till I've seen it in full tomorrow . . ."'

As far as this group are concerned, *Nationwide* are:

'exploiting raw emotion . . . they encourage it . . .'
'sensationalising items . . .'
'It's entertainment . . . raw entertainment value . . .'
'It's basically dishonest . . . I don't think it's representative . . .'
'As entertainment that's . . . maybe . . . acceptable . . . you can lead people by the nose . . . now if you're talking about communicating to the public and you're actually leading them, I think that's dishonest . . .'

In startling contrast, for example, with group 17's insistence that items should be short, fast and to the immediate point, a perspective from which *Nationwide* was seen to fall short, this group feel that *Nationwide*:

'. . . try and pack far too much into one particular programme . . . questions are asked, and before somebody had really got time to satisfactorily explain . . . it's into another question . . . and you lose the actual tack . . .'
'I can't bear it . . . I think it's awful . . . one thing . . . then chop, chop, you're onto the next thing.'

This concern with the coherence and development of an argument leads them to single out the interview with the tax expert, Mr Worthington, as praiseworthy. They feel that the item was a little unbalanced:

'Particularly that accountant from Birmingham . . . was . . . very much taking a view very strongly, that normally would only be expressed with someone else on the other side of the table . . .'

But their predominant feeling is that at least the item contained a fully developed and coherent argument:

'There he was allowed to develop it . . .'

The programme certainly fails to provide this group with a point of identification, presumably because of the disjunction at the level of the programme's mode of address:

'I couldn't identify with any of them.'
'I didn't identify myself with the middle management . . .'

For them the whole tone of the programme makes it quite unacceptable to them, and they hypothesise, perhaps for others:

'There's a great danger, I'm sure Frank Bough isn't doing it deliberately, of being patronising or condescending . . . and this I found irritating –

that "there's going to be £1.20 on your kind of income" . . . to me, Frank Bough on £20,000 a year . . . it's enough for a . . .'

They hypothesise that the target audience is:

'The car worker . . . the middle people . . . and below.'

and wonder aloud that the programme might have been:

'talking down . . . even to the lowest paid worker.'
'They place an emphasis on what this meant to the British worker . . . to a range of workers . . . I think it needed the same thing in a much more intelligent way – appealing to the more intelligent aspects of the people involved . . .'
'I wonder if they've underestimated their audience.'

But this is a perspective which is not unchallenged; their view of the 'middle people . . . and below' also leads them to wonder:

'Would many of the population be capable of absorbing the informa- tion . . . even the simple part of the question . . . especially in a programme of that sort . . . ?'

Because, they argue:

'They do not understand – the man in the street does not understand the issues: they understand "£10 a week" . . .'

The ideological problematic embedded in the programme provokes little com- ment. It is largely invisible to them because it is so closely equivalent to their own view. The lack of comment is I suggest evidence of the non-controversial/shared nature of the problematic. Indeed, they go so far as to deny the presence of *any* ideological framework; it's so 'obvious' as to be invisible:

Q: 'What was the implicit framework?'
'I don't think they had one . . .'
'. . . there wasn't a theme . . . like an outline of the Budget . . .'

The only point made by the presentation of the Budget, as far as they can see, is:

'It left you with a view . . . the lasting impression was that [Healey] didn't do very much for anyone . . .'

But they are very critical of this 'superficial' view precisely because it has not explored what they see as the crucial socio-political background:

'There is another side to the coin, he didn't do a lot, but there was full reason at the time why he couldn't do a lot, and that was virtually ignored . . .'

Group 22

An all male group of white, full-time, trade union officials (Transport and General Workers Union, Union of Shop, Distributive and Allied Workers, Union of Construction, Allied Trades and Technicians, Bakers, Food and Allied Workers Union, National Union of Agricultural and Allied Workers), aged 29–64, with a working class background, on a TUC training course; exclusively Labour.

The group find the problematic of the programme quite unacceptable and accompany the viewing of the videotape with their own spontaneous commentary:

Programme	Commentary
Link after vox pop interviews:	
'Well, there we are, most people seem agreed the tax system is too severe . . .'	'That's a bloody sweeping statement, isn't it? . . . from four bloody edited interviews!'
Interview with Mr Worthington:	'Is this chap a tax expert? Seems like a berk . . .'
	'Poor old middle management!'
	'Aaaagh!'
'. . . ambitious people . . .'	'Avaricious people, did he say?'
	'What about the workers!!'
	'Let's watch *Crossroads*.'
'. . . and of course the lower paid workers will benefit . . . from . . . er . . . the . . . er . . .'	'Extra crumbs falling from the table!'
Three Families Section-Manager:	
'He doesn't own a car . . .'	'Ha, Ha! That's a good one!'
'A modest bungalow . . .'	'Family mansion! His lav's bigger than my lounge!'
'. . . we can't have avocados any more . . .'	'We had to let the maid go!'
Mr Tufnall digging in his garden	'Did you hear that!'
	'Those aren't Marks & Spencer's shoes he's wearing.'
'However much you get – someone else is waiting to take it away . . .'	'Good! Redistribution of wealth and fat . . .'
'What, of course is a tragedy is in respect of his child still at college . . .'	'They didn't mention that for the other peasants.'
'One has to run a car . . .'	'Does one! He doesn't "run a car".'
'His child at college . . .'	'I worked nights to do that.'
'actually in the hands of the trades unions . . .'	'Yurgh!'

This group began by commenting that the programme was:

> 'Obviously contrived, wasn't it, the whole thing . . . all contrived from
> start to finish to put the image over . . . I'm of the opinion the ones
> we've got to watch for the image creation are the local programmes.'

This they see as an unacceptably right-wing perspective, also seen as characteristic of:

> 'most ordinary TV programmes; serials . . . you get, em, *General Hospital*,
> It's so right-wing it's unbelievable – it's pushing the senior management
> at the people all the time, "you must respect the consultants and doc-
> tors", and "they're the people who make the decisions . . . and they
> know what they're doing". . .'

They say of the vox pop sequence in the programme that it is far too narrow
and class-specific a sample of opinion to provide the 'ground' which *Nationwide*
represents it as providing for their 'summation' of 'what most people think'.

> 'Then the way the actual interviews were . . . very carefully selected in
> the centre of Birmingham, mid-afternoon . . . with the shoppers and
> businessmen – there wasn't one dustman around . . . there wasn't any
> agricultural workers with their welly-boots on . . . it was purely middle
> class shoppers out buying their avocado pears or something; then at the
> end he says "everybody agrees" – he's met four people. I don't know
> how many people live in Birmingham, but there's more than four . . .
> he only shows what he wants to show.'

Mr Worthington, the tax expert, is dismissed as a 'berk':

> 'Of course everybody believes that this chap is the expert, the TV tells us
> so, and the things he was saying, he might as well be reading a brief
> from Tory Central Office, which I think he probably was anyway . . . and
> they didn't just ask him to lay out the facts, they actually asked him his
> opinion, and to me an independent expert is supposed to tell you the
> facts, not necessarily give you their opinion on general policy . . .'

The group feel that Mr Worthington is allowed 'free rein' in the programme, very
different from their experience of being interviewed by the media:

> 'The development of the scene was allowed to go on and on, wasn't it?
> Glamour boy [i.e. the interviewer] just sat back and let him get on with
> it . . .'
> '*We've* found that local sort of media – y'know we've got good

relations – and yet we're cut all the time, as compared with the management's views.'

The group do, at one point, comment on the form of the programme's presentation, or mode of address:

'My major complaint against most of the *Nationwide* programmes, apart from the political ones, is the way in which they trivialise every topic they seem to take up – and just when the topic begins to blossom out, they suddenly say, "well that's it. . ."'

But crucially, as distinct for instance from group 21, for whom the mode of address of the programme is the dominant issue, for this group it is the political perspective or problematic of the programme which is the dominant focus of their concerns. The perspective is one which they vehemently reject:

'The perspective was that of the poor hard-pressed managerial section . . . they had the farm worker there . . . that was, sort of, "well, you've got £1.90 now – are you happy with that – now go away" and then "Now, you, poor sod, you're on £13,000 p.a. . . . and a free car . . . Christ, they've only given you £1.10 – I bet you're speechless!" . . .'
'. . . the sympathy was, you're poor, and you're badly paid and we all know that, because probably it's all your own bloody fault anyway – the whole programme started from the premise that whatever the Budget did it would not benefit the country unless middle management was given a hefty increase – that was the main premise of the programme, they started with that . . . they throw the farm worker in simply for balance at the other end of the scale. . .'

The visibility of this distinct 'premise' for this group is in striking contrast, again, with group 21, for whom this premise is so common-sensical as to be invisible and for whom the programme had no particular theme or premise of this kind.

This group feel that *Nationwide*, because of its politics, is not a programme for them. It is:

'Not for TU officials. For the middle class. . .'
'Undoubtedly what they regard as being the backbone of the country, the middle class . . . they allowed the agricultural worker to come in so as the middle class can look down on him and say "poor sod, but I can't afford to give him anything because I've had to do without me second car, etc!"'

As far as they are concerned the whole union/employer discussion is totally biased against Scanlon:

'He [interviewer] was pushing him into a corner . . . that was the first comment, immediately getting him into a corner, then the opponent [i.e. Fraser] who was supposed to have been equal . . . more or less came in behind Bough to support Bough's attack on Scanlon.'
'Yes, except you've got to realise Scanlon slipped most of those punches expertly – a past master . . .'
'but pointed, direct questions . . .'

There is, however, another thread to this group's comments which emerges particularly around the question of tax and incentives. In line with the group's dominant political perspective, there is some defence of progressive taxation:

'What about the social wage? It's only distribution . . . the taxation takes it from you and gives to me . . . I mean, if you're not taking income tax from those who can afford to pay, you can't give anything to those who aren't paying. . .'
'So long as I get benefit for the tax I pay, I'm happy enough.'

But at this point a more 'negotiated' perspective appears which shares much in common with the Labour 'Realpolitik' of some of group 20's comments; they say that to criticise *Nationwide*'s perspective on tax and incentives is misguided:

'It's not necessarily a criticism of the programme . . . a lot of highly paid skilled operatives fall into exactly the same trap . . . they probably listen to the programme themselves . . .'

As they somewhat uneasily put it, extending in a sense, some of Scanlon's own comments on the need to 'look after' the 'powerful . . . skilled elements':

'One of the main objects of the full-time official is to maintain differentials . . .'
'I'm not saying differentials are good . . . but as a trade unionist you've got to be able to maintain it. . .'

Indeed they extend this to a partial defence of *Nationwide*'s perspective; at least to an implicit agreement about what, in matters of tax, is 'reasonable':

'. . . I think we should try to get the income tax in this country to a respectable level to allow everyone to work and get something out of it . . . because there's no doubt about it, the higher up the ladder you go, the harder you're hit for income tax.'

They remark in justification of this perspective that the problem is that 'incentives' have been destroyed, because:

'They've increased the income tax in this country to such a degree that it don't matter how hard you work. . .'

Indeed, they also take up one of the other themes of the dominant media discourse about trade unionism:

'There's a lot of . . . unions in this country that could produce a lot more . . . British Leyland's one for a start-off.'

This is not to say that they wholeheartedly endorse this negotiated/'realist' perspective. They cannot, for it is in contradiction with much of the rest of their overall political outlook. It is rather to point to the extent to which this is a discourse of 'negotiated' code, crossed by contradictions with different perspectives in dominance in relation to different areas, or levels, of discussion.

Group 23

A group of mainly white, male and female shop stewards and trade union activists (Transport and General Workers Union, Civil and Public Services Association, National Society of Operative Printers, Graphical and Media Personnel, Society of Graphical and Allied Trades), with upper working class backgrounds, aged 23–40, studying part-time for a diploma in Labour Studies at a London Polytechnic; predominantly socialist or Labour.

Like group 22 they produce a spontaneous 'commentary' on viewing the programme:

Programme	Commentary
Mr Worthington	'Aah, poor middle management.'
	'Who does he represent?' 'Aargh.'
'few very good hard workers'	'Oh, no . . .'
'benefit from the extra . . . er'	[interrupts] 'Exploitation!' (cf. group 22)
	'As if everyone's aspiring to be middle management!'
Dallason: 'not at expense of services'	'Good lad'
Bough: 'every little does help . . .'	'Fucking bastard!'
Manager: 'he doesn't own a car . . .'	'Tell us another.'
Mrs Tufnall	'Listen to that accent! Dear me . . .'
	'Yeah, you really starve on £7,000 p.a. !'
'. . . speechless is the right word . . .'	'Shut up then!'
'One has to run a car . . .'	'It's paid for by the company!'
'. . . he's doing chartered accountancy'	'Learning the tax fiddling game!'
'We're actually in the hands of the unions.'	'Here we go!'

Like many of the other working class groups they express a preference for the less reverent and staid style of the ITV equivalent to *Nationwide, London Today*:

> 'It's amazing, the difference in *Nationwide* and *Today* – the BBC just happens to be quite a lot more patronising.'
> 'There used to be a Friday night debate on *Today*, sort of open forum, unrehearsed . . . and you'd get ordinary leaders of the public, spokesmen and they would be totally unrehearsed, so if it was say, the leaders of the GLC they would come under a lot of genuine fire that you would be able to see . . . members of the audience getting up at random and saying what they've got to say you know, I used to think that debate was quite reasonable.'

They can to some extent endorse *Nationwide*'s mode of address or at least not dismiss it by reference to the criteria of 'serious current affairs'. They grant that *Nationwide* is:

> 'light entertainment isn't it? I mean, you know, there is that . . .' 'It takes the issues of the day and it is quite entertaining.'
> 'It was easy watching.'
> 'You know, like, did you see that guy trying to fight that budgie or something, and he lost! . . .'

However, they object, on the whole, to *Nationwide*'s:

> 'sort of soothing, jolly approach . . . as if you can take a nasty problem and just wrap it up . . . you know – "we're all in the same boat together" and clearly we're all going to live to fight another day . . . you get rational, cheerful people . . . cheering us all up just a little bit at the end so it's not so bad. . .'

But the 'style' of the programme is not their overall concern; even a comment that begins by focusing on this aspect shifts in mid-stream towards their dominant focus of interest, the class politics of the programme:

> 'I'm not discussing the actual credibility of the arguments used . . . but it's the sort of jolly show-like atmosphere they create, and there's all these people laughing at their own misfortunes . . . as if they [producers] would encourage that resignation . . .'
> '. . . except for middle management – and they weren't encouraged to do that then – it was "you must be speechless", and there's no jollity there – it's "tragedy" . . . that very sympathetic "umpire" said to this guy . . . he used the word at least four times, he said "unfortunately" at least four times in a minute, which is amazing.'

They reject what they see as the programme's highly partial treatment of the personnel manager:

> 'I didn't believe it anyway. I don't believe the personnel manager at Tate and Lyle's only gets that.'
> 'Yeah, but he's got a car . . . benefits . . . the £7,000 is the declared tax value, the rest comes in benefits.'
> 'And they had more sympathy with him . . . they used the word "unfortunate" . . . "unfortunate" all the while with him . . .'

Similarly they see the trade union/employer discussion as highly partial:

> 'Even in BBC terms, there wasn't any neutrality in it . . . at all.'
> 'The guy from Rolls Royce didn't even have to open his mouth. I was amazed, he just sort of said "We can ask Mr Scanlon and he can hang himself".'
> (cf. those groups who interpret the fact that Fraser *talks* less to mean that the programme is biased against him.)
> 'He said to Scanlon, "well look, the burden is with you . . . you're fixing his wages" . . . union leaders are always being told, "well, you're running the country".'
> 'And then when he said to that bloke, "well you must be shattered. Industry must be depressed." (That's right!) ". . . we're all in the hands" (That's it!) "of the unionists . . ." (The link's there all the time) yes, as you've said the debate was confined in a very narrow channel . . . you see this is the problem . . .'

Although, in a rather cynically well-informed way, they feel that Scanlon 'did all right':

> 'Actually, Scanlon was very crafty, all that "rank and file" stuff . . . "my rank and file will decide" – his rank and file never knew about the pay policy till it was made compulsory . . .'

They reject the programme's claim to represent 'us':

> 'What was really frightening was the first line of the whole programme which was *telling* us what our "grouse" was, the main grouse, isn't it, you know is Income Tax.'

Further, they reject what they see as the programme's premise of national unity of interest:

> 'The whole thing about that programme was that really there's a unity of interest, I mean . . .'

'Workers who talk about tax being too high/lack of incentive – which is the sort of thing I remember the Tories pushing (Right) and the media hammering like "no-one wants to work" . . . poor sods at various levels of the social scale all hammered by exactly the same problems . . .'
'When they said, "well, how are they coping?" they had the poor old middle management, er, digging in the garden . . .'
'They've got these bits in common – that they'd all be prepared to do a bit of digging if they had to, you know, all of them, you know. Yeah, it's rather like when the war's on, "all ranks, er, go and do their bit," you know.'

They do not identify with the 'we' which they see the programme as attempting to construct:

'I mean they want 'we' and they want the viewer, the average viewer, to all think . . . "we" . . . That's why we've got these three families (Yeah) and they appear so sympathetic so that the "we" sticks, "we are" . . .'

The group are highly critical of what they see as a whole range of absences within the programme, issues excluded by *Nationwide*'s problematic:

'There's no discussion of investment, growth, production, creation of employment . . .'
'Well, nobody mentioned unemployment. I mean that's pretty amazing . . .'
'. . . the whole, I mean . . . budgets in the past have always been to do with the level of employment, to get through the whole thing without even mentioning the fact that it's not doing anything about unemployment!' 'There's no real, I mean, not an intelligent discussion of economics, actually. You know, no talk of, em, em, investment, er, productivity, how to expand the economy, anything like that at all . . .'
'. . . as if all the economy hinged on taxation control or, or . . . (Yeah) There's no such thing as growth or, or, investments.'

In particular they are critical of what they see as the programme's 'one-sided' approach to the problem of tax:

'The line was . . . we haven't had any tax cuts, and that's what's wrong with the country.'
'And the whole thing. There was no mention at all about what happens to taxes. Should we be taxed, you know. The only answer is, Yeah, of course we should be taxed.'
'There's no mention anywhere in all this run up against "taxation's bad" and "you shouldn't have to pay this sort of level", that there are

those people that, through no fault of their own, are so lowly paid that they have to have it bumped up by somewhere else, which has to come out of the tax system . . .'
'Yeah . . . tax is a drag . . . but like it's a drag to have to drive down the left hand side of the road! – I mean, trying driving down the other side!'

They are aware of odd moments in the programme in which they feel these issues begin to surface but feel that they are quickly dismissed:

'There was one guy [Dallason] made one very interesting point, that . . . yes, we need, incentives all right – but not at the expense of cutting hospitals and schools – and that was never taken up.'

Similarly they feel:

'There was one brief mention of pay policy. Scanlon picked that up at the end but that was in the last two minutes and he's a big bad trade unionist anyway.'

And crucially:

'No reference whatsoever to stocks and shares. You know, the things that are accumulating money all the time without lifting a finger, you know, no reference at all . . .'

The group's perspective is oppositional in the fullest sense: they do not simply *reject* the content or 'bias' of the particular items – they *redefine* the programme's problematic and implied evaluations into quite other terms:

'And always the assumption that people over a certain level . . . in a certain job have got a basic right to eat avocado pear and everybody else hasn't, for example . . . I mean we might put the boot on the other foot and say somebody who does manual, physical work, coupled with his head as well, so that he doesn't crash into trees with his tractor, em, you know, would need to eat equally well, if not better (Right), since the middle class don't.'

They feel precisely that *Nationwide* is:

'supposing that that emphasis should be put . . . you know, as if it's more important the fact that you're a Chartered Accountant, more important than somebody who's actually digging the food that we eat . . .'

As far as they are concerned the relative value and importance of the different categories of labour represented in the programme is quite different from that suggested there:

'. . . there's this big emphasis by almost everybody, the presenters, the experts, apart from individual workers, about middle management. (Yeah) Now this runs all the way through. And right at the very end you suddenly get the fact that it's Scanlon and all these, you know, terrible union people that are ruining industry because they keep asking for too much money. (Yeah) It was amazing you know, I mean there's a guy who is a farm worker that produces the stuff that we eat. Nobody thinks *he's* essential. There's a skilled tool room worker, nobody thinks *he's* essential . . . there's that personnel manager, which for all our experience, you know [laughter] they could hang up tomorrow and nobody'd notice the difference, *he's* suddenly essential, extremely important to the whole of industry, i.e. the economy, i.e. the nation (Right) . . . it's a political line that runs under the whole thing.'

This implicit theory simply does not fit with their own experience:

'The whole point was, it would appear to be that the farm labourer is irrelevant, the toolroom worker's irrelevant, everybody's irrelevant barring the manager . . . one little strata within industry that is so important . . . where, I mean, all our experience is that they do more bloody harm than good. Get rid of them – when this Ford's thing was going on recently, when the foremen came out on strike for two days, and they had to scuttle back because it didn't make a blind bit of difference . . . suddenly people had found out, they didn't need them any more . . .'

Moreover, it is not simply a rejection at the level of 'experience'; it is also a theoretical rejection, in terms of an economic theory about the origins of value, opposed to the theory of classical economics which they see enshrined in the programme:

'And this is the belief in the entrepreneur's special skill which makes wealth appear like magic (Yeah) by telling all these idiots what to do, you know, er, it's a sort of special skill. Well, yeah, it's, mind you it really relates . . . to classical economic theory, the point there is that you see the factors of production, of inputs, workers . . . costing and everything else . . . and it's only the sort of skill of the overall managers and all their executives, who can sort of cream off, you know, this exact pool of skill and machinery and get profit from somewhere and therefore these individuals, the ones who create profit because it's their judgement

and skills who produce it, not the actual graft, the workers, who should get surplus, then take home a certain amount, you know, that's obviously . . . it's two totally different interpretations of where wealth comes from – basic stuff.'

The group have reservations about the representation of women in the programme too:

'Interesting the way they use women too: "I ask Kathy about the family budget", like she stays at home and looks after the kids and feeds the cat.'

Moreover, they do not simply reject this programme, or *Nationwide* as such:

'The thing is, I mean, I don't think you can really, sort of, take *Nationwide* in isolation, I mean take *Nationwide* and add the *Sun*, the *Mirror*, and the *Daily Express* to it, it's all the same – whole heap of crap . . .'
'. . . then you begin to realise, you know . . . the whole thing is colouring everything.'

Interestingly, it is also this group who are most articulate about the social/political conditions of their 'reading' of the programme, seeing it clearly in terms of socio-political structure rather than simply being a question of different 'individual' views:

'Let's be fair . . . and say we watch that as a group of people very committed to a certain thing . . . I mean, no doubt your reactions for a bank manager would have been totally different.'

Group 24

Owing to a fault in the tape recording this group had later to be omitted from the analysis.

Group 25

This is a group of mainly black students (West Indian, Zimbabwean) mostly women, ranging in age from 18 to 37. The group has a lower working class background and is in full-time further education studying 'A' level sociology at an F.E. college in Hackney; predominantly Labour.

The group's response to *Nationwide* is overwhelmingly negative:

'I go to sleep when things like that are on . . . it's boring.'

And this is partly to do with their lack of identification with the image of the

audience inscribed within *Nationwide*. They are clear that it is not a programme for them, but for:

> 'Affluent people . . . middle class people . . . When they were talking about tax forms [i.e. in the vox pop section where the audience is presented with a surrogate image of itself], all those people seemed fairly middle class.'

– almost exactly repeating the comment of the TU group 22: 'all those middle class shoppers and businessmen . . .'

When asked to describe how they saw *Nationwide*'s basic perspective they again identified it as one they rejected, moving from an account of this rejection within the terms of their sociological education to one in terms of their own viewing:

> '*Nationwide*'s Conservative. Always within the dominant normative order . . . Recently *Nationwide* have been very conservative – they did a thing on Astrid Proll – they made those prisons in Germany look very, very comfortable and everything, you can walk around wherever you want to go . . . They made the people who supported her seem very, sort of, into their own political games, living in communes and that.'

The programmes that they do prefer, and identify with to some extent, are those that are more directly grounded in some localised sense of working class life, in whatever limited and mediated ways.

They prefer the ITV equivalent to *Nationwide*:

> 'There's plenty of pictures and a lot less talk . . . perhaps it's because it's local, it's not nationwide . . . perhaps it's more in touch with its audience . . .'

And they (surprisingly at one level, given the disjunction between their black subculture and the white/northern culture of the programme – though they share a sense of class) identify with:

> '*Coronation Street* . . . perhaps [laughter]. Well, maybe . . . we hear people coming in and saying "Did you hear what happened, it's like mine . . . ", you know, and people do tend to identify a bit with that. Not that they say, "Well, that's an exact replica" – of course it isn't, but you know, like gossip corners in the local pub, and the rest of it . . .'

But beyond these mediated identifications there is also that very small segment

of broadcasting which this, predominantly black, group can relate to directly, and which also raises resentments in so far as they feel that it is ignored by the white audience:

> 'I remember when *Roots* was on, and I was dashing to watch it, sit glued to the TV and I might sit and discuss *Roots* and then I'd go to work and nobody'd say a word about it. And if you do, eventually, "Yeah, it's a good programme" – and shut up. When *Holocaust* was on, everybody discussed that.'
> '. . . it gets on to *Roots* and *Martin Luther King* and you get a block. I mean you could talk about it on your own. You could talk about it among your friends and your relatives because they could identify with it as well as you, but if you . . . I'm not saying all . . . but a lot of white people . . . they don't want to know. They say, "yes, it's a good programme", or, "yes, I can see why King had to", you know, what they were fighting against, but no, they don't want to know.'
> 'They won't see it's anything to do with them.' 'They don't want to know so much . . .'

The group make a consistently oppositional reading of *Nationwide*, basically focusing on, and rejecting wholesale, its problematic; by contrast, the mode of address is not commented on. They reject the programme's 'hierarchy of credibility' as between different speakers because of their class perspective:

> '. . . in *class*, I would have more sympathy with the agricultural worker than I would with the management person, much more.'

although they can see that the discourse of the programme (and its preferring of certain codes of speech and presentation taken over from other social/educational hierarchies) privileges the manager; because:

> 'the farm labourer, from his own experience, the way he put it over, I mean he wouldn't know how to put it over as well as the manager, would he?'

They accept that their reading is in disjunction with that preferred by the programme, and they reject the preferred reading precisely because of its lack of any class perspective:

> Q: 'Does your reading fit with what the programme is doing?'
> 'No, I just disagree – no, I don't think it does. I think the programme's just more or less saying, [i.e. at the level of connotation, meta-language] "look, it's not just the working class, it's not just the lower class people who are being treated like this, it's all the classes." I think that's all it's

doing, I don't think it's really looking at it from any real [= class?] point of view.'

The tax expert, Mr Worthington, is decoded in a way that precisely reverses the 'generalising mechanism' of universalisation – from particular to general interest – which is embedded in his speech. His speech is deconstructed quite crudely to the level of self-interest:

'You got a feeling it would obviously work for him . . . he said that it would benefit directly middle management and increase incentive, and indirectly benefit the working population [cf. the TU groups' interjections in his speech here] . . . because the middle management would be better off, more gross product would be raised . . . he was directly for the incentive approach, the top . . .'

This reading is in striking contrast with that of the trainee print management group 26, who argue that he is not talking about 'his personal salary . . . it's more profits in order to reinvest . . . and create new jobs . . .', obviously reading the speech at the level of the 'general interest'.

Again in contrast with group 26 (who see the 'trade union' discussion as biased in Scanlon's favour) this group clearly read this discussion as structured around a problematic which is anti-union in a way they totally reject. The Rolls Royce chairman and the presenter are seen as uniting powerfully against Scanlon:

'They kept going on about him, the union running the country . . . I could see they were goading Hugh Scanlon . . . focusing on him, and this other manager . . . chairman of Rolls Royce, like sitting back cool . . . like sitting back "with us", saying, "look at what he's doing to us, and I'm also included . . ."'

But they also think that, despite this structure, Scanlon is not 'caught out':

'I don't think so . . . some of the questions he was very clever at answering, especially the last one . . . where they were trying to make him say what . . . and he said, "well, I'll take it to the unions and see what they say, and I'll have to, you know, act on that." I thought . . . he really got out of that one well.'

The group read the whole 'Families' section as clearly weighted in favour of the personnel manager:

'I thought the middle management guy got free rein in a way – 'cos they just asked a question and he went on and on . . .'

'They brought him over in a really good light . . . he's seen as desirable . . . necessary to the future of the company . . . so he should be in a much better position – yeah: when his £1.10 popped up, you know – "GASP, SHOCK, HORROR" . . . it came over as if he was badly off – you know, £1.10 – gosh!'
'Will you be able to feed your kids?!'
'I mean, they're *really* hard done by!'

And they are particularly critical of the absences in the programme's perspective on the manager:

'They didn't say anything about the manager's entertainment . . . the way the managers entertain themselves, his leisure, they didn't say anything about that at all – I mean, apart from her saying, "oh, we won't have any more avocado pears!" . . . being a manager you expect him to entertain a bit, and they didn't say anything about that at all, what they spend on their leisure time . . . and the fact that he ran a company car as well, and they pay.'

It is the moment when the manager's wife complains that she is unable any longer to afford avocado pears which reduces them, beyond mere criticism, to incredulous laughter:

'It was just the way she said [i.e. in a very 'plummy' accent], "well now, we'll have to cut down on our eating!" It didn't look like they had at all, you know! . . . that's a luxury she's talking about – she said you can't have avocado pears!!'

Moreover, they are aware of another level of poverty off the bottom of the scale shown in the programme:

'. . . another thing . . . they showed the agricultural labourer, they didn't show the labourer in the industrial city . . . the agricultural labourer . . . OK, he earns such and such, but he's able to have his little bit of land to grow his vegetables . . . he can supplement his income, and the industrial worker can't . . .'

More than any of the others, this group also produced a specifically feminist critique of the 'Three Families' section in its portrayal of sex roles:

'When they were talking about it . . . they said to her, "how does Ken's money go?" They didn't ask her about her money, what she did with her money. As far as they were concerned that's pin money . . . just like when they talked about the agricultural labourer – they talked about his

luxury, what was his luxury, but not hers, which I thought was really typical.'

Moreover, to take up the point made by MacCabe (1976), ideologies do have to function as 'descriptions' or 'explanations' of the 'reader's life', and it is in so far as they succeed or fail to do this that 'the ideological viewpoint of the text' is accepted or rejected. This group reject the 'description' of their life offered by the programme. They can find no 'point of identification' within this discourse about families, into which, Bough has assured us, 'most people in Britain' should fit. Their particular experience of family structures among a black, working class, inner city community is simply not accounted for. The picture of family life is as inappropriate to them as that offered in a 'Peter and Jane' reading scheme:

'It didn't show one parent families, how they would count, the average family in a council estate . . . all these people seemed to have cars, their own home . . . property.'

Further (and this is to validate John O. Thompson's (1978) critical remarks on *Everyday Television: 'Nationwide'*) which argued for a reading of 'Nationwide's discourse as one which is no less in flight from Freud than from Marx') this group are very aware of the inadequacies of Nationwide's portrayal of family life, in terms of the absence of any idea that the whole domestic field is also one of struggle and contradiction:

'They show it . . . like all the husbands and wives pitching in to cope with it, cope with looking at problems. I mean, they don't show conflict, fighting, things that we know happen. I mean it's just not, to me it's just not a true picture – it's too harmonious, artificial.'

Or, put more simply:

'Don't they think of the average family?'

which of course Nationwide would claim precisely to do. This simply shows the lack of a 'unitary sign community' in relation to central signifiers like 'family'. The representation of 'the family' within the discourse of Nationwide has no purchase on the representation of that field within the discourse and experience of this group – and is consequently rejected.

Group 26

A small group of male, mainly white, European management trainees, between the ages of 22 and 39, with a principally upper middle class background; predominantly Conservative.

The basic orientation of the group towards the programme is one of criticism and

disjunction, but from a trenchantly right-wing Conservative perspective, which sees *Nationwide* as being to the political 'left'. This may be the result of the lack of fit between the respective political spectrums of the speakers' countries of origin – South Africa, Belgium, Greece – and those of Great Britain; however, this political disjunction co-exists with a simple lack of familiarity with the codes of British television and their dominant political connotations.

Where group 25 criticised the programme for the lack of any 'real' (class?) perspective this group find that aspect of the programme's problematic quite acceptable and in keeping with their own perspective:

> 'I think it's pretty evenly balanced, they say, "well, this guy isn't better off, the lower paid aren't better off," you know, it's really all the same thing, nobody's really better off.'

However, the international scales of comparison, when it comes to income figures, introduce complications:

> 'They regarded that personnel manager as already a high wage – it's not a high wage, £7,000!'

From this point on a major theme in the discussion is that *Nationwide* is seen as a left-wing programme:

> 'An awful fact of *Nationwide* is that they're very subjective; the people are very pro-Labour . . . I watch them very often, they're always biased. If there's anybody, for example, who earns £10,000 p.a. they are sort of looking at them as if they were a rich bastard. That's what I've always found on *Nationwide* . . .' 'They mentioned something . . . the person who has more than £20,000. Then they were saying, "oh, yes, the bastard . . . " I find that extremely biased, saying something like that . . . I watch them very often, *Nationwide*, that's why I have this thing in my head, it's always the same thing with them . . .'

From their perspective this group decode *Nationwide*'s uneasy combination of 'radical populism' as simply radical. In a sense this group do not share the cultural codes within which the discourse of *Nationwide* is situated – to the extent that they even interpret the programme as being against small businesses:

> 'I've always found that *Nationwide*, they rank people, as soon as they have a bit too much money, like this thing pidgeonhole, they really drag people through the mud, because they're small businessmen, they're not regarded as very important.'

Further, their decoding of the trade union/employer discussion is focused on the

form only – who talks most – rather than on the structured dominance of the employers' perspective, which is not a relation of force established on the basis of who gets most speaking time, but rather of whose problematic sets the terms of the discussion:

> 'The guy from the union said everything, then they ask something from the man from Rolls Royce and immediately the guy from the union had the last word again.'
> '. . . they didn't give him a chance, the guy from management.'

The 'explanation' of *Nationwide*'s supposed political radicalism is later produced through a tightly economistic perspective:

> 'I mean it's BBC and ITV. ITV can't be socialists because it's private enter-prise. BBC is a state-owned thing, so it's socialist. That's how it works in this country.'

– a perspective which will clearly have no truck with the quirks of relative autonomy!

However, there is also a subordinate thread of interpretation in the group which goes somewhat against the grain of this trenchantly conservative view. The students' immersion in an academic discourse of business economics (as trainee managers) leaves them dissatisfied with the level of complexity of *Nationwide*'s arguments:

> 'You can't talk about taxation levels without saying what public expen-diture is about . . . I mean higher tax may mean you have a better post office . . . road communications . . . it's not really a decrease in your income, it's just another way of seeing your income. If you don't see the figures of public expenditure you can't really speak about higher or lower incomes.

and again:

> 'I find it's a silly idea – very naive to say you can lower public spend-ing . . . I mean you can say cut public expenditure, but in what ways? Is it defence, is it transport, what is it? Housing?'

And at this point one of the more reticent speakers moves the discussion from the level of criticism of the programme's lack of complex argument towards the level of political criticism, from a Labourist perspective:

> 'The part of the system I really don't understand or support is the sup-plementary benefits they give to people. I think people who work should

be given enough basic salary that they would not have to go for supplementary benefits – it's not fair enough, because a lot of people are ashamed to go in for supplementary benefits . . .'

– a problematic clearly to the left of those considered by *Nationwide*.
However, this contribution is out of key with the views expressed by the other members of the group and is not developed.

The dominant conservative theme is also articulated with the 'academically' orientated criticism that *Nationwide* fails to develop sufficiently complex arguments. Surprisingly, this is even a point made about the interview with Mr Worthington (the tax expert) who was identified by many of the groups as being allowed free rein to develop his points:

'That's always the case in *Nationwide*, they try to make you say whatever they want you to say. They don't allow you the time, or give you the chance to explain what you think and go deeper.'

These criticisms of the form of this interview notwithstanding, the perspective of classical free-market economics which Worthington is advancing is heartily endorsed by the group. As noted, group 25 decode this as a truly 'ideological' speech, disguising personal/sectional interests as representative of the universal/general interest. Group 26 defend Worthington's argument in a precisely contrary fashion:

'It's not him personally . . . he does not say the manager should be paid more – he says that business should be allowed to have more profits in order to reinvest, and it circulates money and creates new jobs . . . makes money go round . . . so I'm not sure he was talking about salaries or wages: he was talking about expenditure and investment.'

And, to the suggestion that an increase in profits will not necessarily lead to an increase in investment, their developed free-market problematic of course replies:

'That's because management in this country is afraid of investing. They've made management afraid of investing because it's a very uncertain time.'
Q: 'Who's made management afraid?'
'The TUC, the general appearance of the government. Everything seems to be working for Labour . . . but in the wrong way, however . . . they don't look into the future . . . to tomorrow's situation . . .'

The problematic is internally coherent and far-reaching, moving from the justification of personal response:

'I come from a very conservative family. Several times I've wanted to pick up the phone and phone *Nationwide*, because I have seen people being pulled through the mud there because they have too much money.'

'. . . *Nationwide*, for them, they're pigs, the pigs of this society who rob all the money.'

to a fully blown defence of the classical economic theory of the origin of value (cf. the trade union groups' insertion of the labour theory of value here):

'But you must not forget these are the people who provide this country with everything this country has . . . they are the ones who are employing the people . . .'

'Of course they deserve it. People are not paid according to what they can do here in this country.'

and in conclusion makes the emphatic point:

'And if you have a free market system, everybody is free to do what he wants . . .'

'. . . if you want to get something, you can do it.'

Note

In a sense this group are so far to the right of the political spectrum that they might be said to be making a right-wing 'oppositional reading' of *Nationwide*, which they take to be a 'left'/'socialist' programme. However, the substance of their arguments pulls in precisely the same direction as those of the discourse of *Nationwide*; apart from the difficulties of international comparisons and unfamiliarities, there is perhaps more similarity between their perspective and that of *Nationwide* than they realise. Considered only in a formal sense – i.e. in the form of the relation between the group as subject in relation to the signifying chain of the discourse – the responses of groups 25 and 26 could be considered to be equivalent: both are 'subjects out of position' in relation to this signifying system. However, the inadequacy of such a formalistic approach is precisely revealed by the way in which this formal equivalence is displaced through the quite different political/ideological problematics of the two groups. It is the articulation of the formal *and* ideological levels of the discourse, and its decoding, which is in question.

Group 27

This is a group of 18/19 year old white, male, upper working class apprentice printers, members of the National Graphical Association; no dominant political orientation.

They, like group 26, characterise *Nationwide* as:

'To the left, they're going to the left . . . the majority of people think that
Nationwide's left . . .'

and again, like group 26, concentrating on the form of the union/employer dis-
cussion rather than the structure of it, read it as biased in the unions' favour:

'They're talking more to Hugh Scanlon, aren't they?'
'More questions to him . . .'

They are clearly unhappy with what they take to be *Nationwide's* pro-union
stance. Their own experience of the print unions is predominantly one of cyn-
icism and self-interest disguised as principle. From this perspective they are
cynical about the presentation of the case of Ken Dallason, the Leyland tool-
room worker:

'As for the tool worker, that's a bit dodgy, saying he's only earning £45
a week, knowing tool workers, the amount of money they get in over-
time . . .'

And their decoding of this item is informed by, and leads into a generalised expo-
sition of, a stereotype of the 'greedy car worker/mindless union militants'
presumably derived, at least in part, from the media:

'They have got too much power . . . the car unions have got too much
power . . . they go on strike, the government puts more money into it
[British Leyland], the taxes go up, it doesn't go nowhere . . . They kick
up a fuss, the unions, just to sort of show the workers that they're there,
they're trying to help them. But if I had a choice I wouldn't join a
union . . . to me they're more trouble than they're worth . . .'
'The car workers, they're very petty, they sacked one bloke for nicking,
then the whole place comes out on strike, so they've got to re-employ
the bloke, pay him all his back pay even though he's been nicking . . .'
'. . . they're one of the worst of the line, the toolroom workers. It's usu-
ally them that cause the trouble, them or the blooming paintshop . . .'

Moreover, this stereotype is strengthened in its credibility for them because
they can ground it, at least in part, in their own experience; it does have a par-
tial basis in reality (cf. Mepham, 1972; Perkins, 1979).

Q: 'What do you think of the Ford workers?'
'Friend of mine . . . he works at Langley . . . you know. Normally he
goes there and has a game of football, this is true, he has a game of foot-
ball in the machine rooms, muck about, play darts . . . and they're
covered for weeks on end . . .'

250

'They don't work for weeks, because the place is so big, I mean, I know
a lot about the Ford workers because I know quite a few people who
work there, and they can be covered for weeks on end . . . It's because
they're overmanned . . . you can have someone sitting there playing
cards all day, it's either your turn or my turn to play cards . . . you could
do a bit of mini-cabbing . . . even at my place we've got taxi drivers . . .
they're earning a bomb . . .'

This is a view of unions which, whatever its basis in their experience, is resolved
at the level of ideology into an acceptance of a dominant stereotype of unions and
shop stewards, even at a comic level:

'Did you see that film with Peter Sellers in it? [I'm *All Right, Jack*] The one
about unions? . . . really typical, it was on about two Sundays ago . . .
absolutely typical, I mean, it's unbelievable – he was the shop steward,
sitting on his backside in his little wooden hut all day long, "brothers
this and brothers that."'

– clearly an interpellation this group would refuse.

The correlate of this negative disposition towards the unions is a stress on self-
reliance and the 'farm worker' section of the programme is decoded in these
terms. Rather than sympathy being the dominant frame of reference, here the
stress is on the worker's own responsibility to 'sort things out' for himself:

'If you think of that farm worker . . . this is my view . . . if you can't
afford to live properly . . . wouldn't it be best to have two kids, not three
kids? . . . His wife could go out to work . . .'
'. . . you've got to move to a place where there is a lot of work.'

Here this group are employing a perspective to the right of the programme which
most groups see as presenting the farm worker in a quite sympathetic, if pat-
ronising, light. When it comes to tax cuts, as proposed for instance by Mr
Worthington, the tax expert, the group's perspective clearly meshes with that pro-
posed by the programme:

'They could reduce all benefits. Unemployed benefit . . . some people live
on the dole . . . they should pay people below the average living wage
so that they're struggling all the time to get a job, that way you [the tax-
payer] pay less.'

Here the group share the problematic of the programme at a fundamental level,
despite being 'out of position' in relation to the relatively academic mode of
address through which Mr Worthington articulates these propositions:

'I didn't know what he was talking about . . . Well, he goes on, a bit here and a bit there, doesn't give a definite answer.'

However, the decodings of the programme made by this group, despite their cynicism about unions and their stress on work and self-reliance, are not re-solvable into a straightforwardly Conservative problematic. Their views exist in contradictory formulations; for, despite the refusal to accept any directly class perspective in relation to unions and 'scroungers', they also reject and dislike what they see as the programme's partiality towards those who are already 'well off'. In this respect they reject the uncritical presentation of the personnel manager's 'plight':

'They seem particularly concerned with the one that's earning the most money . . . it seemed to be more than just what he was earning, some-thing about his mortgage, and how much he paid out . . .'
'He can always get perks . . . he's got a car on the firm . . . petrol . . . travel expenses . . . it's perks, loopholes. He gets everything . . .'

Moreover, their criticisms of 'the unions' are also articulated not simply as a critique of unionisation in general, but rather as a critique of what they see as a particular, sectional form of unionisation:

'The amount of money there is in the printing at the moment, it's just stupid . . . The unions, they look after Fleet Street, but they're not both-ered about anybody else that much . . . They look after Fleet Street . . . more treatment for Fleet Street than anybody else . . .'

Further, what they go on to object to is the consequences of the operation of free collective bargaining for those sections of the workforce who, through no fault of their own, do not have the power of the print or car workers unions:

'People who seem very low paid seem to be the ones doing the most important jobs . . . policemen, firemen . . . ambulance drivers, they do a good job . . . you've got to have those central people . . . got to have the dustmen, otherwise you won't get the rubbish cleared away . . .'

– evidently a perspective which could articulate as well, if not better, with a socialist rather than Conservative political outlook.

Indeed, at the level of 'politics' their views are distinctly equivocal. They clearly do not see themselves as situated within either of the dominant political parties' perspectives. 'A change of government' is seen as a good thing in itself: perhaps a registration of alienation from, rather than confusion within, the field of established party politics:

'It's good to have a change of government anyway . . .'
'Personally I would prefer it if Labour had stayed in, because I mean, I thought they were slowly clearing the trouble up. No government seems to be in long enough to actually clear things up . . .'
'. . . you get another bunch of idiots in and they turn it all upside down, you get another three-day week . . .'
'. . . I don't know how anybody can vote for the Liberals either.'
'. . . I think it's good to have a change of government anyway . . .'
'I think the Labour government will be back in five years.'
'I reckon they will as well, 'cos Thatcher's going to make a right balls-up . . . Well, I think it's good to have a change now and again. 'Cos it's got to the stage now . . . I voted Conservative, I just didn't know what to vote, you know . . . so I voted Conservative, for a change.'

Similarly, their perspective on 'management' is contradictory rather than monolithic:

'Some of the managers are like that . . . worked their way up . . . some go out on all these so-called "business trips" round the golf-course, "business talk" and all this rubbish . . . but some, if they got rid of them, the place would come to a standstill.'

– clearly a different perspective from the militantly anti-management stance of the shop stewards (group 23) as much from the trainee managers' (group 26) monolithic view of management as 'the people who provide this country with everything this country has'.

The equivocation, finally, also applies to the unions: when pressed, their apparently anti-union stance becomes more complex. The point shifts from the attack on the unions *per se* towards a criticism of a particular form of unionisation, a contradictory prescription for 'unions without power':

'Yes . . . it's a good thing to have unions, but not with power . . .' 'You got to have union power, but not too much . . .'
'I mean, when you had small unions, I mean it's better, but you have a big union, it gets worse and worse . . . corrupt, I reckon.'

Group 28

An all male, all black (mainly Nigerian) group of management trainees, aged 22–39, mostly with a middle/upper middle class background; predominantly 'don't knows' politically.

This group have little familiarity with British politics or with the codes and cultural conventions of British television, hence discussion moves to an abstract level at which 'taxation' is dismissed as an abstract issue, to be argued over at the level of philosophical principle, as a perennial problem which 'a nation' must face.

There is little detailed discussion of the actual programme material shown, because, presumably, much of it is difficult to grasp at the level of connotation – simply in the sense that they do not share, or understand, the framework of taken-for-granted cultural references which underpins the discourse of *Nationwide*. To a large extent, it could be argued that the programme is literally 'unintelligible' to them, beyond the level of the facts and figures given. As 'members' of the English language community they can grasp these aspects of the programme, but as they are not 'members' of the cultural sign community whom *Nationwide* is addressing, they make contradictory and unpredictable decodings of the cultural/connotative messages of the programme.

The dominant response is that:

'The programme is good.'

Indeed they argue that:

'you should watch it because it will make you think more of what is happening in this society . . . if you don't watch such a programme you won't know how people are so affected or what is happening within this society . . .'

Here they perhaps decode the 'place' of *Nationwide* as an 'educational/serious' current affairs programme, interpret it, rather respectfully, within this context, and accordingly approve it.

They claim to 'agree' with what the programme says (although as we shall see later they hold very contradictory views as to what it did say):

'So I think that what they say in the programme . . . to me it makes a lot of sense . . .'

Moreover, contrary, for instance, to groups such as the trade unionists and the sociology students, who criticise the programme precisely for its unbalanced 'sample' of the population and its exclusion of certain groups, this group, probably because of their lack of experiential criteria with which to judge the issue, applaud its range of representation:

'I enjoyed it because it showed a cross-section of the entire populace.'

The same speaker continues, claiming to 'agree' with the programme, to advance a semi-Marxist theory of taxation which is quite at odds with the interpretation preferred by the programme:

'Yes . . . strictly speaking, taxes should be cut according to needs. From every man according to his ability and to him according to his needs.'

Because of the group's difficulty in placing the cultural messages of the programme, questions on specific items in the programme are reinterpreted as questions about the 'issues in principle', and at the resulting level of abstraction any commitment to 'one side or the other' is evaded. The emphasis is rather on the need to 'think broadly' and 'sit down and plan':

> 'What I'm getting at . . . cutting taxes wouldn't solve the problem. The problem is you need taxes for hospitals and schools and so on. And you have to give incentives to people who are going to work. There are two sides to the affair and it's a very difficult decision: the government has to sit down and plan.'
> '. . . it's a very difficult question, actually . . .'
> 'What I'm saying now is that the society in general, we are sick because we are not, as I was saying, thinking broadly on things . . . not that I'm on the side of the government or on the side of any industry . . .'

When pressed on the specific question of the programme's presentation of the role of trade unions, the response is again contradictory, starting by situating itself within the preferred mode of the programme:

> '. . . I know I'm just new to this country . . . I will say the unions are given too much power, because if the union helped with the job, the government would definitely do something to help the ordinary working man . . .'

But the same speaker continues, without apparently remarking on the contradiction with the preferred reading now proposed:

> '. . . the union are the people who are fighting for the right of the ordinary fellow . . . the people who are very close to the citizens are the people who are their representatives. That is why I wouldn't say the unions are being given much power, more than necessary – they're actually doing their job . . .'

This level of contradiction within particular decodings is also present as between the different political perspectives which different members of the group propose. It is rather as if, because their decoding of the programme is so mediated by cultural unfamiliarities, it can coexist with radically different political perspectives: on the one hand a straightforwardly Conservative interpretation of the country's problems:

> 'If you just go on taxing . . . even if you've got £2m and you take away £1m, then where is the investment? There will be money required for investment, where will it come from, and if you cut out your

investment, where are the taxes to come from? . . . A lot of investors have left this country because of taxation . . .'

And on the other hand it can be articulated with a quite contrary Labour perspective, which, interestingly is the one point where the articulation does begin to provide a consistent grip on the specific material of the programme:

'On the programme we had the personnel manager, I think he had everything a man would like to have, a good job, a good home, and telephone and a son at university . . . and yet he wasn't satisfied . . . I mean that's a lot of cash to me, and yet he's complaining . . .'
'. . . to me, I think the top management, they don't need any incentive, because they don't produce anything. It's the skilled workers . . . they are the people that they should give some incentive – because for a man earning £400 p.w., he doesn't need any incentive to do his job because he's producing nothing . . . the man working in Leyland, he said, well they are importing foreign cars into the country. I know what he was talking about, he was talking about losing his job. He said he's been in the job for about 20 years, so if people like him are given incentive, or the farm worker, then definitely he'll do a better job, then the more crops he'll produce at the end of the farming year.'

Group 29

Owing to a fault in the tape recording this group had later to be omitted from the analysis.

6

COMPARATIVE ANALYSIS OF DIFFERENTIAL GROUP DECODINGS

Notes on the pattern of group readings

In summary, then (and at the cost of ignoring for the moment contradictory positions within the same groups), the apprentice groups, the schoolboys and the various managers are the groups who most closely inhabit the dominant code of the programme.

The teacher training college students inhabit the 'dominant' end of the spectrum of 'negotiated' readings, with the photography students (inflected by an ideology of 'media' professionalism) and the university students (in a 'Leavisite' version) positioned closer to the 'oppositional' end of the spectrum.

The black students make hardly any connection with the discourse of *Nationwide*. The concerns of *Nationwide* are not the concerns of their world. They do not so much produce an oppositional reading as refuse to read it at all.

The groups involved with the discourse and practice of trade unionism produce differentially inflected versions of negotiated and oppositional decodings, depending on their social positions and positioning in educational and political discourses, in combination with those of trade unionism.

The problematic proposed here does not attempt to derive decodings directly from social class position or reduce them to it; it is always a question of how social position *plus* particular discourse positions produce specific readings; readings which are structured because the structure of access to different discourses is determined by social position.

At the most obvious level, if we relate decodings to political affiliations then it does appear that the groups dominated by Conservatism – the apprentices, teacher training students and bank managers – produce dominant readings, while those dominated by Labour or socialist discourses are more likely to produce negotiated or oppositional readings. This is not to suggest that it is an undifferentiated 'dominant ideology' which is reproduced and simply accepted or rejected. Rather, it is a question of a specific formulation of that ideology which is articulated through a particular programme discourse and mode of address. Readings are always

257

differentiated into different formulations of dominant and oppositional ideology, and in their differential focus on the ideological problematic and/or the mode of address and discourse of a programme.

The concept of code is always to some extent indefinite. To take the example of dominant code, as employed here it exists in three different versions: for the managers in 'traditional' and 'radical' Conservative forms, for some of the teacher training students in a Leavisite form, and for the apprentice groups in a populist form.

Of these three, according to our characterisation of *Nationwide*'s specific ideological problematic, the groups with the closest match of codes to that of the programme are the apprentice groups – that section of the audience that inhabits a populist 'damn-all-politicians' ideology comparable to that of the programme; indeed, decodings are most 'in line' for these groups. For the bank managers and teacher training students the *Nationwide* formulation of dominant code and ideological problematic fails to 'match' their own formulations exactly (for both, from their different perspectives, *Nationwide*'s presentation is 'insulting' and therefore to some extent unacceptable). Moreover, there is a disjunction here at the level of 'mode of address': these groups find the *Nationwide* mode unacceptable in terms of a more 'classical' conception of 'good'/serious/educational TV discourse which *Nationwide* does not inhabit.

However, there are problems even with the apprentice groups. Some of these groups (e.g. group 6) identified with ATV *Today* rather than with *Nationwide*, because of a greater degree of 'fit' with the discourse of ATV *Today* (more human, 'have a good laugh', etc.): an evaluation/identification informed by a populist sense of ITV as more 'entertainment' versus BBC as too 'serious'/middle class.

Conversely, we must distinguish between different forms and formulations of negotiated and oppositional readings, between the 'critique of silence' offered by the black groups, the critical reading (from an 'educational' point of view) elaborated in articulate form by some of the higher education groups, and the different forms of 'politicised' negotiated and oppositional readings made by the trade union groups. (We can also usefully refer here to Richard Dyer's (1977) comments on the problems of dominant and oppositional readings of, for instance, films with a liberal or 'progressive' slant. What Dyer's comments bring in to focus is the extent to which the tripartite 'meaning-systems'/decodings model derived from Parkin assumes that it is dealing always with messages or texts cast within a dominant or reactionary ideological perspective. Dyer's comments on 'aesthetic' and 'substantive' readings are also relevant to the discussion below of the concepts of ideological problematic and mode of address.)

The diagram is presented in this spatial rather than linear form (as in a one-dimensional continuum from oppositional to dominant readings) because the readings cannot be conceived of as being placed along *one* such continuum. For instance, the black F.E. students are not more 'oppositional' than the University students on the same dimension, rather they are operating along a different dimension in their relations to the programme.

The overall 'spread' of the groups' decoding strategies in relation to the two phases of the project is displayed schematically below:

Phase 1: *Nationwide* 19/5/76

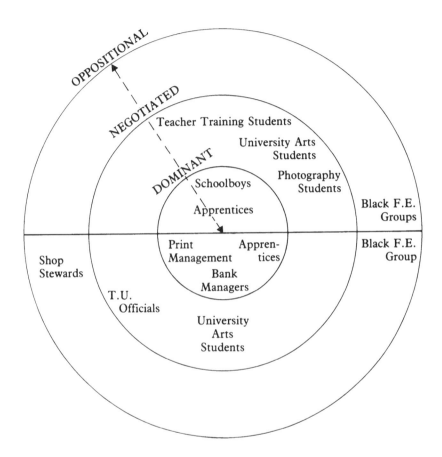

Phase 2: *Nationwide* Budget Special 23/3/77

Thus, in the case of each of the major categories of decoding (dominant, negotiated, oppositional) we can discern different varieties and inflections of what, for purposes of gross comparison only, is termed the same 'code':

Forms of Dominant Code
Groups

26	Print Management: radical Conservative
21, 24	Bank Management: traditional Conservative
1–6 & 27	Apprentices: Populist-Conservative/cynical
10, 12	Schoolboys: deferential (?)

259

Forms of Negotiated Code

14, 15	Teacher Training College Students: Conservative Leavisite
7, 19	University Arts Students: radical Leavisite
8, 18	Photography Students: technicist 'professional' perspective
20, 22	Trade Union Officials: Labourist 'official' perspective

Forms of Oppositional Code

11,13,16,17, 25	Black F.E. Students: alienated 'critique of silence': sub-cultural perspective
23	Shop Stewards: radical rank & file perspective: class perspective

Thus, social position in no way directly correlates with decodings – the apprentice groups, the trade union/shop stewards groups and the black F.E. student groups all share a common class position, but their decodings are inflected in different directions by the influence of the discourses and institutions in which they are situated. In one case a tradition of mainstream working class populism, in another that of trade union and Labour party politics, in another the influence of black youth cultures.

Indeed, in the case of the decodings of the 19/5/76 programme, with the exception of the black groups (who arrive at an oppositional perspective through a different, sub-cultural route) the education system inflects the groups' decodings in a pattern such that it is those more highly placed in that system (and in general those with a more middle class background) who come closer to an oppositional perspective.

Interestingly, in the case of the decodings of the 'Budget' programme (which deals much more directly with issues of class and politics) with the exception of the apprentice group, whose insertion in the mainstream/populist tradition inflects their reading towards the dominant perspective, it is here that we find a greater convergence of middle class positions with dominant or negotiated perspectives and working class positions with more oppositional readings. This is true even within one category: the university arts group in Phase 1 produces negotiated readings with a distinctly 'oppositional' tinge, while the similar group in Phase 2 produces a negotiated reading much closer to the 'dominant' edge of that category, once it is confronted directly with issues of a specifically 'politico-economic' rather than 'cultural' relevance.

Moreover, there are of course some differences between groups from the same category – between the different apprentice groups, or between the different trade union groups, for instance; differences which would require for their systematic investigation much more in the way of time and resources than were available. I can only reiterate my view that these are subsidiary differences, within the perspective taken, as are the differences between individual readings within each group – differences which are to be acknowledged, but which, I would argue, do not erase the patterns of consistency and similarity of perspectives within groups which I have attempted to establish at a more fundamental level.

In order to attempt to demonstrate this claim I now provide, by way of overview, some recapitulation of the basic levels of differential decodings between groups in the different categories.

Inter-group differences: an overview

1 Apprentice groups

These working class groups inhabit a discourse dominated on the one hand by Conservatism and on the other by a populism which rejects the whole system of party politics (they are militant non-voters: 'they're all as bad as each other/they've all got the same ideas'), and to some extent identify with the National Front. (Note: these groups are the only ones in my sample which showed any NF influence.) The tone of their overall response to the programme is one of cynicism and alienation.

However, despite the overall tone of rejection and cynicism, most of the main items in the programme are decoded by these groups within the dominant framework or preferred reading established by the programme. The situation here seems to be the converse of that outlined by Parkin in his account of working class groups who accept a dominant ideology at an abstract or generalised level but reject it, or 'negotiate' its application, in their own specific situation. Here, on the contrary, we have working class groups who proclaim a cynical distanciation from the programme at a general level but who accept and reproduce its ideological formulations of specific issues.

This disjunction may be conceptualised in two different ways. In the first place, we might hypothesise that the general tenor of cynical response amounts to a defensive stance. It is an attempt to appear worldly-wise, not to be taken in by television − a stance which, because it is not produced by adherence to any definite, ideological problematic other than that provided by the programme, fails to deliver any alternative formulations in which the particular issues dealt with can be articulated. It thus returns the viewer, by default, to acceptance of *Nationwide's* formulations. This, then, is a peculiarly weightless cynicism which combines quite readily with an acceptance of the framework of meanings established in the programme.

There is a second way of conceptualising the disjunction noted above. We can adapt Steve Neale's (1977) distinction between the ideological problematic of a text − 'the field and range of its representational possibilities' and the mode of address of a text − its relation to, and positioning of, its audience. The concept 'ideological problematic' designates not a set of 'contents' but rather a defined space of operation, the way a problematic selects from, conceives and organises its field of reference. This then constitutes a particular agenda of issues which are visible or invisible, or a repertoire of questions which are asked or not asked. The problematic is importantly defined in the negative − as those questions or issues which cannot (easily) be put within a particular problematic − and in the positive

as that set of questions or issues which constitute the dominant or preferred 'themes' of a programme.

The concept of 'mode of address' designates the specific communicative forms and practices of a programme which constitute what would be referred to in literary criticism as its 'tone' or 'style'. In Voloshinov's terms these are the 'occasional forms of the utterance', those forms which are deemed situationally appropriate. This 'appropriateness' is principally defined in relation to the programme's conception of its audience. The mode of address establishes the form of the relation which the programme proposes to/with its audience. Thus the disjunction noted earlier must also be characterised as one where these groups reject at a general level the programme's mode of address or articulation – as too formal/middle-class/'BBC-traditional' – but still inhabit the same 'populist' ideological problematic of the programme, and thus decode specific items in line with the preferred reading encoded in the text.

The sharing of this ideological problematic is particularly difficult to investigate or articulate precisely because it is the problematic of 'common sense' and as such is deemed obvious and natural. However, the point is that 'common sense' always has a particular historical formulation; it is always a particular combination constituted out of elements from various ideological fields and discourses – what is shared here is a particular definition of 'common sense'.

These groups are at times hostile to the questions being asked, annoyed at being asked about what is obvious; it seems hard for them to articulate things which are so obvious. There is also a defensive strategy at work. Judgement words such as 'better', 'boring', etc. are used without explication, and explication is impossible or refused because 'it's only common sense, isn't it?' *Nationwide's* questions are justified as 'natural', 'obvious' and therefore unproblematic: 'They just said the obvious comment, didn't they?'

The *Nationwide* team are seen as 'just doing a job', a job seen in technical terms, dealing with technical communication problems. To ask questions about the socio-political effects of *Nationwide's* practices is seen as going 'a bit too far in that . . . approach . . . it's going a bit too deep really . . . after all people don't sit by the fireside every night discussing programmes like we're doing now, do they?'

In these discussions, the terms of criticism are themselves often derived from the broadcasters' own professional ideology. Thus the most critical term is precisely that of bias or balance: 'They're biased though, aren't they . . .' 'it biased it before it even started.' But the limit of criticism is also set by the problematic of 'bias': specific items may be biased, at exceptional moments 'they' might 'slip in the odd comment, change it a bit', but these are merely exceptions in a balanced world, produced by programme-makers just doing a job like everyone else. This is the ideological structure described by Poulantzas (1973) as one whereby:

'The dominated classes live their conditions of political existence through the forms of the dominant political discourses: this means they often live

even their revolt against the domination of the system within the frame of reference of the dominant legitimacy.'

(p. 223)

When I began the research I expected to find a clear division so that decoding practices would either be unconscious (not recognising the mechanisms of construction of preferred readings) and as such, in line with the dominant code or else, if conscious, they would recognise the construction of preferred readings and reject them. In fact, the recognition of 'preferring' mechanisms is widespread in the groups* and combines with either acceptance or rejection of the encoded preferred reading; the awareness of the construction by no means entails the rejection of what is constructed.

This is to point to the distinction (cf. Stevens, 1978: 18–19) between the level of signification at which the subject is positioned in the signifying chain; and the level of the ideological at which particular problematics are reproduced and accepted or rejected. The two levels can actually operate in variable combinations: on the one hand, the positioning of the subject does not guarantee the reproduction of ideology (the same subject position produced from/by the text can sustain different ideological problematics); conversely, a break in, or deconstruction of, the signifying mechanisms of the programme (an interview 'seen through' as 'loading the questions', etc.) will not automatically produce or necessitate an oppositional reading, if there remains an underlying shared and accepted ideological problematic.

2 Trade union groups

Contrary to Blumler and Ewbank's study, which found little difference in decoding between ordinary trade union members and full-time officials, my material shows the considerable influence on decoding of different kinds and degrees of involvement in the discourse and practices of trade unionism.

Comparing groups 1–6 and 20, 22, 23 – groups with the same basic working class, socio-economic and educational background – there is a profound difference between the groups who are non-union, or are simply *members* of trade unions, and those with an active involvement in and commitment to trade unionism, the latter (groups 20, 22, 23) producing much more negotiated or oppositional readings of *Nationwide*. So the structure of decoding is not a simple result of class position, but rather (cf. Willemen, op. cit.) the result of differential involvement and positioning in discourse formations.

However, this is not a simple and undifferentiated effect. There are significant differences between the three trade union groups as well, which need to be

*This in fact provides an interesting extension of John O. Thompson's (1978) comments in his review of *Everyday Television: 'Nationwide'*, where he questions the extent to which this project has itself failed at times to escape the trap whereby only the media analyst is assumed, for some unspecified reason, to be beyond the influence of the 'dominant ideology'.

explored in terms of the differential involvement in discourses which produce these readings. There are, on the one hand, differences between the two groups of full-time trade union officials – group 22 producing a noticeably more 'oppositional' reading than group 20 – which we can only, hypothetically, ascribe to the effects of working in different unions, differentially placed in the public/private and productive/service sectors – in short to differences within the discourse of trade union politics.

Further, there are the significant differences between the articulate, fully oppositional, readings produced by the shop stewards as compared with the negotiated/oppositional readings produced by groups 20 and 22 taken together (full-time officials). This, I would suggest, is to be accounted for by the extent to which, as stewards, group 23 are not subject so directly to the pressures of incorporation focused on full-time officials and thus tend to inhabit a more 'left-wing' interpretation of trade unionism. The difference between these groups also has to be accounted for by the effect for group 23 of their on-going involvement in a highly politicised educational situation, as part-time students on a labour studies diploma run by the student collective. This educational context in combination with the experience of working as a shop steward is probably responsible for the development of such a coherent and articulate oppositional reading of the programme as this group makes.

3 *Teacher training college groups*

While the teacher training students (groups 14 and 15) share with the apprentices (1–6) a dominant political affiliation to the Conservative party (although already differently inflected in each case), their insertion in the discourse of Higher Education acts, in combination with this 'Conservatism', to shift their readings further into the 'negotiated' as opposed to 'dominant' area. It is this discourse which differentiates their situation, and their readings, from those of the other 'conservative' groups.

Taking the involvement in educational discourse as a variable we can compare the decodings (manifested for instance in differential use of the term 'detail' as a value-judgement/criterion by which programmes are assessed) of groups 14 and 15 – student training to be teachers, heavily implicated in the discourse of education – with groups 11, 13, 16 – black students resistant or without access to this particular discourse, with its high estimation of serious, educational TV and its concern for information and detail. From the black students' perspective the programme is seen to go 'right down into detail' and as a consequence is 'boring' and fails to live up to their criterion of 'good TV' as principally entertaining and enjoyable. For the teacher training students the *Nationwide* programme fails because it does not have enough detail or information and fails to be serious or worthwhile.

The differentially evaluative use of the same term 'detail' noted above, as it functions in different discourses, is a perfect example of Voloshinov's concept of

the 'multi-accentuality' of the sign, and the struggle within and between different discourses to incorporate the sign into different discursive formations.

The differential involvement in the discourse of formal education of the teacher training student groups and the black 'non-academic' students groups can precisely account for their responses to the programme and for the different framework within which they articulate and justify these responses. Moreover, the notion of differential involvement in educational discourse can be mobilised to explain the decoding of the students' 'rubbish' item by some of the teacher training students groups as opposed to most of the other groups. The groups who inhabit this same educational discourse tend to read sense into the students item; the other groups tend to accept *Nationwide*'s implicit characterisation of the students as 'wasting time'.

The comparison of perspectives is at its sharpest in the case of these groups because they stand at opposite ends of the spectrum of involvement in educational discourse. Trainee teachers groups 14 and 15 are probably those most committed to that discourse in the whole sample, as the working class black groups (11, 13, 16) are probably those most alienated from the discourse of formal education.

4 Black further education students

These groups are so totally alienated from the discourse of *Nationwide* that their response is in the first instance 'a critique of silence', rather than an oppositional reading; indeed, in so far as they make *any* sense at all of the items, some of them at times come close to accepting the programme's own definitions. For example on Meehan: 'all I heard was that he just come out of prison . . . something he didn't do, that's all I heard'. In a sense they fail, or refuse, to engage with the discourse of the programme enough to deconstruct or refine it. However, their response to particular items is, in fact, overdetermined by their alienation from the programme as a whole.

Taking up the argument (from Carswell and Rommetveit, 1971, *Social Contexts of Messages*) that the action of any one discourse and its interpretation always involves the action of other discourses in which the subject (as the site of interdiscourse) is involved, the differential interpretation (and rejection) of *Nationwide* by the predominantly black groups (11, 13, 16) is not to be explained as the result of some interruption of the 'natural flow' of communication (cf. Hall's, 1973, criticisms of this model of 'kinks' in the communication circuit). Rather, what this points to is that these groups, not simply by virtue of being black, but by virtue of their insertion in particular cultural/discursive forms, and their rejection of or exclusion from others (which insertion is structured, although not mechanistically determined, within their biographies, by the fact of being born black), are unable or unwilling to produce 'representations' which correspond to those of the programme, or to make identifications with any of the positions or persons offered through the programme.

As Henry puts it ('On processing of message referents in Contexts', in Carswell and Rommetveit, op. cit.):

> Differences between representations indicate differences in the analysis of the real, assumed or imagined events, situations . . . which the message is about, as well as differences in the positions of speakers. They can also indicate differences in the loci occupied by different speakers within the social structure and hence also differences in their economic, political and ideological positions . . .
> . . . in order to interpret the messages he receives, the addressee must elaborate representations with those messages . . . if the addressee is not able to build up such representations the message is meaningless for him.'
>
> (pp. 90–1)

Here we have a clear case of disjunction between the 'representations' of the programme and those of these black students' culture. However, this 'effect' – which appears as 'disruption' of communication – must alert us to a wider question. Here the action of the cultures and discourses which these groups are involved in acts to block or inflect their interpellation by the discourse of *Nationwide*; as a negative factor this is quite visible. We must note, however, the converse of this argument in the cases of those groups (all the others except 11, 13, 16) who are not involved in these particular discourses and therefore do not experience this particular blocking or inflection of *Nationwide* discourse. Here it is not simply a case of the absence of 'contradictory' discourses; rather it is the presence of other discourses which work in parallel with those of the programme – enabling these groups to produce 'corresponding' representations. Positively or negatively, other discourses are always involved in the relation of text and subject, although their action is more visible when it is a case of negative – contradictory rather than positive – reinforcing effect.

5 Higher education students

It is among these groups, inserted in the discourse of higher education but unlike groups 14 and 15 away from the conservatism of the teacher training college, that we find an articulate set of negotiated and oppositional readings and of redefinitions of the framework of interpretation proposed in the programme. Moreover, because of their particular educational backgrounds they consistently produce deconstructed readings; that is to say, they are particularly conscious of the methods through which the *Nationwide* discourse is constructed.

These groups, rather like the bank managers at times, dismiss *Nationwide*'s style and mode of address as simply 'undemanding entertainment/teatime stuff', again criticising *Nationwide* from a framework of values (in their case a Leavisite notion of 'high culture') identified with those of 'serious BBC current affairs'.

As argued above, their decodings of the 'Budget' programme (as opposed to

their decodings of the 'Everyday' programme) are consistently less oppositional. In that programme, in the sections with the tax expert and the three families, they make, again like the managers, little or no comment on the problematic employed by the programme. They criticise the style as 'patronising' and further, also like the managers, see no *particular* class theme in the 'families' section – while accepting *Nationwide*'s reduction of class structure to individual differences: 'different classes . . . it's a fact of life . . .' I would argue that this lack of comment is evidence of the invisibility rather than the absence of themes, an invisibility produced by the equivalence between the group's problematic and that of the programme in this respect.

Code	Group	Mode of address	Ideological problematic
Dominant	Bank Managers	Extensive critical* comment: focused	Little comment – invisible/ non-controversial/shared
Negotiated/ Oppositional	Trade Unionists	Treated as subordinate issue	Rejection – focus on the problematic*

* It is interesting to compare these findings with those quoted in Sylvia Harvey (1978): 147. Paul Seban (author of the film *La CGT en mai '68*) is discussing the differential responses to screenings of the film on the part of management and workers:

'This has often been reported to me. Workers see the film and say: "That's our strike." Engineers and office staff see it and say: "It's well made. The images are beautiful."'

Dominant and oppositional readings: mode of address and ideological problematic

The differential decodings of the bank managers as opposed to the trade unionists, represented diagramatically above, raise important theoretical problems concerning the nature of decoding. If we contrast these two groups of readings across the two dimensions of communication defined by Neale (1977) as mode of address and ideological problematic we see that the dominant and oppositional readings focus on quite opposite aspects of the programme.

Interestingly, the managers hardly comment at all on the substance of the ideological problematic embedded in the programme. Their attention focuses almost exclusively on the programme's mode of address, which they reject as 'just a tea-time entertainment programme, embarrassing . . . patronising . . . exploiting raw emotion . . . sensationalism'. Their adherence is to a mode of address identifiable as 'serious current affairs'; they mention the *Daily Telegraph*, *Panorama* and the *Money Programme* as models of 'good coverage' of these issues, and dismiss *Nationwide* in so far as it fails to live up to the criteria established by this framework.

By contrast, the shop stewards can accept the programme's mode of address to some extent: 'It's light entertainment/not too heavy/easy watching/quite good entertainment': what they reject is *Nationwide*'s ideological formulation of the 'issues'. Thus in the case of the 'Budget' programme the dominant readings

concentrate their comment (which is largely critical) on the programme's un-acceptable style or mode of address, while for them the ideological problematic passes invisibly, non-controversially; whereas the oppositional readings focus immediately on the unacceptable ideological problematic, and the mode of address is treated as a subordinate issue and given little comment – or even appreciated.

To theorise these findings we can extend the argument made by Ian Connell in respect of the transparency of programme discourse to cover the case also of the transparency of an ideological problematic in cases of 'fit' between the problem-atic employed in the encoding and that of the decoding. As Connell (1978) argues in respect of programme discourse:

> We must ask whether these roles or 'spaces' in the discourse are accepted, modified or rejected, by whom and for what reasons. We shall take as an indicator of acceptance, for example, the absence of any spontaneous comment about the discourse as such, and about the roles advanced in it. In other words, for those who share the professional sequencing rules the discourse will not 'intrude', and they will spontaneously talk about the topic . . . When there is modification or rejection, we would expect explicit comments concerning the organisation of the discourse.

Similarly, for those who share the ideological problematic of the programme the problematic does not intrude (indeed the bank managers and students deny the very presence of any particular problematic) and they spontaneously talk about the discourse or mode of address. Where groups, such as the trade unionists, do not share the problematic it is quite 'visible' because it is 'controversial' to them. Presumably, in the limiting case of exact 'fit' between encoding and decoding in both mode of address and ideological problematic the whole process would be so transparent/noncontroversial as to provoke no spontaneous comment at all.

This is to propose the general principle that the unasserted (what is taken as obvious/natural/common-sensical) precedes and dominates the asserted (partic-ular ideological positions advanced within this taken-for-granted framework). As long as the (unasserted) 'frame' is shared between encoder and decoder then the passage of the problematic embodied in that frame is transparent. We can then speak of four decoding positions, represented diagrammatically below:

1) Where the problematic is unasserted and shared, and passes transparently (e.g. the unstated premise in a report that 'race' is a problem – which premise is 'unconsciously' shared by the decoder).

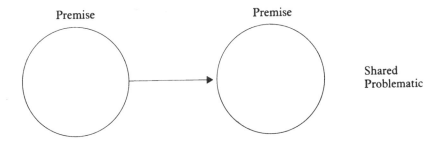

2) Where a particular position within a problematic is asserted and accepted; here the encoded position is accepted by the decoder but it is consciously registered as a position (not a 'natural fact') against other positions. To the extent that this is then a recognition of the necessary partiality of any position it is a weaker structure than 1 (e.g. the explicitly made and accepted statement that blacks cause unemployment).

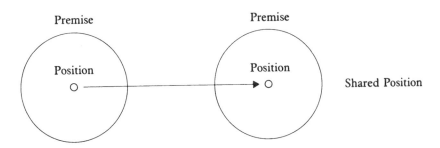

3) Where a particular position within a problematic is asserted but rejected, while the problematic itself is not brought into question (e.g. the explicitly made statement that blacks cause unemployment is rejected as simply another of the politicians' endless excuses for their failures and the racist problematic is not necessarily challenged).

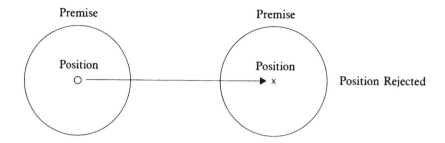

4) Where the underlying problematic is consciously registered and rejected (e.g. a particular report with racist premises is deconstructed to reveal those premises and another problematic is inserted in its place).

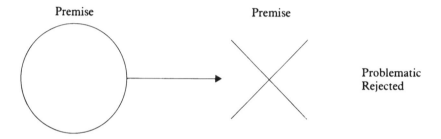

7

DECODING TELEVISION

Theorising determinations

The effectivity of the text

It seems that media and film studies are still subject to the kind of oscillation described in Chapter 1. At one moment the field is dominated by a theory (such as 'uses and gratifications' in recent years) which holds the media to have little or no direct 'effect' on its audiences, and at the next moment the pendulum swings towards the dominance of a theory (such as that developed in *Screen* more recently) of the near total effectivity of the text, in their terms, in the 'positioning of the subject'. In order to escape from this oscillation we need to develop a theory which gives due weight to both the 'text' and 'audience' halves of the equation.

Having situated the project in relation to the dominant paradigms of the sociology of mass communications in the earlier chapters, I shall concentrate here on the relation of this project to that body of film theory developed predominantly in *Screen*, and in particular, focusing on the audience ('subject')/text relation proposed there. There is space here to discuss that body of work only in its broad outlines; to this extent I may be faulted for presenting this theory as more monolithic than it in fact is. It is of crucial importance here to note the contributions of Neale (1977) and Willemen (1978), who while writing within the framework of *Screen* seem to raise problems which highlight the deficiencies of the 'orthodoxy' developed by Heath, MacCabe and others and lead in the direction of possible solutions to these problems.

As we have seen in the research outlined at length in the previous chapters, a given text can be appropriated by readers in different ways, read to produce divergent interpretations. Thus the text does not construct or determine the reader – that is to grant complete determinacy to the text and hence to conceive of readers as:

> blanks, mere functions supporting the text, and passively to be constructed and put into place according to the whim of the text.
>
> (Willemen, op. cit.: 49)

This is the point of Steve Neale's argument that textual characteristics are no

271

guarantee of meaning. In the case he examined, texts without the characteristic textual mode of address of propaganda were able to function as propaganda in certain circumstances, and, conversely, texts with a propagandist mode of address could be 'defused' by the context in which they operated. However, 'interpretations' are not arbitrary but are subject to constraints contained with the text itself. Textual characteristics do have effectivity, though not absolute effectivity; for:

> Some texts can be more or less recalcitrant if pulled into a particular field, while others can be fitted comfortably into it.
> Texts can restrict readings (offer resistance) although they can't determine them. They can hinder the productivity of the plurality of discourses at play in them, they can emphasise certain discourses as opposed to others (through repetition or other 'foregrounding' devices).
>
> (Willemen: 63)

In recent years *Screen* has made a consistent intervention into the field of film and media studies which has usefully focused on a number of important questions concerning the formal operations of ideology. However, I would argue that the problematic proposed there is often flawed precisely by a mechanistic assumption that the audience/viewer is necessarily 'positioned' or placed by a programme so as to reproduce the dominant ideology. Their concern is with the (re)production of the ideological subject by the text, but the problematic is overly deterministic:

> an important – determining – part of ideological systems is then the achievement of a number of machines (institutions) that can move the individual as subject.
>
> (Heath, 1976)

> In the brief action of finding Vincent, Linda and Keith in this section the viewer is placed in the enounced, in the enunciation and in the setting of the unity of the two, the programme's process – and – position.
>
> (Heath and Skirrow, 1977)

> it maps out little fictions . . . in which the viewer as subject is carried along.
>
> (op. cit.: 58)

> . . . to expose TV in its programmes . . . has a value against the sufficiency of the 'institution and its unquestioned performance of the subject'.
>
> (op. cit.: 59)

I would argue that we need precisely to question that 'performance'. Heath and Skirrow's formulation *assumes* the efficacy of the programme's structure and strategy in placing its audiences into a given position in relation to a text. What in the formulation of 'preferred readings' is presented as a problematic attempt at the

structuration of meaning for the audience is here presented as a necessary result. I would not argue with Heath and Skirrow's formulation of TV as a medium where:

> the viewer doesn't make his own decision what to look at: it is made for him.
>
> (op. cit.: 33)

In *Nationwide*, for example, a programme link may take a form such as:

> 'And after your own programme, we go racing . . .'

– and the point is that 'we' are implicated, because if they go racing, we go racing, unless we switch off. But this is already to grant the space between text and audience. The presenter attempts to implicate us, as audience – but it is an attempt which may be more or less successful; it is not a pre-given and guaranteed achievement.

Here I would want to insist on the active nature of readings and of cultural production. Too often the audience subject is reduced to the status of an automated puppet pulled by the strings of the text. As Connell (1979) correctly argues:

> Any reading is never simply consumptive, a mere adoption of the subject-forms mapped out by the formal operations of a text. Any reading is also, and always, interrogative. In short, the reading of a text is, at all times, a practice of 'expanded reproduction' (Marx), a reconstruction of the text in and through extra-textual discursive formations.
>
> (p. 133)

At this point I would like to take up some of the implications of Paul Willis' work on forms of working class cultural opposition within the school system, work which gives due weight to the unevenness of those practices which act to reproduce social structures, and their contradictions. As Willis (1978) argues, the problem is that:

> Structuralist theories of reproduction present the dominant ideology . . . as impenetrable. Everything fits too neatly. There are no cracks in the billiard ball smoothness of process . . .
>
> (p. 175)

As he goes on to say:

> Social agents are not passive bearers of ideology, but active appropriators who reproduce existing structures only through struggle, contestation and partial penetration of those structures . . .
>
> (p. 175)

The point is that dominant ideological and cultural forms are:

> not produced by simple outside determination [but] . . . also from the
> activities and struggles of each new generation . . . which actively pro-
> duce and reproduce what we think of as aspects of structure. It is only
> by passing through this moment that determinations are made effective
> in the social world at all.
>
> (pp. 120–1)

This is also to say that, if we are to speak of the reproduction of a dominant
ideology, we must see that such an ideology can *only* have effectivity in articulation
with the existing forms of common sense and culture of the groups to whom it
is addressed.

However, this is not to argue that subordinate groups are free to produce their
own cultural life and forms, or readings of dominant forms, in unlimited space.
Parkin effectively makes the point that:

> values are not imposed on men in some mechanistic way. Men also
> impose their will by selecting . . . from the range of values that any com-
> plex society generates. At the same time individuals do not construct
> their social worlds in terms of a wholly personal vision, and without
> drawing heavily on the organised concepts which are part of public
> meaning systems. Variations in the structure of attitudes of groups or
> individuals . . . are thus to some extent dependent on differences in
> access to these meaning systems.

This is the process to which Willis refers when he argues that subordinate groups
produce their own cultures 'in a struggle with the constrictions of the available
forms' (p. 124) – a process which is not 'carried' passively by *tragers*/agents but
contradictorily produced out of a differentially limited repertoire of available cul-
ture forms.

Signification and ideology: the problem of specificity

I would argue that Hirst and his followers, in their concern with the specificity
of 'signifying practices', have themselves consistently tended to reduce ideology
to signification; to reduce, for instance, a particular television text to an example
of 'Television-in-General', or 'Televisionality'.

Tony Stevens (1978) has recently criticised the 'Encoding/Decoding' model for
assuming 'more of a "lack of fit" between ideology and signification than is ne-
cessary to grasp the significance of their non-identity'. This argument seems to me
to depend on the unjustified equation of the reproduction of ideology with the
production of subject positions. Moreover, this is linked to his second criticism,
that the model 'conceives the text in terms of the transmission rather than the

production of messages'. But what he seems to want to substitute is a model in which the text is the total site of the production of meaning rather than working within a field of pre-existing social representations, and the production of the subject is placed entirely on the side of signification, ignoring the social construction of the subject outside the text. This connects with the third criticism, where the distinction between the social subject and the reader of the text in the Encoding/Decoding model leads Stevens to argue that the model 'admits no way in which the text constructs its own reader and in this denies the very nature of reading'. On the contrary, the model's conception of the preferred reading of a text relates precisely to this point – but it is not assumed here, as it is usually within the *Screen* problematic, that the preferred reading will necessarily be taken up by the reader of the text.

An alternative way of conceptualising the problem of 'specificity' is to pose the concept of professional code as precisely being the theoretical space where the 'specificity' of TV as a medium is to be situated, and is to be seen to have determinate effects (*pace* Hirst) in terms of a sedimented set of professional practices that define how the medium is to be used (i.e. it is not a quality of the medium as such). The point here, however, is that this 'specificity' is not a world apart from that of ideology but is always articulated with and through it. This articulation is precisely the space in which we can speak of the relative autonomy of the media.

An example from the programme used in Phase 1 of the project may help to illustrate the point. The Meehan item is opaque – hard to read. What *Nationwide* have chosen is a particular focus on the 'human', subjective or expressive aspect of that person's experience. What is 'not relevant' as far as they are concerned is the whole political background to the case. Now that is not to say that this is a straightforwardly ideological decision to block out the political implications of the case. It's much more, in their terms, a communicative decision, as it appears to them; that is their notion of 'good television', to deal in that kind of 'personal drama'. This is an example of the operation of 'professional codes': a case where a dominant code or ideology has to pass through the concerns of a professional code. The decision to focus on a close-up of Meehan's face is a decision within the terms of a professional code. Its consequence is that the 'sense' of the case, of the background to the item, is virtually impossible to 'read' and the viewer is made more than usually dependent for clarification on the presenter's 'summing up' of the item: the 'professional' decision thus has ideological consequences.

Within the terrain mapped out by *Screen*, the concern with analysing the specificity of televisual signifying practice often gets re-written as a concern:

to discover television itself. (Caughie, 1977: 76)
to insert the question of television itself. (Heath and Skirrow, 1977: 9)

The concept of 'television itself' is on a par with the concept of 'ideology in general' or 'production in general': as an analytic abstraction which cannot be related

directly, without further socio-historical specification, to the business of analysing the production and reproduction of specific ideologies in concrete social formations at a stage in their historical development.

In fact Heath and Skirrow themselves state that:

> it is only in the detailed consideration of particular instances that the effective reality of television production can be grasped.
>
> (p. 9)

but this seems to sit unhappily with the formulations quoted above, which indicate a tendency to abstraction or hypostatisation – no doubt informed by a concern with 'specificity' – of the level of signifying practice, to the point where it becomes unclear what relations these practices contract with other levels of the social formation.

Heath and Skirrow seem to go further. They argue that 'the level of social connotations' is not their concern; here the concern with 'television itself' leads to a position where:

> what counts – initially – institutionally, is the communicationality [not] the specific ideological position.

Indeed they argue that it is of:

> little matter in this respect what is communicated, the crux is the creation and maintenance of the communicating situation and the realisation of the viewer as subject in that situation.
>
> (p. 56)

The question of 'what is communicated' is, however, not so simply to be relegated to a subordinate position. *Nationwide*, for example, is in the business of articulating 'topical' ideological themes for its audience, and if we are to understand the specificity of *Nationwide* discourse, we need to pay attention to 'what is communicated' within the general framework of the 'reproduction of the communicative situation and the realisation of the viewer as subject in that situation' (Heath and Skirrow: 56).

As ideologies arise in and mediate social practices, the 'texts' produced by television must be read in their social existence, as televisual texts but also as televisual texts drawing on 'existing social representations' within a field of dominant and preferred ideological meanings. For this reason a concern with the 'level of social connotations' (Heath and Skirrow: 13) must remain as a central part of the analysis. It is only through an analysis of the historical specificity of ideological themes, as articulated by particular programmes in specific periods, that we can begin to map (albeit perhaps only descriptively) the shifting field of hegemony and ideological struggle which is the terrain in and on which the specific practices of television are exercised. This is to argue for an articulation of

discursive/signifying practice with political/ideological relations much closer than that proposed in the problematic of a concern with 'television itself'.

Alan O'Shea (1979) has usefully introduced Voloshinov's (1973) distinction between 'themes' and 'mechanisms' (presented in *Marxism and the Philosophy of Language*, p. 100) to deal with the articulation between the question of what an ideology is and how it comes to be appropriated. As he rightly argues:

> themes are only articulated through the mechanisms – which have a determining effect on what the themes are – but . . . the study of the mechanisms . . . only bears fruit when analysed in conjunction with what is represented.

The *Screen* problematic focuses exclusively on the process of signification as the production of the subject. But signification always occurs in ideology, and when the passage of dominant meanings is successful this is so as a result of operations at both levels. Not simply because of the successful positioning of the subject in the signifying process (the same signification or position is compatible with different ideological problematics; successful positioning in the chain of signification is no guarantee of dominant decodings); but also because of the acceptance of *what* is said.

The 'what' of ideology

This is to insist on the importance of 'what gets said' and also on the question of 'what identifications get made by whom'. MacCabe (1976) attempts to introduce into the *Screen* problematic the question of 'readers' who are offered 'explanations' of their lives, ideological viewpoints which they may or may not adopt. The difficulty is that the established *Screen* problematic provides no theoretical space into which this question can be inserted – as Adam Mills and Andy Lowe (1978) point out in their critique of MacCabe:

> If ideology is posed as a structuring moment then the matter of content is irrelevant, since the ideological position remains the same (regardless of content) . . . if on the other hand MacCabe proposed that the ideological position is given not by . . . identification as process, but by what specific imaginary is constituted (i.e. regardless of process) then this must have, necessarily, radical effects for what is now proposed as the body of concepts relevant for this work . . . up until now the subject . . . has been an effect of the signifying chain, as a mechanism, as a regulated process . . . But ideology is now presented as an explanation, which must deal with contents, and to which an individual (not apparently as subject) can maintain a critical distance and exercise a choice. The vital question is, by what means? In all the preceding analyses there has been no provision for an individual entering into any relation with

signification as anything but a subject. The individual can be present in discourse only as a subject, and the ordering of that discourse has permitted no contradiction in determining the form of that subjectivity.

In order to provide the theoretical space in which these concerns can be inserted it is necessary to amend the terms of the problematic. It has to be accepted that the matter of 'what specific imaginary is communicated' is important both positively and negatively – in cases of both successful and unsuccessful interpellation – not simply as a negative consideration that at times 'interrupts' the process of signification.

Jim Grealy (1977) puts this well in relation to the ideological effectivity of Hollywood cinema. He argues that popular cinema cannot:

> avoid the real concerns of [its] audience. Hollywood cinema elaborates a certain understanding of the common experiences of the individual subject in capitalist, patriarchal society and it is this ability to elaborate conflicts which have a real basis in the daily struggles of the individual subject/spectator, and its ability to propose representations/fantasies in which the spectator can find imaginary unity that allows Hollywood to find a popular basis and to carry an important ideological charge.
>
> (p. 9)

To return the argument to the Heath and Skirrow piece on *World in Action*, Alan O'Shea contends that the authors, in their exclusive concentration on the form of signification, leave:

> no place for the other 'circuit', the viewer as bearer of a complex of interpellations, many of which are not constructed by the TV text.

To take an example from the *World in Action* analysis, the authors argue that Dudley Fiske – the 'expert' called in to sum up on the problem of truancy – has the power that he does within the discourse of the programme by virtue of his formal position within the structure of the text and narrative (the 'overlook'/Fiske as 'ideal viewer'). However, while Fiske's contribution is a powerful attempt at closure of the potential decodings of the programme, that power derives from two sources: both from his formal position within the text and from his social status (derived from a point outside the field of media discourse although necessarily realised within it) as an 'expert' on the relevant subject. It also depends on what he says, and the relation of the discourse within which he speaks to the discourses of the various sections of his audience.

This cuts both ways: if a member or section of the audience accepts the 'positionality' offered to him/her through Fiske's account of the problem then he/she does so as a result of both factors. Moreover (and this I think Heath and Skirrow would find it hard to account for), because both factors are relevant it is possible

for the decoder to refuse or negotiate the 'position' offered through Fiske, despite his powerful structuring position in the text, if that interpellation is blocked or contradicted by the interpellations of other discourses in which the subject is involved, say as parent, truant or politician.

Taking up Neale's (1977) distinction between mode of address (textual characteristics) and ideological problematic we may attempt to reformulate the *Nationwide* model with reference to both dimensions. This is to argue for an articulation between the formal qualities of the text and the field of representations in and on which it works, and to pose the ideological field as the space in which signification operates. I would argue with Neale that:

> what marks the unity of an ideology is its problematic, the field and range of its representational possibilities (a field and range governed by the conjuncture) rather than any specific system of address.
>
> (pp. 18–19)

Our attempt in *Everyday Television: 'Nationwide'* to identify such a 'unity' at the level of problematic was couched descriptively. We attempted to construct a sentence: 'England is a country which is also a Nation in the modern world, with its own special heritage and problems' which would identify the particular 'combinatory' which constitutes *Nationwide*'s transformation and unification of elements from other ideological fields. Here again, Neale theorises the necessity of this process in his recognition that:

> an ideology . . . is never . . . a single, self-contained discourse or unit of themes, but is rather the product of other ideologies and discourses converging around and constituting those themes.
>
> (p. 18)

The absence of this level of attention is apparent in the Heath and Skirrow piece. As O'Shea argues, what they end up doing, because they are not concerned with the programme's specific ideological formulation of the problems of the educational system, is to import through the back door the assumption that the programme is simply about 'truancy' as if this 'subject' existed unproblematically as a shared referent for all members of the audience rather than being, necessarily, constructed in its specific form through the process of signification.

Discourse analysis

What is necessary is an attention to the level of 'referential potentiality' of signs and words – rather than the assumption of a model in which:

> words are thought of as labels applied to real or fictitious entities.
>
> (Henry, 1971: 77)

We must move to the level of discourse analysis:

> The emphasis upon referential potentialities of content words, as opposed
> to the notion of rigid connections between words and referents, moreover,
> paves the way for hypotheses concerning ways in which 'referents' are
> established in the process of social interaction . . . discourse must be
> understood as a process of construction of social realities and imposition of
> these realities upon the other members of the communication process
> rather than as an exchange of information about externally defined referents.
>
> (Carswell and Rommetveit, 1971: 9–10)

This is to argue that contexts (both intra and extra discursive contexts) determine
which referential potentialities will be activated in any particular case: the point
being that referents are connected to discourses, not languages. In this sense there
is no given referent for the word 'truancy', for example: referents are relative to dis-
courses produced and interpreted in given conditions, not to 'dictionary meanings':

> Words, expressions and propositions have no meaning other than in
> their usage within a determinate discursive formation.
>
> (Woods, 1977: 75)

The analysis must aim to lay bare the structural factors which determine the
relative power of different discursive formations in the struggle over the necessary
multi-accentuality of the sign – for it is in this struggle over the construction and
interpretation of signs that meaning (for instance the meaning of 'truancy') is pro-
duced. The crucial thing here is the 'insertion of texts into history via the way
they are read' in specific socio-historical conditions, which in turn determine the
relative power of different discursive formations. This is to recognise the deter-
mining effects of socio-historical conditions in the production of meaning:

> the relationship between the significations of an utterance and the socio-
> historical conditioning of that utterance's production is not of secondary
> importance but is constitutive of signification.
>
> (Woods: 60)

Meaning must be understood as a production always within a determinate dis-
cursive formation; this is to abandon Saussure's equation of meaning with
linguistic value, for his formulation:

> disguises the fact that within a single language community there can be
> distinct systems of linguistic value. That is to say, words and expressions
> (as signifiers) can change their meaning according to the ideological
> positions held by those who use them.
>
> (Woods: 60)

This is to insist on the social production of meaning and the social location of subjectivity/ies – indeed it is to locate the production of subjectivity always within specific discursive formations.

Woods may provide us with a way of thinking the specificity of signification or discursive practice within ideology. He quotes Balibar, who argues that:

> if language [langue] is 'indifferent' to class divisions and struggle, it does not follow that classes are indifferent to language. They utilise it, on the contrary, in a definite way in the field of their antagonism, notably in their class struggle.
>
> (p. 60)

Woods goes on (and the argument can be extended to cover the specificity of the TV discourse):

> the indifference of language to class struggle characterises the 'relative autonomy of the linguistic system', i.e. the set of phonological, morphological and syntactic structures, each with their own internal laws, constitutes the subject of linguistics. The non-indifference of classes to language, their specific utilisation of it in the production of discourses, is to be explained by the fact that every discursive process is inscribed in ideological class relations.
>
> (p. 60)

It is this latter connection that is generally absent in the *Screen* position, e.g. in Heath and Skirrow, whose approach parallels that of the linguists whom Calvert criticises for failing to study:

> the status of language itself in society: its role in the class struggle, its ideological determination, etc. [This linguistics] contents itself with studying language [or signification] as a closed system, as one studies a mechanism . . . as a 'neutral instrument' excluded from the field of social and political relations.
>
> (quoted in Marina de Camargo, 1973: 10)

You cannot analyse signification without reference to the ideological context in which it appears; there is no way you can 'read' signification (e.g. a TV programme) without knowing what the words mean in the specific cultural context.

The tendency towards an abstracted analysis, divorced from ideological and connotational context, concentrating on the text or 'product', is also criticised by Voloshinov. As Henriques and Sinha (1977) point out:

> For Voloshinov the proper object of study for a science of ideology is the living socially embedded utterance in context. It is the process of

production and generation, not its abstracted and reified product, that provides the key to understanding the expression of ideology in consciousness and communication.

(p. 95)

This, then, is to situate signifying practice always within the field of ideology and class relations – as Henry (1971) puts it:

> The study of discursive processes, of discourses functioning in connection with other discourses, implies that we work with a corpus of messages and that we take into account the loci of speakers and addressees . . .
> The question is . . . how sentences . . . are interpreted in different ways depending on the loci at which they are assumed to be produced . . .
>
> (pp. 84–9)

Carswell and Rommetveit (op. cit.: 5) make the proposition that we must 'expand our analysis of the utterance from its abstract syntactic form via its content, toward the patterns of communication in which it is embedded'. Substituting the terms of the argument, we can propose that we must expand our analysis of the TV text from its abstract signifying mechanisms (or mode of address) via its ideological themes towards the field of interdiscourse in which it is situated.

The structure of readings

Henry distinguishes between locus (in the social formation) and position (in discourse), arguing for the determination of position by locus:

> economic, institutional and ideological factors [determine] the locus occupied by an individual in the social structure. These factors constitute the conditions of production of the individual's discourses and the conditions of interpretation of those he receives. Through these conditions of production, the range and types of positions a given individual can adopt are determined . . . conditions of production and interpretation of discourses are tied to the different loci assigned to people by social structure.
>
> (pp. 83–4)

Thus, the subject's position in the social formation structures his or her range of access to various discourses and ideological codes, and correspondingly different readings of programmes will be made by subjects 'inhabiting' these different discourses. What are important here are the relations of force of the competing discourses which attempt to 'interpellate' the subject: no one discourse or ideology

can ever be assumed to have finally or fully dominated and enclosed an individual or social group. We must not assume that the dominant ideological meanings presented through television programmes have immediate and necessary effects on the audience. For some sections of the audience the codes and meanings of the programme will correspond more or less closely to those which they already inhabit in their various institutional, political, cultural and educational engagements, and for these sections of the audience the dominant readings encoded in the programme may well 'fit' and be accepted. For other sections of the audience the meanings and definitions encoded in a programme like *Nationwide* will jar to a greater or lesser extent with those produced by other institutions and discourses in which they are involved – trade unions or 'deviant' subcultures for example – and as a result the dominant meanings will be 'negotiated' or resisted. The crucial point to be explored is which sections of the audience have available to them what forms of 'resistance' to the dominant meanings articulated through television.

Texts, readers and subjects

The problem with much of *Screen*'s work in this area has recently been identified by Willemen (1978) as the unjustifiable conflation of the reader of the text with the social subject. As he argues:

> There remains an unbridgeable gap between 'real' readers/authors and 'inscribed' ones, constructed and marked in and by the text. Real readers are subjects in history, living in social formations, rather than mere subjects of a single text. The two types of subject are not commensurate. But for the purposes of formalism, real readers are supposed to coincide with the constructed readers.
>
> (p. 48)

Hardy, Johnston and Willemen (1976) provide us with the distinction between the 'inscribed reader of the text' and the 'social subject who is invited to take up this position'. They propose a model of 'interlocking subjectivities, caught up in a network of symbolic systems' in which the social subject:

> always exceeds the subject implied by the text because he/she is also placed by a heterogeneity of other cultural systems and is never coextensive with the subject placed by a single fragment (i.e. one film) of the overall cultural text . . .
>
> (p. 5)

Nevertheless, the structure of discourse has its own specific effectivity, since:

> the social subject is also restricted by the positionality which the text offers it.

The 'persons' involved are always already subjects within social practices in a determinate social formation; not simply subjects in 'the symbolic' in general, but in specific historical forms of sociality:

> this subject, at its most abstract and impersonal, is itself in history; the discourses . . . determining the terms of its play change according to the relations of force of competing discourses intersecting in the plane of the subject in history, the individual's location in ideology at a particular moment and place in the social formation.
>
> (Willemen, 1978: 63–4)

In his editorial to *Screen* v.18, n.3 Nowell-Smith rightly points to the particularity of Neale's approach, breaking, as it does, with the ahistorical and unspecified use of the category of the 'subject'. In his summary of Neale's position, Nowell-Smith points out that:

> [Propaganda] . . . films require to be seen, politically, in terms of the positionality they provide for the socially located spectator.

and this is 'on the one hand a question of textual relations proper, of mode of address' but also of 'the politico-historical conjuncture' because 'the binding of the spectator takes place' (or indeed fails to take place, we must add) 'not through formal mechanisms alone but through the way social institutions impose their effectivity at given moments across the text and also elsewhere.'

Woods' (1977) article on Pecheux provides us with the concept of interdiscourse in which the subject must be situated. He argues that.

> the constitution of subjects is always specific in respect of each subject . . . and this can be conceived of in terms of a single, original (and mythic) interpellation – the entry into language and the Symbolic – which constitutes a space wherein a complex of continually interpellated subject-forms inter-relate, each subject-form being a determinate formation of discursive processes. The discursive subject is therefore an interdiscourse, the product of the effects of discursive practices traversing the subject throughout its history.
>
> (p. 75)

Alan O'Shea (1979) links this argument to Laclau's usage of the Althusserian notion of interpellation. For Laclau:

> the ideological field contains several 'interlocking and antagonistic' discourses . . . any individual will be the 'bearer and point of intersection' of a number of these discourses (in relations of dominance and subordination); and, as in the social formulation as a whole, within the

individual these subjectivities will be articulated in a 'relative coherence' . . .

<div align="right">(Laclau, 1977: 163)</div>

Thus, O'Shea agrees, the individual is:

> the site of a particular nexus of the available ideological discourses, i.e. having a particular relationship with the ideological field, itself structured in dominance in a relation of dominant and dominated articulations. So just as there is a class struggle across the ideological level of the social formation, there will be a form of struggle within the individual's set of interpellations . . . which, like ideological discourses, can displace antagonism into difference in times of stability, but in crisis will be the site of several contradictory 'hailings' one of which will have to prevail.

<div align="right">(p. 4)</div>

Thus, the 'subject' exists only as the articulation of the multiplicity of particular subjectivities borne by an individual (as legal subject, familial subject, etc.), and it is the nature of this differential and contradictory positioning within the field of ideological discourse which provides the theoretical basis for the differential reading of texts: the existence of differential positions in respect to the position preferred by the text. As Sylvia Harvey (1978) puts it:

> authors and readers can be studied in relation to those often different codes (processes for the production of meaning) for which they are the site of intersection. The encounter between reader and text is thus the complex sum of a number of different histories, the histories of the different codes for which author, text and readers are the site of intersection.

<div align="right">(p. 114)</div>

In conclusion I want to argue that these concepts may now allow us to advance beyond two key problematics, one derived from *Screen*, one derived from Frank Parkin. The *Screen* one is that which Neale characterises as an 'abstract text-subject relationship', in which the subject is considered only in relation to one text, and that relation is contextualised only by the primary psychic processes of the mirror/Oedipal phases, etc., which the present relation replays, or which provide the foundation of the present relation.

Parkin provides us with a sociologically informed critique of the abstract relation outlined above but into which demographic/sociological factors, age, sex, race, class position, etc., are introduced as directly determining subject responses. These factors, however, have often been presented as objective correlates/determinants, for instance, of differential decoding positions without specification of how they intervene in the process of communication.

<div align="center">285</div>

Now while I would insist on the centrality of the question of structural determination and the articulation of signifying practices with the field of ideology, as it is structured by the 'real', nevertheless we must accept with Willis (1978) that:

> It cannot be assumed that cultural forms are determined in some way as an automatic reflex by macro determinations such as class location, region, and educational background. Certainly these variables are important and cannot be overlooked, but *how* do they impinge on behaviour, speech and attitude? We need to understand how structures become sources of meaning and determinations on behaviour in the cultural milieu at its own level . . . the macro determinants need to pass through the cultural milieu to reproduce themselves at all.
>
> (p. 171)

We need to construct a model in which the social subject is always seen as interpellated by a number of discourses, some of which are in parallel and reinforce each other, some of which are contradictory and block or inflect the successful interpellation of the subject by other discourses. Positively or negatively, other discourses are always involved in the relation of text and subject, although their action is simply more visible when it is a negative and contradictory rather than a positive and reinforcing effect.

We cannot consider the single, hypostatised text-subject relation in isolation from other discourses. Neither should we 'read in' sociological/demographic factors as directly affecting the communication process: these factors can only have effect *through* the action of the discourses in which they are articulated. The notions of interdiscourse, and of multiple and contradictory interpellations of the subject, open up the space between text and subject. We no longer assume that the subject is effectively bound by any particular interpellation, and thus provide the theoretical space for the subject to be in some other relation to the signifying chain from that of 'regulated process'.

Crucially, we are led to pose the relation of text and subject as an empirical question to be investigated, rather than as an *a priori* question to be deduced from a theory of the ideal spectator 'inscribed' in the text. It may be, as MacCabe (1976: 25) emphasises, that analysing a film within a determinate social moment in its relation to its audience 'has nothing to do with the counting of heads' but this is a point of methodological adequacy, not of theoretical principle. The relation of an audience to the ideological operations of television remains in principle an empirical question: the challenge is the attempt to develop appropriate methods of empirical investigation of that relation.

AFTERWORD

This is not a conclusion, as the very nature of the research project on which this monograph is based precludes any such finality. The project has been conducted as a preliminary investigation, at the empirical level, of the potential of the 'encoding/decoding' model as applied to the TV audience.

In its original form the research was designed to cover both a wider range of televisual material and a wider range of groups, as well as a more intensive examination of group and individual readings. However, this plan was premised on a level of funding (for two full-time researchers) which was not available. I can only express my gratitude here to the BFI for providing the funds which enabled the project to take place at all – though, of necessity, it was scaled down to the level of one, part-time, researcher, plus a considerable amount of voluntary help.

I have been able to do no more than to indicate some of the ways in which social position and (sub)cultural frameworks may be related to individual readings. To claim more than that, on the basis of such a small sample, would be misleading. Similarly, I would claim only to have shown the viability of an approach which treats the audience as a set of cultural groupings rather than as a mass of individuals or as a set of rigid socio-demographic categories. Clearly, more work needs to be done on the relation between group and individual readings.

However, while these are important considerations for further research, the limitation of which I am most conscious, and which I would see as the priority for further work in this area, lies at the level of methodology. Here the question is one of developing methods of analysis which would allow us to go beyond the descriptive form in which the material is handled here.

The material from the groups is presented at such length here precisely because of the absence of any adequate method which would enable us to formalise and condense the particular responses into consistent linguistic and/or ideological categories. The difficulty here is obviously that of the complex and overdetermined nature of the relation between linguistic (or discursive) and ideological features. In the absence of any method capable of satisfactorily meeting these difficulties, it seemed more useful to present the material in a descriptive format, in the hope that it would then be more 'open' to the reader's own hypotheses and

interpretations where mine seem inadequate. It is in this area, of the relations between linguistic, discursive forms and particular ideological positions and frameworks, that this work most needs to be developed.*

As the reader will no doubt have noted, the theoretical framework which informs this work is presented in relation to quite different theoretical debates in different chapters – at one point in relation to work in mainstream sociology, at another in relation to psychoanalytic film theory. Over the project's long period of gestation it has been developed through and against these varied theoretical protagonists and it seemed best to leave the marks of these debates visible, so as to make it clearer where the perspective employed has developed from. If it then seems that I have taken us down some wrong turnings, it may be possible for the reader to more easily find his or her way back, or onwards, out of the swamp.

*For some attempts in this direction see Kress and Trew (1979) and Fowler *et al.* (1979).

BIBLIOGRAPHY

Althusser, L. (1971), 'Ideology and ideological state apparatuses', in *Lenin and Philosophy*, NLB, London.

Armistead, N. (ed.) (1974), *Reconstructing Social Psychology*, Penguin, Harmondsworth.

Bandura, B. (1961), 'Identification as a process of social learning', in *Journal of Abnormal and Social Psychology*, Vol. 63, No. 2.

Berelson, B. (1952), *Content Analysis in Communication Research*, Free Press, Glencoe, Ill.

Berkowitz, L. (1962), 'Violence and the mass media', in Paris Stanford Studies in Communication, Institute for Communication Research.

Bernstein, B. (1971), *Class, Codes and Control*, Paladin, London.

Beynon, H. (1973), *Working for Ford*, Penguin, Harmondsworth.

Blumler, J. and Ewbank, A. (1969), 'Trade unionists, the mass media and unofficial strikes', in *British Journal of Industrial Relations*, 1969.

Bourdieu, P. (1972), 'Cultural reproduction and social reproduction', in Brown (ed.) (1972).

Brown, R. (ed.) (1972), *Knowledge, Education and Cultural Change*, Tavistock, London.

Bulmer, M. (ed.) (1977), *Social Research Methods*, Macmillan, London.

de Camargo, M. (1973), 'Ideological Analysis of Media Messages', CCCS mimeo, University of Birmingham.

Carswell, E. and Rommetveit, R. (eds) (1971), *Social Contexts of Messages*, Academic Press, London.

Caughie, J. (1977), 'The world of television', in *Edinburgh '77 Magazine*.

Connell, I. (1978), 'The reception of television science', Primary Communications Research Centre, University of Leicester.

Connell, I. (1979), 'Ideology/Discourse/Institution', *Screen*, Vol. 19, No. 4.

Connerton, P. (ed.) (1976), *Critical Sociology*, Penguin, Harmondsworth.

Counihan, M. (1972), 'Orthodoxy, Revisionism and Guerilla Warfare in Mass Communications Research', CCCS mimeo, University of Birmingham.

Coward, R. (1977), 'Class, Culture and Social Formation', *Screen*, Vol. 18, No. 1

Critcher, C. (1978), 'Structures, Cultures and Biographies', in Hall and Jefferson (1978).

Curran, J. *et al.* (eds) (1977), *Mass Communication and Society*, Arnold, London.

Deutscher, I. (1977),'Asking Questions (and listening to answers)', in Bulmer (ed.) (1977).

Downing, T. (1974), *Some Aspects of the Presentation of Industrial Relations and Race Relations in the British Media*, Ph.D. thesis, London School of Economics.

Dyer, R. (1977), *'Victim*: hermeneutic project', *Film Form*, Autumn 1977.

Eco, U. (1972),'Towards a semiotic enquiry into the TV message', in *Working Papers in Cultural Studies*, No. 3, CCCS, University of Birmingham.

Elliott, P. (1972), *The Making of a Television Series*, Constable, London.

Elliott, P. (1973), 'Uses and gratifications: a critique and a sociological alternative', Centre for Mass Communications Research, University of Leicester.

Ellis, J. (1977), 'The institution of the cinema', in *Edinburgh '77 Magazine*.

Fowler, R. *et al.* (1979), *Language and Control*, RKP, London.

Garnham, N. (1973), *Structures of Television*, BFI TV Monograph No. 1.

Gerbner, G. (1964), 'Ideological perspectives in news reporting', in *Journalism Quarterly*, Vol. 41, No. 4.

Giglioli, P. (1972), *Language and Social Context*, Penguin, Harmondsworth.

Grealy, J. (1977), 'Notes on popular culture', *Screen Education*, No. 22.

Hall, S. (1973), 'Encoding and Decoding the TV message', CCCS mimeo, University of Birmingham.

Hall, S. (1974), 'Deviancy, politics and the media', in Rock and McIntosh (eds) (1974).

Hall, S. and Jefferson, T. (1978), *Resistance through Ritual*, Hutchinson, London.

Halloran, J. (ed.) (1970a), *The Effects of Television*, Panther, London.

Halloran, J. *et al.* (1970b), *Demonstrations and Communications*, Penguin, Harmondsworth.

Halloran, J. (1975), 'Understanding television', *Screen Education*, No. 14.

Hardy, P., Johnston, C. and Willemen, P. (1976), 'Introduction', to *Edinburgh '76 Magazine*.

Harris, N. (1970), *Beliefs In Society*, Penguin, Harmondsworth.

Hartmann, P. and Husband, C. (1972), 'Mass media and racial conflict', in McQuail (ed.) (1972).

Harvey, S. (1978), *May '68 and Film Culture*, BFI, London.

Heath, S. (1976), 'Screen images, film memory', in *Edinburgh '76 Magazine*.

Heath, S. and Skirrow, G. (1977), 'Television: a world in action', *Screen*, Vol. 18, No. 2.

Henriques, J. and Sinha, C. (1977), 'Language and revolution', in *Ideology and Consciousness* No. 1.

Henry, P. (1971), 'On processing message referents in context', in Carswell and Rommetveit (eds) (1971).

Hirst, P. (1976), 'Althusser's theory of ideology', in *Economy and Society*, November 1976.

Katz, E. (1959), 'Mass communications research and the study of popular culture', *Studies in Public Communication*, Vol. 2.

Katz, E. and Lazarsfeld, P. (1955), *Personal Influence*, Free Press, Glencoe, Ill.

Klapper, J. (1960), *The Effects of Mass Communication*, Free Press, Glencoe, Ill.

Kress, G. and Trew, T. (1979), 'Ideological transformation of discourse', *Sociological Review*, May 1979.

Kumar, K. (1977), 'Holding the Middle Ground', in Curran (ed.) (1977).

Laclau, E. (1977), *Politics and Ideology in Marxist Theory*, NLB, London.

Lazarsfeld, P. and Rosenberg, M. (eds.) (1955), *The Language of Social Research*, Free Press, New York.

Linné, O. and Marossi, K. (1976), *Understanding Television*, Danish Radio Research Report.

MacCabe, C. (1976), 'Realism and pleasure', in *Screen*, Vol. 17, No. 3.

McQuail, D. (ed.) (1972), *Sociology of Mass Communication*, Penguin, Harmondsworth.

Mann, M. (1973), *Consciousness and Action among the Western Working Class*, Macmillan, London.

Mepham, J. (1972), 'The theory of ideology in Capital', *Radical Philosophy*, No. 2.

Merton, R. (1946), *Mass Persuasion*, Free Press, New York.

Merton, R. (ed.) (1959), *Sociology Today*, Free Press, New York.

Merton, R. and Kendall, P. (1955), 'The Focussed Interview', in Lazarsfeld and Rosenberg (1955).

Miliband, R. and Saville, J. (eds) (1973), *Socialist Register*, Merlin, London.

Mills, A. and Lowe, A. (1978), 'Screen and Realism', CCCS mimeo, University of Birmingham.

Mills, C. W. (1939), 'Language, Logic and Culture', in *Power, Politics and People*, OUP, London and New York.

Moorhouse, H. and Chamberlain, C. (1974a), 'Lower class attitudes to the British political system', in *Sociological Review*, Vol. 22, No. 4.

Moorhouse, H. and Chamberlain, C. (1974b), 'Lower class attitudes to property', in *Sociology*, Vol. 8. No. 3.

Morley, D. (1975), 'Reconceptualising the media audience', CCCS, University of Birmingham.

Morley, D. (1976), 'Industrial Conflict and the Mass Media', *Sociological Review*, May 1976.

Murdock, G. (1974), 'Mass communication and the construction of meaning', in Armistead (ed.) (1974).

Murdock, G. and Golding, P. (1973), 'For a political economy of mass communications', in Miliband and Saville (eds) (1973).

Neale, S. (1977), 'Propaganda', in *Screen*, Vol. 18, No. 3.

Nicholls, T. and Armstrong, P. (1976), *Workers Divided*, Fontana, London.

Nordenstreng, K. (1972), 'Policy for news transmission', in McQuail (ed.) (1972).

O'Shea, A. (1979), 'Laclau on Interpellation', CCCS mimeo, University of Birmingham.

Parkin, F. (1973), *Class Inequality and Political Order*, Paladin, London.

Perkins, T. (1979), 'Rethinking stereotypes', in M. Barrett *et al.* (eds) *Ideology and Cultural Production*, Croom Helm, London.

Piepe, A. *et al.* (1978), *Mass Media and Cultural Relationships*, Saxon House, London.

Pollock, F. (1976), 'Empirical research into public opinion', in Connerton (ed.) (1976).

Poulantzas, N. (1973), *Political Power and Social Classes*, NLB, London.

Riley, J. and Riley, M. (1959), 'Mass communications and the social system', in Merton (ed.) (1959).

Rock, P. and McIntosh, M. (1974), *Deviance and Social Control*, Tavistock, London.

Rosen, H. (1972), *Language and Class*, Falling Wall Press, London.

Stevens, T. (1978), 'Reading the realist film', *Screen Education*, No. 26.

Thompson, E. P. (1978), *The Poverty of Theory*, Merlin, London.

Thompson, J. O. (1978), 'A nation wooed', *Screen Education*, No. 29.

Voloshinov, V. (1973), *Marxism and the Philosophy of Language*, Academic Press, New York.

Willemen, P. (1978), 'Notes on subjectivity', *Screen*, Vol. 19, No. 1.

Willis, P. (1978), *Learning to Labour*, Saxon House, London.

Woods, R. (1977) 'Discourse analysis', in *Ideology and Consciousness*, No. 2.

Woolfson, C. (1976), 'The semiotics of workers' speech', in *Working Papers in Cultural Studies*, No. 9, CCCS, University of Birmingham.

Wright, C. R. (1960), 'Functional analysis and mass communication', *Public Opinion Quarterly*, 24.

Part III

RESPONSES

MICHAEL BARRATT, 'IT'S ALL JUST CODSWALLOP'

Extract from 'Profile: Michael Barratt' by Graham Wade, *Video* December 1978: 64–5

'Yes I saw some of it. Well, I think it's all just codswallop. You know all those people with their long-haired notions about TV programmes and so forth. *Nationwide* did and does a very important job and part of that job is to provide some kind of mental relaxation for people who have, we hope, worked an extremely hard day at work.

Nationwide is a sort of mirror which responds, I would argue in a most intelligent way, to the requirements of the day. If today nothing of real significance, socially or politically, has happened, then *Nationwide* will go and do a jolly item – that will make us all laugh – on a duck that plays the piano. But similarly, on a day that the prime minister calls an election, the entire programme will be thrown – all the ducks will disappear with the dishwater – and the whole programme will become an in-depth examination of political issues.'

'A NATION WOOED', FROM
SCREEN EDUCATION 29 (1978): 91–6

John O. Thompson

Everyday Television: 'Nationwide'
Charlotte Brunsdon and David Morley,
BFI Television Monograph, 1978,
100 pp., £0.75.

1. Charlotte Brunsdon and David Morley have written an attractive extended essay on the BBC's twelve-year-old news and features programme for the early evening, *Nationwide*. It is based in part on earlier work on the programme done by a larger group at the Centre for Contemporary Cultural Studies in Birmingham; and further Centre research in this area is promised. Monograph form seems exactly right for the material at this stage: there's too much here for an article in the Centre's own *Working Papers in Cultural Studies*, yet there is no sense of the desperate stretching which book-length expansion of critical writing on television still often involves.

Everyday Television is divided into four chapters. The first chapter gives an orienting characterisation of *Nationwide*, sketching how its 'brief' has developed. Currently it has secured an identity based on (i) a specific variety of *regionalism* ('"Let's go *Nationwide* . . . and see what the regions think . . ."' becomes the characteristic Nationwide form of presentation' [p. 4]; and (ii) a distinctive form of *discourse* ('*Nationwide* employs a kind of populist "ventriloquism" . . . which enables the programme to speak with the voice of the people: ie to mirror and reproduce the voice of its own audience' [p. 8]), aimed at sugaring the news and current affairs pill. Chapter 2 attempts a categorisation of the 182 items which appeared on twenty-nine programmes, breaking them down into *categories* (World of Home and Leisure, People's Problems, Images of England, National/Political, Sport) and *thematisations* (Nationwide Events, Individual, Traditional Values, Advice, Concern and Care, Family, Report). As usual, the end result of the breakdown in tabular form is much less important than the reflections on programme content which carrying out the exercise has prompted B&M to make. Chapter 3 attempts a detailed analysis of some aspects of a single *Nationwide* edition, concentrating on studio links and item introductions; the stress here is on how the viewers of *Nationwide* are constantly 'placed' by the presenters' discourse in a manner which makes it

difficult for them not to participate in a 'preferred reading' of what they see and hear. Chapter 4 aims to bring together earlier insights into the nature of these intended readings in a critique of *common sense*, seen as the invisible ideological constraint inflecting everything on *Nationwide* towards providing confirmation for bourgeois notions of the individual, the family and the state.

Brunsdon and Morley write enjoyably; readability is much enhanced by their nose for lethal quotes from the programmes themselves and from descriptions of their aims by broadcasters. I am going to spend the rest of this review being mildly critical, so I should make it clear right away that the monograph should be of great interest to all *Screen Education* readers, as well as being a valuable new teaching resource. Indeed, it's my sense that most readers of this review will want to read the monograph itself which frees me from needing to summarise it more thoroughly. More useful, I hope, will be a few remarks on the limits within which B&M's own discourse operates. In one sense this hardly constitutes a criticism of this monograph at all, since the limits have enabled the job to get done and indeed maximised its polemical force. But it seems to me that further work will need to recognise more fully the contradictoriness and uncertainty of the phenomena in question (as opposed to their 'one-dimensionality' and success).

2. One of B&M's most interesting claims is that 'the *Nationwide* discourse [is] articulated, above all, through the sphere of *domesticity*' (p. 74), and part of their larger concern is to show what a deplorable construction the bourgeois concept of domesticity is. This demonstration is hard-hitting and persuasive, but perhaps too compressed to avoid certain confusions. A table on p. 25 attempts 'very schematically' to capture the 'underlying "preferred" structure of absences and presences' in the *Nationwide* discourse.

ABSENT	PRESENT
world	home
work	leisure
production ⎫	
reproduction) ⎭	consumption
workers (functions)	individuals (bearers)
structural causation	effects

The domestic sphere, which 'has been signified, ideologically, as the sphere which is separated and protected from the nasty business of making, doing and producing' (p. 75) – i.e. from the *world of work* – is largely defined by the home-leisure-consumption-individuals complex in the Present column. A quick inspection of the Absent column reveals to the initiated that its items are not just *any* absences: they are, with the exception of 'world', concepts themselves generated within a specific disclosure (a mildly Althusserian Marxism). If the table were doing much work in B&M's exposition, we should have to ask suspiciously how it happens that the Absent concepts fall so neatly into place as (i) B&M's own, and (ii) oppositional one-to-one to the concepts that characterise the ideology being criticised. Such a coupling makes sense only if the two discourses are related thus:

the real | the repressed

Or, even more classically, thus:

truth | lies/error/illusion

Since B&M carefully signal the schematic nature of their table, and do not write like manichean dogmatists, it would be impertinent to repeat here the general arguments against attempting to equate ideology and error. But the slide in that direction – which is fearfully difficult to avoid, of course – has certain effects which should perhaps be pointed out, since they might interfere with further work on *Nationwide* and programmes like it.

From the outset B&M have no difficulty in showing that *Nationwide* is seen by those responsible for it as frothy stuff: it must contain a good deal of 'light relief' as opposed to 'demanding', 'heavy' or 'serious fare',[1] because its early-evening audience is just recovering from 'a hard day's work' (p. 6). And B&M demonstrate quantitatively (p. 38) that 'the world of home and leisure . . . is the primary space of *Nationwide*'s concerns'. The only problem with this demonstration is that the broadcasters involved could so readily agree. It is they who equate the world of home and leisure with the undemanding. When B&M write that 'it is crucial to note that whereas *Panorama* or *This Week* treat individuals in their public-institutional social roles, *Nationwide* treats individuals as members of families' (p. 74), *Nationwide* broadcasters can only nod in agreement (before inquiring, 'And why not?'). This *Panorama*/*Nationwide* opposition is surely part of broadcasters' common sense about current affairs programming. (B&M sometimes seem tempted to use *Panorama* as a stick to beat *Nationwide* with, as we shall see, though no doubt on another occasion – in another monograph? – they would show themselves less impressed by *Panorama*'s grasp of the Larger World.)

How easy it is to slide into complicity with the broadcasters. They define the 'domestic' in such a way as to render it appropriately 'light' – a realm of (as B&M gleefully assemble the clichés) '"the brighter side", "what can be done", "the good news among the bad"' (p. 10). B&M oscillate between recognising the domestic as a real realm (behind which 'lies the long historical process through which the household has gradually been separated . . . from the relations of production and exchange' and which is 'concerned exclusively with the *essential* functions of maintaining and reproducing the labourer and his family' [p. 75: my italics]) and – numbed no doubt by the sort of *Nationwide* treatment of it that they are criticising – dismissing it as intrinsically trivial. Consider this passage, which appears in the course of a discussion of how *Nationwide* is 'a programme of care and concern [which] consistently runs stories on "people's problems": the problems of the lonely, the abnormal, underprivileged and (especially the physically) disabled':

> *Nationwide*'s treatment of people's problems is, then, immediate: we are
> shown 'what it means in human terms'. This 'humanising' emphasis can
> be seen to have its basis in the specific communicative strategy of the
> broadcasters – in trying to 'get the issue across' what better way than to

concentrate directly on the feelings of those immediately involved? However, the consequent emphasis, being placed almost exclusively on this 'human angle', serves to inflect our awareness of the issue; what is rendered invisible by this style of presentation is the relation of these human problems to the structure of society. The stress on 'immediate effects', on 'people', on getting to the heart of the problem, paradoxically confines Nationwide rigidly to the level of 'mere appearances'.

(pp. 33–4)

The implication is that every nontrivial story must have the social structure at its core: no 'human problem' can exist the very *essence* of which does not lie in its 'relation . . . to the structure of society'. This essentialism slightly weakens the fine demonstration B&M give of how Nationwide systematically formulates those questions of class and power it does raise in an anti-'social' fashion.

Thus, B&M are rightly suspicious of Nationwide's emphasis on physical abnormality; they point out that items of this sort are well designed to allow natural rather than social determinants to be foregrounded by the programme.

But the way they use scare-quotes in pursuing this point is itself a bit scary.

Nationwide deals with these stories in a quite distinctive way; rather than the discussion between experts that we might get on Panorama about the background to some 'social problem' Nationwide takes us straight to the 'human effects' – the problems and feelings of the 'sufferers', what effect their disability has 'on their everyday lives' . . . [T]he 'problem' is seen to have natural, not social origins . . .

(p. 32)

There cannot be sufferers, only 'sufferers', until the social background is dealt with; a problem can only be a 'problem' unless it is treated socially: 'the items on people suffering from physical disability do not address themselves to the differential class experience of these problems'. We are not quite far enough here from a familiar vulgar-Marxist reductionism whereby (at its most caricatural)[2] any topic to qualify as serious must demonstrate that it was or could have been discussed in *Capital* and any treatment of the topic is judged on how closely it approximates to that discussion. We might call this the 'Where's-the-class-struggle-in-Jane-Austen?'-*dismissiveness* Fallacy – without at all wanting to say that 'Where's the class struggle in Jane Austen?' is a bad question. Neither is 'What about the differential class experience?' a bad question; but it is not a privileged one.

The tendency I am describing only occasionally surfaces in B&M's work, and can for their purposes even be seen as heuristically useful. What might happen, though, is that further work might find itself lumbered with the assumption that the only way to get at Nationwide's trivialisation effects is to accept its definition of the domestic as 'light', hence unimportant – or to argue that the domestic is *only* an ideological construction and that there are really no 'domestic problems', only

social problems misconstrued. But if the domestic (the household, the family) is the *real site*, in our culture, of the production of human subjects, then it is anything but trivial; and a number of discourses (one thinks of Freud, of Lacan; indeed, of the Bateson-Laing-Esterson schizophrenia work) exist to remind us that accounts of the domestic need not be comfortable. It might be productive to try reading *Nationwide*'s discourse as one which is no less in flight from Freud than from Marx.

3. But the other danger B&M's approach sometimes runs – and here they are in the company of most radical culture critics – is that of seeing 'flight' every-where. The *Nationwide* discourse is such that no *Nationwide* initiative could be other than ultimately escapist, because the programme is tied to common sense, i.e. to 'an understanding of the world which is *always* "more or less limited and provin-cial, which is fossilised and anachronistic"' (p. 90: my italics). Common sense is escapist because, as they quote Stuart Hall, it 'does not require reasoning, argu-ment, logic, thought; it is spontaneously available, thoroughly recognisable, widely shared' (p. 91). It represents a flight from the demanding and threaten-ing (but liberating) perspective which alone could enable one 'to grasp either the social formation as a whole or the role, for instance, of "political" institutions, or of the sexual division of labour within this complex whole' (p. 90). Instead:

> The immediate obviousness of common sense, its inbuilt rationale of ref-erence to 'the real', its structure of *recognition*, forecloses historical and structural examination of its conclusions.
>
> (p. 88)

It would take too long to argue the point properly here, but I think there is some-thing one-sided about the characterisations of common sense which B&M assemble. Hall is probably not claiming – which would be absurd – that reason-ing, argument, logic and thought are *absent* from common sense, only that they regularly remain implicit, unavailable for reflexive scrutiny. But even this is too broad a judgement. It is easy to resent common sense as simply a barrier to pro-gressive ideas in the political and economic fields; but it should be borne in mind that (i) common sense has equally stood as a valuable bulwark against 'unspon-taneous' ideologies constructed within 'sciences' which we would probably agree need to be *rejected* (e.g. strict Behaviourism; the Rational Economic Man of neo-classical economics); and (ii) common sense generates arguments against certain areas of Marxism – especially its political practice – which are, perhaps unfortu-nately, neither wholly 'thought'-less nor negligible. Hence I would not agree with B&M that the 'crusading', anti-bureaucracy side of *Nationwide*, ideologically inflected towards the domestic though it is, can be dismissed quite so briskly. Their scorn at items dealing with housing policy (p. 30) and gas price increases (p. 32) simply because it was the effect on families of these matters which was highlighted seems one of the monograph's less persuasive gestures.

Much of B&M's detailed analysis is devoted to uncovering the mechanisms whereby *Nationwide* lulls its audience with recognition effects. They develop an

account whereby, roughly, a passive spectator is *kept* passive by being fixed in the 'happy' position of recognising a mirror-image of what he or she already 'knows'; making the subject-matter 'reflect' the viewer is the work of *Nationwide* presentation, and this is done by appropriately *framing* each item. (More precisely, there is a tendency to set things up so that the viewer is first confronted with something he or she cannot yet 'know', and then the work of the presentation resolves 'this temporary "suspense-effect"' [p. 62] to the viewer's 'benefit' – leaving the viewer *grateful* to the presenter.) This account allows B&M to define sharply what is needed if an un-co-optable interviewee is successfully to resist such presentation:

> To make an 'unacceptable' reply, whilst maintaining coherence, relevance, continuity and flow, entails a very special kind of work – a struggle in conversational practice: first, to re-frame or re-phrase (e.g. to break the 'personal experience' frame, and to replace it with an alternative 'political' frame); second, then to reply within the reconstituted framework.
>
> (p. 70)

How 'mirrored' do actual audience-members feel by a programme such as *Nationwide*? B&M report that since September 1976 there has been a research project at the Centre for Contemporary Cultural Studies attempting 'to explore the range of differential decodings of the programme [analysed in B&M's Chapter 3] arrived at by individuals and groups in different socio-cultural locations', so their own analysis is simply 'the base line against which differential readings may be posed' (p. v). This is modest and realistic. Any textual analysis produces as one of its own effects the figure of an ideal reader or viewer who does optimally what the text-as-analysed wants done – a sort of 'friction-free' receiver. For some purposes this idealisation is harmless: the ideal reader is essentially the author of the analysis purged of particularities, a figure whom the analyst wishes the reader of the analysis to have the pleasure of becoming. But when what is to be determined is whether the text analysed has the power to dominate and deceive an audience, it is clear that to assume that the audience is a function of the optimal working of the text is to beg the whole question. This way lies functionalism – and, for the opponent of the system the functioning of which proceeds so smoothly, despair.[3]

Even for a 'base line' reading B&M make perhaps inadequate provision for an account of aspects of the programme which might trigger the viewer's scepticism or distaste. One can accept most of the critique of common sense and still feel that certain resistances to this discourse (which after all B&M themselves exemplify) are not so difficult for the viewer to mount. For example, take the operation which B&M call 'coupling' and which they describe very well:

> The use of voice-over film reports – where the commentary 'explains' the meaning and significance of the images shown – is the most

tightly-controlled form in which the 'actuality' material is presented: here, the verbal discourse is positively privileged over the visual. It is important, analytically, to hold a distinction between these two, distinct, signifying chains. The visuals could, potentially, be 'read' by some section of the audience outside of or against the interpretative work which the commentary (voice-over) or meta-language suggests. But the dominant tendency — which the specific work of combination accomplishes here — is for the visual images to be 'resolved' into those dominant meanings and interpretations which the commentary is providing. This interpretative work is, however, repressed or occluded by the synchronisation of voice-over with images, which makes it appear as if the images 'speak for themselves' — declare their own transparent meaning, without exterior intervention.

(p. 62)

Granted the cogency of this description, what still needs allowing for is the possibility that a voice too can be 'read' against its own statements. After all, much of the immediate polemical effect of B&M's strategy of quotation-assemblage and transcription derives from the fact that the broadcasters' own conception of *Nationwide* is such a deeply condescending one, and this talking-down is bound to leave its traces in the texts. Even leaving aside the effects of reading what was originally spoken, a bit of inanity like the following seems less than wholly hypnotic:

> Well you know, isn't it marvellous, every time you come outside the studio the rain seems to come with you. I think that what we've done with this kind of programme is to create a new kind of rain dance ha ha but I'll tell you one thing it certainly isn't going to bother David Stevens because he's back inside waiting to read the news.
>
> (p. 46)

Or take the most egregious quoted passage of all, this time from a printed original, anchorman Michael Barratt's autobiography:

> And outside the studio, how good is the good life? The post restaurants and the plush hotels. The fast cars, the fat cheques. Another myth. I enjoy eating out with Joan or with close friends (who are more likely to be country men than 'personalities') in restaurants not too far from home, preferably where it is not necessary to wear a jacket or tie. Cod and chips out of paper is my delight. Its only rival is roast lamb at home for Sunday lunch.
>
> (quoted p. 75)

It seems to me intuitively obvious that a good chunk of the viewing population could recognise that something phoney is being put across here, just as we, as

B&M's readers, can be relied upon to enjoy the awfulness of such passages without being nudged. (B&M are consistently tactful about not nudging, incidentally.) There is a spontaneous mistrust of television at work in the culture the semiotics of which deserve study as a complement to the (slightly paranoid) analytic reconstruction of the mechanisms that should guarantee the preferred reading's invincibility. I agree that this mistrust may be insufficient by itself to send viewers elsewhere in search of discourses more adventurous and more adequate to the real. But it needs to be recognised as being there to be *worked with*.

Notes

1 Broadcasters seem to have a penchant for describing the programme in terms of food. Viewers are thought not to want a 'demanding, hard-tack diet every night' (p. 6); the introductions at the beginning of the programme are known as the 'Regional Menu' and the 'National Menu'. B&M themselves speak of '"heavy" items like Britain's involvement with the IMF, which are the staple diet of serious current affairs programmes (like *Panorama*)' (p. 10). The (in)digestibility metaphor applied to messages might be worth investigating.

2 E.g., recently, Roger Bromley 'National Boundaries: The Social Function of Popular Fiction' in *Red Letters* 7 1978 pp. 34–60: 'Only "people" are presented in popular fiction: what, of course, is invariably absent is the socially determining economic personifications, e.g. capitalists are present, but without their specified relation to the workers which signifies them as capitalist: the worker is in a similar position. What happens is that individuals are presented without their economic definitions (therefore, by implication, they do not exist) which, in a materialistic analysis, is socially impossible' (p. 43): 'What is crucial to Marx's analysis of men in their social relations (and what is so conspicuously absent from popular fictional representation) . . .' (p. 46). Bromley too sets up a table of Absent and Present elements to characterise popular fiction. He believes (giving as his reference Eli Zaretsky, whom B&M also quote approvingly) that 'it was with the bourgeoisie that the idea of a conflict between the individual and society first took root and in time assumed a material existence' (p. 46).

3 In a characteristically oblique but valuable review of Raymond William's *Keywords* (*New York Review of Books* 27 October 1977 pp. 21–2), William Empson writes, 'Part of the gloom, I think, comes from a theory which makes our minds feebler than they are – than they have to be, if they are to go through their usual performance with language.'

REVIEW OF *EVERYDAY TELEVISION: 'NATIONWIDE'*, FROM *VIDEO AND FILM INTERNATIONAL* NOVEMBER (1978): 47

Graham Wade

Everyday Television: 'Nationwide' by Charlotte Brunsdon and David Morley, published by the British Film Institute in the Television Monograph series at 75p (paperback), 94pp.

This booklet takes as its subject the BBC news magazine programme *Nationwide* which started out on the air way back in 1966. The trend of books looking at popular television output – *Hazell* was recently reviewed on this page – would seem to be a growing one. Indeed it is a development that should be encouraged as far too little serious attention has been paid to those programmes which several millions of viewers tune into regularly.

However, this slim volume – which comes to us courtesy of the British Film Institute's Educational Advisory Service – is hardly likely to promote interest in the field. Rather it will put people off. I would go so far as to say it is an anti-educational piece of writing because it is written in a language and style that would be virtually inaccessible to the vast majority of the population. It is a work that reeks of the most offensive arrogance. Strong words. But why?

A brief quote from the introduction: 'Our analysis focuses on the ideological themes articulated in the programme only partially relating these to their material bases in the formal properties of the discourse . . .' Come again? Or what about: 'The linking/framing discourse, then, which plays so prominent a part in structuring any sequence of items in *Nationwide*, and guides us between the variety of heterogeneous contents which constitute *Nationwide* as a unity-in-variety, not only informs us about what the next item is, and maintains the naturalism of smooth flow and easy transitions – bridging, binding linking items into a programme.'

Yes, you've guessed it. To understand this book you need to have a master's degree in sociology, which, so I'm reliably informed, 99.8% of the public haven't got. What a pity. What's even more of a pity is that some of the saner ideas in this book – yes, there are some – will be thrown out of the window with the dirty bath water. I don't happen to like *Nationwide* either. I also feel that most of the

items presented on it are designed *not* to make people think. I was watching it tonight and the major story seemed to be the promotion of a John Revolting and Olivia Newton-John disco dancing competition for 'anyone over 13'. Even the graphics on *Nationwide* are bad.

There are more technical mistakes on *Nationwide* than any other programme. The presenters seem to be even more upper middle class than those usually thrust upon us by the BBC. In his Sainsbury's advertisements Michael Barratt — the main-stay *Nationwide* presenter for years, or was it decades? — even insists on appearing in ill-cut suits that are two sizes too small for his portly figure.

I am sure that a good many others are also gripped by mild nausea at the very thought of *Nationwide*. What an opportunity for writing a book that could con-vincingly demolish this mean little programme! It could appeal to millions. But no. The chance has been missed by Ms Brunsdon and Mr Morley. Instead we have been presented with a pile of trendy intellectual goo written by a university research student and a university research associate, who, no doubt, both thought they were doing their best.

The bibliography at the back of the book includes no fewer than 58 sources. There are five works quoted by an S. Hall, which is two more even than for a K. Marx. I wonder who this S. Hall is? Well I never! He turns out to be none other than the research student's and the research associate's professor.

So that's who they were trying to impress with their book.

'OBFUSCATED BY EPIPHENOMENA', FROM *BROADCAST* 4 SEPTEMBER 1978

Michael Tracey

In their book, *Everyday Television: 'Nationwide'*, Charlotte Brunsdon and David Morley attempted to lay bare the underlying assumptions of an everyday programme like BBC1's 'Nationwide'. In this review, MICHAEL TRACEY argues that the authors have missed their mark.

I have watched 'Nationwide' regularly now for several years. Recently it began to worry me. No, annoy me. It seemed to be toppling into a bottomless pit of utter triviality.

I know that it occupies a slot which used to be known as the Toddlers Truce but the programme did seem to be getting a little too much like 'Blue Peter'. It had 'Save Our Species', 'Puzzle Corner', an adopted racehorse, an adopted football team, adventure trips to deserted islands, happy little trips into Europe, items about babies, a letters spot with a pet cartoon pigeon, carol contests for children.

Only occasionally did there seem to be more substantial items, or items which matched in their appeal those of years past – now they were like those rare chunks of chicken in canned soup. It wasn't just the style or even the content that failed, but that indefinable sense of quality which is easily recognised but ill-defined.

As a fan of long standing though, I knew it wasn't always so and I have one treasured memory of the programme, one particular item which was 'Nationwide' at its best. It must have been four or five years ago and was about a bus-driver in Blackpool who had an obsession with the band leader Joe Loss and his orchestra. His whole life revolved around listening to the records and collecting memorabilia of the Loss band. In his home he had a series of enormous press-cuttings books which for some ill-explained reason he called 'Diddy Book No 1', 'Diddy Book No 28' and so on. An when they talked with him about this passion he spoke of the joys of the music and the greatness of the man; and then he played some of his collection of Loss records and when the trumpet sounded he would fashion his hands into the shape of a trumpet and he was there playing along with the band, and when the saxophone sounded he was the saxophonist. He told them of his dream which was to have on his bus a record player and a little dance floor so that as he drove along he could put on his Joe Loss music and the passengers would be able to dance as he drove, could themselves love the

306

music. So for one journey they made it all come true for him, the music, the dance floor, the dancing passengers, this man and his singular joy. It was marvellous, warm, human, beautifully done. It lingered in the mind so that here, years later, one can still smile – not *at* but *with* him.

We now have a book which is little more than a prolonged sneer at 'Nationwide' and this kind of item. It disapproves because it sees the programme as part of the obscuring fog of common sense thought which hides those truths of life and society 'known' to the authors.

Someone once told me that one of the nice things about reviews of books in *Broadcast* was that they were very long and told you so much that you didn't have to actually read the book. In my own previous humble efforts at reviewing I have tried to give the gist of the work as well as to add my own thoughts on it. With this latest work from the University of Birmingham's Centre for Contemporary Cultural Studies I am not so sure that I have either the ability or the inclination to try and extract the gist or the structure or the message or whatever and to lay it bare for the long-suffering reader of this magazine. The book is called *Everyday Television: 'Nationwide'* and the authors, Charlotte Brunsdon and David Morley, are, respectively, research student and research associate at the CCCS.

A clue to some of the problems of the book lies in the preface where they describe how 'the work on which this monograph is based was originally carried out collectively by the Media Group at the Centre for Contemporary Cultural Studies, University of Birmingham, in the period 1975–76.' There were five members of this study group, including Stuart Hall. 'This work was discussed by the group and individuals wrote up contributions on different aspects of the programme.'

Unfortunately the book reads a little like a committee did write it. The chapters are too bitty, with so many sub-headings that reading it is rather like taking a ride in a car with no suspension along a bumpy road.

The so-called account of the 'historical development of the programme' is woefully weak. Yes, as they suggest, it is the kind of programme which was to be used as a 'hooker' for peak time audiences. I'm not quite sure, however, what they mean when they say that 'The "regionalism" of 'Nationwide' was seen as a necessary basis for any sense of national unity in the conditions of the late 60s and 70s.' And had they explored the regional aspect of the BBC they would have realised that an emphasis on regionalism has been a feature of BBC programming since at least 1928 to my knowledge and also that the regions were such powerful bodies within the structure of the whole Corporation that a senior executive of the BBC recently described to me how the regional controllers were for years the Barons to the DG's King John.

And no, the start of 'Nationwide' had nothing to do with the McKinsey Report and the policy 'that fuller use should be made of the company's regional studios, allowing for regional specialisation and a "rationalisation" of resources (and cost effectiveness).' McKinsey wasn't even commissioned till April 1968 whereas they point out 'Nationwide' started in 1966.

307

Crucially though, had they delved more deeply into their subject and actually talked to the people involved (I find it quite astonishing that they can write about a programme in the way they do without actually seeing anybody connected with it) they would have realised that what are meant by them to be revelatory statements are in fact no more than descriptions of what the programme was always meant to be.

They themselves say that the 'study details the methods through which the programme addresses itself both to a national audience united in the diversity of its regions, and an audience of ordinary individuals, grouped in families: everyday television for everyday people.' Now they are definitely not saying that this is any great thing. The 'endeavour' of 'Nationwide' they say 'is to establish the time/place/status/immediacy of events and people involved in them – making these where possible concrete and personalised . . .' Thus, an abstract issue like inflation will be presented in terms of 'how it will affect "our" day-to-day living.' (Something which, I must say in passing strikes me as a sensible and interesting way of looking at inflation so long as it isn't the only way.) They make the point that important issues – unemployment, inflation etc 'only enforce attention within the "Nationwide" discourse where they can be shown to have immediate effects on everyday life.'

But then comes the sneer, 'when this happens "Nationwide" can wheel in Robert McKenzie and his clapboard and graphics to tell us what this "IMF loan business" is all about.' In this way, they later observe, the programme moves 'within the limits of what Marx described as "the religion of everyday life" in its exclusive attention to the level of "appearances" and consequent neglect of their determining social relations. While the immediate appearances and "forms of appearance" of capitalist society "contain some part of the essential content of the relations which they mediate" (Hall 1973, p. 9) they represent this content in a distorted form.' What they mean is that because things are only partly what they seem they are in essence a distortion. Thus 'Nationwide' is part of that cultural curtain behind which lie the real relations and truths of this life.

Certainly the emphasis of the programme is on people, normal and abnormal, rather than on processes and abstractions, but then it was always *meant* to be so and had the authors done a little more background research and reading instead of making elaborate readings of single sentences from single programmes they would have appreciated the fact. 'Nationwide' is out of 'Tonight' by Donald Baverstock. You simply can't understand it if you don't understand its predecessor and its creator, yet the authors seem to have made no effort to understand the programme's past. It is interesting, for example, that their bibliography contains all the radical chic references to Marx, Althusser, Mattelart and co, but does not contain the one book which has discussed with the greatest authority the origins and intentions of 'Tonight', Grace Wyndham Goldie's *Facing the Nation*.

Baverstock always had a basic empathy and respect for the ordinary man, an antipathy for authority and a fascination with 'private' man. I once asked him why 'That was the Week That Was' went out on a Saturday night. It was, he said,

because at that time of the week the audience was 24 hours away from being at work and 24 hours away from going to work, 'then they are their least public and most private'. He knew precisely what he wanted with 'Tonight'. His first ideas had been for a weekly programme which would be a 'magazine type of programme about people – their personalities, their characters, their behaviour, their longings and fears, their preferences and their prejudices.' It was as he put it to be a 'TV column about human nature'. In this way he reasoned he would get to his viewers directly by constantly making them think 'I'm like that' or 'I'm not like that'. The whole point of the programme he argued would be to get the viewer to say 'how much I am like other people' or 'how astonishing people can be'.

The emergence of 'Tonight' constituted in fact much more than just a new programme. It was a crucial part of the process of humanising the BBC and transforming it from an organisation which looked down on the masses with the distant hope of raising them to its dizzy heights to one which neither held people in such contempt nor sought to do anything other than entertain and inform them, as equals – if they, as adult citizens so chose to be entertained and informed. Baverstock knew that there would be illusory elements to his new style, that for example, if the aim was to get onto a 'level of conversation with the viewers' it was 'inevitably one-sided' (the authors make this point by saying that 'This terrain of framing and contextualising is the exclusive preserve of the "Nationwide" team!'). What Baverstock was after in December 1956 was a programme which brought to the screen the sense of people being alive, the projection and enjoyment of life, its celebration, not its explication. He fashioned 'Tonight' 22 years ago out of the quarry of his own imagination; he pursued those 'everyday' people, wanted to bring them to the screen and what the authors have done in this book is to find out that his creation lives on. They don't like it, most everybody else does. They may be perfectly right that the programme operates at the level of appearances, that it is fixed within a certain commonsensical superficiality, but if it is, it is a self-created and self-conscious fixation.

Much of the argument of the book is, I am afraid, lost in a fog, but occasionally it does peep through to the surface with a certain clarity. For example, pointing out that 'The world of home and leisure is by far the dominant single element in the "Nationwide" discourse, accounting for 40% of the items in the sample', they add, that the 'first thing to remark is that this "presence" betokens the almost total absence (except in some local news items) of the world of work, the struggle of and over production . . . "Nationwide" leaves us suspended in the seemingly autonomous sphere of circulation, consumption and exchange: the real relations of productive life, both inside and outside the home, have vanished.' The authors so desperately want these truths to be revealed, to show the way the world really is to all those ignorant masses who watch 'Nationwide' and who therefore can have no idea what this world is all about. There is, in fact, a kind of oozing, caring, compassionate arrogance about the work reminiscent of those Victorian missionaries in Africa who patted the natives on the head and thought

'poor little chaps, we must teach them so much, we must bring them knowledge and culture, show them what they should know, which is what *we know*'.

That's the trouble with this book, it's just too God-damned clever, smart, all-knowing. But what at the end of the day does it know. It knows what most people know: that the programme is trivial, superficial, friendly, rooted in the viewer's world and not the academicians', closer to the *Mirror* than the *Times*, that it looks at the eccentric, at the way in which important issues of politics and economics affect the pocket and the home. Most people know all this (I assume – and I have about as much evidence on this as the authors have for making alternative assumptions) and they don't mind, in fact they rather like it, they are not eager for edification or truth or profundity or items which display the injustices of gender, race and class. At the end of the day at work they'd rather ease into a slumber with Uncle Tom Coyne and Aunty Val, and who can blame them. In short, they'd rather watch 'Nationwide' than read this book.

As missionaries, though, the authors cannot so sit back. Theirs is an ideological battle, they want to change the programme – no, they want to change the world of which 'Nationwide' is a distorted image. Hurrah to that, but this book is not the way to go about it. The book has points to make but is written in such an opaque style that they are almost impossible to see: to whit, 'Both Roman Jakobson and Roland Barthes have pointed to the critical position of the personal pronouns in discourse as the location of what Jakobson calls "duplex structures". Personal pronouns are shifters, in the sense that if, in conversation, A speaks to B in terms of "I" and "you", B can only reply coherently by transposing or "shifting" the terms. A's "I" and "you" become B's "you" and "I". Jakobson calls "shifters" terms of transference, the site of a critical overlapping and circularity in discourse which thus, through the ambiguity of the "double structure" of language, can become at the level of the code, the site of complex ideological work'. The mind boggles at what all those 'everyday people' would make of that, or of quick throwaway gems such as 'the most immediately "appearance-like" level of all – the form of spontaneous appropriation of lived relations in immediate consciousness'.

It is in effect a book for a closed community, who may read it because they have access to the language of sociological Latin which is useful precisely because of its exclusively and ostensible cleverness. All those people who should think about broadcasting and read about it, all those everyday people on both sides of the screen, will avoid this work, in the same way that they avoid most critiques of this style, like the plague. It is to say the least then ironic that this work is produced by the BFI Educational Advisory Service. Its efforts at communication, at teaching and explaining are an illusion. In fact reading the book I feel as if I were watching a new version of the Tom Stoppard play in which the hero is put in a cell with a madman who believes himself to be conducting an orchestra. In this book we have the full array of sociological instruments on show: the data-woodwinds, the observational brass section, the Althusserian-strings. Brunsdon and Morley conduct the ensemble with their singular style while in the wings,

listening to the sweet music produced by his protégés is the composer himself, the inspirer and master technician who has penned a thousand symphonies, Ludwig von Hall. The tragedy is that it is all an illusion, there is no music, no audience, except in the minds of the conductors. The real masters of the music, the ones who make the feet tap, the pulses run to their rhythms, play elsewhere to large and real audiences. Politicians, lobbyists, journalists, pundits whistle their tunes and others – sometimes unconsciously and unwittingly – hum along. Meanwhile back at the empty theatre the illusory sociological orchestra plays on.

I can't help thinking though that maybe the problem is in the reviewer, that I despair too much for the state of sociology or at least this branch of it. Perhaps this work is saying something important and profound, something which will be whistled by others, hummed in a seminar room, then pub, then home and factory to become part of all those golden oldies which we all love and which make our lives that bit more explicable, that bit more tolerable and in the long run that bit different. Maybe I'm tone deaf and should be saying, as Michael Holroyd said recently, I can *see* that the orchestra is playing brilliantly, but I just can't hear the tune.

REVIEW OF *THE 'NATIONWIDE' AUDIENCE*, FROM *MEDIA, CULTURE AND SOCIETY* VOL. 3, NO. 2, APRIL 1981

John Corner

The 'Nationwide' Audience: Structure and Decoding, **David Morley, BFI Television Monograph Number 11, £2.95.**

Despite its valuable, sustained and pioneering emphasis on the processes and practices of 'symbolization' as a crucial phase in the social operation of the mass media, the 'cultural studies' perspective has not yet generated much substantive work which has managed to break free from a form of criticism, extrapolating both backwards and forwards from a textual analysis. Backwards into ideas of media organization, policy and practice and forwards into questions of audience perception, the complex activity of reading/viewing and the modes of ideological domination.

The socio-literary inheritance at work has unhelpfully combined with more recently acquired anxieties about 'empiricism' to block the taking through of research ideas and hypotheses into an empirical moment.

David Morley's excellent new book decisively breaks with that phase of inhibition and offers a detailed, empirically grounded study of how different groups 'read' two Nationwide programmes – a study based on videotape viewings followed by discussion with some focused questioning in the latter stages.

As Morley points out, his project to some extent picks up and develops the suggestions made by the Italian researcher Umberto Eco 15 years ago (translation Eco, 1972) in which semiological textual analysis was viewed as only one part of a comprehensive inquiry into media languages, an inquiry which importantly included 'fieldwork' on audience receptions.

The main body of the book consists of transcripts from the group discussions with a subsequent attempt by the author to map the various interpretations and responses in terms of their degree of 'alignment' with the programme. In a prefatory and then a concluding section, Morley develops a more general and theoretical discussion which, lucidly if with some compression, locates his own research in the context of previous and current thought about 'meaning', 'interpretation' and the media audience.

He concentrates particularly on the Uses and Gratifications school (which actually side-steps the whole question of meaning in the process of arguing that audiences 'use' media texts to fulfil their 'needs') and the work of certain theorists connected with the journal *Screen* (who have appeared at times to argue that texts virtually 'construct' their own readers through the sheer minatory or seductive power of their formal operations). Both positions display a functionalist inclination, one derived from a particular psycho-social perspective, the other from a theory of textuality and the reader's formation as a 'subject'. Morley's expositions and critiques are economically and pointedly presented with useful references to the more detailed debates surrounding the approaches and methods he discusses.

His own work is clearly rooted in the Media Group activity of the CCCS at Birmingham but he breaks with textual analysis as the exclusive method by taking seriously the idea that audiences, coming from different social locations and inhabiting different frameworks of understanding, will actually make different sense of what is said and shown on television.

There is no one meaning (*the* meaning) which can be ascribed to a media text by rigorous analysis, and Morley does not believe that the range of possible, socially contingent meanings is discernible or inferable from a textual inquiry alone.

In seeing audience 'interpretation' as a form of production however, Morley does not thereby follow recent materialist literary criticism (Bennett, 1979) in exchanging all the problems of seeing texts simply as *sources* of meaning (e.g. difficulty in accounting for audiences as differentiated interpreter/producers) for the problems of declaring them to be *sites* for reader constructions (e.g. difficulty in accounting for the referential and connotative/ideological power of media output, for handling cultural meaning as produced *through* texts as well as *upon* them).

Using the idea of 'preferred reading', the notion of the text as a rhetorical structure within which the connotational fields of words and images are variously trimmed, expanded, merged and contrasted (my grope words, not his!) to articulate a particular (preferred and proferred) interpretation, Morley seeks to reveal the specific and different framings at work in the *audience's* 'readings'. These readings, though often regarded as 'taken' or 'received', are in fact made from, with and against the referential and connoattive guidance of textual mechanism.

This view of textuality and reading, at a general level, skewed neither towards textual closures nor towards 'reader as writer' theories, is certainly not new but, given some recent, bizarre excesses in text-audience arguments, it is a welcome restatement and development.

So much then, for the general arguments and debates which the book develops. What does Morley actually do?

What he does seems to me to add up to something of a breakthrough in British media research. His transcript material draws from 26 recorded sessions held with diverse groups, all of whom were undergoing some form of education or training at the time, thus providing Morley with an available context for his

lightly-funded research. Video screenings were used in a two-phase inquiry. Phase one involved screenings of a Spring 1976 *Nationwide* offering something of a representative 'mix' whilst phase two was based on a 1977 *Nationwide Special* on the Budget and its implications.

The earlier volume on *Nationwide* (BFI Television Monograph Number 10, co-authored with Charlotte Brunsdon) offered a socio-textual reading of the programmes in which it was argued that certain 'preferred readings' were identifiable, a matter of links, voice-overs, interview methods, film-editing and other features of the programmes' discourse. Using Parkin's (1973) basic typology of meaning-systems — dominant, negotiated and oppositional — with a view to its empirical testing and subsequent criticism, extension and modification, Morley here first plots to what extent those 'preferred readings' were recognized and either 'taken up' or 'refused'. He then traces how such takings up or refusals correlate with the socio-economic position of audience members and the location of those members within the different discourses operating across the socio-economic positions.

On the matter of recognizing the 'preferred reading' Morley notes:

> In fact, the recognition of 'preferring' mechanisms is widespread in the groups and combined with either acceptance or rejection of the encoded preferred reading; the awareness of the construction by no means entails the rejection of what is constructed.

So the viewer being aware of the 'setting-up' of an angle on the material is no indication that what is thus 'set-up' will thereby be rejected.

Discussing the responses of groups of apprentices to the programmes' trades union items (all apprentice groups are finally mapped as decoders using 'dominant' frame works), Morley notes that the Parkin argument about the difference between general and situationally specific forms of ideological reproduction and struggle is questionable:

> The situation here seems to be the converse of that outlined by Parkin in his account of working class groups who accept a dominant ideology at an abstract or generalised level but reject it, or 'negotiate' its application, in their own specific situation. Here, on the contrary, we have working class groups who proclaim a cynical distinction from the programme at a general level but who accept and reproduce its ideological formulations of specific issues.

Morley's thesis that the direct relating of decoding practices to class positions is unhelpfully reductive is borne out by the complexity and variations of reading displayed by groups with identical or very similar locations of this sort. It is quite clear that among the trades unionists groups interviewed the differences in 'decoding' are very much to do with the different discourses of trades unionism

(e.g. full-time officialdom, shop stewardship, public/private sector differences) and that these form almost as crucial a set of differentiating factors as that produced by a common trades unionism within broadly working class occupations.

The full range of debates (which includes sessions with student apprentices, management trainees, bank managers on in-service training, arts undergraduates, black students at different formal levels, and all-male, mixed and all-women groups) shows a very wide spread of interpretation and response. The use of institutionalised educational settings for the sessions, however informal the sessions were in themselves, along with the inevitable positioning of Morley and his colleagues as having something of the 'teacher' about them, would surely have skewed some of the responses, though it is hard to calculate precisely how this would have occurred and, anyway, what we are given is certainly enough to fuel the sort of ethnographic argument Morley is concerned to open up.

Although diverse 'criticism' of the programme's format is apparent (ranging from accusations of dullness (apprentice groups) to charges of triviality and lack of investigative depth (student groups) and although many groups adopt negotiated or oppositional stances on more substantive grounds with respect to particular items, Morley finds only two kinds of group which can be said to offer an 'oppositional reading' as such. One of these, black F.E students, is especially problematic since the members display not so much a critique of the programme as an almost total lack of connection with its discourses ('we're not interested in this like that', 'I just didn't think while I was watching it', 'I couldn't understand a thing he was saying').

The other 'oppositional' group consists of shop stewards who were, at the time of the sessions, on a labour history course. This group certainly offers a thorough critique of the Budget Special programme, almost ignoring matters of presentation in order to launch straight into an interrogation of the version of economics with which the Nationwide account is framed. The only problem here is that this group only sees and discusses the Budget Special, which means that the oppositionality of their readings across a wider area of Nationwide programming – on recreation, the family, crime, human interest stories etc. is not registerable. This leaves some important questions about the relation, within this group, of radical economic ideas to other attitudes, assumptions and framings rather marginally engaged with.

Nevertheless, the transcripts are well worth having and Morley's own reading of them is careful, clear and illuminating, bringing out the absolute necessity of conducting future research with the factors and problems he raises and discusses centrally in mind. The project as a whole offers data and discussion rather than any hard set of conclusions.

I have a number of reservations about the continued usefulness of the 'encoding/message/decoding' model for media enquiry, but Morley's usage is generally heuristic rather than categorical and there is not space here to pursue that argument, though one part of it would be to work out how far 'decoding' as a concept covers (confusingly?) questions both of perception/understanding and evaluation/response.

There is also the question of to what extent the suggestive but tricky notion of 'preferred reading' (obliquely placed in relation both to formal concepts like 'mode of address' and to notions of substantive ideological reproduction) can help research outside the area of broadcast journalism. It was developed primarily with that directly informational and referential mode in mind, to help plot the largely verbally-anchored rhetorics of apparently 'viewless' or else 'balanced' news and current affairs material. Its use within work on more narrative-based, fictional or visually dominant forms might present a harder job of analysis and categorization when it came to plotting audience 'actualizations' against each other and against the dominant structures of particular texts. Once again though, Morley's general approach is one which helps to progress questioning, debate and investigation of this sort.

In his final theoretical section, Morley criticises the authors of an article in *Screen* (Heath and Skirrow, 1977) for attempting to offer a political analysis of a television programme without regard for the extra-textual dimensions of its content and their interconnection with matters of media form and power. Indeed, the authors felt sufficiently free of obligations in this area to remark with polemical *hauteur*

> It should be stressed that no attempt will be made to deal with the level of 'social connotations' so constantly and laboriously the preoccupation of cultural studies.

Morley's monograph, in contrast, places 'social connotations' right at the centre of research and directs the cultural analysis of television into a new and potentially most productive phase.

John Corner

References

Bennett, T. (1979). *Formalism and Marxism*, London, Methuen New Accents Series.
Eco, U. (1972). Towards a semiotic inquiry into the television message, *Working Papers in Cultural Studies*, No. 3 CCCS, University of Birmingham. Also reprinted in Corner, J. and Hawthorn, J. (eds) (1980). *Communication Studies: An Introductory Reader*, London, Arnold.
Heath, S. and Skirrow, G. (1977). Television: a world in action, *Screen*, vol. 18, No. 2.
Parkin, F. (1973). *Class Inequality and Political Order*, St Albans, Paladin.

INDEX

317